JEWELRY

Ancient to Modern

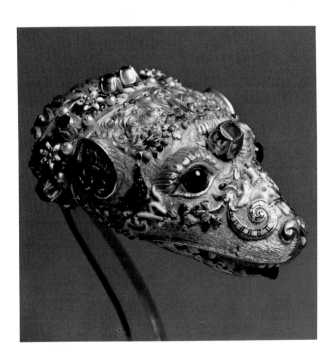

A Studio Book

The Viking Press
New York
in cooperation with
The Walters Art Gallery, Baltimore

All rights reserved
First published in 1980 by The Viking Press,
625 Madison Avenue, New York, N.Y. 10022
Published simultaneously in Canada by
Penguin Books Canada Limited

Library of Congress Cataloging in Publication Data
Jewelry, ancient to modern.

 (Studio book)
 Bibliography: p.
 I. Jewelry—Exhibitions
 I. Walters Art Gallery, Baltimore
NK7306.J49 739.27′074′015271 79-19527

ISBN 0-670-40697-x
Printed in the United States of America

Typeset in Garamond with headings in
Goudy Oldstyle by Alpha Graphics, Inc.,
Baltimore, Maryland

Color separations by Capper, Inc.,
Knoxville, Tennessee

Printed by Collins Printing and Litho-
graphing Company, Baltimore, Maryland

Designed by R.S. Jensen and Associates, Inc.
Production assistant: Peggy Rytter
Preliminary page design by Pete Traynor
Drawings by Bruce Bowersock

Acknowledgments

The catalogue has been made possible by a
generous grant from the National Endow-
ment for the Arts, a Federal Agency. It is
the composite work of six scholars who
wrote or prepared certain special sections
of the text, and whose names appear as
authors on those portions of the catalogue.
The editorial staff, photographic and con-
servation departments, and the registrar's
office have also made an immense con-
tribution to the work.

Contents

Edited by Anne Garside

Color Photography by Harry J. Connolly, Jr.

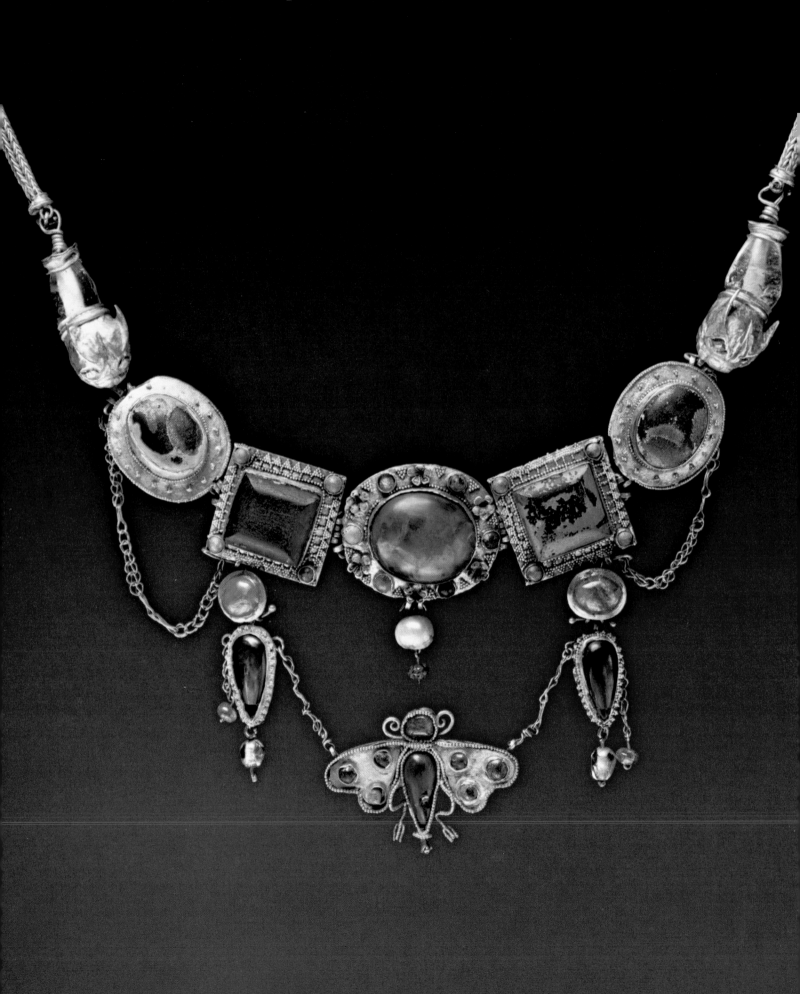

Foreword

As a collector Henry Walters is perhaps best summarized by Claudio's line in *Much Ado About Nothing,* "Let every eye negotiate for itself/and trust no agent." The eye of young Henry was quietly and steadily trained by his father William T. Walters, who took him as a perennial companion to the studios of the artists from whom he was selecting his contemporary collection. From the ateliers of Alfred Jacob Miller and Rinehart in Baltimore as a child to those of Gérôme, Millet, Corot, Daumier, and Barye in France as a nineteen and twenty year old, Henry went on the forays with his father.

By 1862 William Walters had developed new interests in the arts of Japan, and later in Chinese ceramics, and shared these passious with his son, who helped to write the later catalogues. The son might, of course, have reacted against this, but when William Walters died in 1894, Henry began immediately to express his own catholic taste for all of the great creations of mankind.

One of his earliest purchases, a group of Assyrian and Ancient Near Eastern cylinder seals, bought at the Century of Progress Exhibition from Dikran Kelekian in 1893, set the stage for his passion for the small and the precious. While his collections include the great paintings of the Renaissance and monumental Roman sculptures, they abound in the rich workmanship of small, lovable objects such as watches, gold boxes, ivories, and jewelry. The story is told of him that he often was seen in Paris with his left hand in his jacket pocket. Someone asked an acquaintance if Mr. Walters had injured his hand, but the reply was "that he was playing with his latest purchase."

From the start, Henry collected works of art of all cultures simultaneously. His taste knew no bounds. The collections of jewelry, therefore, grew over the entire spectrum of his life, and the early purchases indicate the variety of directions that his eye discerned. The great sapphire brooch in the shape of an iris by Tiffany and Company was purchased after its exhibition in 1900. In 1904 Walters visited the St. Louis World's Fair where he acquired the entire display of glass jewelry by René Lalique. And in 1903 he visited Naples and bought from the elderly Giacinto Melillo a series of necklaces in the neo-Etruscan style.

In that same year, Walters attended the sale of the Newton-Robinson gem collection and began his purchases of cameos and intaglios of the renaissance and Roman world. In 1909 the sale of the Marlborough gems attracted his attention, and he purchased a number of pieces of interest, though none of the most important examples. At the Gilhou sale of 1905 he bought some of the finest items including the Hellenistic diadem with the Hercules knot and a late Roman ring with two intaglios.

Walters had acquired the steam yacht *Narada* for his European excursions, and sailed across the Atlantic and as far as Constantinople on many occasions. In 1900, while the *Narada* lay in the harbor of Saint Petersburg beside the yacht of the Czar, Walters was ashore buying four jeweled parasol handles for the ladies of the family at the shop of Fabergé. There was a lull in collecting during the First World War, and then the Twenties saw an incredible quickening of pace, with purchasing on a much grander scale than in earlier years.

Walters was born in 1842, so that he was in his seventies when he became most active as a collector. He had devoted his early life to bachelorhood, the perfection of the family business, the Atlantic Coast Line Railroad, and to collecting. In his seventies he married, semi-retired from business, and devoted the majority of his time to collecting. The crates of objects received at his museum in Baltimore were legendary in the 1920's.

Yet there was a mystery about the man and his collection. Early in the century, for practical business reasons, Henry Walters moved the headquarters of the railroad to New York and took up his residence there. He surrounded himself with some of his most favored possessions, but sent all his other purchases to Baltimore, to the private museum he had erected between 1905 and 1909. That institution, open upon certain occasions to the public, was most famous for its collections of renaissance painting and the 19th-century collections of his father. But Henry was also quietly building major holdings in medieval art, the French 18th century, Islamic pottery, and antiquities.

He had been elected a trustee of the Metropolitan Museum in 1905 and had made prodigal gifts to that organization, such as the Siege of Troy shield to the Armor Department and the Egyptian Middle Kingdom jewelry of three princesses. The Metropolitan fully expected that their benefactor would will his collection to New York. Baltimore expressed no hopes of receiving the collection, and founded a civic museum in 1927. It was, therefore, a considerable surprise at the time of Walter's death in 1931 that his museum and its contents were willed to Baltimore. New York was much disappointed.

The complete collection comprised over 25,000 items in 1931, and it has been incorrectly surmised by historians that many agents must have had a hand in gathering so much material. Yet the few records that exist, as well as the memories of a number of contemporaries, attest the fact that with rare exceptions, the material was carefully selected and bought piece by piece by Henry Walters himself.

There were three existing collections that he purchased, the first being the most significant. This was the collection of Don Marcello Massarenti, which included both the finest of the Roman sculpture and a wealth of Italian renaissance paintings. It was for the Massarenti Collection and the modern collection of his father that Henry built his Gallery in 1905. For his library he bought the important Leo Olschki Collection of incunabula, and in 1928 he acquired the famous E. M. Hodgkins collection of Sevres porcelain.

In all other instances Walters seems to have followed a consistent pattern. He established relations with good dealers and visited them with regularity. Some, like Dikran Kelekian, supplied him throughout his life. Others like Berenson and Joseph Brummer entered the scene for shorter periods. Jacques Seligman and his brothers were constant in their attention to their client's desires, and the morning of Thanksgiving Day was reserved for Mr. Walters at Seligman's New York shop. In London, Harding took care of his commissions and shipped the material gleaned from many other dealers.

The jewelry came from many sources from the 1890's onwards, all of which are noted in the catalogue. The staff of the Gallery have acquired a number of pieces since 1934, especially Marvin C. Ross who took advantage of the Joseph Brummer sale to enrich the Migration collection. Dorothy Hill purchased important ancient items, especially in the Greek area, and Byzantine and medieval pieces have been added in more recent times. The 19th-century collection has been growing with the gifts of many generous friends.

The preparing of the catalogue, which has taken some years to accomplish, could not have succeeded without the support and encouragement of the Trustees over those years. Virtually every staff member, volunteer, and friend has in some way become involved, and they all deserve special thanks.

Richard H. Randall, Jr.
Director

Facing: The Butterfly Necklace from the Olbia Treasure (no. 281)

Glossary of Jewelry Terms

brilliant cut

cabochon

pendeloque cut

rose cut

table cut

Stone Cutting

brilliant cut—A style of cutting a stone into fifty-eight facets, used mostly for diamonds.

cabochon—A style of polishing a stone to give it a smooth, rounded top surface.

en cabochon—Cut in the cabochon style.

pendeloque cut—A tear-shaped style of cutting a stone which is then faceted in the brilliant style.

rose cut—A cut with twenty-four facets that resembles an unopened rosebud in shape.

table cut—A style of cutting a stone to give it a flat, table-shaped surface often surrounded by a beveled edge or smaller facets.

Settings

à jour—An open style of setting that exposes all the facets of a stone.

box setting—A setting in which the stone is secured by a rectangular metal frame.

pavé setting—A setting in which small stones are arranged in close proximity to one another secured by metal prongs.

Less Common Gemstones and Other Materials

almandine—A type of garnet of a deep red or purplish color.

baroque pearl—A large irregularly shaped pearl often used by renaissance goldsmiths to form the head or torso of an imaginary creature.

bloodstone (heliotrope)—Used frequently for seal stones; this stone is a type of chalcedony composed of plasma with dots of red jasper.

chalcedony—A type of quartz of milky, bluish-grey, greenish, or yellowish color of which the varieties are agate, cornelian, and chrysopase.

citrine—A variety of yellow quartz, ranging in color from pale yellow to a reddish hue.

cornelian (carnelian)—A translucent quartz, usually dull red in color, with a waxy lustre.

demantoid garnet—A variety of garnet which is green in color.

electrum—Known as 'white gold', electrum is an alloy of silver and gold.

faience—A general term for glazed earthenware.

haematite—A blue-black opaque stone often used for intaglio seal stones and beads.

hyacinth (jacinth)—This name refers to both an orange-red garnet and to a zircon of similar color.

jasper—An opaque quartz, varying widely in color. A large number of impurities in the stone, most frequently iron, create this wide color range (brown, yellow, red, green).

jet—Black lignite that takes on a brilliant sheen when polished.

lapis lazuli—A silicate of opaque nature, dark blue with white dots.

malachite—A translucent or opaque green stone mottled with dark or light bands.

matrix—A section of the parent rock in which a mineral is embedded.

meerschaum—A fine, clay-like substance, whitish in color, that solidifies and becomes hardened when heated. Heat also causes this substance to become totally white in color.

niccolo—An onyx, frequently used for cameos or intaglios.

opal—Semitransparent, milky white stone with shimmering, rainbow-like color effects.

plasma—A dark green type of chalcedony similar to jasper in composition.

rock crystal—A colorless, transparent quartz, differentiated from glass by its properties of greater hardness, coldness, and double refraction.

sard—A stone often used for seals. This mineral is a translucent chalcedony of a brownish-red color.

sardonyx—A variety of chalcedony that has parallel red and white stripes, the red being sard.

steatite (soapstone)—A variety of talc that is brown or greyish-green in color.

tourmaline—A greenish blue or light blue stone used as a gem.

Technical Terms

aglet, aiglet—Ornament sewn to the costume.

beaded wire—Wire with a grooved pattern pressed into it.

beveled—The plane formed by two surfaces at some angle less than a right angle.

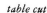

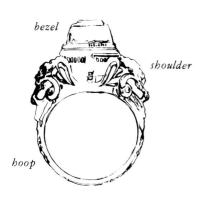

bezel—The top part of a ring, containing the stone, device, or other ornament.

boss—A raised ornamentation, similar to a knob, that protrudes from an object.

botonée—Decorated with rounded or trefoil ends.

casting—The manufacture of an object by pouring a metal in a liquid state into a mould, thus making an impression of that mould when the metal hardens.

chasing—The ornamentation of sheet metal using a hammer, chisels, and punches applied from the front.

cloison—An enclosure made of strip metal which surrounds a cut stone or enamel.

cloisonné—Enamel divided by partitions of metal secured to a base of metal.

champlevé—Enamel which is fused over a field of metal where the colors merge and blend.

émail en résille sur verre—The design is cut into a piece of glass or rock crystal, the depressions are then lined with a thin piece of gold foil which is then filled with translucent enamels.

émail en ronde bosse—An enameling process where the enamel is adhered to figures modeled in high relief. This technique was often used on the ornate pendants so popular during the renaissance period.

engraving—The process of cutting away a surface (metal or other) with a sharp instrument in order to create a linear design.

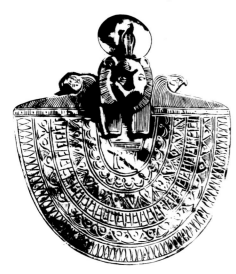

Symbolic designs are chased on the front of this ancient Egyptian insignia.

fibula—A brooch resembling a safety pin used in early times to secure folds of clothing.

filigree—A technique of twisting and soldering thin strands of gold or silver wire into patterns.

finial—A crowning ornament or detail.

flange—A band set inside a bezel that holds the stone firmly in place.

foil—A thin sheet of metal put under a paste or gemstone to enhance its brilliance or color.

granulation—A technique of soldering tiny metal balls onto a metal surface.

grisaille—A type of enamel painted with dark and light colors of similar hue to give a monochromatic effect.

hoop (shank)—The part of a ring that surrounds the finger.

inlaying—The process of setting a decorative material (usually a precious stone or piece of colored glass) into the surface of another substance, usually metal, without elevating the surface of the ground material.

intaglio—An engraving or incised design cut below the surface of a stone or piece of metal. When the stone or metal is pressed into a softer substance, an image in relief is made.

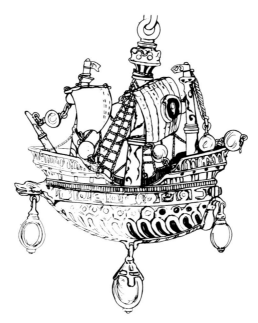

This intricate galleon pendant of gold, enamel, gems, and pearls, displays the virtuosity of the renaissance goldsmith's art.

niello—Any of several metallic alloys of sulfur with silver, copper, or lead giving a deep black color. Used for decorating silver and less frequently gold.

parure—A matching set of jewelry usually consisting of necklace, earrings, brooch and bracelet.

pectoral—A decorative piece worn on the breast. It may be pinned like a brooch or hung as a pendant.

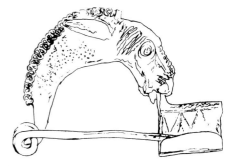

A Hunnish horsehead fibula.

pennanular—Almost circular in shape.

plique à jour—Enamel used over an openwork design, so that the light strikes it from the back.

repoussé—The working of sheet metal in relief from the reverse, using a hammer and punches.

shoulders—The sections of a ring hoop closest to the bezel or central ornament.

strapwork—A type of ornamentation in which flattish metal bands or strips are intertwined into decorative patterns.

verre eglomisé—An intricate method of painting on glass which is first coated with gold leaf. The outline of the design is traced onto the gold leaf, then covered, and the remaining gold leaf removed. The outline is painted in and finally the piece is varnished and backed with a reflecting metal foil. The technique reached its peak during the Renaissance.

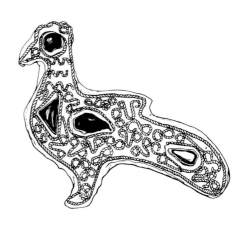

A Frankish peacock fibula decorated with filigree.

The Jewelry of The Ancient Near East

The civilizations which flourished in Asia from Iran westwards to the Mediterranean between 3000 B.C. and the conquest of Alexander the Great in the 4th century B.C. are usually grouped together as the Ancient Near East. This general term covers such diverse peoples as the Sumerians, whose language was unrelated to any other, the East Semitic-speaking Babylonians and Assyrians, the West Semitic Canaanites and Hebrews, the West Indo-European Hittites of Asia Minor, and the East Indo-European Persians of Iran, to name the most familiar. Many other names could be added to the list. The political situation in the area shifted endlessly, often violently. Still we may legitimately think of the Ancient Near East as a cultural entity for the civilizations there shared many common traditions. This was in part due to far ranging trade which, because natural resources were unevenly scattered in the area, developed very early. A major impetus for trade was the demand for the brightly-colored stones and gleaming metals with which to make jewelry. One might even claim the magical power of jewelry as a civilizing agent in the Ancient Near East. It is at least of historical significance that the "cradle of civilization," ancient Sumer in southern Iraq, where writing and the concept of cities was invented, had neither stone nor metal. The Sumerians' quest for gold and silver from as far as the west coast of Turkey and for lapis lazuli from Afghanistan, must have been instrumental in spreading knowledge of their civilized ways throughout the area.

It is appropriate that the first items in this catalogue of magnificent jewelry should be simple stone amulets from the heartland of the Ancient Near East. These well-worn talismans, painstakingly repaired in antiquity, are a reminder of the original amuletic purpose of jewelry—something magical, worn on the body to protect the wearer or increase his powers. Jewelry in the ancient world never quite lost its amuletic significance. This is obvious in Ancient Egypt where symbols, like the signs in the hieroglyphic script, remained in the form of concrete pictures from beginning to end. It is less apparent in the Ancient Near East, for there writing and symbols took on abstract forms in very early times. We know, however, that rosettes, stars, floral elements, quadruple spirals had religious significance. Jewelry was given as a votive to the gods. It was worn by statues of the gods used in ritual and constituted a significant part of the treasuries of the temples—important economic units of the ancient cities.

Evidence for the history of jewelry in the Ancient Near East is at once rich, sporadic, and contradictory. Actual examples of jewelry are rare. This is not surprising in light of the turbulent history of the area, the frequent sacking of cities, and with them, presumably, of royal tombs and graveyards. Only a few undisturbed burials, such as the Royal Tombs of Ur in Sumer, or Alaca Hüyük in Asia Minor, have been discovered. None of the burials of the great rulers of empire, which may have vied in richness with those in Egypt, have been found intact. Of the great treasuries stored in palace and temple, we have only a few hoards, hastily gathered and hidden in time of siege, never to be retrieved. Such treasuries are likely to be a hodge-podge of primitive and fine work, local and imported pieces, contemporary jewels and some thousands of years old—mixtures which reflect the other important function of jewelry in ancient times. In a world without coinage it served as a measure of wealth and a means of exchange. It was accumulated from many sources and kept for generations because of its intrinsic value. In trying to isolate the various sources for pieces in a treasure, we are helped by a few hoards from jewelers' workshops, and a greater number of ancient moulds for jewelry which have survived.

Ancient near eastern texts tell us how much jewelry we are missing. Jewelry is included in inventories of temple treasuries and royal dowries, lists of tribute and booty, and descriptions of gifts. The representation of jewelry in art, on the other hand, is sometimes misleading. The greatest collection of ancient near eastern jewelry comes from the Royal Tombs at Ur in Ancient Sumer, dating to the second half of the third millennium B.C. In this series of burials, some of them sacrificial, the dead were richly, even gaudily bedecked with headdresses, necklaces, earrings, rings, hair ornaments, and pins of gold, silver, lapis lazuli, and carnelian. The techniques of polishing and cutting hard stone, solid casting, repoussé, granulation, and filigree work in gold were already highly developed. Thick gold chains, with loops interlocked to form a square section, could be made. On the statues representing the upper classes of the period, however, no jewelry at all is shown. In fact, until the 9th century B.C., only very simple jewelry is seen on statues of kings or officials—a high collar necklace for women, a single strand of heavy beads for men, and an occasional simple bracelet. Some amulets strung around the neck are seen in Syrian frescoes from about 1800 B.C. Only on crude clay figurines or plaques representing votaries (often nude women) or deities can the elaborate jewelry of the Ur tombs be matched. It is not yet clear what this contradictory evidence as to fashions in jewelry means. The statues surviving from these times represent people in pious attitudes and it may be that there was some restriction against wearing finery "in church." The palace reliefs which began to be made in the 9th century B.C. in Assyria and Syria are more secular in nature and this may be why people are shown wearing a great deal of jewelry: diadems, earrings, necklaces, bracelets, armlets, as well as crowns and robes studded with gold appliqués. Ivories of the time from Syria show women in elaborate headdresses. Actual examples of jewelry from this period are extremely rare which is why the famous gold crowns shown here (no. 14) are so precious, although of rather primitive manufacture.

The jewelry seen on figures in the Assyrian reliefs obviously comes from several sources. Some pieces may have been tribute or booty. Foreign types may also have been made within Assyria since craftsmen from all over the Ancient Near East were brought to work at court. In sorting out the different types represented on the reliefs, stylistic analysis based on other forms of art is not very helpful, for jewelry is seldom representational. Burials of simple folk are, on the other hand, invaluable guides in isolating regional traditions. We know, for instance, that bracelets with stylized lion heads (see no. 25), so often seen on Assyrian reliefs, were actually native to the mountains of Iran for they have been found in graves in Luristan.

The preponderance of fine ancient near eastern jewelry in the Walters, as in many collections, comes from remote areas in Iran. It is probable that our knowledge of ancient near eastern jewelry will always depend on finds in such areas—places which were in contact with the great centers of civilization, but off the beaten track of sacking armies. In fact it is only by assembling many different kinds of evidence for jewelry, that a picture can be drawn from the sketchy remains of this rich but turbulent past.

Jeanny Vorys Canby

Notes:
The very nature of the material has long prevented a comprehensive survey of ancient near eastern jewelry, but K. R. Maxwell-Hyslop's recent pioneering work, *Western Asiatic Jewelry, c. 3000-612 B.C.* has done much to improve the situation.

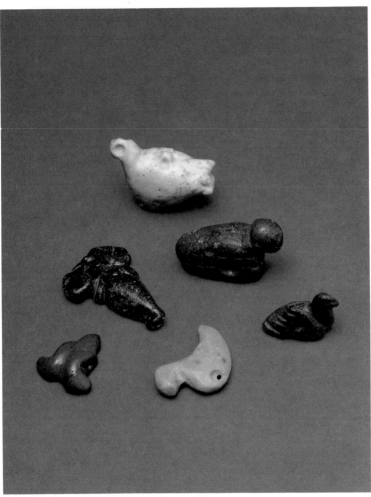

1, 2, 3, 4, 5, 6

Pendants 1-12

Mesopotamian, about 3000 B.C.

These simple amulets in the shape of animals show signs of wear and ancient repairs. They are of a type known from a period before writing (Prololiterate Period) in ancient Mesopotamia.

1. A worn pendant of white stone representing a plump dove. The feet and tail feathers are modeled, the line of the wings incised. A recessed circle (for inlay?) marks the eye. The perforated projection on the back is broken. (42.1463)

Total L. 1-3/16 in (.03 m)

2. An amulet in the shape of a ram's face with curved horns and notches that mark the eyes. There are perforations in the center of the horns, two finished, and one unfinished between horns. (42.1457)

L. 1-3/16 in (.03 m)

3. A simplified representation of a bird, made of red stone, with cross lines incised over the body and base, and two lines down the back. Perforated crosswise through the body. (42.1454)

H. 3/4 in (.019 m)

4. The frog amulet, smoothly carved of red-brown stone, is flat on the back side. Perforated sideways above the feet. (42.1462)

H. 11/16 in (.015 m)

5. A pink stone amulet carved in the shape of a single claw. (42.1456)

L. 7/8 in (.022 m)

6. A duck of black stone with broad incisions marking feathers. Perforated crosswise through the body. (42.1455)

H. 9/16 in (.015 m)

7. Pendant amulet smoothly carved of banded agate in the shape of a plump bird nesting. Perforated at an angle through the tail. (42.1460)

H. 1/2 in (.012 m)

8. Pendant of light brown stone smoothly polished, with incised details representing a seated bird with thick down-curved beak. Perforation between tail and legs. (42.1452)

H. 3/4 in (.019 m)

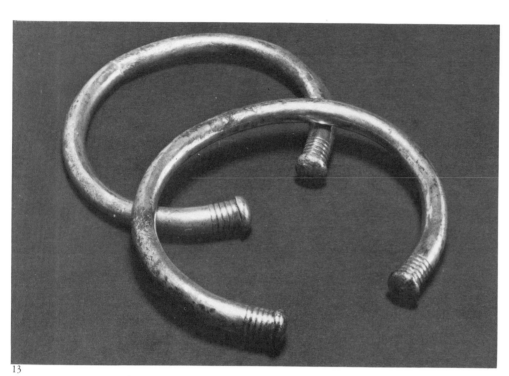

13

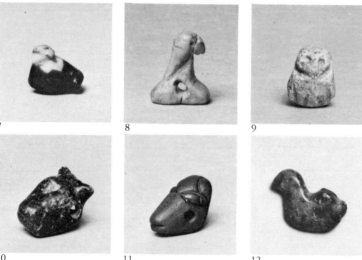

7 8 9

10 11 12

9. Pendant carved of porous white stone in shape of an owl; wide incisions mark head and wings. Perforated through shoulders. (42.1453)

H. 9/16 in (.017 m)

10. Ram's head pendant of smooth greenish stone, with incisions indicating horns, eyes, mouth, and indentation below jaw-bone. Perforated through jaws. (42.1461)

L. 13/16 in (.02 m)

11. Bull's head pendant of grey speckled stone. Incisions mark eyes, mouth, and indentation beneath jaw. A triangle is recessed on forehead to hold inlay. The old perforation across back of head under horns was broken and a new one made vertically down behind horns to old one. (42.1458)

L. 13/16 in (.02 m)

12. Smoothly carved bird with prominent tail feathers made of speckled green and black stone. Perforated crosswise through the body. (42.1459)

Total L. 1-1/8 in (.028 m)

History:
purchased from Sotheby and Company, (sale, London, November 26, 1968, lot 20)
Publications:
6. and 7. Jeanny Canby, "Most Ancient Folk Art," *BWAG,* 21, no. 7, April 1969
Notes:
for specific parallels to these pieces see Max Mallowan, "Excavations at Braq and Chagar Bazar," *Iraq,* British School of Archaeology in Iraq, IX, London, 1947, plates X:3, XIV, 1:17, XV:6, 7, 15

Armlets 13
Mesopotamian

A pair of heavy armlets of solid silver tapering towards the ends which are shaped like nail heads and decorated by incised lines. The inside diameter of the pieces suggests they were worn on the upper arm. The bracelets, one broken in two, were so heavily covered with corrosion, that they were originally classified as bronze. A similar pair of armlets, made of gold, was excavated in 1922 in the ancient E-nun-mah Temple at Ur under a floor of the Persian period (6th century B.C.). This hoard contained objects from as far back as the late third millennium B.C. Therefore it cannot provide a certain date for the bracelets. (57.621-2)

Max. Int. D. 3-3/16 in (.081 m) Max. Int. D. 2-5/16 in (.075 m)

History:
purchased by Henry Walters from Edgar Banks as "from Ur," 1930
Notes:
for the Ur bracelets see Sir Leonard Woolley, *The Neo-Babylonian and Persian Periods,* Ur Excavations, vol. IX, The University Museum of the University of Pennsylvania and The British Museum, London, 1962, U 457 plate 21, and pp. 29 ff. and 106

Two Gold Crowns 14

Ancient Syria, late 2nd millennium B.C.?

These gold crowns have been much dis-
cussed since they were first made known by
Robert Zahn who reconstructed them as
they now stand. The reconstruction (as
crowns rather than breastplates or collars),
and the authenticity of the plaques, now
seem to be generally accepted. A controversy
still exists, however, as to whether they
should be dated to the 8th-7th century B.C.
or five centuries earlier. The crowns differ
stylistically, iconographically, and techni-
cally, and it could well be that they were not
made in the same period. Old photographs
of the objects before reconstruction were
given to the Gallery forty-five years ago by
the dealer Fahim Kouchakji. These show
Crown A in two parts, hinged with hooked
gold wires, as were six plaques of Crown B.
The damaged portions of B, the gold foil
rosettes, which may once have been attached
to the crowns, as well as the ring, (no. 15),
appear in one of these photographs shown
here. Kouchakji also said that the pieces
were found before World War I in Latakiyeh,
Syria.

A. In the upper register of each of the seven
gold plaques of this crown is a winged sun-
disk under which two figures with conical
head (-dresses?) cup their breasts. Between
the women are pillars which support the
winged disk and a plant element. In the
lower register is a stiff row of three flowers
probably iris. The designs are bordered by
rosettes. The figured section was pressed
into a die, the rosettes stamped from the
back, the wings and flowers worked in
repoussé, and chased with a fine point. The
workmanship is often careless. A strip of
gold around the design area was rolled over
to make the hinges with which the sections
are fastened together. On the side, this strip
was divided into six sections, alternately
rolled or bent against the back of the panel.
On the adjacent panel, the strips are rolled
and bent in reverse sequence, thus forming
six neatly interlocking hinges through
which a gold wire could run. Traces of a
bungled attempt to work the female figures
into the die remain (upside down) under the
flowers of one section (see detail). The
winged disk supported by pillars suggests
a second millennium date. (57.969)

H. of plaque 4-1/2 in (11.5 cm)
W. of decorated surface 2-3/4 in (7 cm)
Max. Interior D. 6-1/2 in (15.8 cm)

B. In the top register of each of the nine
plaques of this gold crown, a sturdy goat
nibbles on plants through which it wanders.
In the rectangle below two nude girls in
heavy wigs hold hands and dangle an *ankh*
("life" sign) in their free hand. The girl at
left wears a horizontally ribbed crown, the

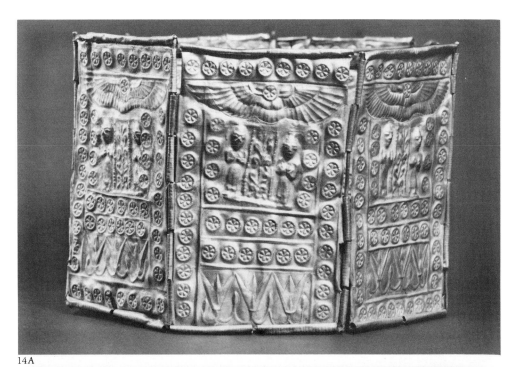

14A

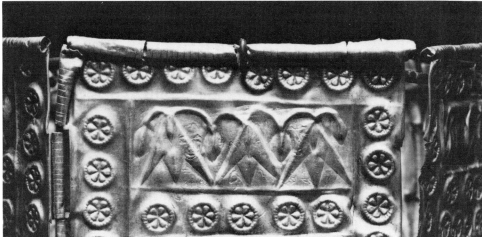

14A detail

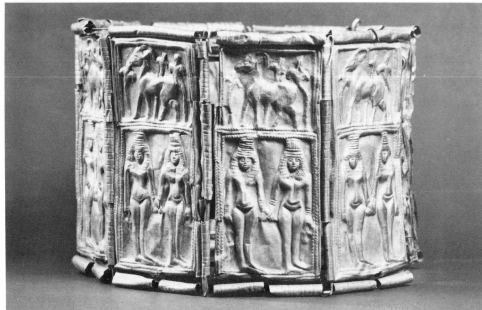

14B

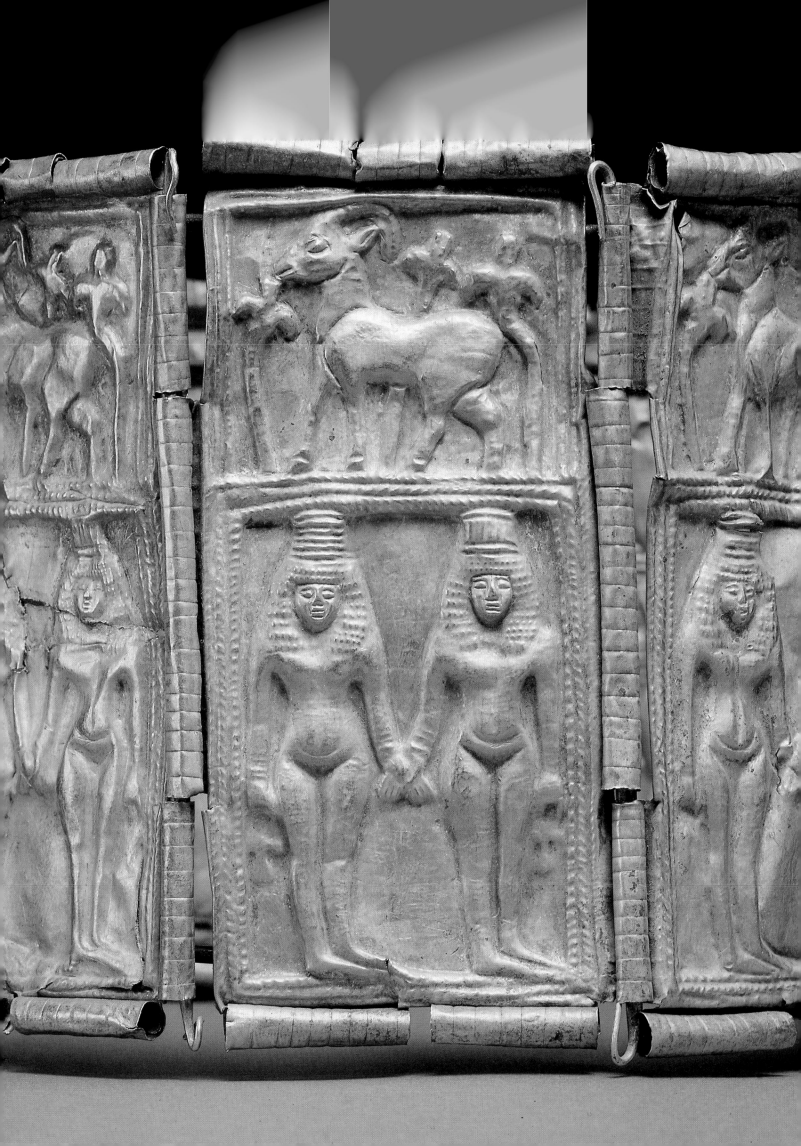

one at right, a vertically ribbed one. These designs were made by working sheet gold over a single die. Details were crisped somewhat haphazardly by chasing. The plaques are joined as in the above crown. The hinges are wider and the sides divided into two small hinges flanking a large central one. (57.968)

H. of plaques with hinges 4-9/16 in (11.6 cm)
W. of decorated portion 1-15/16 in (.049 m)
Max. Interior D. 6-1/4 in (16 cm)

History:
Crowns A and B: collection of Adolf Schiller; purchased by Henry Walters from Bachstitz, 1929

Publications:
Crowns A and B: Robert Zahn, *Illustrated London News,* March 16, 1929, p. 457; Zahn, *Schiller,* 1929, no. 106 a and b, pp. 50-51, see also p. 12, plates 39, 40; Robert Zahn, "Two Phoenecian Gold Crowns," *The Burlington Magazine,* 54, March 1929, pp. 139-140; Carlo Albizzati, "Nuove e vecchie trovate dei fabbricanti d'antichità," *Historia, studi storici per l'antichità classica,* vol. III, Milan, 1929, pp. 665 ff., figs. 11, 12; Robert Zahn, "Die Sammlung Schiller," *Pantheon,* vol. III, Munich, 1929, p. 128, fig. la, b; José Pijoán, *Arte del Asia Occidental,* Summa Artis, vol. II, Madrid, 1931, p. 411, figs. 594, 595, listed as 'Museo de Beyrout,' discussed, p. 414; Elizabeth Riefstahl, "Doll, Queen, or Goddess?", *Brooklyn Museum Journal,* 1943-44, p. 11, pl. 3, fig. 4; Carl Watzinger, *Handbuch der Archäologie I,* Handbuch des Altertumswissenschaft, vol. VI, p. 807; Richard Barnett, *A Catalogue of the Nimrud Ivories with Other Examples of Ancient Near Eastern Ivories in the British Museum,* London, 2nd edition, 1975, p. 105; William Culican, *The First Merchant Venturers, The Ancient Levant in History and Commerce.* Library of the Early Civilizations (ed. Stuart Piggott), London, 1966, pp. 102-103, fig. 112; Canby, *Ancient Near East,* nos. 28 a, b; William Culican, "The Case for the Baurat Schiller Crowns," *JWAG,* vol. XXXV, 1977, pp. 15-35.

Crown A only: George Hanfmann, *Altetruskische Plastik I,* Würzburg, 1936, p. 23, no. 46; E. Kukahn and A. Blanco, "El Tesoro de 'el Carambolo'," *Archivo Español de Arqueologia,* vol. XXXII, Instituto Español de Arqueologia, Madrid, 1959, p. 43, fig. 13

Crown B only: Valentine Müller, "Das phönizische Kunstgewerbe," *Geschichte des Kunstgewerbes,* ed. Helmuth Th. Bossert, vol. 4, Berlin, 1930, p. 139, fig. 1; Dorothy Kent Hill, *The Fertile Crescent, Art and History of Bible Lands as Illustrated in The Walters Art Gallery,* Baltimore, 1944, p. 16, fig. 18, and pp. 21-22; Pierre Demargne, *La Crète dédalique, ètudes sur les origines d'une renaissance,* Bibliothèque des écoles françaises d'Athènes et de Rome, fasc. 164, Paris, 1947, plate VII; Helmuth Th. Bossert, *Altsyrien, Die ältesten Kulturen des Mittelmeerkreises,* vol. 3, Tübingen, 1951, no. 774, p. 227; Dieter Ohly, *Griechische Goldbleche des 8, Jahrhunderts v. Chr.,* Deutsches Archäologisches Institut, Berlin, 1953, pp. 107-108, plate 31; Giovanni Becatti, *Oreficerie Antiche dalle Minoche alle Barbariche,* Instituto Poligrafico dello Stato, Rome, 1955, pp. 63, 171-172, no. 217, plate 38; Ann Farkas *et al., Thou Shalt Have No Other Gods Before Me,* The Jewish Museum, New York, 1964, no. 126; Ekrem Akurgal, *Orient und Okzident, Die Geburt der Griechischen Kunst,* Kunst der Welt, Baden-Baden, 1966, pp. 156, 157, 174, fig. 42; Roland Hampe, *Kretische Löwenschale des siebten Jahrhunderts v. Chr.,* Sitzungsberichte der Heidelberger Akademie der Wissenschaften, Philosophische-historische Klasse, 1969, 2nd Abhandlung, Heidelberg, 1969, p. 35, plate 16:1; Robert Fleischer, *Artemis von Ephesos und Verwandte Kultstatuen aus Anatolien und Syrien,* Leiden, 1973, p. 409

Facing: Detail of Crown B

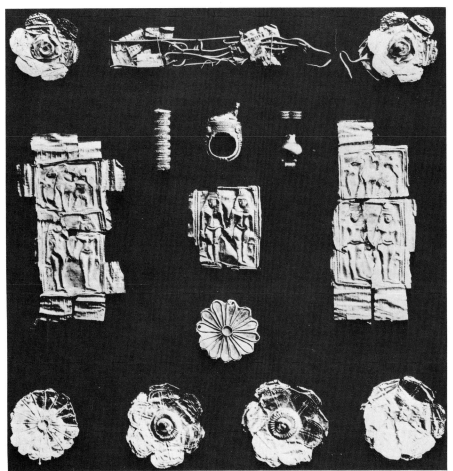

Photo showing pieces before reconstruction

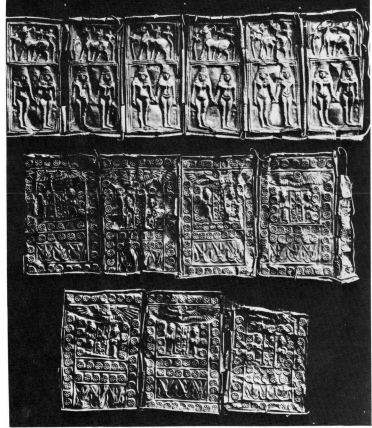

Photo showing reconstruction of crowns

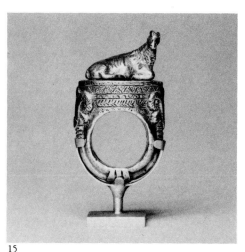

15

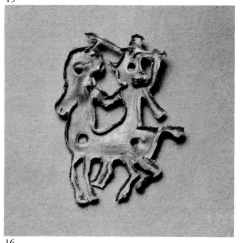

16

Ring 15
Ancient Syria, 2nd millennium B.C.

A heavy ring cast of gold or electrum with chased details. The hoop is elaborately decorated with lotus blossom in relief and bands of crudely chased geometric designs. On the bezel lies a well modeled ram. This seems to be a provincial version of an elaborate type of Egyptian ring of the New Kingdom period. (57.970)

H. 1-7/8 in (.048 m) Interior D. 11/16 in (.018 m)

Publications:
Zahn, *Schiller,* 1929, no. 106 c, p. 52, plate 46; *idem, Illustrated London News,* March 16, 1929, fig. 6; Canby, *Ancient Near East,* no. 24; William Culican, "The Case for the Baurat Schiller Crowns," *JWAG,* vol. XXXV, 1977, pp. 30 ff., figs. 9, 10
Notes:
for Egyptian rings see Aldred, *Jewels,* plate 91, and p. 217

Pendant 16
Ancient Syria, 15th-12th century B.C.

Only the gold base plate and frame of this pendant representing Astarte, the goddess of love and war is preserved. She wears a high crown with streamer and brandishes a spear above her plumed mount. Traces of white paste in the hat and light blue elsewhere, are all that remain of the original inlay(s). The piece was made by working sheet gold into a mould, leaving edges to hold the inlay. In some areas, where the edge was not high enough, more gold was added rather crudely. Three holes pierce the base plate, at the head of the goddess, and at the rump and shoulders of the horse. There is a horizontal suspension loop behind the neck of the goddess and behind the horse's plume. (57.1593)

H. 1-13/16 in (.045 m)

History:
purchased by Henry Walters, 1929
Publications:
Canby, *Ancient Near East,* no. 25
Notes:
for gold frames of the type from Carchemish, see Ursula Seidl, "Lapisreliefs und ihre Goldfassungen aus Karkamis," *Istanbuler Mitteilungen,* vol. 22, Deutsches Archäologisches Institut, Abteilung Istanbul, Tübingen, 1972, pp. 15-42; for mention of our piece see pp. 17 ff.

Pair of Earrings 17
Ancient Syria, 11th-10th century B.C.

These seem to be variants of a type of earring with pendant "mulberry" elements, which has been found in Syria, Palestine, Cyprus, and Iran in late 2nd millennium B.C. context. From a tall triangular ear wire hang a cluster of five biconical gold beads attached together at pointed ends. The bead at top is flanked by hollow disks, the one at bottom has a cluster of four granules. The beads are made in two halves in repoussé. (57.608-9)

Total H. 1-5/16 in (.034 m)

Notes:
for the closest parallel see K. R. Maxwell-Hyslop, *Western Asiatic Jewelry c. 3000-612 B.C.,* Methuen's Handbook of Archaeology, London, 1971, pp. 225 ff., plate 200 (right)

Two Pendants 18
Ancient Iran, about 1000 B.C.?

These glass pendants in the form of a ram's head have large holes drilled up under the chin. The face and ears of one ram (a.) are white with lines of black and yellow; the eyes are black surrounded by yellow, and horns and jaws are black. The head of the other ram (b.) is white, the eyes black surrounded by blue, the horns brown and white striped, the lines marking the nostrils and mouth black.

Such pendants were thought to be Etruscan but the recent discovery of a similar pendant in Iran, where sophisticated glass working is attested in the early first millennium B.C., suggest that area may have been the center of manufacture. (47.96-7)

a. L. of entire pendant 1 in (.025 m)
b. L. of entire pendant 7/8 in (.022 m)

History:
a. source not known b. purchased by Henry Walters, 1913
Publications:
a. Canby, *Ancient Near East,* no. 39
Notes:
for Etruscan examples see *BMCJ,* nos. 1454, plate XXIII, and p. 143 on no. 1453; for the example from Iran see Oscar W. Muscarella, "Excavations at Dinkh Tepe 1966," *BMMA,* vol. 27, 1968, p. 194, fig. 19

Bead 19
Ancient Iran, early 2nd millennium B.C.?

The surface of this hollow, spherical gold bead is neatly covered with hollow hemispheres placed close together. Spaced evenly between these are eight cloisons now empty. The bead is dented. The combination of cloisons and granulation recalls beads from Trialeti, Georgia, dated to around 2000 B.C. (57.2036)

Max. D. 5/8 in (.015 m)

History:
acquired in Tabriz; gift of Carlton S. Coon, Jr., 1977
Notes:
on Trialeti bead see K. R. Maxwell-Hyslop, *Western Asiatic Jewelry c. 3000-612 B.C.,* Methuen's Handbook of Archaeology, London, 1971, p. 75, plate 54

Spacer Bead 20

Ancient Iran, 9th century B.C.?

This bead of light blue frit has two tiny perforations through the biconical elements. The piece is broken on two sides. It would have been part of a necklace of at least three strands. (48.2431)

Preserved W. 7/16 in (.012 m)

History:
acquired in Tabriz; gift of Carlton S. Coon, Jr., 1977

Bead 21

Ancient Iran, 9th-7th century B.C.

This bead is covered with rounded conical gold elements, which appear to have been pressed into a die. It is made of a hemispherical piece of gold foil, tucked over a flat base. A gold loop is attached to the upper part of the back. (57.2037)

D. 3/4 in (.020 m) Max. H. 3/8 in (.010 m)

History:
acquired in Tabriz; gift of Carlton S. Coon, Jr., 1977

Spacer Bead 22

Ancient Iran, 9th-7th century B.C.?

This long bead in the shape of opposing shells was made of sheet gold worked in repoussé. The cloison for inlay at the base of each shell, made of a rolled strip of gold, is surrounded by two strands of twisted wire. Double tubes (made by rolling sheet gold in opposite directions), attached behind the shells, suggest the piece divided two strands of a necklace. (57.2040)

H. 1-1/4 in (.032 m)

History:
acquired in Tabriz; gift of Carlton S. Coon, Jr., 1977

Button (Appliqué) 23

Ancient Iran, 9th-7th century B.C.?

The thin disk of grainy gold appears to have been cast. The central cloison and the wires which surround the bosses were added rather carelessly. A wide loop attached in the center of the back is now flattened. The piece was probably meant to be attached to clothing. (57.2038)

D. 9/16 in (.020 m)

History:
acquired in Tabriz; gift of Carlton S. Coon, Jr., 1977

18b 18a

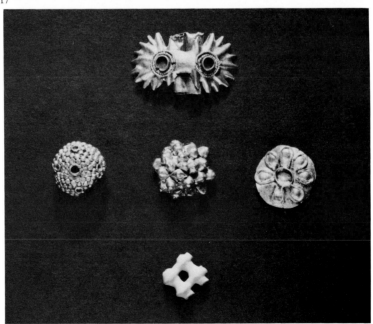

17

	22	
19	21	23
	20	

Key

19, 20, 21, 22, 23

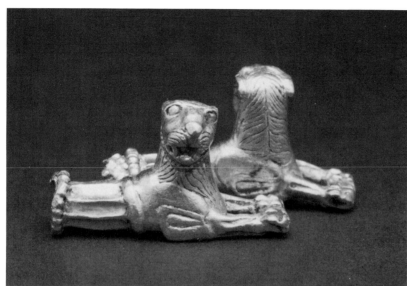

24

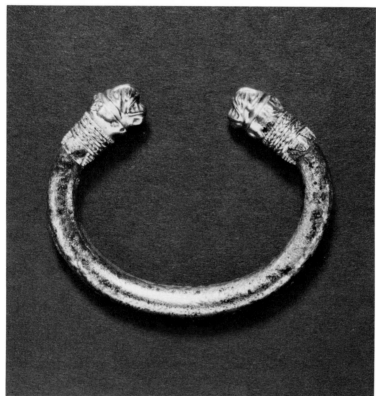

26

Armlet 24

Ancient Iran, about 1000 B.C.

These two cast gold terminals with extensive surface working probably belong to an armlet made of thick gold wire wound into a double circle with which they came into the collection, as the fluted tube behind the lion protomes fits snuggly over the wire. One end of the wire is melted off and a lump of melted gold remains in one of the tubes. The lions have a low forehead and only one fang represented on either side of a receding jaw. The mane with a small ruff hangs in thick strands over the chest, but is parted in the back, where it is represented as thick triangular tufts. The comical provincial style has some parallels in Iran. (57.1558a-c)

L. 15/16 in (.024 m) Interior D. of collar 1/4 in (.006 m)

History:
purchased by Henry Walters from Dikran Kelekian, 1911; said to come from "Pontus"

Notes:
for flat-headed lions and treatment of the mane see Edith Porada and Robert Dyson, "Notes on the Gold Bowl and Silver Beaker from Hasanlu," *A Survey of Persian Art* (ed. Arthur Upham Pope and Phyllis Ackerman), vol. XIV, London, 1967, pp. 2971-2978, figs. 1043, 1044

Bracelet 25

Ancient Iran, 9th century B.C.?

The terminals of this cast bronze bracelet are in the shape of lion heads. Recessed triangles over the snout and between the ears presumably held inlays. The underside of the head is hollow. This feature, as well as the mint condition of the piece and the presence of zinc in the metal, cast doubt on the authenticity. (54.125)

H. 3 in (.077 m) Interior D. 2-1/4 in (.057 m)

History:
purchased by Henry Walters from Dikran Kelekian in a group of Luristan bronzes in 1931; said by him to be "from Nehavend, Persia"

Notes:
for bracelets of this type see K. R. Maxwell-Hyslop, *Western Asiatic Jewelry,* Methuen's Handbook of Archaeology, London, 1971, pp. 246 ff. and fig. 230; for a discussion of zinc in such bronzes see P. R. S. Moorey, *Catalogue of the Ancient Persian Bronzes in The Ashmolean Museum,* Oxford, 1971, pp. 298 ff.

Bracelet 26

Ancient Iran, 8th century B.C.

The silver bracelet has gold terminals in the shape of roaring lion heads. Each head was made in repoussé from two pieces fastened together along the line of the snout. Gold filigree decoration behind the head consists of wires notched to imitate granulation and wires laid side-by-side to imitate braid. The pendant triangles are made of strips of wire notched to imitate filigree. (57.1853)

Max. Interior D. 2-1/4 in (.058 m)

History:
purchased from E. S. David, New York, 1955
Publications:
Dorothy Kent Hill, "Gold and Electrum Bracelet," *BWAG,* vol. 8, no. 1, 1955, p. 3; Canby, *Ancient Near East,* no. 50
Notes:
The mate of this piece is in the Metropolitan Museum of Art, New York (acc. no. 51.72.3).

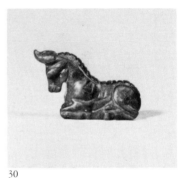

25 27

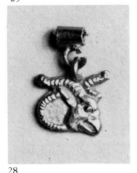
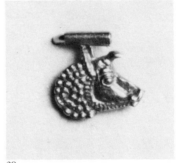
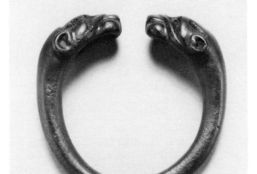

28 29 30

Fibula Clasp 27
Urartean, 8th century B.C.?

A human hand attached to a griffin with head turned sideways, would have held the pin of this ancient type of brooch. The piece, cast of bronze (?), has sockets reserved for inlaid eyes and brow. The tail is pierced for an attachment. The bird has a spiral crest below which a stiff ruff runs to the shoulders. Semi-ovals mark the neck feathers. The muscles of the foreleg are indicated by a tulip pattern, those of the back leg, by curved lines. The fierce head of the beast and other stylistic detail recall works from ancient Urartu, modern Armenia. (54.2232)

Max. H. 1-3/8 in (.035 m)

History:
old label "P 2124"; purchased by Henry Walters from Joseph Brummer, 1925
Notes:
for good photographs of bronze furniture elements of the same style from the Haldi Temple at Toprak-kale, see Guitty Azarpay, *Urartian Art and Artefacts: A Chronological Study,* Berkeley, 1968, plates 54 and 51 (head turned sideways)

Pendant from Necklace 28
Persian, 5th-4th century B.C.

The griffin's head, cast in solid gold, must once have formed part of a necklace. A loop attached to the head between the horns let the piece swing freely on a second gold loop attached to a tubular gold bead. The elegant stylization of the fierce beast is typically Achaemenid (the style of the ancient Persian Empire). (57.2042)

H. of griffin's head 1/4 in (.006 m)

History:
collections of Arthur U. Pope; George Hewitt Myers; purchased from the Textile Museum, Washington, D.C., 1977
Notes:
for this type of necklace see Helene J. Kantor, "Achaemenid Jewelry in the Oriental Institute, Oriental Institute Museum Notes No. 8," *Journal of Near Eastern Studies,* vol. XVI, Chicago, 1957, pp. 4-5 and plate II; for griffins see *ibid,* pp. 8 ff., and plates IV, VIc.

Pendant from Necklace 29
Persian, 5th-4th century B.C.

This element from a necklace is solid cast of gold in the shape of a boar's head. The ears are attached to a hollow tube of sheet gold which held the bead rigid. (57.2041)

H. of whole bead 6/16 in (.005 m)

History:
collections of Arthur U. Pope; George Hewitt Myers; purchased from the Textile Museum, Washington, D.C., 1977
Notes:
for this type of necklace see Helene J. Kantor, "Achaemenid Jewelry in the Oriental Institute, Oriental Institute Museum Notes No. 8." *Journal of Near Eastern Studies,* vol. XVI, Chicago, 1957, pp. 4-5 and plate II; for the stylization of the boar's head, see bracteates in Roman Ghirshman, *The Arts of Ancient Iran from its Origins to the Times of Alexander the Great,* The Arts of Mankind series, New York, 1964, figs. 551-552, in the Teheran Museum

Ring Bezel? 30
Persian, 6th-5th century B.C.

A typically Achaemenid bull carved with fine detail from lapis lazuli perforated lengthwise just above the base. If strung, it would hang upside down, and therefore it seems more likely that the piece was wired as a ring bezel. (42.221)

H. 5/8 in (.012 m)

History:
purchased by Henry Walters from Dikran Kelekian, 1912
Publications:
Canby, *Ancient Near East,* no. 51; Denise Schmandt-Besserat *et al., Ancient Persia: Art of an Empire,* The University Art Museum, University of Texas at Austin, 1978, no. 85

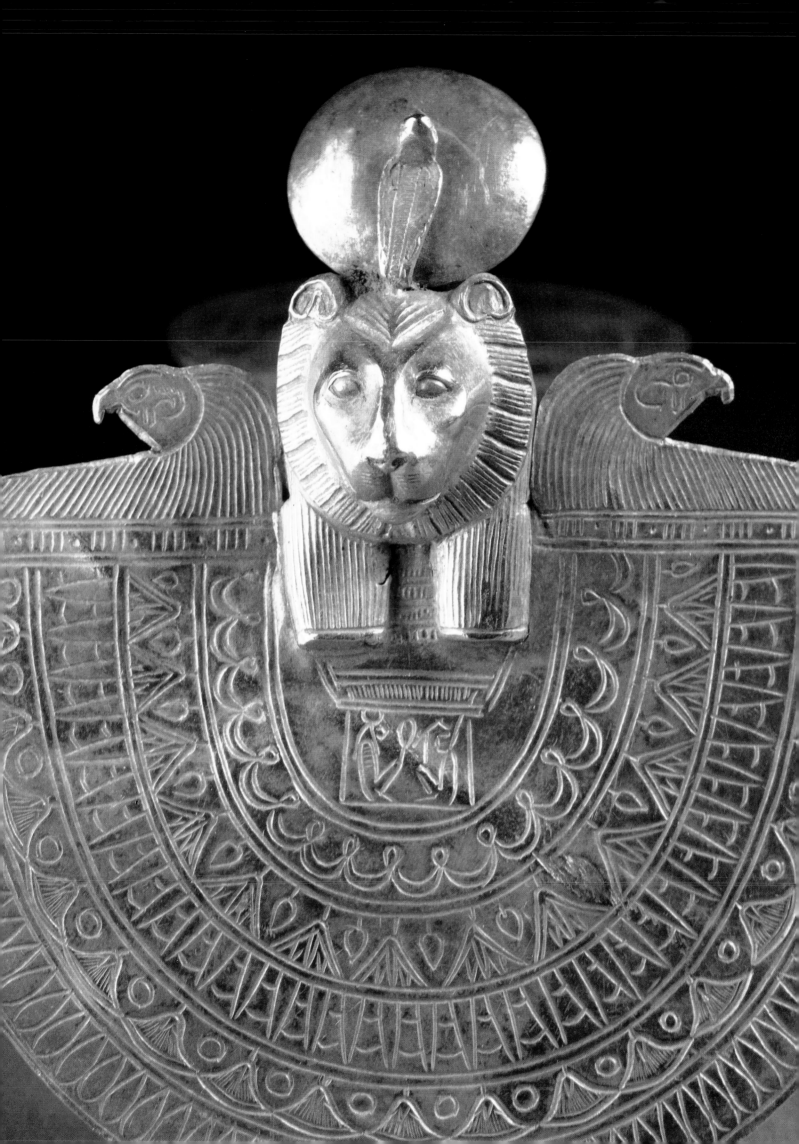

The Jewelry of Ancient Egypt

One of the more appealing aspects of the long-lived civilization which flourished in the Nile valley from before 3000 B.C. down to Roman times was the cheerful belief that life in the next world was much like life in this. The corresponding notion that the things of this life were needed in the next is responsible for the wealth of well-preserved jewelry from tombs in Ancient Egypt that has survived to our own times. Unlike what remains from the Ancient Near East, much of this is royal jewelry. The now familiar treasures of King Tut-ankh-amun are but the richest in a long series of royal jewels going back as far as the first historic dynasty, about 3000 B.C. Jewelry inscribed with the name of the owner making it easy to date, as well as wonderful pictures on the walls of tombs showing jewels being worn and ancient jewelers at work, have provided a wealth of evidence from which it has long since been possible to study ancient Egyptian jewelry.

Some of the jewelry from tombs, although exquisitely made, is obviously too fragile to have been worn and must have been made specifically for use in the other world. Some, however, shows signs of having been worn. In many cases it is impossible to distinguish between "personal" and "funerary" jewelry if the provenance is not known, unless like the Ba bird (no. 118), which represents the soul of the dead, it is specifically connected with the iconography of the afterlife. Nor was the distinction necessarily of great importance to the ancients. Amulets form one of the largest categories of extant Egyptian jewelry, for it was the custom to place these within the wrappings of the mummy. These amulets, however, are nearly always provided with a means of suspension, indicating that they were still conceived of as something which could be worn.

As in the Ancient Near East, jewelry was worn in Egypt by men as well as women and by statues of the gods. Here, too, it served as a measure of wealth and a means of exchange. Heavy gold collars were the standard royal reward for officials and generals. With the great demand for jewelry in this life and the next, it is no wonder that the craft early developed into a complex and refined art. The infinite patience and rigorously high standards characteristic of Egyptian artisans is nowhere more evident than in the jewelry they produced. Working with only bronze and stone tools, open brazier and blow pipe, they created exquisite pieces which can equal those of the better equipped jewelers of later times.

Egypt was fortunate in having at hand an abundance of raw materials for making jewelry: gold, turquoise, agates and amethyst from the desert to the east, or from Sinai. Silver and lapis lazuli, however, had to be imported. Glazes and glass-like substances were also used extensively as substitutes for precious stones. The Egyptians early discovered that steatite, which was easy to carve, would take a glaze and become hardened in the firing process. Faience, a vitreous paste, which self-glazes to a beautiful blue-green when fired, was also discovered early. True glass with the bright opaque colors the Egyptians preferred was manufactured in the New Kingdom about 1500-1100 B.C. when it was, strangely enough, cut and inlaid in cloisons rather than fused into them as in real enamel work.

Necklaces were particularly popular in Egypt. The most typical form is a wide collar which lay in a broad circle below the throat. The Walters collection has one section of such a necklace which came disguised as a gold choker with dangles (no. 33). Heavy bead necklaces and pectorals were also popular. Diadems, armlets, girdles, bracelets, anklets and various hair ornaments were also worn but earrings, which were always popular in the Ancient Near East, were not introduced into Egypt until the New Kingdom (about 1500 B.C.). Most of this jewelry had amuletic significance. The exquisite little pendant figures, of which there are so many in this collection, represent deities or their sacred animals and were used as talismans to help or protect the wearer. Elegant amulets have been found strung merely on twine or clustered on a wire with no apparent interest in the aesthetics of the arrangement. The elements of the intricate and pleasing designs are usually hieroglyphs with symbolic meaning.

The familiar scarab represents a dung beetle, an insect the Egyptians believed to be self-created from the ball they observed it rolling. As they associated this behavior with the rising and setting of the sun, the beetle took on the amuletic significance of creation, rebirth and power. The earliest rings were merely scarabs tied to the finger. Gold wire crudely knotted replaced the string, and finally a more elegant hoop was devised. The bottom of the scarab was sometimes flattened and decorated, later inscribed with a person's name and this, after centuries, led to the development of the signet ring. The rings shown here illustrate much of this development.

It is often impossible to date Egyptian pieces, in part because of the amuletic character of the jewelry. There was, understandably, little innovation in the represen-

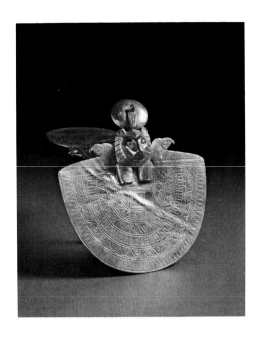

tation of sacred or magical subjects over the years. A lively conservatism is, furthermore, the very essence of Egyptian art. Forms developed in the earliest periods remained standard for thousands of years, although they seldom became static or dull. Paradoxically, the very wealth of well-dated court jewelry has contributed to the problem of dating pieces, for it has postponed the tiresome analysis of minute stylistic differences which poorer material demands. The royal jewels of Egypt have understandably dazzled all eyes.

Jeanny Vorys Canby

The inscriptions in this section have been translated by Hans Goedicke, Professor of Near Eastern Studies, The Johns Hopkins University. The chronology is based on that in Cyril Aldred's *Jewels of the Pharoahs: Egyptian Jewelry of the Dynastic Period,* and George Steindorff's, *Catalogue of the Egyptian Sculpture in The Walters Art Gallery.*

Facing and above: Lion-headed goddess wearing broad collars and pectoral (no. 31)

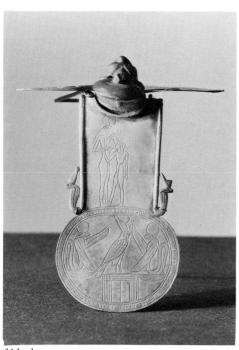

31 back

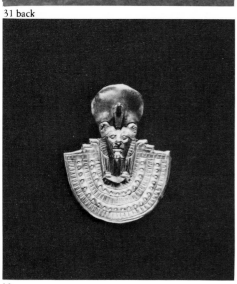

32

Insignia 31
Egyptian, 10th-9th century B.C.

Designed to be placed in the hand of a statue of the lion-headed goddess Sakmet (see no. 103), or offered to her as a gift, this gold cult object is included here because it illustrates some of the most common forms of Egyptian jewelry. The piece consists of an *aegis*, the head of Sakmet wearing a sun disk and *uraeus*, mounted over a formal collar necklace with falcon-head terminals (see no. 33). This is attached at an angle to a *menat*, the ancient Egyptian term for an elaborately decorated counterweight used to balance a heavy necklace made of a mass of plain beads. The object also underscores the symbolic complexity of many motifs used in Egyptian jewelry. The necklaces represented here were popular types of real jewelry, but pictures of necklaces also served as signs in the hieroglyphic script (see sign on no. 46), and models of them were used as amulets (see no. 34).

The broad collar of the *aegis* has rows of beads in the shape of dates, papyrus blossoms, leaves, and lotus blossoms held neatly in order by rigid terminals. The threads of the necklace are shown gathered from the cross piece into the falcon-head terminals. The lines of another collar necklace worn by the goddess may be seen between the lappets of her wig. Below this collar hangs a typical shrine-shaped pectoral (see nos. 44-48). Inside the pectoral are pictured the goddess seated opposite a god wearing the crown of Upper Egypt.

Dangling beside the upper part of the *menat* are two serpents, the one at left wearing the high white crown of Upper (southern) Egypt, the one at right, the low red crown of Lower (northern) Egypt. In the space between, the lion-headed goddess is seen nursing a child, probably the god Harpocrates. In the circular area below, the sky god Horus, a falcon wearing the double crown, is supported on either side by winged serpents with sun disks perched on a basket—the hieroglyph of the goddess Buto of Lower Egypt used in royal titles.

The collar and *menat* were made of sheet gold (1 mm. thick) on which the designs were chased. The disk, *uraeus*, and hollow lion head, made in repoussé with chased details, were fashioned separately and fastened over the broad collar. The solid-cast serpents of the *menat* were also made separately. A hinge at the back of the counterweight holds the two sections together, while a collar attached to the opposite side holds them apart at an angle. (57.540)

L. of counterweight 2-11/16 in (.068 m)

History:
purchased by Henry Walters, 1924

Publications:
The Detroit Institute of Arts, *Life and Art in Ancient Egypt,* 1963, no. 88
Notes:
for a close parallel dating to the time of King Osorkhon, see Émile Vernier, *La bijouterie et la joaillerie égyptiennes,* L'Institut français d'archéologie orientale du Caire, Mémoires, vol. 2, Paris, 1907, plate XIX, 1, and p. 115; for the type of object see Charlotte R. Clark, "An Egyptian Bronze Aegis," *BMMA,* November 1953, pp. 78-83, and Dows Dunham, "An Egyptian Bronze Aegis," *BMFA,* vol. 29, no. 176, December 1931, pp. 104-109.

Pendant 32
Egyptian, XX Dynasty?, 13th-11th century B.C.

Pendant of thin sheet gold depicting a lion's head, decked with wig, disk, and *uraeus* above a broad falcon collar. Many gold examples of such *aegis* amulets are known. The pale gold was partly cast, partly worked in repoussé. The head is hollow. The *uraeus* and suspension loop attached behind the disk were made separately. (57.1429)

H. 1-1/8 in (.029 m)

Notes:
for some similar examples see Williams, *Catalogue,* p. 66, no. 9 a, b, plate V; Émile Vernier, *Bijoux et orfèvreries,* Catalogue général, vol. 48, no. 3, plate 41, no. 52 693, and *ibid,* vol. 48, no. 4, plate XCV, no. 53 218 for a necklace made up of *aegis* amulets; for the type in other materials, see Petrie, *Amulets,* no. 195, plate XXXV and p. 42.

Collar Section 33
Egyptian, New Kingdom? 16th-12th century B.C.

These beads have been restrung as a collar necklace. The date-shaped beads of gold foil with loops at either end and the drop pendants of gold foil with a back face covered with foil certainly belonged to such a necklace. The cylindrical beads of green glass (top) and biconical beads of translucent red stone (second row), and the tiny gold dangling elements may also have belonged. The hollow biconical gold beads are ancient but seem too big for the piece. The tubular beads with hangers are modern. (57.601)

L. of drop pendants 7/16 in (.012 m)

Notes:
see necklace of Smenkh-ka-re in Aldred, *Jewels,* fig. 71 and p. 211

Amulet 34
Egyptian

Bright blue faience was used to fashion this flat amulet into the shape of a counterpoise of a necklace (see nos. 42, 103). Pictured in relief on the front is a lion's head of Sakmet wearing a wig, disk and *uraeus* mounted over a broad collar from which dangle serpents with disks on their heads. Between them is a *wedjet* eye (see no. 82). In the circle at the

bottom two winged serpents flank a squatting figure with lion head surmounted by a disk. The back is flat except for the reverse of the lion's face. The outline of the wig, with two long streamers, is indicated by incised lines. (48.1626)

H. 3-3/4 in (.095 m)

Notes:
see M. G. A. Reisner, *Amulets*, vol. II, Catalogue général, vol. 35.2, Cairo, 1958, plate VII, no. 12719, 12721, 12722, plate XXIV

Necklaces and Beads	35-43

Necklace 35
Egyptian, Middle Kingdom?, 20th-17th century B.C.

This (restrung) necklace consists of biconical carnelian beads, beads of rolled strips of sheet gold, and ten amulets. The rooster and couchant animal at either end of the necklace, cast of a pale yellow metal, probably do not belong. Below the rooster at left is a tiny heart amulet of carnelian. The other amulets are cut out of sheet gold of varying thickness and have rolled sheet gold loops attached to the back. Below the couchant animal at right is an amulet showing a man holding palm branches, which symbolized "millions of years". The six remaining figures are hieroglyphics as well. The three birds at left probably represent the sacred ibis of the god Thoth although the long body of one and thick bill of another seem more appropriate to ducks. Two amulets show the double crown resting on a basket, which signified royal power in Upper and Lower Egypt. Another basket amulet has something protruding from it. (57.1515)

H. of largest amulet 7/16 in (.011 m)

Notes:
for heart see Petrie, *Amulets*, no. 7, and Alan H. Gardiner, *Egyptian Grammar: Being an Introduction to the Study of Hieroglyphics*, Oxford, 1927, F 34; for ibis and ducks see Petrie, nos. 66, 247, Gardiner, G 26-29, 38-39; crowns on basket, see Petrie, no. 50, Gardiner, S 6; for the last amulet ("bind?") see Gardiner, V 37

Spacer Bead 36
Egyptian, XII Dynasty, 20th-18th century B.C.

A gold leopard's head has been strung with ancient amethyst beads to show how it could reduce two strands to one. The bead was made from two identical pieces which must have been worked over the same mould. The style of the leopard with its fierce brows is very close to that of the spacer beads in the girdle of Princess Sit-Hathor-Yunet and Queen Mereret of the XII Dynasty. The forehead is dented. (57.1980)

H. 5/16 in (.006 m)

33

37 front

37 back

History:
collection of Suydam; purchased from John E. Kieffer, Jr., 1966
Publications:
Canby, "New Egyptian Jewelry," p. III, plate I, fig. 1
Notes:
see Aldred, *Jewels*, color fig. 36 and pp. 191 ff., and Émile Vernier, *Bijoux et orfèvreries*, Catalogue général, vol. 48, part 3, no. 53075, pp. 352 ff., and plate LXXIX

Bead 37
Egyptian, XII Dynasty, 20th-18th century B.C.

A flat rectangular bead made of grey steatite with a single, worn perforation on the long axis. The front is carved in relief showing a seated ape, a reed, and a tree. A three column hieroglyphic design is incised on the back of the bead. The central column may be the name of King Sesostris III. (42.87)

L. 1-1/8 in (.028 m) Max. thickness 2-1/16 in (.06 m)

History:
purchased by Henry Walters from Dikran Kelekian, 1923

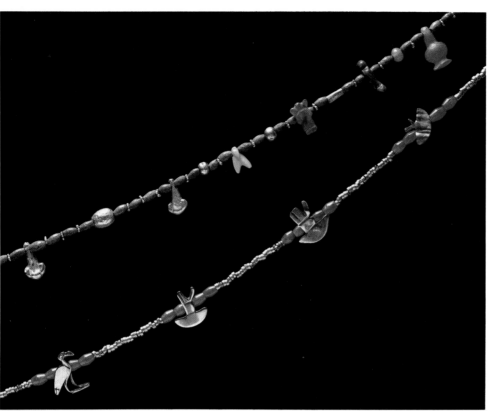

35 top, 38 bottom (details)

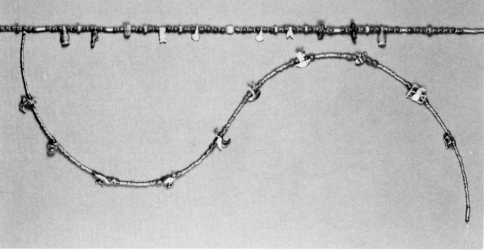

35, 38

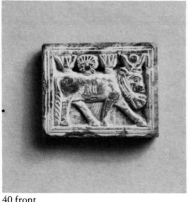

40 front 40 back

Necklace 38

Egyptian, New Kingdom?, 16th-12th century B.C.

Beads of gold, blue faience, and carnelian are interspersed in a modern arrangement with thin gold beads decorated with granulation and eleven amulets. At either end of the necklace are the familiar cornflower pendants carved of carnelian. Next, crude faience pendants (jackal heads?); then, hippopotamus-heads carved of carnelian. Next at left, the hippopotamus goddess Toeris (patroness of birth), carved from a thin sliver of light blue glass, matched at right with a fly (a military emblem), cast of shiny, light blue glass. Next, gold pendant-amulets in the shape of serpent heads. These are hollow and flat on the back. The top side, has sketchy details in repoussé. In the center of the necklace is a gold scarab-shaped bead made in the same way. The use of glass suggests a New Kingdom date (see no. 124). (57.1516)

H. of cornflowers 1/2 in (.012 m)

History:
purchased by Henry Walters from Dikran Kelekian
Notes:
for jackal-head amulet see Petrie, *Amulets,* no. 22; for hippopotamus head amulets see *ibid,* no. 237; for snake head amulets see *ibid,* no. 97. All three are apotropaic (evil-averting). The fly, *ibid,* no. 19, is also used as a hieroglyph, see Alan H. Gardiner, *Egyptian Grammar: Being an Introduction to the Study of Hieroglyphs,* Oxford, 1927.

Spacer Bead 39

Egypt, New Kingdom, 14th-12th century B.C.

This cartouche-shaped bead made of faience, subsequently glazed with blue and white faience, served to divide three strands of a necklace. On the back are three rounded ridges over each of the three perforations. The hieroglyphs inside the *cartouche* give the throne name of King Amenophis III (1410-1372 B.C.) (42.86)

H. 1-1/8 in (.03 m) Thickness 3/8 in (.09 m)

History:
purchased by Henry Walters from Dikran Kelekian, 1923

Spacer Bead 40

Egypt, 6th century B.C.

This bead of greyish steatite, with traces of greenish glaze, has three lateral perforations. The designs are carved in high relief within a rectangular frame. On one side is the Apis bull (see nos. 92, 93), wearing a disk between its horns and a heavy necklace. Above his back are lotus blossoms and a palmette of ancient near eastern type. The opposite face has three columns of hieroglyphs, the outer ones giving the names of King Amasis (570-526 B.C.). The central column reads "The good-god, lord-of-the two-lands, may he live eternally." (42.377)

L. 1-1/4 in (.032 m) Max. thickness 2-1/16 in (.07 m)

Bead 41

Egyptian

This large openwork bead made of blue faience has on either side five different goddesses, each identified by a headdress. The hollow space between suggests the two sides of the plaque were made in identical moulds and joined before firing. Perforated lengthwise. (48.1662)

L. 2-1/8 in (.053 m)

Notes:
Petrie, *Amulets*, no. 153a, plate XXVII

Spacer Bead 42

Egyptian

A bead made of steatite, glazed light green-brown, with six perforations along the edges. The back side is hollowed out. (48.2053)

H. 1-1/16 in (.027 m)

History:
gift of Dr. Eleanor P. Spencer, 1952

Bead 43

Egyptian

This lentoid bead made of turquoise-colored faience is perforated longitudinally and may have been part of a bracelet. Carved into the rounded upper side are two apes flanking a palm tree. On the back is a kneeling figure with crocodile(?) head beneath which are two crocodiles, the lower one wearing a plumed headdress. (42.382)

L. 1-15/16 in (.05 m) Max. H. 1/16 in (.015 m)

Notes:
for apes see Fouad S. Matouk, *Analyse Thématique, Corpus du scarabée égyptien*, vol. 2, Académie Libanaise, Beyrout, 1976, p. 345, design nos. 580 a-g; for crocodile-headed figure see *ibid*, p. 338, design nos. 299, 302, 303

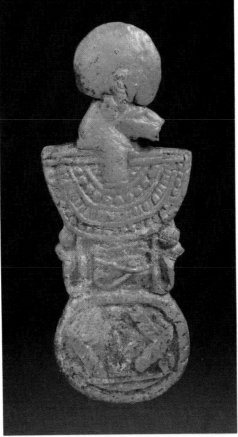

34

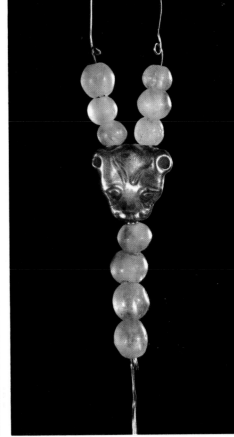

36

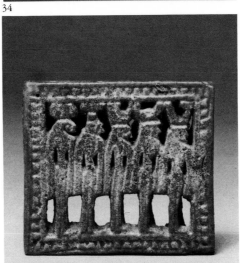

41

43 front 43 back

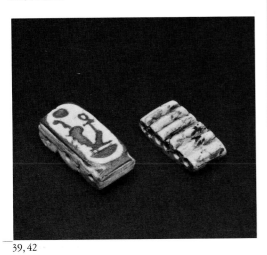

39, 42

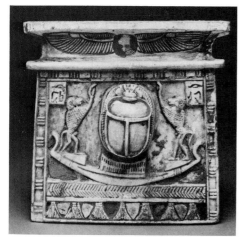

44 front

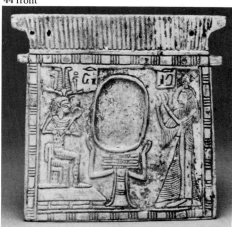

44 back

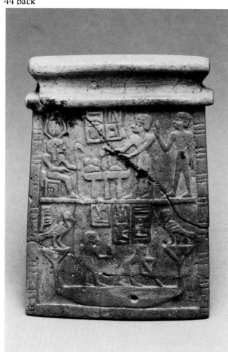

48

Pectorals 44-50

An important item of Egyptian funerary jewelry was a large pendant in the shape of the facade of a shrine, the front side having an overhanging cornice. In the center of the pectoral there was often a heart scarab, a substitute for the real heart of the deceased, sometimes inscribed with magical spells. The gods of the afterworld appear on these pectorals: Osiris (or his *djed* pillar), chief god of the dead; Isis, his wife, and her sister Nephthys (or the *tyet,* the girdle knot symbolizing them); the ape of the god Thoth, or the jackal of the god Anubis, both of whom were involved in the weighing of a person's heart. These pectorals were usually perforated by holes, which run from the top edge to the back side of the piece so that the attachment would not be seen. The examples here are of well known, non-royal types.

Pectoral 44
Egypt

On this glazed steatite pectoral traces of red paste remain in the background areas, and blue paste beneath the boat. Triangles were inlaid in the paste between the lotus blossom frieze on the front side. On the front, two apes of Thoth stand in a boat, paws raised as if to support the central scarab attached to an oval recess. On the reverse is seated the god Osiris, wearing a notched garment, which suggests his role as a grain god. He is adored by a woman in flowing gown with a perfume cone on her head. Between the figures a *djed* pillar has arms raised to support an oval, which may have held another scarab. All four hieroglyphic inscriptions read "Osiris". (42.91)

H. 3-3/4 in (.095 m)

History:
purchased by Henry Walters(?), 1929
Notes:
see Erika Feucht, *Pektorale nichtköniglicher Personen,* Ägyptologische Abhandlungen, 22 (eds. Wolfgang Helck, Eberhard Otto), Wiesbaden, 1971, no. 99 A, plate XIV, nos. 107 B, E, plate XVI, no. 108 B, plate XVII

Pectoral 45
Egyptian, XIX Dynasty, 1320-1200 B.C.

Yellow faience, a material which appeared in the 15th century B.C., is used for this pectoral. The lines on cornice and sun disk, and the figures on the back, are rendered in dark blue faience. The dresses of the women are red, part of the boat is green, and the border is made up of alternating red, blue, green and yellow squares. Cracks along the edges suggest that these different colored faiences were inserted into the yellow faience matrix before firing. On the front side beneath the

winged disk (shown here under the roof) are two goddesses kneeling at either end of a boat, hands raised toward the empty oval, which must once have held the scarab. At left "Nephthys, the god's sister" is identified by hieroglyphs; at right, "Isis, the god's mother." On the back, seated gods also identified by hieroglyphs support the scarab. At left is "Harendotis," at right, "Anubis who is in Ut." The eight perforations at the top are incomplete and damaged. There are four vertical holes in the bottom edge. The piece has been repaired with gold metallic paint. (42.199)

H. 4-3/8 in (.111 m)

History:
purchased by Henry Walters from Joseph Brummer, 1926
Notes:
for yellow faience see E. Terrace, *BMFA,* vol. LXIII, 1965, p. 222; for type see Erika Feucht, *Pektorale Nichtköniglicher Personen,* Ägyptologische Abhandlungen, 22 (eds. Wolfgang Helck, Eberhard Otto), Wiesbaden, 1971, no. 38, plate IV

Pectoral 46
Egypt

A glazed steatite pectoral with incised design. On the front a woman wearing a perfume cone worships the jackal god Anubis seated on a shrine. Above him are two symbols: the *wedjet* (eye of Horus, see no. 82) and a collar signifying "gold" (see nos. 31, 32). On the back a *djed* pillar is flanked by two *tyet* girdles, symbolizing Osiris between Isis and Nephthys. (42.89)

H. 2-13/16 in (.072 m)

Notes:
see Erika Feucht, *Pektorale Nichtköniglicher Personen,* Ägyptologische Abhandlungen, 22 (eds. Wolfgang Helck, Eberhard Otto), Wiesbaden, 1971, nos. 167-172, plate XXVIII, no. 178 C., plate XXIX, nos. 205 K-217, plate XXXV-XXXVII

Pectoral 47
Egyptian

The black painted designs on this faience pectoral have faded. On the front the jackal of Anubis lies on a shrine, on the back side a *djed* pillar is flanked by *tyet* knots (see no. 46). (42.88)

H. 3-15/16 in (.097 m)

Notes:
see Erika Feucht, *Pektorale Nichtköniglicher Personen,* Ägyptologische Abhandlungen, 22 (eds. Wolfgang Helck, Eberhard Otto), Wiesbaden, 1971, nos. 120-144, plates XXII-XXV, nos. 205 K-217, plates XXXV-XXXVII

Pectoral 48
Egyptian

This unusual faience pectoral has scenes carved on the front face, the back is blank. In the top register two worshippers in short kilts stand before a table of offerings set

before the seated Osiris; in the bottom register, a man stands in a boat while another poles it along. Birds are perched on the papyrus blossoms at either end of the craft. (42.90)

H. 3-3/8 in (.085 m)

History:
old labels "2836" and "4099"; purchased from Hadji Mohassah at Luxor; purchased by Henry Walters from Dikran Kelekian

Parts of Pectorals 49
Egyptian

a. This steatite plaque may have been part of a pectoral. The front is carved in relief depicting two apes of the god Thoth at either end of a boat, raising their paws beside a winged scarab that supports a crescent and a disk. Incised on the back is a scene in which the god Harakhty (Horus with falcon's head) is seated at left, opposite Atum, the sun god, at far right. Between them is Horus-the-Falcon. (42.378)

L. 2 in (.05 m)

History:
purchased by Henry Walters from Maurice Nahman, 1930

b. This element, probably from a pectoral, was made by attaching two flat faience plaques to a plaster core. Over these were attached plaster figures in relief, covered with gold foil. There is a dark adhesive material on the bottom edge and both side edges of the piece. On the front two figures on a boat raise hands toward a central scarab with extended legs. On the back are shown the four sons of the god Horus, who protected different parts of the body in the Netherworld (see no. 153). (42.379)

L. 2-13/16 in (.071 m) Max. thickness 2 in (.05 m)

History:
purchased by Henry Walters, 1913
Notes:
for use of plaster see Williams, *Catalogue,* no. 137, p. 196

Pendant-Pectoral 50
Egyptian, XIX Dynasty, 1320-1200 B.C.

Related to the pectorals is this steatite pendant, suspended by a perforated tang. Stone inlays are set in black paste. On the front is a beetle with outstretched legs in high relief. On the flat reverse tiny inlays filled the recessed figures. Shown within a square frame is a male figure in the elaborate dress of the Ramesid period adoring Osiris. The hieroglyphs at top identify the figures as "Osiris" and "The Osirian Mose." (42.83)

L. 2-7/16 in (.061 m)

History:
purchased by Henry Walters from Maurice Nahman, 1930

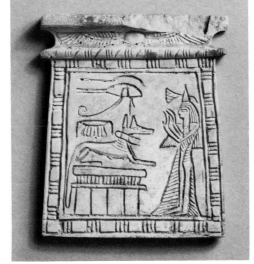
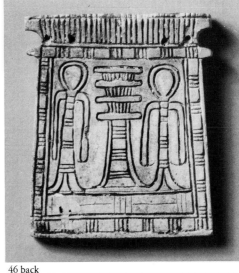
46 front 46 back

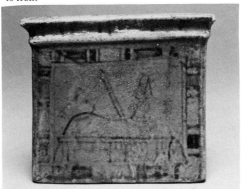
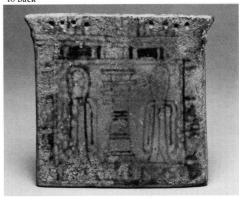
47 front 47 back

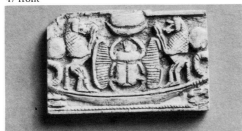
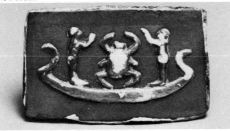
49a front 49a back

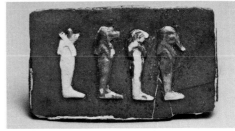
49b front 49b back

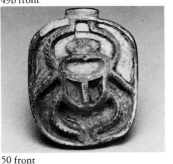
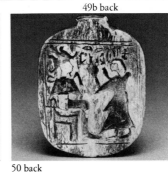
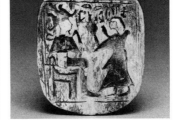
50 front 50 back

Amulets were an important part of funerary equipment and the position in which some of them were laid on the mummy suggests that they were thought of as jewelry. The deities who appear most frequently on these amulets are: Isis, wife of the great god of the Netherworld, Osiris; her son Horus-the-Child (the Greek Harpocrates), who is shown as a nude youth with side lock, sucking his thumb; Nephthys, the sister of Isis; the ram-head god Khnum, creater of mankind; the falcon-headed Horus wearing double crown symbolizing his position as national god, or disk, symbolizing his role as god of heaven; and the ibis-headed Thoth, god of wisdom (literature and science), or his sacred animals the ibis, or baboon.

Amuletic Necklace 51
Egyptian

Because these light blue faience beads of crude workmanship appear to have been made in the same shop, they have been strung together. From left to right are Horus wearing a disk, two plaques with Horus-the-Child flanked by Isis and Nephthys, Thoth, Horus in double crown, Nephthys, Shu (god of the atmosphere), Nephthys, Horus with disk, Thoth, two plaques, Horus-the-Child between Nephthys and Isis, and Khnum. The figures are pierced at shoulder height through a back pillar against which they stand. The plaques have pierced flat bands protruding from them.

(48.1676-7, 1679, 1680, 1684, 1701, 1702, 1705, 1708, 1709-1711)

H. largest plaque 1-1/8 in (.028 m)

Publications:
Steindorff, *Catalogue,* no. 460, plate LXXVII; no. 461, plate LXXVII; no. 465, plate LXXVI; no. 466, plate LXXVI; no. 468, plate LXXVI; no. 469, plate LXXVI; nos. 538, 565, 567, 570, 585, 593

Amuletic Necklace 52
Egyptian

At either end of this necklace of light blue faience are four *djed* pillars, symbols of Osiris. Following these at left comes Thoth, Horus with disk, a papyrus column, Isis flanked by Horus with double crown, Horus with disk, and Khnum. The amulets have been restrung in the order of those found on a mummy at Hawara. All figures have pillars behind them and these are pierced at shoulder level. (48.1685-99)

H. *djed* pillars 1-1/8 in (.028 m)

Publications:
Steindorff, *Catalogue,* no. 459, plate LXXVII; no. 563, plate LXXXVIII; nos. 564, 568, 569, plate LXXXVIII, nos. 584, 592, plate LXXXVIII

Notes:
see Petrie, *Amulets,* plate L, no. 1, for Hawara mummy

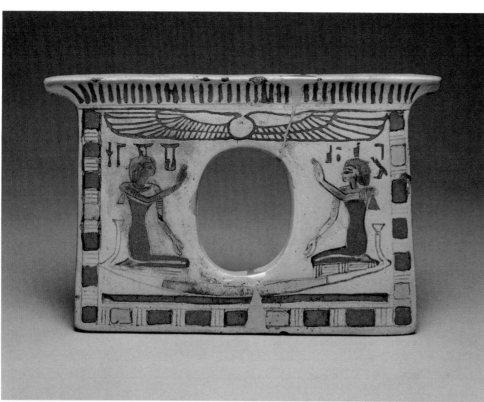

45 front

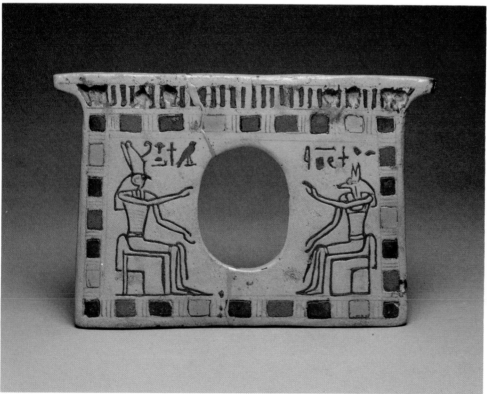

45 back

Pendant 53

Egyptian

A lapis lazuli amulet representing the goddess Isis seated on a throne decorated with a scale pattern. She holds her left breast and raises the head of infant Horus on her lap. The broad face and squat proportions may indicate an early date. The back is perforated at shoulder level. (42.346)

H. 1-9/16 in (.04 m)

Publications:
Steindorff, *Catalogue,* no. 404, plate LXX

Pendant 54

Egypt

A cast silver pendant representing the goddess Isis nursing Horus (now missing). The tips of the horns above her crown are also missing. There is a large loop behind the headdress. (57.1426)

H. 1-5/8 in (.04 m)

History:
purchased by Henry Walters from Dikran Kelekian

Publications:
Steindorff, *Catalogue,* no. 400

Pendant 55

Egyptian

This mould-made pendant of royal blue, glass-like faience (?) with some carved detail represents Horus-the-Child seated, knees drawn up, holding a broken flail over his left shoulder. Behind the neck is a loop for suspension. The right arm and leg are missing. (42.198)

H. 1-3/8 in (.035 m)

History:
collection of Carmichael, (sale catalogue, *Antiquities of the Collection of the Late Lord Carmichael of Skirling,* Sotheby and Company, London, Wednesday, June 9, 1926, lot no. 245); purchased by Henry Walters from Dikran Kelekian, 1926

Publications:
Steindorff, *Catalogue,* no. 455, p. 116; the material is wrongly listed as lapis lazuli

Amulet 56

Egyptian

The feet have broken away from this black-speckled carnelian representation of Horus-the-Child, but the angle of the legs suggest he was seated on his mother's lap (see no. 107). A loop protruding from the shoulders is also broken off. (42.195)

Preserved H. 3/4 in (.02 m)

History:
collection of Carmichael (sale catalogue, *Antiquities of the Collection of the Late Lord Carmichael of Skirling,* Sotheby and Company, London, Wednesday, June 9, 1926, lot no. 235); purchased by Henry Walters from Dikran Kelekian, 1926

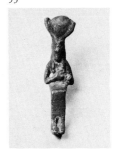
53
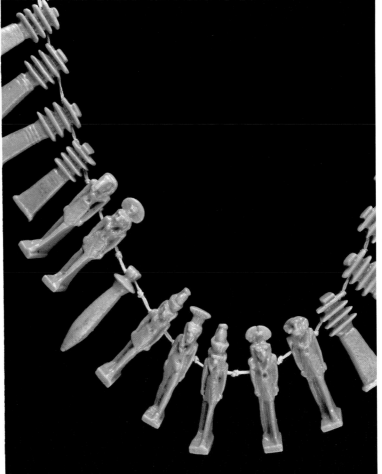
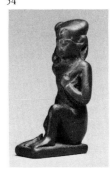
54
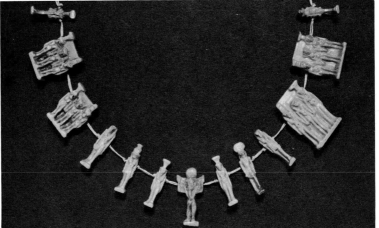
55
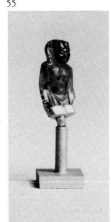
56
52
51

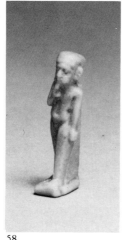

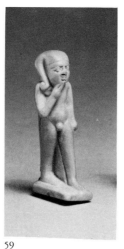

57

58

59

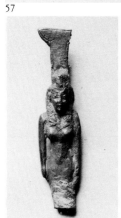

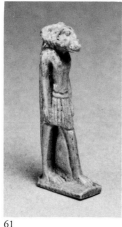

60

61

62

Pendant? 57
Egyptian

The god Horus-the-Child seated on a pillow, knees drawn up, is carved in relief on both sides of a thin piece of lapis lazuli. A perforation runs from the top of the head to the back of the skull. (42.222)

H. 1-1/4 in (.032 m)

History:
purchased by Henry Walters from Dikran Kelekian, 1912

Amulet 58
Egyptian

Horus-the-Child made of light blue faience, pierced through the back pillar. (48.1596)

H. 1-3/8 in (.035 m)

Publications:
Steindorff, *Catalogue*, no. 438

Amulet 59
Egyptian

Horus-the-Child made of light blue faience, pierced through back pillar. (48.1703)

H. 1-7/8 in (.022 m)

Publications:
Steindorff, *Catalogue*, no. 439

Pendant 60
Egyptian

A cast silver amulet representing the goddess Nephthys, the sister of Isis, standing. She wears a small crown surmounted by the hieroglyph for her name, loop behind crown, legs broken off. (57.1478)

H. 1-7/8 in (.047 m)

Publications:
Steindorff, *Catalogue*, no. 458

Pendant 61
Egyptian

This very well modeled version of the god Khnum is made of pale green faience. (48.1924)

H. 1 in (.025 m)

History:
gift of Dr. Charles W. L. Johnson, 1945

Pendant 62
Egyptian

A ram, sacred animal of the god Khnum, is smoothly carved of lapis lazuli. It has a round pierced projection on back. (42.343)

H. 3/4 in (.02 m)

Publications:
Steindorff, *Catalogue*, no. 694

Pendant 63
Egyptian

Djed pillar, symbol of Osiris, made of royal blue faience (see no. 85). (48.1700)

H. 13/16 in (.021 m)

Pendant 64
Egyptian

This version of the god Thoth is finely carved of lapis lazuli. The end of the beak is broken. (42.345)

H. 1 in (.025 m)

History:
purchased by Henry Walters, 1913

Publications:
Steindorff, *Catalogue,* no. 594

Pendant 65
Egyptian, late predynastic period, about 3200 B.C.

This caricature of a seated, chattering ape (later sacred to Thoth) with bulging eyes was carved from some non-elephant ivory. Geometric patterns carved under the base suggest that the piece may have been a seal. The shoulder is perforated. (71.525)

H. 1 in (.025 m) Thickness 5/16 in (.006 m)

History:
collection of MacGregor (sale, Sotheby, Wilkenson, and Hodge, London, June 29, 1922, lot 708); purchased by Henry Walters from Dikran Kelekian

Publications:
Steindorff, *Catalogue,* no. 14, p. 20, plate I

Pendant 66
Egyptian, late predynastic period, about 3200 B.C.

A squatting figure carved from some non-elephant ivory probably representing a monkey. Traces of crossed lines on the base suggest the piece may have been a seal. Perforated through the shoulders. (71.526)

L. 1 in (.025 m) Thickness 1/4 in (.007 m)

History:
collection of MacGregor (sale, Sotheby, Wilkenson and Hodge, London, June 29, 1922, lot 708); purchased by Henry Walters from Dikran Kelekian

Pendant Amulet 67
Egyptian

In this tiny baboon made of faience, the characteristic features of the standard Egyptian representation are exaggerated. He is seated hands drawn up on knees and nearly enveloped by a solid mass of hair. The hair is perforated behind the ears. (48.1562)

H. 9/16 in (.014 m)

Publications:
Steindorff, *Catalogue,* no. 689

67

63 64

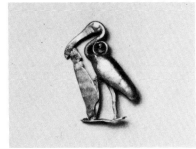

68

Pendant 68
Egyptian, Middle Kingdom?, 20th-18th century B.C.

This tiny gold amulet in the shape of an ibis holding a feather represents the god of wisdom, Thoth. The body was made of two pieces of sheet gold worked over a core. Gold wire, used for the neck, was flattened out to form the head. The legs were made of gold wire, the feathers and base of thin sheet gold. A loop for suspension was attached behind the neck. (57.1979)

H. 3/4 in (.016 m)

History:
collection of Suydam; purchased from John E. Kieffer, Jr., 1966

Publications:
Canby, "New Egyptian Jewelry," p. 3, plate I, fig. 3a, plate II, fig. 3b

Notes:
for a VIth Dynasty (about 2200 B.C.) version of the type, see *Ägyptisches Museum Berlin,* Berlin, 1967, no. 256, p. 29; see Petrie, *Amulets,* no. 247a, plate XLII

Key

73, 74, 75, 76, 77, 78

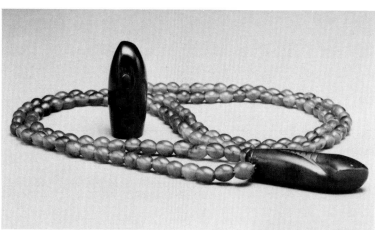

69, 70

71

Pendants in the shape of Other Gods and Symbols 69-118

Snake Amulet 69
Egyptian

This carnelian amulet strung on a necklace of (modern?) lentoid carnelian beads represents the upper body and head of a snake. The eyes are recessed under the diamond-shaped top of the head. Incised lines indicate the hood marking eyes and mouth. The piece, perforated at the end opposite the head, was designed to be worn on the neck of a mummy. (42.356)

L. 1-1/2 in (.038 m)

History:
purchased by Henry Walters from Abemayor, 1931

Snake Amulet 70
Egyptian

This snake head amulet of carnelian is shorter than the above. The eyes are indicated by incision. (42.357)

L. 1-1/4 in (.032 m)

Notes:
for the discussion of the type see I.E.S. Edwards, *Tutankhamun's Jewelry,* The Metropolitan Museum of Art, 1976, no. 21, p. 38f, the underside of the snake is illustrated there

Amulet 71
Egyptian

This smoothly carved amulet of a greenish stone represents the great god of the united kingdom, patron of the king, Horus with falcon head, in tight skirt, seated with hands drawn up on knees. A pierced loop projects from mid back. (42.348)

H. 7/8 in (.023 m)

History:
purchased by Henry Walters from Khawam, 1930

Publications:
Steindorff, *Catalogue,* no. 573

Pendant 72
Egyptian

This pendant carved of hippopotamus tusk into the shape of a hawk-headed, mummiform figure wearing a wig and double crown (of Upper and Lower Egypt) probably represents the god Horus. Perforated through the shoulders. (71.556)

H. 1-5/8 in (.042 m)

Publications:
Steindorff, *Catalogue,* no. 571, plate LXXXVIII

Falcon Pendants and Amulets 73-81

The great Egyptian national god Horus could also be represented as a falcon, and amulets representing him occur in all periods, materials, and techniques.

Pendant 73

Egyptian, Middle Kingdom, 21st-17th century, B.C.

The essential forms of this plump, seated falcon of amethyst are smoothly carved. Sharp grooves mark edge of wings, tail feathers, and beak. The eyes are inlaid with gold pellets. Fragments of the metal ring from which the piece hung remain. Perforated through the shoulder. (42.225)

H. 13/16 in (.021 m)

History:
purchased by Henry Walters from Maurice Nahman, 1930

Publications:
Steindorff, *Catalogue,* no. 671, plate C

Amulet? 74

Egyptian

This falcon is carved of quartz of a smokey hue with interior faults which display interference colors (resembling iridescense of glass) characteristics of rainbow or iris quartz. The lack of a perforation as well as the rough surface, suggest that the piece was never finished. Slight chips showing concoidal fractures typical of quartz. (42.226)

H. 1-1/16 in (.028 m)

History:
old label "N 13"; purchased by Henry Walters from Maurice Nahman, 1929

Pendant 75

Egyptian

In this heavy breasted falcon carved of lapis lazuli, only the general forms, the round eyes and the line across the beak are presented. There is a peculiar sharply cut depression behind the head which suggests a ruff (?) (42.224)

H. 1-5/8 in (.041 m)

History:
purchased by Henry Walters, 1913

Publications:
Steindorff, *Catalogue* no. 670, plate C

Key

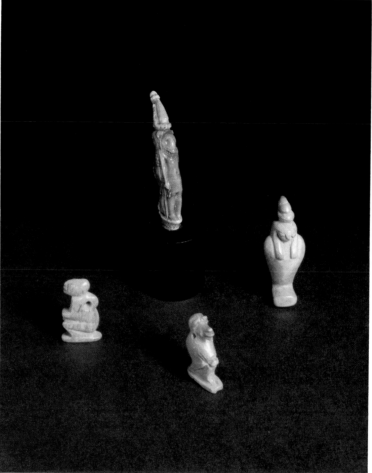

65, 66, 72, 112

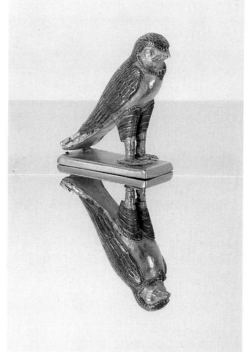

79 front

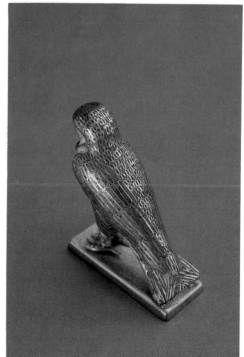

79 back

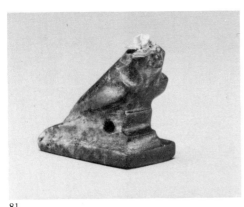

81

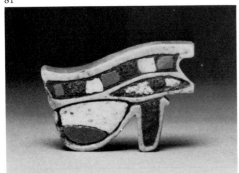

82

83

85

84

Pendant 76
Egyptian

A slender falcon (shaped like a dove) of lapis lazuli with simplified details of the wing feathers indicated by light incisions. (42.192)

H. 7/8 in (.022 m)

Amulet 77
Egyptian,

The wing and tail feathers of this black stone falcon are indicated by incision. The eyes were made of a polished black stone set into a lid of sheet gold. Right eye damaged; repairs to the beak. Hole (D. .4 cm) in the base. (22.343)

H. 1-9/16 in (.040 m)

Publications:
Steindorff, *Catalogue,* no. 666, plate CI

Pendant 78
Egyptian, New Kingdom?, 16th-12th century, B.C.

A falcon with disk and crescent on head, made of turquoise-colored faience. The breast feathering is indicated in relief. (48.1556)

H. 2-7/16 in (.062 m)

Publications:
Steindorff, *Catalogue,* no. 673, plate C

Amulet 79
Egyptian, Ptolemaic period, 4th-1st century, B.C.

A falcon made of sheet gold over a core, assembled from several pieces. The feathers represented in true cloisonné work have blue glass paste fused within and between thin gold cloisons, oval in shape. Blue cloisonné stripes decorate the upper part of the leg. The figure is attached to a solid gold plate. The falcon is unusual in wearing a necklace with a palmette pendant in front and "anklets" of twisted gold wire. (57.1484)

H. 1-1/2 in (.038 m)

History:
old labels: "3042 L STT," "Facture 12," "Epervier"; purchased by Henry Walters from Joseph Brummer, 1927

Publications:
Steindorff, *Catalogue,* no. 676a; for the detailed discussion of this figure, its parallels and dates, see Arielle P. Kozloff, "A New Species of Animal Figure from Alexandria," *AJA,* Vol. 80, 1976, pp. 183-185, plate 32, figs. 4-6

Pendant 80
Egyptian

A solid gold falcon wearing a double crown of silver. Traces of chased lines in the eye area and wedge-shaped indentations on the body (best preserved on the upper right leg) suggest that details were originally indicated. A loop for suspension is attached to the bird's left shoulder. (57.1433)

H. 1-1/2 in (.038 m)

Publications:
Steindorff, *Catalogue,* no. 676

Pendant 81
Egyptian

The falcon rather crudely carved of lapis lazuli has the remains of a headdress of gold foil attached to a rather battered brow. The piece is perforated behind the legs. (42.220)

H. 3/4 in (.019 m)

History:
purchased by Henry Walters from Dikran Kelekian, 1929 (?)

Publications:
Steindorff, *Catalogue,* no. 669

Amulet 82
Egyptian

A flat bead, perforated laterally, in the shape of the *wedjet* eye of Horus-Re. The frame for inlay is made of light green faience. Set into a black paste in these cloisons are pieces cut from yellow, black and red faience and blue glass. (47.265)

W. 1-1/2 in (.038 m)

History:
purchased by Henry Walters, 1929

Pendant 83
Egyptian

This amulet made of a bright blue glass-like faience (?) was made in a mould with some later working. It represents Maat, the personification of Truth, as a woman seated with knees drawn up. There is a hole in the head to attach an ostrich feather, the hieroglyph for her name. A loop projects from the back of her head. (42.426)

H. 1-1/2 in (.038 m)

History:
old label: "90125"; purchased by Henry Walters from Dikran Kelekian, 1912

Publications:
Steindorff, *Catalogue,* no. 554, plate LXXXVIII, where the material is wrongly listed as lapis lazuli

Pendant 84
Egyptian

A sketchily carved amulet of dark lapis lazuli probably representing Maat, personification of Truth. (42.342)

H. 5/8 in (.015 m)

Pendant 85
Egyptian

This figure of Maat, personification of Truth, is made of the same royal blue faience as no. 63. A loop at shoulders has broken off. (48.1706)

H. 11/16 in (.018 m)

Publications:
Steindorff, *Catalogue*, no. 556, plate LXXXVIII

Pendant 86
Egyptian

This tiny pendant, finely carved of green and white jasper, represents Onuris, god of the atmosphere, and a god of war. The facial features and hair are done in relief, the feathers of the crown by incision. (42.344)

H. 1-1/16 in (.027 m)

History:
purchased by Henry Walters, 1913

Publications:
Steindorff, *Catalogue*, no. 531

Pendant 87
Egyptian

This cast silver pendant represents the little known goddess Nebt-hotp standing with hands at her side. She has a *uraeus* on her wig, and wears a *sistrum*, her symbol as a crown. Large loop behind symbol; legs broken. (57.1479)

Preserved H. 1-1/2 in (.038 m)

Publications:
Steindorff, *Catalogue*, no. 557

Pendant 88
Egyptian

An amulet of green blue faience representing the minor god Neheb-ka of the Netherworld, a human figure with serpent's head and tail. The hands supporting the head and peculiar bent-knee stance of the figure is typical of the monster. There is a suspension loop behind the neck. (48.1615)

H. 1-7/16 in (.037 m)

History:
purchased from Sheik Ismael, 1930

Notes:
see Petrie, *Amulets*, no. 254, p. 49, plate XLIII

Publications:
Steindorff, *Catalogue*, no. 603

Pendant 89
Egyptian, XXII Dynasty, 10-8th century B.C.

This pendant cast in pale gold represents the great god of the new kingdom, Amun. The line across the chest represents his scale armor. The loop behind the partly broken headdress was made separately. (57.1978)

H. 7/8 in (.022 m)

History:
collection of Suydam; purchased from John E. Kieffer, Jr., 1966

Publications:
Canby, "New Egyptian Jewelry," p. 112, plate I, 2,a,b

Pendant 90
Egyptian

This cast silver amulet with a poor surface represents the great national god Amun, standing left foot directly in front of right. The lines of his short kilt, necklace, armlets and bracelets are indicated by incision. There is a large suspension loop behind the (broken) plume on his cap. The heavy-featured face suggests this may be a provincial piece. (57.1422)

H. 1-11/16 in (.043 m)

Publications:
Steindorff, *Catalogue*, no. 488, plate LXXVII

Pendant Amulet 91
Egyptian

A flat amulet representing the mummiform figure of the great god Ptah holding his scepter. The piece was worked into relief from a sheet of cast gold. There is a tiny loop for suspension behind the head. (57.1958)

H. 1-1/16 in (.022 m)

History:
gift of the children of Robert Garrett, 1964

86 87

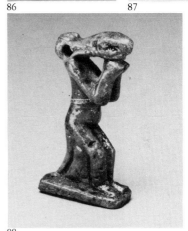
88

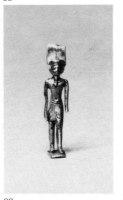
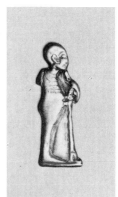
89 91

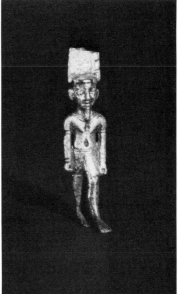
90

Amulet 92
Egyptian

This well modeled bull of pale green faience has a rib cage and mane(!) indicated by an incision. The horns and probably the disk which marked him as the holy Apis bull have broken off. Suspension loop on back. (48.1649)

L. 1-1/2 in (.038 m)

Publications:
Steindorff, *Catalogue,* no. 642

Pendant 93
Egyptian

A cast silver pendant representing the holy bull Apis, who wears a sun disk with *uraeus* between his horns. Incised lines mark the characteristic triangle on the forehead, wide necklaces and saddle cloth. The bull stands on a kind of sled, which divides in two and turns up in front. Loop behind neck. The surface of the metal has deteriorated. (57.1477)

L. 15/16 in (.024 m)

History:
purchased by Henry Walters from Dikran Kelekian

Publications:
Steindorff, *Catalogue,* no. 643

Pendant 94
Egyptian

A cast silver pendant in the shape of a vulture representing the goddess Mut. Eyes and beak are indicated by incision. The lines marking the lower feathers are carelessly incised. The surface has deteriorated. The suspension loop on shoulders is broken off. (57.1427)

H. 7/8 in (.022 m)

History:
purchased by Henry Walters from Dikran Kelekian

Publications:
Steindorff, *Catalogue,* no. 696, plate CIII

Pendant Amulet 95
Egyptian

An amulet made of pale sheet gold representing a cloaked figure seated with knees drawn up. He wears the double crown (of Upper and Lower Egypt) over a long wig. A short sleeve is shown between the flaps of the wig. The flat piece appears to have been worked in a mould with the details of face, hands, and hair later chased. The base to which the figure is attached is solid gold. A loop for suspension is attached behind the crown. (57.1486)

H. 1 in (.025 m)

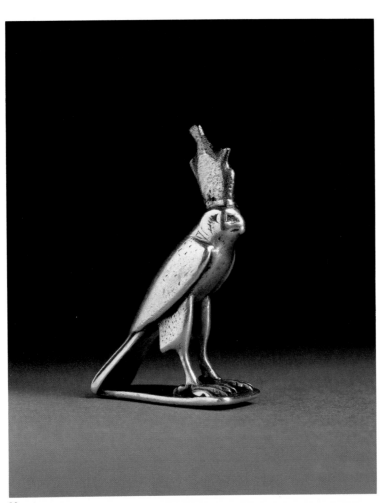
80

92

93

Egyptian

An amulet, smoothly carved of lapis lazuli, representing the heart. (42.347)

H. 5/8 in (.016 m)

History:
purchased by Henry Walters from Khawam, 1930

Pendant 97

Egyptian

An amulet of turquoise-colored faience representing the heart. (48.1657)

H. 1-3/8 in (.035 m)

Pendant 98

Egyptian

This lapis lazuli amulet appears to represent a double headed animal. Pierced under the belly. (42.349)

H. 1/2 in (.012 m)

History:
purchased by Henry Walters from Khawam, 1930

Large Pendants of Precious Metal 99-108

This group of pendants, now quite brittle with interior surfaces very granular, has recently been cleaned and consolidated. Several are made of base silver overlaid with gold or electrum. The first three of these represent the son of the chief god of Memphis, Nefertem, who wears his emblem, the lotus, surmounted by feathers on his head. On either side of the lotus hangs a counterweight amulet.

99. This large silver pendant representing Nefertem standing, left foot advanced, has fine incised lines marking the kilt (with middle piece), the heavy wig and the decoration of the counterpoises on headdress. There is a very large suspension loop behind lotus, and an inscription on the base. The surface is partially well preserved, the top of feathers is broken off. (57.1418)

H. 3-5/8 in (.092 m)

History:
purchased by Henry Walters, 1927

Publications:
Steindorff, *Catalogue,* no. 515

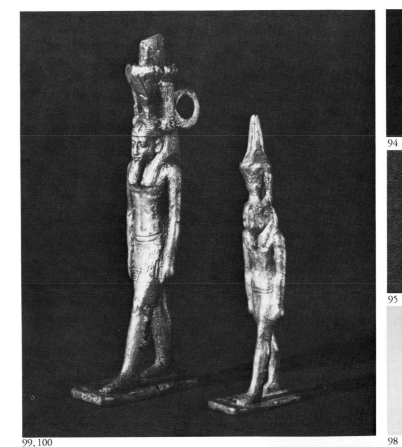

99, 100

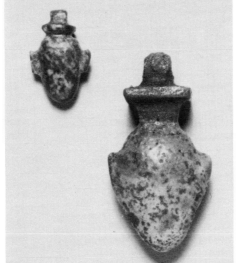

96, 97

99 inscription on base

94

95

98

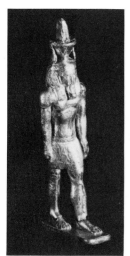

101 101 inscription on base

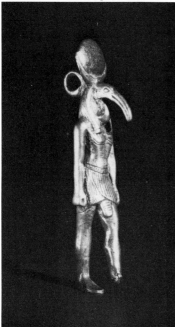

102

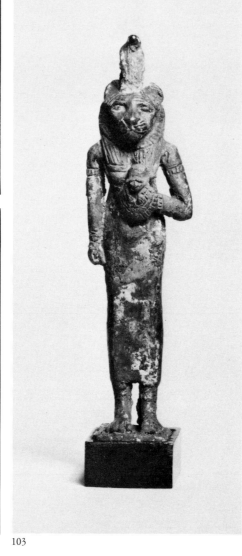

103

100. The surface of this cast silver pendant representing Nefertem is very deteriorated but traces of the incised lines marking kilt and lotus blossom can still be seen. Suspension loop behind blossom and one counterweight broken off. (57.1476)

H. 2-7/8 in (.073 m)

History:
purchased by Henry Walters from Dikran Kelekian

Publications:
Steindorff, *Catalogue*, no. 517, plate LXXXIII

101. This large silver pendant covered with gold represents the god Nefertem with incised lines marking skirt and wig. Inscription on base. (57.1419)

H. 2-7/8 in (.072 m)

Publications:
Steindorff, *Catalogue*, no. 516, plate LXXXIII

102. This large silver pendant representing the god of wisdom Thoth with an ibis head, has a well preserved surface. The wig and decoration of the kilt are indicated by incised lines. A double line is incised across the upper chest. The god wears a crescent and disk on his head. Large loop behind the disk; left foot missing, no base. (57.1423)

H. 2-3/4 in (.070 m)

History:
purchased by Henry Walters from Dikran Kelekian

103. This large pendant cast of silver represents the goddess of joy Bastet with a lion's head who stands holding her insignia (see no. 31) in her left hand. She wears armlets, bracelets, wig and high *uraeus* behind which is a large suspension loop. (57.1421)

H. 3-9/16 in (.09 m)

Publications:
Steindorff, *Catalogue*, no. 600, plate XCII

104. This large pendant representing the great god Amun cast of silver and covered with gold or electrum was very finely made. Incised lines mark skirt and feathers of plumed headdress. There are two lines of inscription on the base. Small loop for suspension above cap behind plume. The piece had been broken in several places and crudely mended with solder. (57.1416)

H. 4-1/2 in (.115 m)

History:
old number "48"; purchased by Henry Walters from Dikran Kelekian, 1924

Publications:
Steindorff, *Catalogue*, no. 486

105. This very fine pendant representing the great national god Amun was cast of silver and overlaid with pale gold. The lines of the split kilt, belt, broad collar necklace, and the feathers of the plumed headdress were incised. The suspension hoop is behind the base of the plume. Two line inscription on base. Neck and ankles missing. (57.1417)

H. 3-7/16 in (.088 m)

History:
purchased by Henry Walters from Dikran Kelekian, 1925

Publications:
Steindorff, *Catalogue,* no. 487, plate LXXVII

106. The surface of this large silver pendant representing the goddess Isis nursing Horus-the-Child has deteriorated. She wears a wig with *uraeus* over forehead and a small crown on top of which are horns with disk between. Large suspension loop behind headdress. (57.1424)

H. 3 in (.076 m)

History:
purchased by Henry Walters from Dikran Kelekian

Publications:
Steindorff, *Catalogue,* no. 399, plate LXXI

107. This cast silver pendant with well preserved surface represents the god Horus-the-Child, seated as if on his mother Isis' lap (see no. 56). He wears a collar necklace and skull cap with a cross band. Horizontal(!) suspension loop behind shoulders; a small base beneath feet. (57.1420)

H. 1-7/8 in (.048 m)

History:
purchased by Henry Walters from Abemayor, 1928

Publications:
Steindorff, *Catalogue,* no. 429

108. The surface of this finely modeled pendant of cast silver with some chased details is in good condition. It represents the goddess Isis standing. The details of her collar necklace and wig are finely engraved. She has a *uraeus* on her brow, a wide low crown and the usual horns with disk between; loop behind headdress. (57.1425)

H. 2-3/4 in (.07 m)

History:
purchased by Henry Walters from Dikran Kelekian

Publications:
Steindorff, *Catalogue,* no. 412, plate LXXI

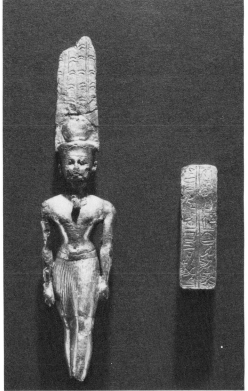
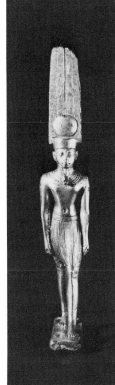
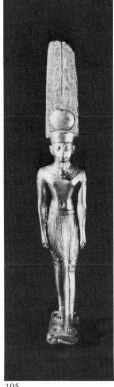

105 inscription on base

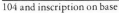
104 and inscription on base

105

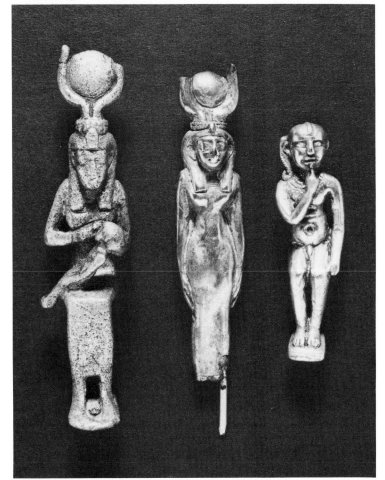
106, 108, 107

inscription on belly of fish

110

109

111

Pendants of Exceptionally Fine Workmanship 109-118

Pendant 109

Egyptian, XII Dynasty, 20th-18th century B.C.

One of the finest of ancient Egyptian jewels, this gold pendant represents in minute detail a species of Nile fish which is peculiar for its habit of swimming on its back which gives it a sunburnt or black belly. From this peculiarity comes its scientific name *Synodontis Batensoda*, the last word being from the arabic for "black belly." A number of pendants, some exceedingly fine, were made in the shape of this virtually inedible fish during the Middle Kingdom, presumably because the species was at the time associated with a constellation. The fish is made of gold with stone inlays. The fins, lips, and tendrills are carefully modeled, the ribbing of the fins, the triangular lines on the gills, the speckled scales of the "hood" characteristic of the species, are chased in fine detail. The inlays are partially preserved on the right side. One stripe is of green faience, one of carnelian, another of black stone. The right eye is inlaid with red stone, the left with green (!). A space for inlay on the belly must once have been filled with black. The main body of the fish, including the notched central stripes, appears to have been cast, but the inside of the piece is hollow and still partly filled with paste. The gold cloisons on either side of the central stripes were added after casting. Fish amulets were sometimes worn on the end of a hair lock. Children may have worn them to prevent them from drowning. (57.1072)

L. 1-9/16 in (.039 m)

Publications:

Dorothy Kent Hill, "An Egyptian Fish Amulet," *BWAG*, vol. 5, no. 2, November 1952; Randall, "Jewellery Through the Ages," p. 76, fig. 4a; Canby, "New Egyptian Jewelry," p. 112, plate 2:5; Aldred, *Jewels*, fig. 77, and p. 213

Notes:

for a full discussion of the species in ancient Egypt see Ingrid Gamer-Wallert, *Fische und Fischkulte im alten Ägypten*, Ägyptologische Abhandlungen (ed. Wolfgang Helck and Eberhard Otto) vol. 21, Wiesbaden 1970, pp. 12 ff., 34 ff., 52, 77, 121; the finest pendant from a tomb is in Aldred, *Jewels*, fig. 78 and p. 213; the example published by Petrie from Diospolis Parva (Diospolis Parva, *The Cemetaries of Abadiyeh and Hu 1898-9*, Egypt Exploration Fund, Memoirs, vol. 20, London, 1901) is now in the University Museum of the University of Pennsylvania as No. E 3989

112

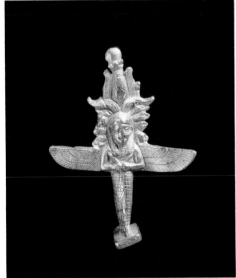

113

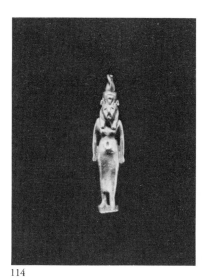

114

115

115 inscription on base

Pendant 110

Egyptian, XII Dynasty, 20th-18th century B.C.

This gold pendant in the shape of a fish is a simpler version of the one described above (no 109). The hollow body is made of two pieces of sheet gold formed in repoussé. The sheet gold tail and the dorsal fins of silver (of which only one remains) were inserted into the body. The lines of gills and the "hood" behind are softly chased. The ridge around the eye was produced by a punch. The hole in the mouth is presumably for suspension. (57.1981)

L. 7/8 in (.023 m)

History:
collection of Suydam; purchased from John E. Kieffer, Jr., 1966

Publications:
Canby, "New Egyptian Jewelry," p. 112, plate II, 4a, b

Pendant 111

Egyptian, New Kingdom?, 16th-11th century B.C.

The anatomical details peculiar to the modern *bolti,* one of the most common and edible of Nile fish, were meticulously portrayed in this pendant carved of translucent carnelian. This species of fish, *Tilapia nilotica* (ancient Egyptian *int*), like our sun-fish, carries its eggs in the mouth until hatched, and so, like the frog and dung beetle was thought to be self-created. It was therefore a symbol for birth and ressurection, associated with the goddess of beauty Hathor as well as the sun god Re. The *Tilapia* also served as one of the two pilot fish which guided the bark of the sun god in his daily journey across the sky. A girdle made of gold fish of this type now in the Metropolitan Museum, was found in the tomb of the three Princesses of Tutmosis III (1504-1450 B.C.). On our example a stiff twisted gold wire was run through a perforation from the right side of the mouth to the belly. Part of the wire forms a loop for suspension in front of the mouth. The rest was tied into several knots so that only one end is visible. This may represent the line to tow the sun-bark across the sky. (42.196)

Preserved L. 1 in (.025 m) Max. thickness 1/4 in (.011 m)

History:
collections of Amherst; Carmichael; purchased by Henry Walters from Dikran Kelekian, 1926, (sale catalogue, *Antiquities of the Collection of the Late Lord Carmichael of Skirling,* Sotheby and Company, London, Wednesday, June 9, 1926, lot no. 233)

Notes:
see Ingrid Gamer-Wallert, *Fische und Fischkulte im alten Ägypten,* Ägyptologische Abhandlungen (ed. Wolfgang Helck und Eberhard Otto), vol. 21, Wiesbaden, 1970, pp. 13, 24 ff., 53 ff., 109 ff., 124 ff.; see also Dorothy W. Phillips, "Fish Tales and Fancies," *BMMA,* February 1944, pp. 184-189 (for a carnelian *Tilapia* in the Metropolitan Museum see *ibid,* fig., p. 188); for girdle, see Aldred, *Jewels,* color fig. 63 and the drawing in Winlock, *The Treasures of Three Egyptian Princesses,* Publications of the Metropolitan Museum of Art, Department of Egyptian Art, vol. X, New York, 1948, plate XXI

Pendant 112

Egyptian

Carved from an animal tooth, this intricate pendant represents two figures standing back to back on a papyrus column. On the outer curve, a lion-headed human figure—the god "Horus-the-grim-looking-lion"—wearing a rush crown with a disk on top, dangles a crook handle from the left hand and a serpent from the right. On the under-curve is a contorted figure of a hawk wearing a wig and a high crown edged with ostrich feathers (the *atef* crown) surmounted by a ball. Under the head, the back of the bird is shown. Over the shoulders is a scarab perforated horizontally. Behind the tail feathers is a thick tail of a crocodile. (71.514)

H. 2 in (.051 m)

Publications:
Steindorff, *Catalogue*, no. 577, p. 136, plate LXXXVIII

Pendant 113

Egyptian, Late Period

Solid cast of gold with some details chased, the pendant represents a hybrid demon: a winged human figure wearing an elaborate high crown of rushes flanked by ostrich feathers (the *atef* crown) set on horns and topped with a disk. A bird's foot grows out of the back of the body. Ovals carved on the front of the hatched skirt may represent fish. Piled above the left wing are: a ram's head, lion's head, a head no longer recognizable, and snake's head; above the right wing, the head of a lion, hawk, snake, and jackal. Such a creature had apotropaic (evil-averting) powers. The suspension loop is behind the figure's head. On all four sides of the base a circle with four rays is incised. The piece, which is made of very soft gold, has suffered damage from some small implement on wings, face, and skirt. (57.1437)

H. 1-9/16 in (.043 m)

Publications:
Steindorff, *Catalogue*, no. 715, plate CIII

Pendant Amulet 114

Egyptian

Every detail is shown in minute scale in this gold pendant representing the lion-headed goddess Sakmet wearing a wig and double crown with a large *uraeus*. The piece is cast. (57. 1431)

H. 9/16 in (.018 m)

History:
purchased by Henry Walters from Maurice Nahman, 1930

Publications:
Steindorff, *Catalogue*, no. 505a

Amulet 115

Egyptian

This seated gold lioness, tail curled over the haunches, was apparently cast in one piece with the suspension loop and flat base. The inscription, deeply recessed into the under-side of the base reads "Bastet, eye of Re', Mistress of the Gods", which suggests the piece was not a seal but a votive to the cult of Bastet, goddess of joy. (57.1430)

H. 5/16 in (.08 m)

History:
purchased by Henry Walters from Maurice Nahman, 1930

Publications:
Steindorff, *Catalogue*, p. 156, no. 711,

Pendant 116

Egyptian, 8th century B.C.

The top side of this oval pendant was made by working sheet gold over what appears to be a dark paste core. This was attached to a flat gold sheet rolled over at one end into a loop. Two pin-sized holes pierce the back plate. The hieroglyphics chased on the front give the royal name Shabaka, the royal designation "Son-of-Re'," and the epithet "may he live eternally." Shabaka was a king of the XXV Dynasty, a time when Kushite (Ethiopian) kings ruled Egypt from the Sudan. (57.1940)

L. 2-1/2 in (.064 m) Max. thickness: 3/8 in (.09 m)

History:
gift of Mr. and Mrs. John Shotwell Townsend, 1963

Amulet 117

Meroitic (Ancient Nubian), late 1st century B.C.

A lion reclining comfortably with paws folded and head turned sideways was formed of gold over a core and then chased. The piece must come from ancient Nubia, where a strongly Egyptianized culture flourished from the 9th century B.C. until the 4th century A.D. The lion's pose is known in ancient Egypt, but the bushy mane below the face is a Meroitic feature. The piece is similar to two smaller lions in the Berlin Museum, which come from the famous Ferlini hoard said to have been found by the Italian doctor in the pyramid of Queen Amaniskete in 1834. Our piece is not perforated. It may be that, like the Berlin lions, it once sat on another gold plate which was perforated. (57.1560)

L. 7/8 in (.023 m) Thickness: 3/8 in (.09 m)

History:
purchased by Henry Walters from Khawam, 1930

Notes:
for the Berlin lions see *Ägyptisches Museum Berlin, Staatliche Museen Preussischer Kulturbesitz*, Berlin, 1967, nos. 1074, 1075, p. 117, and Heinrich Schäfer, *Ägyptische Goldschmiederbeiten*, Mitteilungen aus der Ägyptische Sammlung, vol. 1, Berlin, 1910, no. 246, p. 153 and plate 30

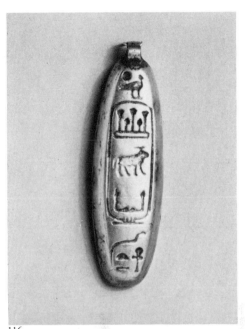

116

117

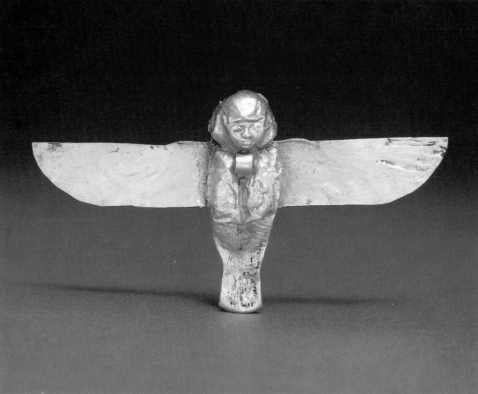

118 front

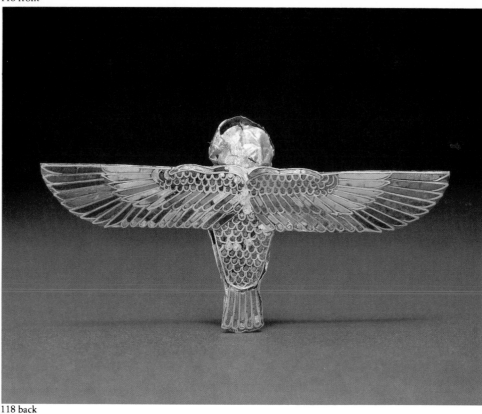

118 back

Pendant 118

Egyptian, Ptolemaic Period, 4th-1st century B.C.

The *Ba,* the soul of the dead represented in this amulet was thought of as a human-headed falcon. The body is made of thin gold foil, the edges of which were merely pressed over a thick gold base plate. The back of the head was made separately of gold foil and attached to the base plate at the edges of the foil wig. A roll of sheet gold forms the suspension loop under the chin. Although the fragile body has been damaged, the fine details of the broad face, short breast feathers, drawn-up claws, and feathers on the lower part of body, and tail are still visible. The back is flat; the feathers are cut out of dark blue lapis lazuli; a turquoise-colored stone and steatite with a reddish cast and are set into gold cloisons. Some of the outer feathers of the wing are made of lapis lazuli filled out with steatite. A similar piece in the Brooklyn Museum is said to have come from a mummy of the Ptolemaic period. (57.1472)

H. 1-1/4 in (.033 m) Wingspread 2-1/2 in (.063 m)

History:
purchased by Henry Walters from Khawam, 1929

Publications:
Randall, "Jewellery Through the Ages," p. 76, fig. 4b

Notes:
See discussion of the type in Williams, *Catalogue,* pp. 172-174 on no. 104, plates XXVIIa, b, XXIXc (which is Aldred, *Jewels,* fig. 143); see also Heinrich Schäfer, *Ägyptische Goldschmiedearbeiten,* Mitteilungen aus de Ägyptische Sammlung, vol. 1, Berlin, 1910, no. 38, p. 36, plates 1 and 9; G. A. Reisner, *Amulets,* Catalogue général, vol. 35, 2, no. 12925, plate XXVI.

Rings 119-151

Ring 119

Egyptian, Late Middle Kingdom, about 1700 B.C.

One of the earliest rings in the collection, this is a good example of a characteristic Egyptian type. A rock crystal scarab, with base and sides covered with thin sheet gold, is attached to the sockets of a tapered hoop by a thick gold wire which runs through the scarab. The inscription, chased on the gold base, reads "Butler of Nefer-Her (the beautiful of face) Heby." The title suggests the piece belonged to a royal butler. (57.1957)

Interior D. 1-3/16 in (.03 m)

History:
gift of the children of Robert Garrett, 1964

Publications:
Geoffry T. Martin, *Egyptian Administrative and Private-name Seals,* Oxford, 1971, p. 38, no. 425, plates 38; 11, with a different reading

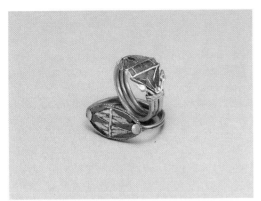

122, 124

Ring 120

Egyptian, 1760-1650 B.C.

A less expensive version of the preceding ring is this glazed steatite scarab set in a wide bronze band. It is attached to a hoop which tapers into a wire small enough to go through the perforation of the scarab. Decorative hieroglyphs are carved into the flat face of the back of the scarab. Above is the red crown flanked by "protection" symbols, below is a *djed* pillar of Osiris flanked by signs in the shape of a basket. (54.2463)

L. of scarab and band 15/16 in (.024 m)
Max. Interior D. 15/16 in (.023 m)

History:
gift of the children of Robert Garrett, 1964

Ring Bezel 121

Egyptian, XII Dynasty, 20th-18th century B.C.

A scarab made of turquoise-colored glazed steatite, perforated longitudinally, and probably once mounted as a ring. The elaborate gold frame around the bottom was made of thick sheet gold to which two strands of twisted gold wire flanking notched gold wire were added. The free movement of the interlocking scroll pattern carved into the base of the scarab witness the influence of Cretan art on Egypt of the period. (42.38)

L. 15/16 in (.024 m)

History:
purchased by Henry Walters, 1913

Ring 122

Egyptian, Middle Kingdom ?, 20th-18th century B.C.

The ends of the triple hoop of this gold ring are attached under the base plate of the bezel. A cluster of five wires bent over the outside

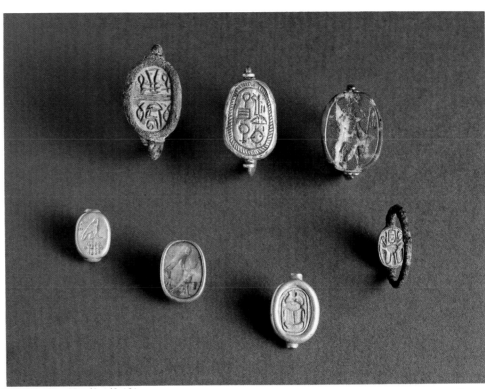

119, 120, 123, 127, 142, 145, 151

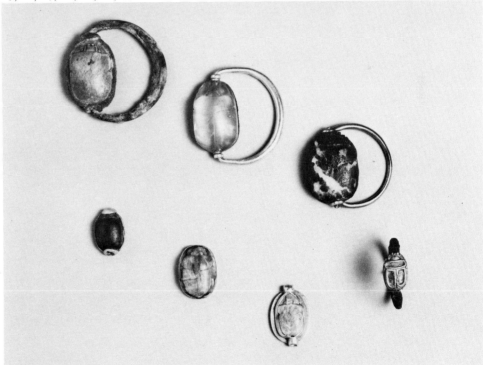

119, 120, 123, 127, 142, 145, 151 scarabs

121 front 121 back

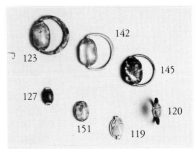

Key

of the hoop from which gold petals spring to frame the lotus blossoms of the bezel, mask the join. The blossoms, made of lapis and carnelian set into gold cloisons open toward each other. The dainty floral motif suggest a Middle Kingdom date. (57.1475)

Interior D. 1/2 in (.013 m) L. of bezel 3/8 in (.010 m) L. of bezel 3/8 in (.010 m)

History:
purchased by Henry Walters, 1913

Publications:
Randall, "Jewellery Through The Ages," p. 76

Notes:
see the floral circlet of Princess Khnumet in Aldred, *Jewels*, plate 28 with notes p. 186

Ring Bezel 123
Egyptian, New Kingdom? 16th-11th century B.C.

A scarab carved of light brown steatite with a thick gold rim around the bottom edge. A lip of gold, pressed around the scarab to hold it in place, is drawn out to form hoop-sockets. Carved into the back of the scarab is a beetle with outstretched legs under a disk. (42.389)

Total L. 3/4 in (.019 m)

Notes:
for base see Fouad S. Matouk, *Analyse Thématique, Corpus du scarabée égyptien*, volume 2, Académie Libanaise, Beyrout, 1976, no. 873, pp. 160 and 353; Late period; the mounting looks New Kingdom, see Williams, *Catalogue*, pp. 85-86, no. 20 a-3, plate VI; see also H.E. Winlock, *The Treasure of Three Egyptian Princesses*, Publications of The Metropolitan Museum of Art, vol. X, New York, 1948, plate XIX,: 15th century B.C.

Ring 124
Egyptian, New Kingdom?, 16th-11th century B.C.

This dainty ring has a slender hoop made of sheet gold rolled over on each side to give the impression of a double wire. The hoop is attached to the lentoid bezel on which opposing lotus blossoms with petals of alternating dark and light blue glass are cut and set into gold cloisons. One petal is missing but the blue paste into which the glass was set remains. The cloisons between the petals are filled with white glass with purple specks. A strip of gold laid across the bezel divides the design. The outer edge of the base plate is decorated by tiny granulations, a type of decoration which, although known by the Middle Kingdom, never became popular in Egypt. Glass was only used in pharonic Egypt in the New Kingdom, when it was cut like stone rather than fused into the cloisons. (57.1474)

Max. Interior D. 3/4 in (.019 m) H of bezel 3/8 in (.09 m)

History:
old label "10" "1009"; purchased by Henry Walters from Maurice Nahman, 1929

Notes:
for the curious history of Egyptian glass, which was of very fine quality in the New Kingdom, see Elizabeth Riefstahl, *Ancient Egyptian Glass and Glazes in the Brooklyn Museum,* Wilbour Monographs, I, The Brooklyn Museum, 1968, Introduction, pp. 1-7; for a rare example of true cloisonné, see Aldred, *Jewels,* p. 128, and plate 103 (from the tomb of King Tut-ankh-amun)

Ring 125
Egyptian 1379-1362 B.C.

A heavy gold signet ring with stirrup-shaped hoop, cast in a single piece, the deeper part of the hieroglyphs having been cut into the wax model. Some details of the signs were later chased. The surface shows much wear. The hieroglyphs give the throne name Nefer-kheperu-re'-wa'-en-Re' of King Amenhotep IV, (Akhenaten.) (57.1471)

L. of bezel 11/16 in (.018 m) H. of bezel 3/4 in (.019 m)

History:
purchased by Henry Walters from Maurice Nahman, 1929

Ring 126
Egyptian, 1222-1217 B.C.

A heavy silver signet ring cast in one piece, with a bezel in the shape of a cartouche. The surface of the bezel has been filed down so far that the hieroglyphs are barely discernible. They give the throne name of Amenmesses, a little known pharoah of the XIX Dynasty, and two epithets "beloved of Amun" and "whom Re had chosen." (57.1488)

Interior D. 3/4 in (.019 m) L. of bezel 1-5/16 in (.033 m)

Ring 127
Egyptian, 1504-1450 B.C. ?

In this type of ring the scarab bezel is fastened by passing the ends of the bronze hoop, pulled out into fine wire, through the perforation, and twisting them around the hoop on the opposite side. The face of the glazed steatite scarab is decorated with a stylized head of the cow-eared goddess Hathor under a *cartouche* of king Thutmosis III. (54.2208)

L. of scarab 7/16 in (.012 m) Interior D. 5/8 in (.018 m)

History:
purchased by Henry Walters, 1913

Ring 128
Egyptian

The hoop of this turquoise-colored faience ring ends in lotus blossoms; the bezel is in the form of a scarab. (48.1253)

Interior D. 7/8 in (.022 m)

History:
purchased by Henry Walters, 1929

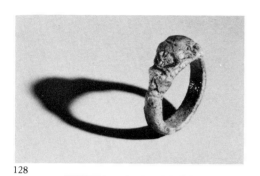

128

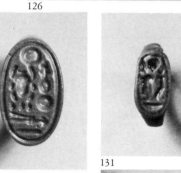

126

130

131

132

133

134

Egyptian XVIII Dynasty ?, 16th-14th century B.C.

The bezel and hoop of this gold ring seem to have been cast in one pin-shaped piece, the hoop being subsequently bent square, the end, attached to the bezel. The design on the lentoid bezel is chased (and partly gouged out). It shows a cow in a boat passing through a papyrus thicket (the stalks and flowers of which appear above the back of the cow). The scene undoubtedly represents the well known story of the cow goddess, Hathor, welcoming the dead in the western marshes. (57.1473)

L. of bezel 5/8 in (.016 m) H. bezel to bottom of hoop inside 9/16 in (.015 m)

Notes:
see Williams, *Catalogue,* no. 31, p. 96, plate IX

Faience Rings with Oval Bezels 130-133

Egyptian, 14th century B.C.

All of these rings date to the late XVIII Dynasty (about 1400-1350 B.C.), the time of the religious revolution of the heretic king Akhenaten. Only the first of these rings is sturdy enough to have been worn. The others served as tokens or funerary rings.

130. A sturdy ring of royal blue faience made in the shape of precious rings of the period (see no. 125). The inscription gives the throne name of King Amenophis IV (Akhenaten). (42.201)

L. of bezel 1-1/8 in (.029 m) Interior D. 13/16 in (.020 m)

131. Blue faience ring of flimsy construction with the throne name of King Amenophis III on bezel. (42.385)

L. of bezel 9/16 in (.015 m) Interior D. 1/2 in (.013 m)

132. Pale turquoise-colored faience ring of flimsy construction with throne name of King Tut-ankh-amun impressed on bezel. (42.386)

L. of bezel 11/16 in (.017 m) Interior D. 1/2 in (.012 m)

133. Blue faience ring of flimsy construction with crudely incised hieroglyphs which refer to the new god Aten of the Amarna revolution. (42.399)

L. of bezel 7/8 in (.022 m) Interior D. 9/16 in (.015 m)

135

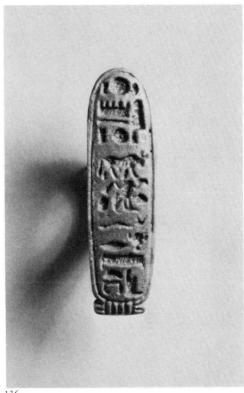
136

Rings with Giant Bezels 134-7

Egyptian, 10th-8th century B.C.

A type of cartouche-shaped signet ring with a very long bezel made of faience was popular from the late XX Dynasty to the XXIII Dynasty (1000-730 B.C.) A question exists as to whether these rings were ever actually used as signets or were for funerary purposes, religious souvenirs, or gifts for special occasions. It seems probable that rings with blank bezels were mass-made in moulds and that, while the material was soft before firing, the inscription was added.

Notes:
for a discussion of the dates for such rings see William C. Hayes, *The Hyksos Period and The New Kingdom (1675-1080 B.C.),* The Scepter of Egypt, A Background for the Study of the Egyptian Antiquities in the Metropolitan Museum of Art, Part II, Cambridge, Massachusetts, 1959, p. 397, fig. 250.

134. A small version is made of blue faience. Incrustations exist in the shallow crudely carved hieroglyphs which read "Men-ib-re, right of voice, the great god," a fictitious name which is attested elsewhere. (42.416)

L. of bezel 1-9/16 in (.04 m) Interior D. of hoop 11/16 in (.018 m)

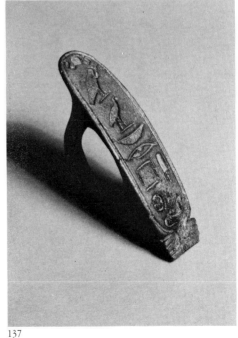
137

138

139

141 back

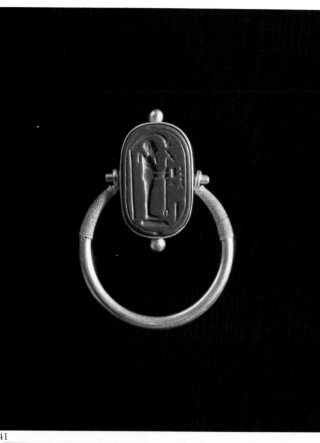

141

125, 129, 140

135. This example of turquoise-colored faience is chipped and has incrustations in the deeply cut, crisp hieroglyphs which read "May your house flourish, may your lifetime be jubilant under the gifts of Amun of Karnak (and) a high old age." (42.417)

L. of bezel 2-9/16 in (.065 m) Interior D. of hoop 3/4 in (.019 m)

History:
purchased by Henry Walters from Dikran Kelekian, 1913

136. In this greenish faience example the surface within the signs is well preserved and bluer than the rest of the ring. The inscription reads "He who is on the seat of Amun-Re'-Kamutef." This god was honored in a special cult at Karnak. (42.418)

L. of bezel 2-9/16 in (.065 m) Interior D. of hoop 3/4 in (.02 m)

History:
purchased by Henry Walters, 1929

137. This greenish faience example has widely spaced hieroglyphs that read "Mut, lady of Asheru." Peculiarities of the writing raise doubts about authenticity. (42.200)

L. of bezel 2-5/8 in (.067 m) Interior D. of hoop 15/16 in (.024 m)

Ring 138
Egyptian, Dynasty? XXI-XXII, 10th-8th century B.C.

A fragile openwork ring made of faience with designs in superimposed registers of plaques. The god Horus, represented as a hawk with disk on head, one wing up, one down, foot forward, alternates with heads of the cow-eared goddess Hathor. In all but one plaque she wears a low crown. In one she wears the characteristic heavy wig with spiral curls. (48.1620)

H. 1-9/16 in (.022 m)

Publications:
Dorothy Kent Hill, "Egypt in Miniature," *BWAG*, vol. 14, no. 8, 1962
Notes:
for the type see Elizabeth Riefstahl, *Ancient Egyptian Glass and Glazes in the Brooklyn Museum*, Wilbour Monographs, I, Brooklyn, 1968, nos. 54, 55, plate IX, pp. 57, 105

Ring Bezel 139
Egyptian, 7th-6th century B.C.

This flat silver bezel with under surface carved to fit the finger, belonged to a type of ring of the XXVI Dynasty in which the bezel perched above the separately cast hoop. The deeply set hieroglyphs which

decorate the bezel appear to have been gouged into the surface with some chased detail. The piece shows signs of much wear. When bought it had a plug of some iron compound under the bezel. This probably represents the efforts of a village tinker of the 19th century A.D. to reattach the hoop. Two unfinished rings of the type in the old Abbott collection (now in the Brooklyn Museum) had been repaired in this fashion. Under the plug on the Walters ring was a lightly scratched sign. The hieroglyphs on the bezel read "servant of Bastet, Djehuty-sotem-nis" (Thoth hears the caller). (57.1487)

W. 11/16 in (.018 m) H. 7/16 in (.011 m)

History:
purchased by Henry Walters from Dikran Kelekian
Notes:
see C. R. Williams, *Catalogue,* nos. 35-37, plate IX, pp. 105-106

Ring 140
Egyptian 6th century B.C.?

The original inscription on the exceptionally narrow bezel of this cast gold ring was erased, and a crude one partly gouged, partly scratched in. It reads "Bastet, Lady of Basta, The Eye of Re', Mistress of the Two Lands." Professor Goedicke has suggested the piece may have come from the treasure of Tell Basta discovered in 1905 in the southeastern Delta. (57.1485)

L. of bezel 1 in (.025 m) Max. interior D. 3/4 in (.018 m)

History:
purchased by Henry Walters from Abemayor, 1928
Publications:
Hans Goedicke, "A Votive to the Goddess Bastet," *BWAG,* vol. 29, no. 2, November 1977

Ring 141
Egyptian Late Period?, 7th-4th century B.C.

The flat bezel of this ring, made of dark green stone, has hieroglyphs carved into one surface, the figure of the god Ptah, on the other. The bezel is surrounded by a gold band with knobs at the long ends, and mounted by hinges on the short side to a hoop which imitates the system of attachment of ancient Egyptian rings (see no. 127). The inscription reads "Good is the kindness of Amun-Re'." (42.387)

L. of bezel with knobs 13/16 in (.021 m) Interior D. 9/16 in (.018 m)

History:
purchased by Henry Walters from Maurice Nahman, 1930

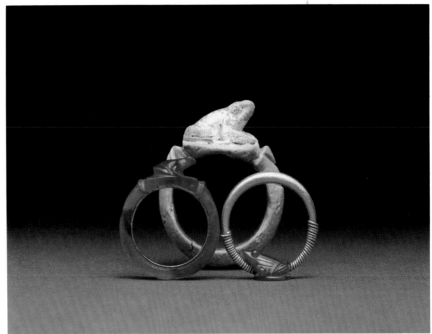
146, 147, 148

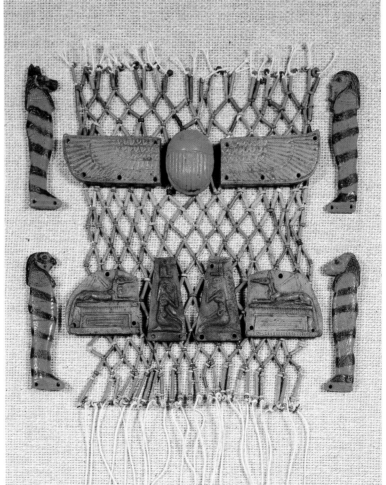
153

150 front

150 back

149

Ring Bezel 142

Egyptian, Ptolemaic period?, 4th-1st century B.C.

The sheet gold which frames the flat side of this scarab of blue translucent stone is neatly tucked into the legs of the insect. No seams are visible. The hieroglyphics on the back are finely carved. There is an owl above and a hawk which has feathering indicated. (42.64)

L. 9/16 in (.017 m)

Ring 143

Egyptian

This ring with a gold hoop of twisted wire, typically Egyptian (see no. 127) but lacking the usual taper, has a swiveling scarab bezel rather crudely carved out of dark green stone. Carved into the back is a short skirted figure with disk over head paying homage to the goddess Isis with outstretched wings. Authenticity? (42.129)

L. of scarab 5/8 in (.016 m) Max. Interior D. 3/4 in (.019 m)

History:
collection of Newton-Robinson (sale, Christie, Manson, and Woods, London, June 22, 1909, lot 2); purchased by Henry Walters from Dikran Kelekian, 1909

Ring 144

Egyptian

This ring with a silver twisted wire hoop of typical Egyptian design (see no. 127) has a swiveling scarab bezel finely carved of dark green stone. The back face has been damaged but a stand in front of an enthroned deity is still visible. Authenticity? (42.128)

L. of scarab 1/2 in (.013 m) Interior D. 3/4 in (.019 m)

History:
collection of Newton-Robinson (sale, Christie, Manson, and Woods, London, June 22, 1909, lot 2); purchased by Henry Walters from Dikran Kelekian, 1909

Ring Bezel 145

Egyptian

Sheet gold neatly moulded across the back and around the edges of a lapis lazuli scarab, form the surface into which finely detailed hieroglyphs were chased. A ring of sheet gold was added around the perforations at either end. The inscription reads "Chiefs of The Priestly Guild of Horus" which suggest that the ring was a mark of professional status. (42.388)

L. 7/16 in (.015 m)

History:
purchased by Henry Walters from Maurice Nahman, 1930

Frog Rings 146-9

Because frogs seem to be self created—born magically from the mud in which they live—they became in earliest times symbols of birth and resurrection and symbols of the birth goddess Heket. Frogs were also used as a sign in the hieroglyphic script, sometimes as an ideogram for "repeating life."

Notes:
for frogs see Alan H. Gardiner, *Egyptian Grammar; Being an Introduction to the Study of Hieroglyphics,* Oxford, 1927, 1, no. 7; Ingrid Gamer-Wallert, *Fische und Fischkulte im alten Ägypten.* Ägyptologische Abhandlungen (ed. Wolfgang Helck und Eberhard Otto), vol. 21, Wiesbaden, 1970, p. 124; for a gold ring with frog bezel from the Amarna period (14th century B.C.) see Aldred, *Jewels,* color plate 69

146. A tiny carnelian frog with incised details serves as a swiveling bezel for a typical Egyptian ring (see above no. 127). Carved into the base is a stylized head of the goddess Hathor (?). (57.1536)

L. of frog 3/8 in (.01 m) Interior D. 11/16 in (.017 m)

Notes:
for Hathor head see Fouad S. Matouk, *Analyse Thématique,* Corpus du scarabée égyptien, vol. 2, Académie Libanaise, Beyrout, 1976, vol. II, p. 376, no. 136

147. A tiny well modeled frog sits on the rectangular bezel of this carnelian ring in which the "end" of the hoop is carved to imitate a cup-fastener. The gold inner facing may be modern. (42.1470)

L. of frog 1/4 in (.06 m) Interior D. 5/8 in (.015 m)

148. The frog bezel of this ring was mould-made of colorless faience, and attached before firing to the hoop made of light blue faience paste. (48.1659)

H. 15/16 in (.033 m) Interior D. 3/4 in (.02 m)

History:
old no. "N 15"; purchased by Henry Walters, 1929

149. This lively frog carefully carved from a piece of green stone is pierced lengthwise through the base. It may have served as a bezel for a ring. (42.193)

H. 5/8 in (.011 m)

History:
collection of Carmichael, (sale catalogue, *Antiquities of the Collection of the Late Lord Carmichael of Skirling,* Sotheby and Company, London, Wednesday, June 9, 1926, lot no. 244); bought by Henry Walters from Joseph Brummer, 1927

Ring Bezel 150

Egyptian

This yellow jasper bead perforated length-wise is an unfinished piece. Carved into one side is an owl hieroglyph. On the other the figure of the king, arm raised to strike is outlined. Mount modern? (42.188)

W. 13/16 in (.021 m) Thickness 5/16 in (.08 m)

History:
collection of Newton-Robinson (sale, Christie, Manson & Woods, London, June 22, 1909, lot 1)

Ring Bezel 151

Egyptian

This lapis lazuli scarab has a hawk-head fig-ure wearing rams-horn crown carved into the back. In his left hand is a staff from which a lotus blossom(?) dangles. Mount modern? (42.151)

L. 7/8 in (.022 m)

History:
collection of Newton-Robinson (sale, Christie, Manson & Woods, London, June 22, 1909, lot 1)

Ring Bezel 152

Egyptian

On the base of this scarab of carnelian, a sphinx in royal war crown reclines over the body of a fallen enemy. (42.187)

L. 7/8 in (.022 m)

History:
collection of Newton-Robinson (sale, Christie, Manson & Woods, London, June 22, 1909, lot 1)

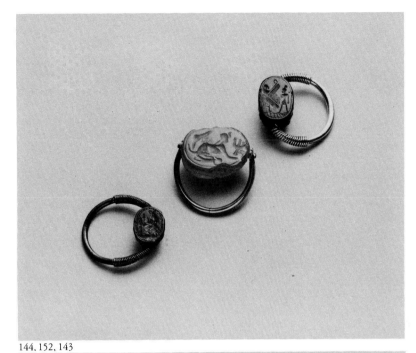

144, 152, 143

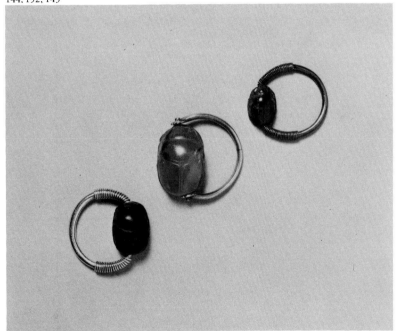

143, 152, 144

Amulets for Mummy Wrappings 153

Egyptian, Late Period

Typical sets of faience amulets such as are found sewn on mummy wrappings are ar-ranged here on a reconstructed net of beads of the kind used to cover mummies. At top is a winged scarab, beneath which are a set of relief plaques, the outside ones represent-ing the jackal of Anubis on his shrine. At left, inside, Isis, at right Nephythys. The four mummiform plaques around the sides are made of painted faience. They represent the four sons of Horus with jackal, falcon, human, and baboon heads.

Scarab 42.373; wings 48.1667, 1668; Isis, Nephthys, Anubis 48.1634-1637; Sons of Horus, 48.1638-41

Max. H. Sons of Horus 3-5/8 in (.09 m)

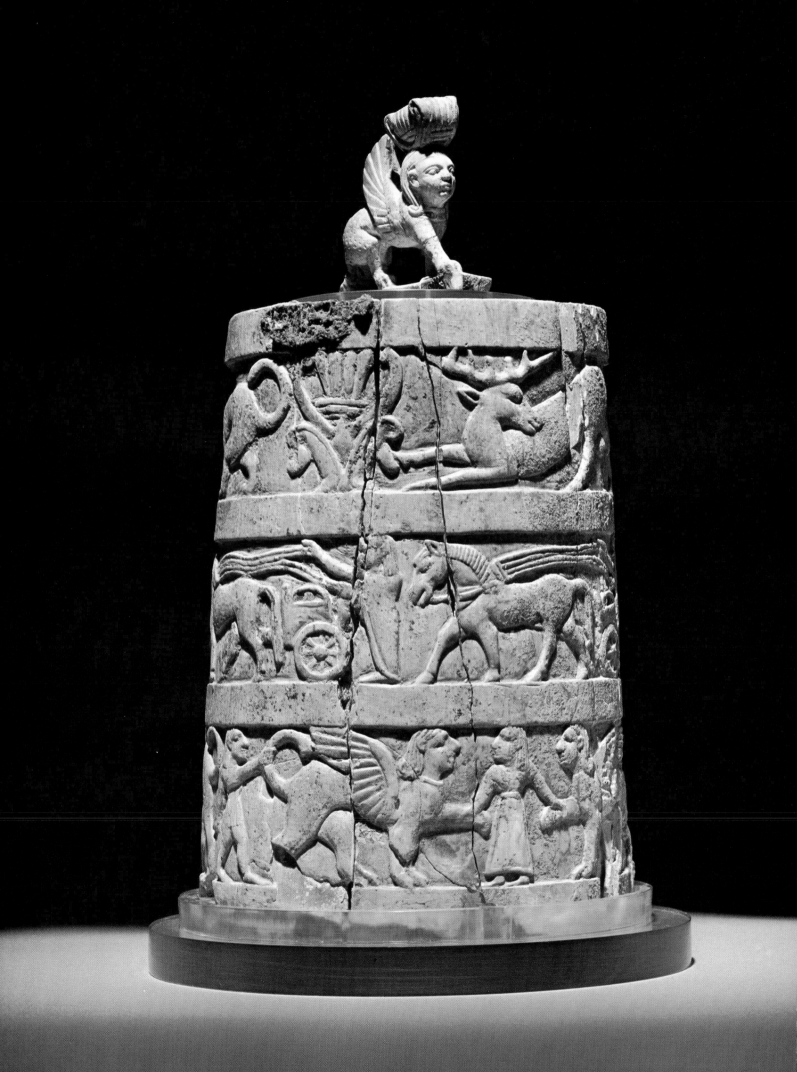

Etruscan Jewelry

Etruscan civilization was already at an advanced level both technically and artistically by 700 B.C. This civilization has long been an enigma to scholars and it is unlikely that we will ever be certain of its origins. Because the Etruscans left few written records, we depend on the observations of Greek and Roman historians, and on the evidence of archaeology, which is neither profuse nor always precise. Otto Brendel in his book *Etruscan Art* summarizes the evidence available and offers the following thoughts on the development of the Etruscan civilization and artistic style. About 800 B.C. the native "Villanovan" population of central Italy migrated suddenly to the coastal areas of Etruria. The reasons for this are unknown, but the result was a vast increase in trade and contact with other areas of the ancient world. The artistic style that we call Etruscan was thus formed from the cross currents of several contemporary civilizations, Syrian, Phoenician, and Greek among them.

A large proportion of the Etruscan jewelry shown here dates to the earliest period of Etruscan art, the 7th century B.C. The jewelry of this period is made with great technical skill, difficult to duplicate even with modern tools. In the earliest period, about 700-625 B.C., granulation was the most important decorative technique: examples are the necklace pendants (nos. 178, 179, 180, 181), the unusual container pendant with human faces on the bottom (no. 190); the feline head pendants (no. 208), or the elaborate labyrinth/lozenge design on the horseshoe-shaped strip (no. 157). Eastern motifs and types abound; note the Syrian winged bulls, sphinxes, and women with long volute locks on the mitra relief (no. 155), or the Phoenician crescent and disk ornaments (nos. 179, 180, 181), or the scarab-holder pendant (no. 193).

At the end of the 7th century and during the 6th century, Greek artistic traditions gradually became dominant in Etruscan art. Greece had also been strongly infused with eastern traditions during the late 8th and 7th centuries, and by the end of the 7th century, the eastern elements had been assimilated. On jewelry, decorative floral elements, such as palmettes and rosettes, although ultimately of eastern origin, come via Greece. Note the palmettes on the earrings (nos. 161 and 164); the necklace pendants (no. 177); the ring (no. 226); as well as the rosettes on the earring (no. 159) and the

plaques (nos. 217, 216). Finger rings, which were rare in the 7th century, are now found; they are mainly of the Egyptianizing types also common in Greece: cartouche rings (nos. 224, 225); and scarab rings (nos. 227, 228, 229). Technically, granulation gives way gradually to filigree, a simpler and faster process. The *a baule* earrings (nos. 159, 158), and leech earrings (nos. 160, 161, 164) illustrate this technique.

The Walters collection is fortunate in possessing three masterpieces of 5th-century Etruscan jewelry, the pair of bullae with palmettes (no. 210a) and the Daedalus bulla (no. 209). The last, with an inscription in the Etruscan alphabet, is one of a very few inscribed pieces of jewelry. Also representative of this period is the hoop earring terminating in a feline head (no. 170), a type that becomes especially popular in Greece at the end of the 4th century.

Late Etruscan jewelry is considered to start about 400 B.C., when filigree and granulation give way to large gold surfaces, often worked in repoussé. This period is sparsely represented at the Walters but the earrings (nos. 165, 172) may date to the early 4th century and a round bulla (no. 211) bearing a mythological subject is also probably of 4th century date.

In the 3rd century B.C., jewelry that can be called specifically Etruscan is supplanted in Italy by jewelry that is essentially Hellenistic, a pan-Mediterranean style with local variations.

It is possible to date Etruscan jewelry on the basis of comparisons with tomb groups found in Etruria. This process has a large margin of error because most tombs were 'excavated' by treasure hunters rather than scientifically. Furthermore, all the objects found in the same tomb cannot be assumed to date to the same time. Objects such as jewelry might be heirlooms, treasured for several generations, and tombs were reused for successive burials for as long as a century. One of the most famous Etruscan tombs, the Regolini-Galassi tomb at Cervetri, illustrates some of the problems faced.

The tomb was opened in the spring of 1836 by the Vicar of Cervetri, Alessandro Regolini, and his partner General Vincenzo Galassi. Regolini and Galassi were looking primarily for gold and silver treasure. They kept no day by day account of their activity, but removed all the precious metal objects in the tomb as quickly as possible for fear of tomb robbers, ignoring the bones of the dead as well as most of the pottery. Most of the finds were removed first to Galassi's house and ultimately to the Vatican where they are today. A few have turned up in other museums and one object from the tomb, an ivory pyxis picked up forty years after the discovery of the tomb by the vicar of the parish even made its way to the Walters Art Gallery. Summary records kept by the exca-

vators and reports by several visitors list the objects and where they were found, but the accounts vary and the actual disposition of the goods in the grave cannot now be ascertained.

The tomb consisted of an antechamber, with niches on either side, divided from an inner chamber by a stone bench. Most of the written accounts and the nature of the finds themselves suggest that there were a series of burials made over a long period: a woman in the inner chamber, buried with a wealth of gold jewelry; a warrior in the antechamber laid out on a bed, chariot and weapons nearby; and a third burial, a cremation, in the right hand niche.

A few fragments of Proto-Corinthian vases, *skyphoi* and *oinochoai* suggest that the latest date for burial in the tomb is 625 B.C. Of the finds said to have come from the inner chamber, Cypro-Phoenician silver bowls, and silver jugs imported from the Near East indicate a date in the first half of the 7th century for the woman's burial.

From the character of the finds and the records of their distribution it is possible to tell something about the people buried in the tomb. The woman's burial was the richest; inscriptions on several vases may give her name, Larthia. Her burial included silver and bronze vessels, and a rich assortment of gold jewelry of which several are very much like examples at the Walters.

Because none of the Etruscan jewelry in the Walters collection has an established provenance, finds from the Regolini-Galassi tomb and others like it provide the only evidence for dating the jewelry and establishing where it might have been made and what it was used for.

Diana M. Buitron

Unless otherwise stated, the Etruscan jewelry was acquired by Henry Walters from Joseph Brummer in 1927.

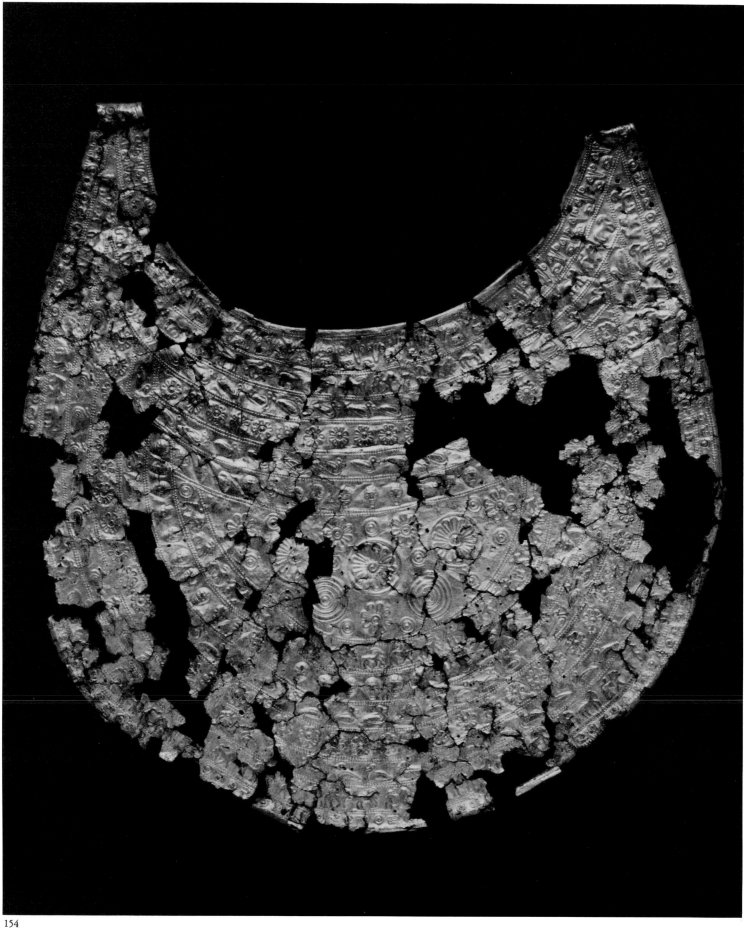

Gold Sheet Relief: Pectoral 154

Etruscan, about 700 B.C.

Crescent-shaped pectoral made of a thin sheet of gold decorated with narrow rows of animals and ornament in low relief. The rows are separated by double lines of dots worked free hand, while the animals and other ornaments are the results of stamps struck while the gold sheet was placed face down in a soft substance such as pitch. In all, ten different stamps were used: goats, lions, ducks, human heads, leaves, leaf rosettes inscribed in a circle, small leaf rosettes, large and small circle ornaments, and birds' heads. The pectoral was decorated starting with the outer registers and working inward to the crescent-shaped core, which is filled with rosettes and circles. All edges of the pectoral are rolled under—traces of copper corrosion under the edges indicate that a copper or copper alloy wire ran around the entire pectoral to support the thin gold. (57.368)

Max. L. 8-5/16 in (.211 m) H. 8-5/16 in (.221 m)

Publications:
Strom, *Etruscan Orientalizing Style*, cat. no. 558, pp. 77-79, fig. 38

Gold Sheet Relief: 'Mitra' 155

Etruscan, about 700 B.C.

The mitra (head or belt ornament) consists of a roughly semi-circular sheet divided into two wide horizontal registers and a narrow frieze, separated by rows of dots with a border of hatched triangles along the semi-circular edge, and four rows of dots along the top. Most of the figures in the two upper zones were probably worked individually, rather than stamped. In the upper zone are three winged bulls to the right; above each bull is a head, and there are three heads under the center bull. Between the bulls are standing women with long volute locks and transparent garments. On the left and right are pairs of goats. In the second register are two winged bulls opposed, four ducks beneath, four double leaf ornaments, four

circle ornaments, and two quadrupeds, perhaps sphinxes, one in each upper corner. In the lowest register is a procession of lions and goats. The lions, goats, heads, ducks, and circles appear to be the same stamps as those found on the pectoral. The edges of the sheet are frayed and crumpled. Along the top the metal is rolled back in three places perhaps to form tubes for suspension. (57.369)

Max. H. 2-5/8 in (.092 m) L. 4-7/8 in (.123 m)

Publications:
Strom, *Etruscan Orientalizing Style*, cat. no. 59, pp. 77-79, 207-8, fig. 39

Notes:
The pectoral and the mitra have been placed by Ingrid Strøm in her group of South Etruscan jewelry reliefs, somewhat Orientalizing in style, dated to around and shortly after the year 700 B.C. To place these reliefs in a relative stylistic chronology, Dr. Strøm chooses certain recurring motifs as the criteria; here, the 'plump duck' is the significant motif. Furthermore, the central area on the pectoral and the two main registers on the mitra show a certain freedom and development in composition and style, rather than a strict division into friezes seen on earlier, Geometric examples.

Somewhat later is the elaborate pectoral found in the Regolini-Galassi tomb at Cervetri dated by Strom to the second quarter or mid-7th century (Strom, *Etruscan Orientalizing Style*, pp. 82 and 175, plates 50-52).

Silver Relief 156

Etruscan, 7th century B.C.

Oblong, slightly curved sheet with holes for attachment at the corners. The sheet is bent back on three sides; cut out and rolled back over a wire on the lower edge to form twenty-two open spaces for the attachment of pendants with women's heads above palmettes of which sixteen are preserved, two fragmentally. Along the sides and lower edge is a cable or rope border. Five horizontal registers contain from top to bottom: guilloche pattern to left; fourteen lions to right and fifteen lions to left with a circle between the two groups; rosettes surmounted by crescents joined by dots; heart-shaped volutes; fifteen lions to left and fifteen lions to right. The three lower registers are bordered by cables, the guilloche is edged by smooth

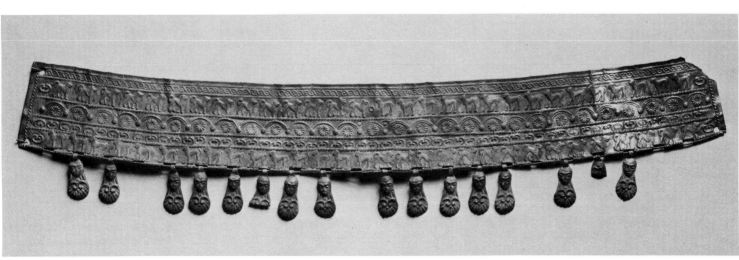

lines. At the ends of the lion processions are heart-shaped volutes. The women's heads on palmettes are almost identical with the gold pendants on necklace no. 177. (57.707)

H. 1-3/4 in (.045 m)
H. of pendants 1 in (.025 m)

History:
acquired by Henry Walters before 1931
Publications:
Strøm, *Etruscan Orientalizing Style*, pp. 75, 81, 86-7, cat. no. S60, fig. 62; George M. A. Hanfmann, *Alte-truskische Plastik* I, Würzburg, 1936, p. 20, note 24
Notes:
The relief is discussed by Ingrid Strøm, who places it in her South Etruscan group with marked Orientalizing influence (SIII) dated generally to the first half of the 7th century.

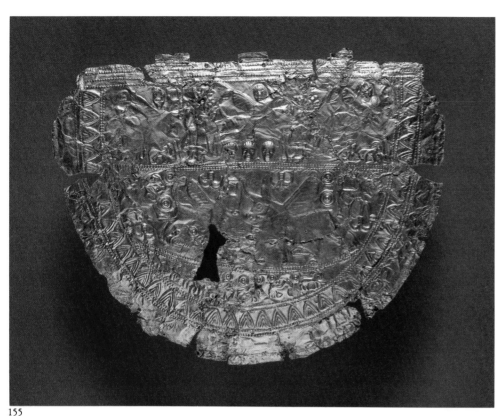

155

Horseshoe-Shaped Strip 157

Etruscan, 7th century B.C.

Gold strip, rolled forward at the ends, bordered by two rows of twisted wire. Double rows of granules form complex labyrinth meanders that meet a central pattern composed of triangles and lozenges with tiny rosettes in their centers. On the back are five gold staples for attachment. Gold strips such as this one must have been sewn onto garments—the shape suggests that this was a breast ornament. (57.409)

W. 3/8 in (.010 m)

Notes:
compare for example two strips with filigree and granulation in London (*BMCJ,* plate XVI, nos. 1262-1263), dated to the 7th century B.C.

157

A Baule Earrings 158-159

Etruscan, 6th-5th century B.C.

A baule, or box-type earrings are an Etruscan creation, known first in tombs of the late 7th century, and continuing into the 5th century B.C. The type is most common in the 6th century B.C.

The earrings are made from a rectangular sheet, rolled to form the greater part of a cylinder. Hinges on the cylinder have silver pins which lock into the wire that passes through the ear lobe. To open the earring, the pins have to be removed. All four edges of the sheet were bent upwards, thus forming the field for decoration.

158. Gold *a baule* earring, the front ornament composed of five gold bosses, each with a globule set in a filigree circle in the center, and four roughly shaped heads (?). The border above is a row of nine and a half tongues, once inlaid, edged by twisted wires on which sit three gold bosses set in rings of twisted

wire surmounted by globules. The border
below consists of four smooth wires. Back:
filigree leaf and bud pattern. The earring is
edged by a smooth wire between two twisted
wires. At both ends the gold hinges with
silver pins are preserved. (57.412)

Max. W. 1/2 in (.013 m)

Publications:
The Detroit Institute of Arts, *Ancient Italic and Etrus-
can Art,* Jan. 15-Feb. 23, 1958
Notes:
Compare earrings from 6th-5th century tombs at
Orvieto (Hadaczek, *Obrschmuck,* p. 58, figs. 106-112);
see also earrings in London (*BMCJ,* plate XVI, nos.
1296-7) and in the Villa Giulia, Rome (Becatti, *Orefi-
cerie,* no. 286).

159. Gold *a baule* earring with an elaborate
flower and leaf ornament on the front. The
heart of the flower is made of four crescent-
shaped tendrils with granules in their spirals,
a granule set in a circle in the center. The
heart is attached to a central shaft of wires
that pierce a sheet of gold leaf cut to form
eight leaves; and another sheet cut into eight
petals. Eight globes on wires are attached to
the central shaft. The top is bordered by a
row of tongues that once had enamel inlays.
Above, set in circles of twisted wire, are a
bull's head between two crowned human
heads, the details worked in repoussé, the
eyes black enamel, the crowns and forelock
of bull rendered in filigree with enamel in-
lays. Underside: three globes each set in a
four-petaled sheet. Back: filigree leaf pat-
tern. The whole is edged by plain and twisted
wires. The gold hinge and slightly corroded
silver pin are preserved at both ends. (57.411)

W. 11/16 in (.017 m)

Publications:
The Detroit Institute of Arts, *Ancient Italic and Etrus-
can Art,* Jan. 15-Feb. 23, 1958
Notes:
compare an earring in Berlin (Greifenhagen, *Berlin* I,
pls. 71, 75, 78-9) and a pair in New York (Alexander,
Jewelry, fig. 33)

Leech Earrings 160-164

Etruscan, 6th-4th century B.C.

Its resemblance to the bloodsucking annelid
worm gives this type of earring its modern
name. Leech earrings are generally made of
one or more sheets joined to form a tubular
hoop decorated with granules, globules, and
filigree. The earring was actually secured by
a wire that pierced the flesh.

The type goes back to the Middle Bronze Age
in Crete, survived in Cyprus through the
Dark Ages, to reappear in Sicily and Greece
in the 7th and 6th centuries B.C.

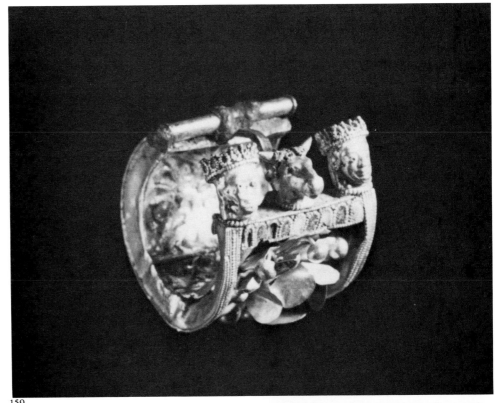
159

160. Gold leech earring made of two sheets,
rolled and joined to form a tubular hoop.
Three twisted wires run lengthwise along
the hoop; the wire on the outer face is
flanked by rows of filigree tongues, the wire
on one side is accompanied by a single row
of filigree tongues, while the third wire, on
the side that presumably lay against the
wearer's head shows no additional decora-
tion. Two S-shaped spirals fill the space at
the bottom center of the earring. Inside the
hoop is a single globule; suspended below
are four globules, each with four granules
attached. At the upper ends of the decorated
portion of the hoop are globules, one on
each side. (57.1643)

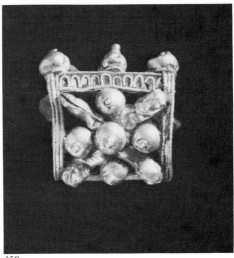
158

Max. H. 7/8 in (.023 m)

History:
collection of Henry Walters before 1931; Mrs. Henry
Walters; purchased from Joseph Brummer, 1941
Notes:
for the spirals in the center compare an earring from
Narce now in the Villa Guilia, Rome (Hadaczek,
Ohrschmuck, p. 60, fig. 114); for the tongue pattern
compare an earring from Volterra dated to the end
of the 6th-beginning of the 5th century B.C. (E. Fiumi,
"La 'facies' arcaica del territorio volterrano," *SE,* vol.
XXIX, 1961, pp. 276-7, fig. 9a-b)

162, 161, 160, 163, 164

165

161. Gold leech earring made of two sheets rolled and joined to form a tubular hoop. Two twisted wires run along either side of the hoop. The outer face is decorated with filigree palmettes and tendrils with granules. Suspended below is a globule with four granules attached. (57.1659)

Max. H. 3/4 in (.019 m)

History:
collection of Henry Walters, before 1931; Mrs. Henry Walters; purchased from Joseph Brummer, 1941
Notes:
for the palmettes compare an earring from Viterbo now in the Vatican (Hadaczek, *Ohrschmuck,* p. 60, fig. 116) 5th-4th century B.C.

162. Gold leech earring made of a single sheet rolled into a tubular hoop, the seam visible on the inner face. The outer face is decorated with half globules bordered on the sides and ends with twisted wire. The back portion of the hoop is undecorated. Suspended below are four globules each dotted with three granules. (57.1678)

Max. H. 13/16 in (.021 m)

History:
collection of Henry Walters, before 1931; Mrs. Henry Walters; purchased from Joseph Brummer, 1941
Notes:
compare an earring from a 4th-century tomb at Praeneste (A. Pasqui, "Palestrina," *NSc,* 1897, p. 263, fig. 5); and an earring in London (*BMCJ,* no. 2245)

163. Gold leech earring made of a single sheet rolled into a tubular hoop. Three twisted wires run lengthwise along the hoop and end with circles of twisted wire. (57.1651)

Max. D. 1/2 in (.016 m)

History:
collection of Henry Walters, before 1931; Mrs. Henry Walters; purchased from Joseph Brummer, 1941
Notes:
compare an earring in London (*BMCJ,* plate XLIV, no. 2265)

164. Gold leech earring made of three sheets joined to form the tubular hoop—one seam is visible on the inner face; twisted wire along the sides of the tube mask two more seams. The outer face of the tube bears filigree palmettes and tendrils with granules in their spirals. A circle of twisted wire edges one end of the hoop, while a crescent-shaped sheet is attached to the front, probably to mask the original fastening. The crescent is decorated with thirteen half-globules surrounded by twisted wire and is edged with plain and twisted wire. Suspended from the hoop are four globules each with a granule attached. (57.1652)

Max. H. 15/16 in (.024 m)

History:
collection of Henry Walters, before 1931; Mrs. Henry Walters; purchased from Joseph Brummer, 1941

Notes:
A similar earring is in London (*BMCJ,* plate XLIV, no. 2251). The addition of the crescent-shaped sheet suggests that this example is later than the preceding examples. In the 4th and 3rd century B.C. the crescent becomes larger and tends to dominate the leech.

Gold Earring 165
Etruscan, 4th century B.C.

The earring is made in two parts: a flat sheet, and four hollow balls. The sheet is lined and edged with twisted wire and terminates at the top in a narrow strip that formed the hook of the earring. The four balls are made in two halves, front and back, the rear half of each with an opening, perhaps to prevent rupture during manufacturing. The balls are festooned with globules, granules and half globules (shown hollow and convex side facing out). The fourth ball, not visible in the photograph, was placed behind to consolidate the setting. (57.1611)

Max. H. 1-3/8 in (.035 m)

History:
collection of Henry Walters, before 1931; Mrs. Henry Walters; purchased from Joseph Brummer, 1941

Notes:
for earrings of this type see Hackens, *Classical Jewelry,* p. 40, no. 6. who dates a pair in Providence to the 4th century B.C. or later. Hackens suggests that earrings with very sharp hooks, like this one, may have been designed for funeral purposes.

Hoop Earrings 166-172
Etruscan, 7th-4th century B.C.

A third major type of Etruscan earring is based on a tubular hoop. Its simplest form is a wire hoop with the ends crossed over and wound around each other (nos. 166-167). In its early variations, one end of the earring may flare out like a trumpet (nos. 168-169), or have an animal head at one end (no. 170). Later, one end of the hoop has a hollow bead (no. 171) and in the most elaborate types, a ring and pendant may be added to the basic hoop (no. 172).

166. Gold hoop earring with the ring formed of a single rounded wire; the ends cross over and are spirally wound around each other. (57.499)

Max. D. 3/8 in (.01 m)

Notes:
A similar earring was found in the Bes Circle at Vetulonia, dated to the 7th century B.C. (Montelius, *Civilisation primitive en Italie,* II, plate 181, 4)

167. Gold hoop earring with a rounded wire whose tapering ends cross over and are spirally wound around each other. (57.498)

Max. D. 7/16 in (.011 m)

168. Gold trumpet earring made from a single sheet which forms a flaring tubular hoop. The wider end is edged with circles of twisted and smooth wire. (57.486)

Max. D. 3/8 in (.01 m)

Notes:
compare a pair of earrings in London (*BMCJ,* plate XLIII, nos. 2198-9), and an earring from a 7th-century tomb at Vetulonia (Bes Circle) (Montelius, *Civilisation primitive en Italie,* II, plates 181, 6)

169. Gold trumpet earring made from a single sheet rolled into a flaring tubular hoop. Half globules form a chevron design on the outer face. The wider end is edged with a circle of twisted wire. (57.1657)

D. 9/16 in (.015 m)

History:
collection of Henry Walters, before 1931; Mrs. Henry Walters; purchased from Joseph Brummer, 1941

Notes:
The type is first found at Vetulonia and Narce in 7th-century contexts (Higgins, *Greek and Roman Jewellery,* p. 137). This example is similar to *BMCJ,* plate XLIII, nos. 2200-2201, dated to the 6th-5th century B.C.

170. Gold animal-head hoop earring with a tubular hoop terminating at one end in a lion's head, the other end tapering and broken off. The lion's head is worked in repoussé with details of face and mane lightly incised. (57.485)

Max. D. 9/16 in (.014 m)

Notes:
for the type compare an earring from a 5th-4th century tomb at Spina (Becatti, *Oreficerie,* plate H, 7); and another from a 5th-century tomb at Bologna (Montelius, *Civilisation primitive en Italie,* I, plate 102, 5).

171. Gold earring with hollow bead. A tubular hoop is decorated all over with smooth wires. At one end is a hollow bead ornamented with twisted wire and flanked by collars of smooth wire. (57.1647)

Max. D. 15/16 in (.023 m)

History:
collection of Henry Walters, before 1931; Mrs. Henry Walters; purchased from Joseph Brummer, 1941

Notes:
Similar pairs of earrings but lacking the smooth wire on the tube are in London (*BMCJ,* plate XLIII, nos. 2215-2216), and in the Metropolitan Museum of Art in New York (accession no. 95.15. 172-3). On the development of this type see Hadaczek, *Ohrschmuck,* pp. 64-66. An example of Florence with wire lengthwise as here is illustrated in his fig. 131. Compare a similar earring from a late 4th-century tomb at Todi (Becatti, *Oreficerie,* no. 418, plate CXII).

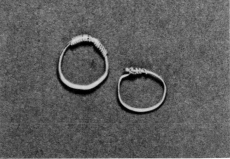

166, 167

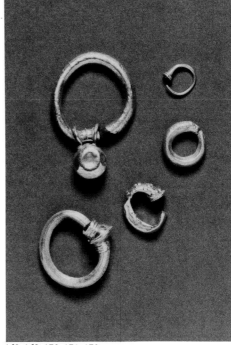

168, 169, 170, 171, 172

173

174, 175

176

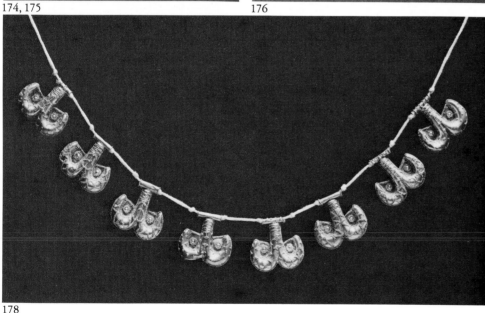

178

172. Gold hoop and pendant from an earring. The hoop is solid bronze overlaid with gold leaf. Attached to the hoop is a small gold bulla, its top formed by a tube decorated with filigree and edged by tiny tubes that spiral where they touch the bulla. The bulla swivels and can lie either within or without the hollow of the hoop. (57.1673)

Max. D. 1-1/16 in (.026 m)

History:
collection of Henry Walters, before 1931; Mrs. Henry Walters; purchased from Joseph Brummer, 1941
Notes:
The whole probably served as the pendant of an earring such as the preceding example. See Alexander, *Jewelry*, p. 23, fig. 76; Becatti, *Oreficerie*, plate CX, no. 414; and Hadaczek, *Ohrschmuck*, p. 65. The date is probably 4th century B.C.

Spirals 173-176

Etruscan, 7th century B.C.

Spirals are especially common in 7th-century Etruscan tombs, and may be made of gold, silver or bronze. Their use is not certainly known—earring pendants, hair ornaments, children's rings—are the usual suggestions. Some are quite ornate, often ending in animal or human heads while others are simply plain gold wire.

173. Two gold spirals. The spiral reverses direction in the center forming a loop. Two smooth wires edging two twisted wires form the spiral; on it are twenty hollow hemispheres, perhaps settings for jewels. The ends have human head finials (one is missing), their faces and hair rendered in repoussé. (57.415-6)

Max. D. 1-1/16 in (.026 m) H. 1-1/16 in (.027 m)

Notes:
compare *BMCJ*, plate XVI, nos. 1320 and 1321; for an idea of how these spirals may have been used as hair ornaments, see *BMCJ*, p. 118, fig. 28

174. Two gold spirals. The spiral reverses direction in the center forming a loop; the loop and ends are flattened, and have oblong strips attached. The strips on the two ends of the spiral are ornamented with a row of nine globules, then a hollow hemisphere that was once filled with glass or paste, then a tenth globule. The strip on the central loop is similar but the hollow hemisphere is replaced with a dark stone, perhaps glass, set in a ring of twisted wire. (57.417-8)

Max. D. 7/16 in (.011 m) Max. H. 5/16 in (.008 m)

Notes:
compare *BMCJ*, plate XVI, no. 1329

175. Gold spiral serpent. A narrow strip, flattened on the inside, rounded on the outside, is coiled three times to form a spiral serpent. Details of the head and scales at both ends are chased. (57.1631)

Max. D. 3/8 in (.01 m) Max. H. 9/16 in (.015 m)

History:
collection of Henry Walters, before 1931; Mrs. Henry Walters; purchased from Joseph Brummer, 1941

176. Five plain gold spirals made of wire. (57.436-40)

Max. D. 7/16 in (.011 m)

Necklaces, Beads and Pendants 177-205

Etruscan, 7th-6th century B.C.

The beads and pendants that follow give a good idea of the great variety in shape, size and decoration possible in Etruscan necklaces and bracelets. In some cases, as the "necklace" shown in no. 177, beads and pendants are strung together: the arrangement is not necessarily the original one, but gives an idea how a necklace might have looked. Other beads and pendants are illustrated separately but can be imagined in various combinations. Most can be dated to the 7th century B.C. through comparisons with tomb groups.

In the descriptions that follow *pendant* means that there is a pipe or rings for suspension while *bead* means that the ornament itself is pierced.

177a. Twenty-three gold relief pendants, each made of a single sheet worked in repoussé. Twelve represent human heads with palmettes, six large, six small. Eleven depict bunches of grapes.

Max. H. 7/8 in (.022 m), 11/16 in (.017 m), 1/2 in (.012 m)

b. Twenty-three glass beads, white and blue on dark blue.

Max. D. 1/4 in (.007 m)

c. Two hundred and two cylindrical zinc beads. (57.1676)

Max. D. 2/16 in (.004 m)

History:
collection of Henry Walters before 1931; Mrs. Henry Walters; purchased from Joseph Brummer, 1941

Notes:
Like most combinations of necklace elements, this one is a reconstruction. Similar relief heads on palmettes are known from the graves of La Pietrera at Vetulonia, dated to the later 7th century B.C. (Randall-MacIver, *Villanovans,* plate 29, 2). The silver pendants of the rectangular relief, no. 175 are also very close. Similar glass beads are found on three necklaces in London (*BMCJ,* plate XXI, nos. 1450 and 1452, and plate XXIII, no. 1454). Zinc beads do not yet appear to be known for this period.

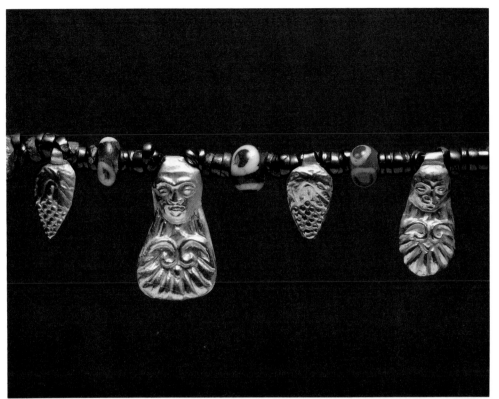

177a, b, c detail

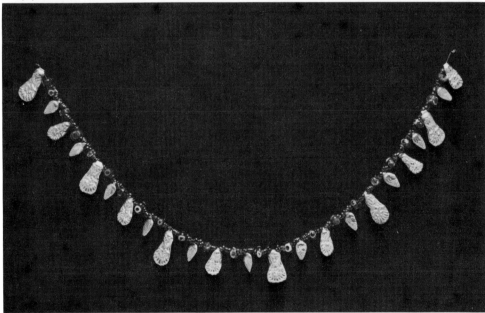

177a, b, c

178. Eight necklace sections each formed of a flat sheet, with sheet worked in repoussé on top, to form raised anchor. Raised circles and granulation on the plaques inside the arms, granulation on the anchor. Top rolled to form long suspension pipe, some with granulation. Anchors and pipes edged with twisted wire. (57.401)

Max. H. 11/16 in (.018 m) Max. W. 3/4 in (.02 m)

Notes:
Necklace sections in the form of an anchor are known from a 7th-century tomb at Vulci (Higgins, *Greek and Roman Jewellery*, p. 140).

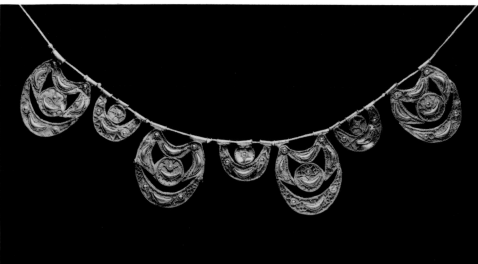

179, 180

179. Three necklace sections. Sheet cut to make a crescent and circle. Applied circles and crescents, granulation design with variations. Three suspension pipes on each. Crescents, circles, pipes edged with twisted wire. (57.408)

Max. H. 9/16 in (.015 m) Max. W. 3/4 in (.019 m)

Notes:
Crescents and circles in a slightly different configuration, but similarly decorated, are found on a necklace in the Metropolitan Museum (Alexander, *Jewelry*, fig. 3) dated to the 8th-7th century B.C.

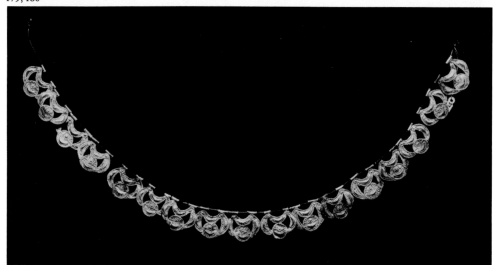

181

180. Four gold necklace sections. Each made of a sheet of metal cut to form four crescents and a circle decorated with raised crescents and circles separately made and applied, along with designs in granulation. Suspension pipes at the top with the addition of two pipes on the backs of all four. Crescents, circles and suspension pipes edged with twisted wire. (57.406)

Max. H. 1-1/8 in (.029 m) Max. W. 1-1/16 in (.027 m)

181. Seventeen gold necklace sections. Each made of a sheet of metal cut to form three crescents and a circle decorated with raised crescents and circles separately made and applied, along with designs in granulation. The scheme of decoration varies slightly; on some the granules have been lost. At the top on both sides the metal is rolled back to form pipes for suspension; on two sections there are pipes attached to the back as well. Crescents, circles and suspension pipes edged with twisted wire. (57.407)

Max. H. 13/16 in (.021 m) Max. W. 1 in (.025 m)

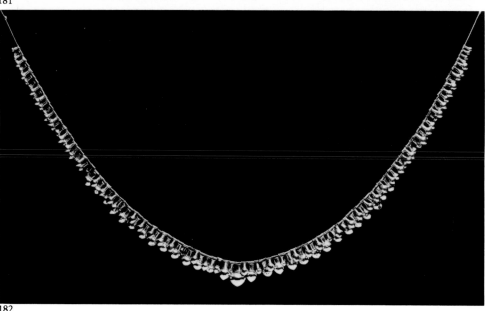

182

182. One hundred and ten gold bottle-shaped pendants with pointed bottoms and long necks. Twisted wire edges the neck. There are three basic sizes: the large pendants have coiled wire attached to the top for suspension, while the two smaller size pendants have a plain pipe. (57.459)

H. of large pendants 1/2 in (.012 m) H. of small pendants 3/8-1/4 in (.009-.006 m)

Notes:
The shape seems to be fairly common in 7th-century tombs. Compare pendants from the Regolini-Galassi tomb at Cervetri (Pareti, *Regolini Galassi,* p. 212, no. 140, plate XIV) and from Tre Fontanile Tomb 2 at Veii (C. Ambrosetti, "Veio," *NSc,* 1954, p. 3, fig. 3).

183. Five gold pendants. Hollow, spherical pendants open at the top. On either side of the opening is a wire loop with a wire circle attached for suspension. (57.462)

D. 5/16 in (.008 m)

184. Gold pendant. Pointed sphere, hollow tube around opening at the top. Suspension ring, made of coiled hollow wire, attached to round plate set inside opening of sphere. (57.463)

Max. H. 15/16 in (.024 m)

Notes:
An electrum pendant of similar shape comes from a 7th-century tomb at Vetulonia (Montelius, *Civilisation primitive en Italie,* II, plate 191, 6). Compare also a pendant container from the Artiaco tomb at Cumae (G. Pellegrini, "Tombe arcaiche greche," *ML,* XIII, 1903, p. 240, fig. 15).

185. Hollow spherical gold pendant, knob at the bottom, open at the top. On either side of the opening is a wire loop with a wire circle attached for suspension. (57.465)

D. 3/8 in (.01 m)

186. Hollow spherical gold pendant with a collar on top edged by smooth wire. Coil of wire for suspension. (57.464)

D. 5/16 in (.008 m)

187. Gold pendant. Circular sheet edged by twisted wire and a row of granules. Eight granule triangles point inward creating an eight-petaled flower. In the center is a gold boss with a single granule circled by a smooth wire between two twisted wires. Attached at the top is a thin sheet rolled to form a tube through which a string could pass. Twisted wire is preserved at one end of of the tube. (57.414)

H. with attachment tube 5/8 in (.016 m) Max. D. 9/16 in (.014 m)

Notes:
Three disks with similar granulation come from the 7th-century Tre Fontanile tomb 2 at Veii (C. Ambrosetti, "Veio," *NSc,* 1954, p. 3, fig. 3). Four others are part of a necklace in the Metropolitan Museum (Alexander, *Jewelry,* fig. 3).

183

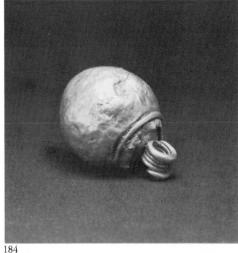
184

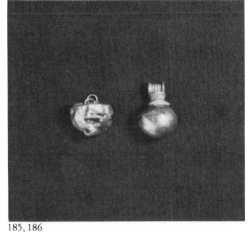
185, 186

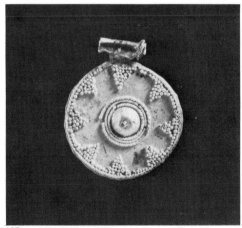
187

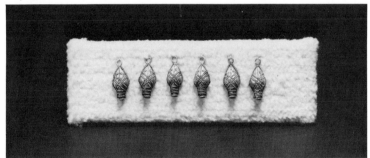
188

188. Six bud-shaped gold pendants. Each made of a flat sheet with a raised sheet above to form a bud. At the back is a smooth wire ring; at the tip, a looped wire hook attached behind. Crossing rows of granules decorate the front. (57.419)

Max. H. without loop 7/16 in (.011 m)

Notes:
compare the silver belt buckle from the tumulus of Val di Campo at Vetulonia (Randall-MacIver, *Villanovans,* plate 26, 3)

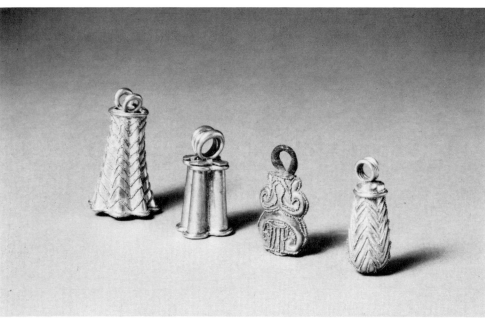

190, 191, 192, 189

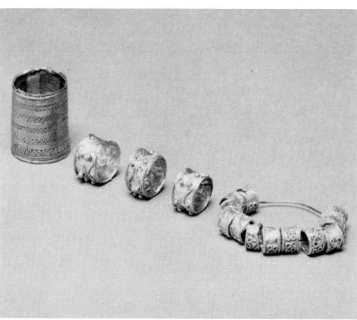

196, 194, 195

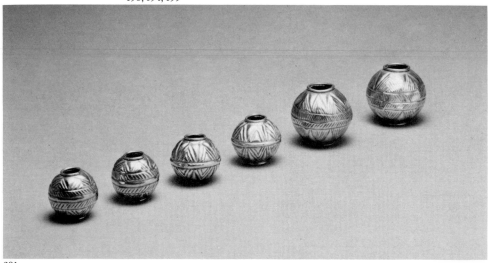

201

189. Gold pendant. Drop-shaped pendant worked in repoussé, decorated with granulation zig-zags on the sides, and four leaves on the bottom. Hollow wire bordered on either side with a row of granules at the top. Wire coil for suspension set on a sheet fitted into the top. (57.490)

H. with coil 1-1/16 in (.026 m)

Notes:
compare two similarly shaped pendants from 7th-century contexts at Marsiliana d'Albegna and Vetulonia (Antonio Minto, *Marsiliana d'Albegna,* Florence, 1921, plate XI, 3a-b; Georg Karo, "Vetuloneser Nachlese," *SE,* VIII, 1934, p. 53, fig. 1)

190. Bell-shaped hollow gold pendant worked in repoussé to form corrugated sides. Eight double rows of granules makes a zig-zag pattern across the bell. A smooth wire and a row of granules edge top and bottom. The bottom is made of an eight-lobed sheet with four human faces worked in repoussé; the lobes and faces edged by granules. A circular sheet with two ring handles and an opening surrounded by a circle of twisted wire is set into the top. (57.491)

H. without ring handles 1 in (.025 m) Max. H. 1-3/16 in (.031 m)

191. Gold pendant. Sheet worked in repoussé to form four cylindrical projections with chased, hatched lines between the projections. Hollow wire edges top and bottom. Top and bottom formed of separate four-lobed sheets. Coil of hollow wire attached to the top for suspension. (57.470)

H. with suspension coil 1 in (.026 m)

Notes:
compare a simpler pendant from Marsiliana d'Albegna (Antonio Minto, *Marsiliana d'Albegna,* Florence, 1921, plate XI, 2) and one from Duvanlij (Bogdan D. Filow, *Die Grabhügelnekropole bei Duvanlij in Sudbülgarien,* Sofia, 1934, p. 43, fig. 50)

192. Gold and silver pendant. Gold leaf over silver core, the gold leaf missing from the suspension ring and from the bottom. The two sides have the same intricate design made with granules. (57.488)

Max. H. 1 in (.026 m)

193. Gold pendant. Crescent-shaped gold tube, two rings at the ends of the arms. Between the arms are two interlocking loops of gold wire, and two short projecting wires, perhaps arranged to hold a jewel in place. Above, two rings with a spiral of wire between for suspension. (57.484)

Max. L. 1/2 in (.012 m) Max. H. 1-5/16 in (.033 m)

Notes:
Similar pendants with the scarabs preserved have been found in the Circle of the Silver Necklace at Vetulonia (Montelius, *Civilisation primitive en Italie,* II, plate 182, 13-14), Bisenzio (E. Galli, "Il Sepolcreto Visentino delle 'Bucacce'," *ML,* XXI, 1912, 404-98, p. 431), and Vulci (G. Pinza, *Etnologia Antica Toscana-Laziale,* Milan, 1915, plate 2).

Three Types of Cylindrical Beads 194-196

Etruscan, 7th-6th century B.C.

194. Three gold cylindrical beads; each made of a sheet rolled and soldered together, and decorated with three sets of filigree volutes with granules in the spirals. Smooth wires edge the cylinders. (57.494-496)

Max. D. 5/16 in (.008 m) W. 3/16 in (.005 m)

195. Twelve gold cylindrical beads. Each is made of a sheet bent to form a cylinder, edged by twisted wire and decorated with three pairs of filigree spirals (57.511)

D. 1/8 in (.004 m)

196. Large cylindrical bead. Sheet bent into cylinder decorated at either end with twisted wire and alternating groups of five smooth wires with a band of looped wire alternately right and left. (57.445)

H. 9/16 in (.014 m)

Notes:
compare the gold ornament, possibly part of a clasp, from the 7th-century Barberini tomb at Praeneste (C. D. Curtis, "The Barberini Tomb," *MAAR*, V, 1925, p. 18, plate 3, figs. 5-7)

Four Types of Gold Beads 197-200

Etruscan, 7th-6th century B.C.

197. Six beads composed of three rows of seven granules soldered together, a smooth wire at each open end. (57.403)

Max. D. 3/16 in (.004 m)

Notes:
compare the beads found in the grave of a young girl at Gordion dated before the middle of the 6th century B.C. (Rodney S. Young, "The Excavations at Yassihuyuk-Gordion, 1950," *Archaeology*, 3, 1950, p. 199, fig. 5)

198. Seven beads that consist of a cylinder on either side of a rounded bead with a ring of coiled wire on either end. (57.399)

L. 3/8 in (.009 m)

199. Six hollow beads worked in repoussé with details chased on the outside. Smooth wire at open ends. Decoration on two consists of four spirals clustered at each opening; on three, alternating leaves and fruits clustered at each opening; and on one, vertical strips with acorns and leaves. (57.404)

Max. D. 5/16 in (.007 m)

200. Three rounded beads worked in repoussé to make ribbing. (57.400)

D. 1/4 in (.006 m)

Notes:
Similar beads come from the graves of La Pietrera at Vetulonia (Montelius, *Civilisation primitive en Italie*, II, plate 201, 2).

Six Biconical Gold Beads 201

Etruscan, 7th-6th century B.C.

Hollow bead, the open ends edged by hollow wire. Design worked in repoussé, then chased. Around the center of the two large beads are two hatched bands; on two of the small beads, a plain band; on the other two small beads, a plain band edged by hatched bands. Above and below on all six are chevrons. (57.452-7)

Max. D. of large beads 1-1/8 in (.028 m) Max. D. of small beads 7/8 in (.022 m) H. of large beads 1 in (.026 m) H. of small beads 3/4 in (.019 m)

Notes:
for similar but smaller beads see *BMCJ*, plate XIII, no. 1194

Four Types of Gold Beads 202-5

Etruscan, 7th-6th century, B.C.

202. Eight hollow, rounded beads open at both ends, a smooth wire placed around the openings on seven of the beads, missing on the eighth. Made of one sheet bent round to form a sphere. (57.461)

Max. D. 3/8 in (.009 m)

203. Sixteen gold beads: twelve hollow round beads with eight granules edging each opening and four smaller biconical beads with seven granules at each opening. (57.405)

Max. D. 1/4 in (.006 m)

204. Fifty-four hollow rounded beads with small openings at both ends. Made of two hemispheres joined. (57.402)

Max. D. 3/16 in (.005 m)

205. Ninety-four plain rounded beads. (57.460)

Max. D. 1/8 in (.003 m)

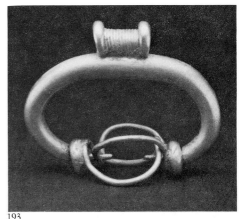
193

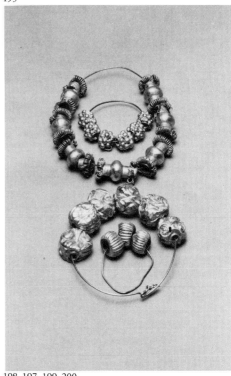
198, 197, 199, 200

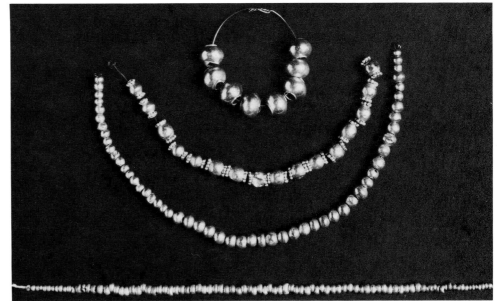
202, 203, 205, 204

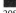

207

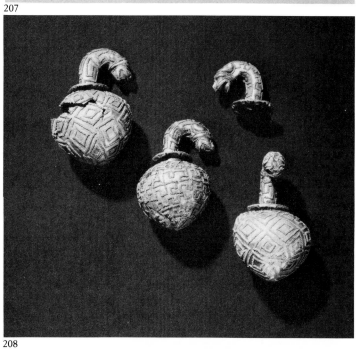

208

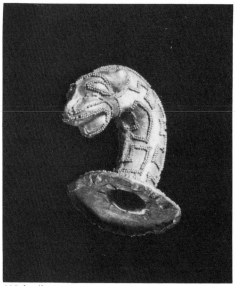

208 detail

206

Gold Necklace 206

Etruscan, 7th century B.C.

A thick rope braid composed of eight pairs of wires twisted together and laid side by side to form the braid is capped on either end by lion-headed finials with loops in their gaping jaws. The lion heads are cast, the loops probably made separately. (57.458)

L. of finials 13/16 in (.020 m)

L. of necklace 26-1/2 in (.673 m)

Notes:
A similar necklace composed of a thick rope braid ending in double lion-headed finials and loops was found in the Regolini Galassi tomb at Cervetri and dated to the mid-7th century B.C. (Pareti, *Regolini-Galassi*, plate V, and Higgins, *Greek and Roman Jewellery*, p. 214). This type of necklace continues in use, the plaited rope replaced with complex chains, into the Hellenistic period (Alexander, *Jewelry*, p. 6). For the technique of the plaited rope, see Hoffmann and Davidson, *Greek Gold*, p. 37.

Gold Ornament on a Rope Braid 207

Etruscan, 7th century B.C.

Hollow gold tube decorated with granulation lozenges and zig-zags. The rope braid is composed of four pairs of wires twisted together and laid side-by-side to form the braid. At either end of the braid are two beads decorated with triangles of granulation, edged by smooth wire. The frayed ends of one end of the braid indicate that it was once longer, the join of the braid to the tube is probably modern. (57.410)

Max. D. of tube 11/16 in (.018 m) D. of beads 3/16 in (.005 m) L. of chain 6-7/8 in (.174 m)

Gold Animal-Head Pendants(?) 208

Etruscan, 7th century B.C.

Parts of four similar pendants—three nearly complete, one consisting of the upper part only (a.). Hollow, spherical body pointed at bottom, topped with a feline head on a long neck set in a disk attached to the sphere. The four feline faces are similarly rendered, the gaping mouths, bulging eyes, flattened ears in double rows of granulation. The long necks have granulation meanders; on the disks are triangles. There is a small hole on the side of the neck on three examples. Two spheres (b., c.) have a star at the base, lozenges covering the surface. The third preserved sphere (d.) has a wheel at the base, then a row of T-meanders, and then two rows of labyrinth meanders. (57.477, 57.480)

Max. H. 1-11/16 in (.043 m) 57.477 H. of feline and base 5/8 in (.016 m)57.480

Notes:
for feline heads see Becatti, *Oreficerie*, pl. LIV, figs. 243a-c, dated to the 7th century B.C. and no. 214, here, WAG 57.489, buckle

Bullae 209-211

The bulla (plural bullae) is an Etruscan ornament in general use from the 5th century B.C. onwards, later adopted by the Romans. It is a hollow pendant that might contain perfume or a charm. A hollow stopper fits between two ring handles. A cord or flexible chain would have passed through the handles and stopper for suspending the container around neck or arm, available at a moment's notice. The stopper would simply be lifted and perfume applied. Releasing the chain would snap the stopper back into place.

Gold Bulla 209
Etruscan, 5th century B.C.

This most elaborate and beautiful bulla depicts the mythical craftsman Daedalus on one side and his ill-fated son Icarus on the other. The figures are named in retrograde Etruscan inscriptions: ƎᗡＡꓕIＩꓶ, "Vikare," or Icarus, and ƎVＴIＡＴ,"Taitle," or Daedalus. Daedalus carries a saw and adze, implements he is said to have invented (Pliny, *NH* VII, 198). Icarus carries a draftsman's square and a double axe, more properly attributes of his father. Both figures are shown flying, wings spread, legs drawn up. The contour of wings and heads is the line along which the sheets that form the bulla are joined. The figures are worked in repoussé, details chased and incised. Around the base and neck are circles of twisted wire. The suspension handles are formed of a hollow hoop and a circle of twisted wire; the stopper has a central hoop with twisted wire on either side and at the ends.

The story of Daedalus and Icarus, a favorite subject in antiquity, is represented on this bulla in a very early, if not the earliest stage. The style suggests a date in the first half of the 5th century B.C. The contents remaining inside were tested and found to include traces of labdanum, a substance used to fix scents. (57.371)

Max. H. 1-9/16 in (.04 m) H. without stopper 1-3/16 in (.03 m) Max. D. 1 in (.026 m)

History:
said to be from Comacchio, near Ferrara; purchased by Henry Walters from Sangiorgi, 1930
Publications:
Franz Messerschmidt, Review of V. Dumitrescu, L'Età del Ferro nel Piceno, in *Gnomon*, 9, 1933, p. 161; George M. A. Hanfmann, "Daidalos in Etruria," *AJA*, 39, 1935, pp. 189-194, pl. XXV; Eva Fiesel, "The Inscription on the Etruscan Bulla," *AJA*, 39, 1935, pp. 195-197; John D. Beazley, "Groups of Early Black Figure," *Hesperia*, 13, 1944, p. 43, 9; Arvid Andrén, "Oreficerie e plastica etrusca," *Opuscula Archaeologica*, 5, 1948, p. 94, fig. 6; Becatti, *Oreficerie*, p. 186, no. 316, pl. 78; Emeline H. Richardson, *The Etruscans, Their Art and Civilization*, Chicago, 1964, pp. 152 ff. pl. XLa; Frank Brommer, *Denkmälerlisten zu griechischen Heldensagen*, 3rd edition, Marburg, 1976, p. 63; Cleveland,

Exhibition of Gold, October 31, 1947 - January 11, 1948; Dayton Art Institute, *Flight: Fantasy, Faith, Fact*, December 17, 1953 - February 21, 1954, no. 138; The Detroit Institute of Arts, *Ancient Italic and Etruscan Art*, January 15 - February 23, 1958; Worcester Art Museum, *Masterpieces of Etruscan Art*, Worcester, April 21 - June 4, 1967, no. 56 (R. S. Teitz)

Pair of Gold Bullae 210
Etruscan, 5th century B.C.

The heart-shaped bullae are worked in repoussé; details are either chased, or consist of smooth or twisted wire applied to the surface. The decoration consists of two zones of palmettes and tendrils, the upper alternately upright and hanging, the lower diagonal. The edges of the palmettes and tendrils are emphasized by tiny punch marks. The strips that separate the palmette zones are also worked in repoussé and chased to form the beads. Circles of twisted wire are applied to the pointed bases of the bullae. Three circles of twisted wire alternating with three circles of smooth wire surround the openings for the stoppers at the tops. The suspension hoops are made of a hollow hoop and a circle of twisted wire; there are globules at the bases of the hoops. The stoppers consist of a narrow hollow tube that fits down into the bullae, and a wider hollow tube open at both ends that forms the stopper itself. On a. the stopper is decorated with smooth and twisted wires, clusters of granules and miniature circular flowers; the stopper on b. has three rings of twisted wire, the two outer rings have a smooth wire inside, the central twisted wire is flanked by smooth wires. (57.574, 57.1950)

a. Max. H. 1-11/16 in (.042 m) H. without stopper 1-1/4 in (.032 m) Max. D. 1-1/4 in (.032 m) 57.574

b. Max. H. 1-11/16 in (.042 m) H. without (.032 m) 57.1950

History:
(a.) purchased by Henry Walters from Sangiorgi, 1930; (b.) purchased by Dorothy Kent Hill at auction in Lucerne, 1964
Publications:
Dorothy Kent Hill, "Perfume, Jewelry and The Etruscans—Story of a Reunion," *BWAG*, vol. 17, no. 4, 1965; *Ars Antiqua*, (auction catalogue), Lucerne, November 7, 1964, no. 141 (for 57.1950 only); Wildenstein & Co. Inc., "An Exhibition of Treasures of the Walters Art Gallery", New York, 1967, no. 74
Notes:
The two bullae were purchased thirty-four years apart but the similarity in size and decoration indicates that they must originally have been worn together as for example the pair of bullae in London (BMCJ plate XLV, no. 2271). For the type compare bullae from the cemetery of Filottrano (Ancona region), I. Dall'Osso, *Guida Illustrata del Museo Nazionale de Ancona*, Ancona, 1915, pp. 231, 233-4, 237.

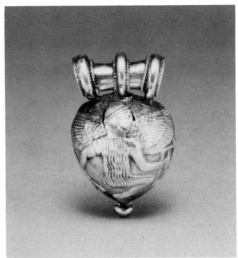

209

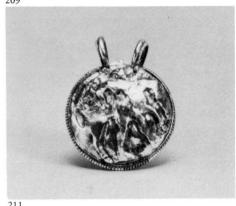

211

210

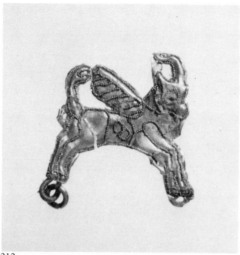

212

213

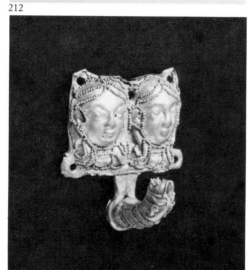

214

215

Gold Bulla 211

Etruscan, 4th-3rd century B.C.

The bulla consists of two circular convex sheets joined, the seam masked by a twisted wire between two smooth wires. Worked in repoussé on the front are a warrior and a horse; the back is plain. The two suspension rings are formed of a hollow hoop and a circle of twisted wire. The stopper is missing. (57.1261)

Max. D. 15/16 in (.024 m) Max. H. 1-1/8 in (.029 m) W. 3/8 in (.01 m)

History:
purchased by Henry Walters from Sangiorgi, 1930
Notes:
Lentoid bullae are known as early as the end of the 6th century B.C. but those with mythological scenes have been dated to the 4th-3rd centuries. See Arvid Andrén, "Oreficerie e plastica etrusca," *Opuscula Archaeologica*, V, 1948, pp. 91-112.

Plaques and Appliqués 212-217

The original purpose of the plaques and appliqués is uncertain. They may have been strung together to form elaborate necklaces, or sewn to fabric as garment trimmings. Plaques and appliqués of similar type have been found in quantities in South Russian tombs from the 6th century B.C. through the Hellenistic period.

Gold Plaque in the Form of a Winged Goat 212

Etruscan, 7th century B.C.

Winged goat, details rendered in repoussé (snout, wings) and granulation. Four holes for attachment as well as a loop, fastened to the hind legs, with a ring fitted into it. (57.513)

Max. H. 1-1/8 in (.028 m) Max. L. 1-1/8 in (.028 m)

Gold Plaque in the Form of a Winged Female 213

Etruscan, 7th century B.C.

Made with two sheets, the back flat, the front worked in repoussé with granulation for details. A winged human figure is represented. Four loops for attachment. (57.487)

Max. H. without loops 9/16 in (.015 m)

Notes:
The treatment of the wings on this and the winged goat can be compared with the treatment of the bird's wings on the comb-shaped ornament from the Bernardini tomb at Praeneste (C.D. Curtis, "The Bernardini Tomb" *MAAR* III, 1919, pp. 7-90.

Gold Plaque (Buckle ?) 214

Etruscan, 7th century B.C.

The plaque has a flat back, but a front worked in repoussé to form two faces with hair and neck rendered in granulation. The lower part of the plaque is a hollow hook that projects outward. It ends in a feline head worked in repoussé and with granules for features and mane. Five holes for attachment. (57.489)

Max. H. 7/8 in (.022 m) Max. L. 15/16 in (.023 m)

Notes:
The hair and faces can be compared with the figures of Artemis on a pair of bracelets found in a tomb at Praeneste and dated to the 7th century B.C. (*BMCJ*, pl. XVIII, no. 1356).

Round Gold Plaque 215

Etruscan, 7th-6th century B.C.

The surface displays a central globule within a twisted wire circle and, surrounding it, two concentric rings of smaller globules, nine in the inner ring, fifteen in the outer. Three holes for attachment. (57.512)

Max. D. 3/8 in (.009 m)

Notes:
A round plaque similarly decorated with twisted wire and globules is in the Metropolitan Museum (accession no. 95.15.282).

Oblong Gold Plaque 216

Etruscan, 6th century B.C.

Roughly rectangular sheet, all edges turned down, four holes for attachment. The plaque is decorated with volutes worked in repoussé and a gold leaf rosette (originally twelve-petaled) with a glass center. (57.448)

L. 3/4 in (.019 m) W. 9/16 in (.014 m)

Notes:
Compare five gold appliqués in the Villa Guilia Museum, Rome (accession no. 59792) from Monte Aùto Vulci; found in a tomb with an Attic black-figure kyathos (accession no. 59790) of the 6th century B.C.

Square Gold Plaque 217

Etruscan, 6th century B.C.

Square sheet, all edges turned down, four holes for attachment. The plaque is worked in repoussé with a globule at each corner and a gold leaf rosette originally with twelve petals in the center. The rosette is attached by means of a glass bead set in a gold mount that pierces the plaque and it turned back beneath. (57.413)

Max. W. 1/2 in (.013 m)

Notes:
For the gold leaf rosette on this and the preceding plaque, see *BMCJ*, pl. XVI, no. 1277*, and six plaques from Ferentium in Boston (Museum of Fine Arts, accession number 98.778-783).

Pins and a Fibula 218-221

Etruscan, 7th century B.C.

Since Etruscan dress, like Greek, generally involved a length of material folded around the body with few seams, fasteners such as pins and fibulae played a most important role. Representations on sculpture and on vases show pairs of pins used at the shoulders, or single pins attaching cloaks. Fibulae could be used like safety pins to gather in several thicknesses of material.

218. Gold Pin. Round globe decorated with granulation. A smooth wire around the base of the globe. Gold shaft. (57.473)

L. 1-9/16 in (.04 m)

Notes:
Compare a pin found in the Circle of the Silver Necklace at Vetulonia, dated to the 7th century (Paul Jacobsthal, *Greek Pins*, Oxford, 1956, p. 168 and Montelius, *Civilisation primitive en Italie*, pl. 182, 1).

219. Two gold and bone pins. Hollow globe made in two parts with five granules on top, and a collar with settings for two granules or gems edged by smooth (a.) or twisted (b.) wires. Bone shaft. (57.471-2)

a. L. 4-1/16 in (.103 m) D. of globe 5/16 in (.008 m) 57.471

b. L. 2-13/16 in (.072 m) D. of globe 1/4 in (.007 m) 57.472

220. Gold pin. Spherical cap, attached to straight shaft. (57.474)

L. 2-1/8 in (.053 m)

221. Gold fibula. Composed of a hollow, leech-shaped bow and a catch-plate with a pin attached to one end of the bow and given tension by three spiral loops. The join of the bow to both catch-plate and pin is masked by a circle of smooth wire decorated with chased lines. The catch-plate, made of two sheets, is decorated with a row of six granules along each side and four short rows of tiny filigree crescents down the center. At the end of the catch-plate are two globes, each surmounted by a circle of smooth wire and five granules. The sheet that formed the sheath for the pin is broken off. The bow, formed of a single sheet joined on the underside worked in repoussé is decorated on top with a row of tiny filigree crescents between smooth wires; and on the sides, with globules. (57.483)

Max. L. 13/16 in (.020 m)

History:
acquired by Henry Walters before 1931

Notes:
A typology of fibulae was established by Johannes Sundwall; this type, called *sanguisuga*, or leech with a long catch-plate appeared toward the end of the 8th century and lasted through the 7th century. Fibulae similar to this one have been found at Orvieto, Vulci, and Marsiliana d'Albegna. See Johannes Sundwall, *Die älteren italischen Fibeln*, Berlin, 1943, type GIV 1, p. 230; and for the later development of the type, see Piero G. Guzzo, *Le fibule in Etruria dal VI al I secolo*, Florence, 1972.

218 220

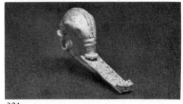

221

219

216 217

Bracelets

Two Pairs of Bracelets 222
Etruscan, 7th century B.C.

Composed of strips of openwork filigree; two smooth wires edged with twisted wires alternate with a waved smooth wire. At the ends of the bracelet are strips composed of a waved smooth wire between twisted wires. The clasp of the bracelet consists of two waved smooth wires between smooth and twisted wires, with a hook and eye for attachment. (57.393-6)

Max. D. of large pair 2-5/8 in (.066 m) H. 1-3/8 in (.035 m)

Max. D. of small pair 1-5/8 in (.042 m) H. 1 in (.025 m)

Notes:
Openwork filigree bracelets are well known in the 7th century especially at Vetulonia where a similar set of two pairs was found in the appropriately named Circle of the Bracelets (Randall-MacIver, *Villanovans*, p. 106). On the technique, see E. Formigli, "L'antica tecnica dei bracciali a filigrana," *SE*, vol. XLIV, 1976, pp. 203 ff., plates 37-9.

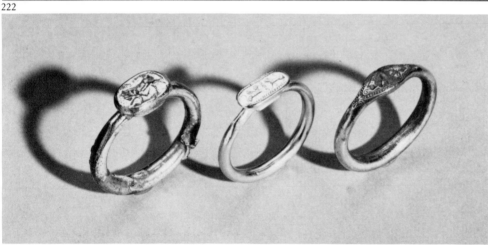

222

225, 224, 226

223

Rings 223-231

Two Gold Rings 223
Etruscan, 7th century B.C.?

Flat hoop edged by twisted wire. Leftward key meander formed of double rows of minute granulation. The "odd man" indicates the join of the ring band. Too fragile for everyday use, these rings may have been intended for funerary jewelry, or may have been part of a bracelet or other cylindrical ornament. (57.492-3)

Max. D. 5/8 in (.015 m) Inner D. 9/16 in (.014 m)

Gold Cartouche Ring 224
Etruscan, 6th century B.C.

Hollow hoop with an oblong bezel engraved with a griffin facing a lion. The animals are separated and surrounded by a hatched line. Cartouche rings, ultimately of Egyptian origin, are the earliest type of ring known in Etruria, popular in the late 7th and 6th centuries. (57.427)

Max. D. 15/16 in (.023 m) W. of bezel 1/4 in (.006 m) L. of bezel 7/16 in (.011 m)

Notes:
for the type see Higgins, *Greek and Roman Jewellery*, p. 144

Gold and Silver Cartouche Ring 225
Etruscan, 6th century B.C.

Gold-leaf over silver hoop tapers slightly at ends and appears to be cast in one piece

with the bezel. The device on the bezel is a bull; no border is preserved. (57.431)

Inner D. 3/4 in (.019 m) D. 1 in (.026 m)

Publications:
John Boardman, "Archaic Finger Rings," *AK* 10, no. 1, 1967, p. 15, B II 53
Notes:
The shape of the bezel on this and the preceding ring, as well as the intaglio device on this ring are more typically Greek than Etruscan; see Boardman, *GGFR*, p. 155.

Silver Ring with Flattened Hoop 226
Etruscan, late 6th century B.C.

Hoop flattened to produce a flat, diamond-shaped bezel engraved with a sphinx and swan with spread wings in a hatched border ending in palmettes. A break and mend are visible running through the middle of the bezel. (57.704)

Inner D. 3/4 in (.019 m) Max D. 1 in (.025 m)

Publications:
John Boardman, "Archaic Finger Rings," *AK,* vol. 10, no. 1, 1967, p. 20, F 31, pl. 5

Three Gold Rings with Fixed Bezels 227-229
Etruscan, 6th-5th century B.C.

227. Plain hoop tapering slightly at ends—collars of smooth wire and a filigree leaf (possibly once with enamel inset) on either shoulder. Bezel formed of smooth wires with ten granulated teeth and bars over the top to hold the inset, most likely a scarab, which is now missing. (57.428)

Inner D. 3/4 in (.019 m) D. 0/0 in (.023 m)

228. Plain hoop tapering slightly at ends—collars of alternately smooth and twisted wire and a filigree leaf with a globule and a trace of green inlay at each side of the bezel. Bezel formed of smooth and twisted wire; granulated teeth to hold the inset. Accretions of corrosion on either side of the bezel. (57.429)

Inner D. 5/8 in (.016 m) D. 13/16 in (.021 m)

229. Exactly as the preceding but does not have accretions of corrosion on either side of the bezel. (57.430)

Inner D. 11/16 in (.017 m) D. 7/8 in (.022 m)

Notes:
for a ring of this type, see *BMCR,* pl. VII, no. 299

Five Gold Rings 230
Etruscan, 6th-4th centuries B.C.

Two are gold leaf over silver, the other three are solid gold. All are round in section. (57.432-435, 57.441)

Inner D. 11/16 in (.018 m) gold leaf over silver 57.432 Inner D. 11/16 in (.017 m) gold leaf over

227, 229, 228

230

silver 57.433 Inner D. 11/16 in (.017 m) gold 57.434 Inner D. 9/16 in (.05 m) gold 57.435 Inner D. 5/8 in (.016 m) gold 57.441

Gold Ring 231
Etruscan ?, early 5th century B.C. ?

Made of two sheets soldered together to form a tubular hoop, the inner face flat, the outer rounded. The ends are worked in repoussé to form the upper parts of winged women whose raised hands probably once supported an engraved gold bezel or gem stone. Details of anatomy and dress are chased or engraved; the wings are separately made and attached to the sides of the heads. (57.370)

Max. D. 1 in (.026 m) Max. W. 11/16 in (.018 m)

History:
Acquired by Henry Walters before 1931.
Notes:
The type seems to relate to archaic Greek lion rings in which two lions grasp an oval bezel with their forepaws. In Etruria the type becomes popular with different figures on the hoops, for example tritons (Berlin 366), sirens (London, *BMCR,* no. 298), or deities (London, C. C. Oman, *Catalogue of Rings,* Victoria and Albert Museum, London, 1930, no. 47). For lion rings see John Boardman, "Archaic Finger Rings" *AK,* 10, 1967, pp. 20-21.

231

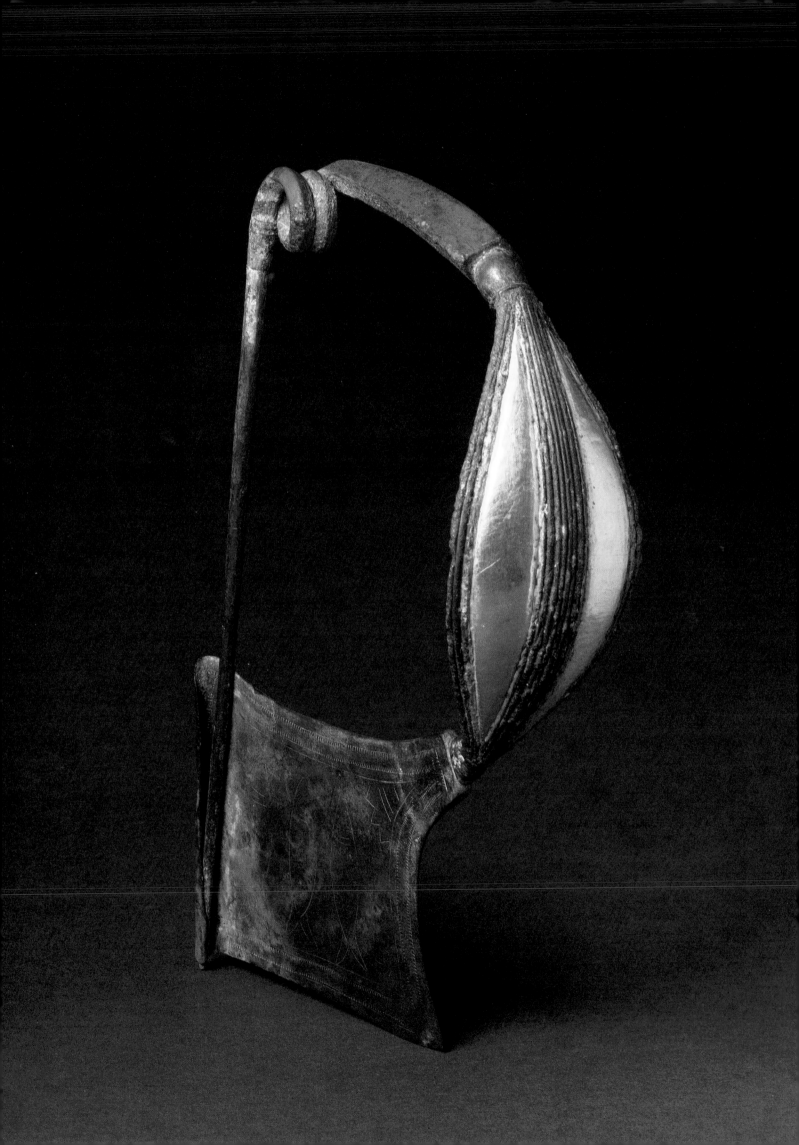

Greek Jewelry

Greek literature makes it clear that jewelry played an important role both as adornment and as a sign of wealth from Homeric times on. Book XIV of the *Iliad* tells us that when Hera dressed up to seduce Zeus she put on an embroidered robe fastened with gold pins, and a pair of earrings with three clustering drops. Penelope's suitors in the *Odyssey*, Book XVII, vied with one another to offer a gift that would win her hand—a robe with twelve gold pins, a cunningly wrought chain strung with amber beads, earrings, a necklace.

That certain jewels also had magical properties, an idea that stems from the Near East, is confirmed by Pliny who tells us that the Herakles knot, often used as the centerpiece of diadems (no. 265) had the power of healing wounds. It is thus not far fetched to look for talismanic significance in the representations of Eros in earrings (nos. 241-2) or rings (nos. 275-6); or in representations of the Isis crown, an allusion to a popular Egyptian cult (no. 245).

Like Etruscan jewelry, Greek jewelry was made for use both in life and death. Ancient representations of women at their toilette show the kind of jewelry a well dressed woman would wear: diadem, earrings, necklace, bracelets, and rings. Favorite ornaments were buried with their owner, and most of the jewelry we have today was preserved in tombs. Certain kinds of ornaments seem to have been made specifically for burial, for example the gold mask, diadems, and ring from a warrior's grave at Chalkidike in northern Greece which are too fragile for actual use (no. 235).

The Homeric descriptions of a wealth of gold jewelry may reflect the actual situation in the Bronze Age civilizations of Crete and Mycenae. Two gold signet rings engraved with cultic or battle scenes similar to examples found in the shaft graves at Mycenae come from this early period. (nos. 232-3).

When, about 1100 B.C., the Mycenaean world collapsed, a period of poverty which lasted nearly four centuries was ushered in during which jewelry was extremely scarce. These 'Dark Ages' began to lighten during the 8th century when contacts between Greece and the more prosperous East were intensified. The earliest piece of truly Greek jewelry in the Walters collection, a large bronze and gold fibula (no. 234), dates from this period.

During the 7th and 6th centuries many new types and techniques appear. A silver and green basalt scarab ring found in Cyprus (no. 268) is an example of an Egyptian type that became popular throughout the Mediterranean world.

By the 5th century, after the Persian wars, exploitation of the silver mines of Laurion, and the gold mines at Mount Pangaeus created a period of prosperity. This affluent state is recorded by Xenophon, writing in the early part of the 4th century, who says that Athenian men spent their wealth on armor, horses and houses, while women went in for expensive clothes and gold jewelry (*Ways and Means*, IV, 8).

Perhaps as a result of this eager market, goldsmiths' work from the Classical period on was recognized as a medium for high artistic achievement. The Eros earring (no. 241) and the horse pendant (no. 256) show that realistic sculpture in the round was possible on a miniature scale. Alexander the Great (356-323 B.C.) had his portrait carved in an emerald and this gave impetus to the fashion for portrait gemstones especially evident among his successors, the Ptolemies, who are represented on three superb rings (nos. 278-280).

After the conquests of Alexander, the Greek world included Egypt, Syria, Cyprus and much of Asia Minor, as well as Persia. The capture of the Treasure of Darius by Alexander's troops resulted in the dissemination of many new motifs such as the lion-griffin (nos. 248 and 258) and more importantly, in the increased use of inlaid stones, glass and enamel, setting the scene for the development of the Roman jewelry style.

We know that during the Hellenistic period important jewelry centers were located at Tarentum, Alexandria and Antioch, each of which must have produced distinctive types of ornaments. Unfortunately, the exact origin of most of the classical jewelry in the Walters Collections can only be surmised. Exceptions include the gold from a warrior's grave at Chalkidike (no. 235), a necklace with lion-griffin finials said to be from Pontus (no. 258), a silver scarab ring from Cyprus (no. 268) and the Hellenistic rings from Tarus and Kerch (no. 279-280). The wide range of types and styles suggests something of the richness and variety of Greek jewelry and indicates the degree of prosperity and elegance that Greek civilization attained.

Diana M. Buitron

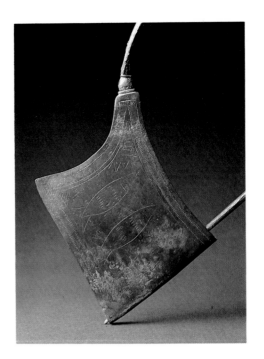

Facing and above: Gold and bronze fibula with three fishes incised on the catchplate (no. 234)

Two Signet Rings 232-3
Mycenaean, 1500-1200 B.C.

Signet rings were popular from the 16th century B.C. onwards. Their practical use, as identifying marks pressed into soft clay or wax, does not seem to have been as important as their ornamental use, since generally the compositions are shown in the natural rather than reverse direction.

The bezels of these two rings are formed of two sheets of gold, the upper decorated, the lower concave to accommodate the finger, seamed together, and applied transversely to the hoops. The intaglio decoration is either driven in with punches or beaten over a mould; the details then engraved.

232. Hoop flat inside, ribbed and slightly convex outside. Lentoid bezel with four figures, from left to right: a warrior with a figure-eight shield and two spears, a warrior with a rectangular shield, both facing right, a palm branch, then a male figure wearing a loin cloth, his right arm raised, and a woman dressed in a flounced skirt, wearing bracelets on upper arms and wrists, both facing left. The hoop has been bent out of shape. (57.522)

Max. L. of bezel 7/8 in (.022 m)

History:
acquired in 1931

232

233

233. Hollow hoop, flat on the inside, the outside convex and worked in repousse to form a central ridge. On the oval bezel is a battle scene: the warrior on the left has fallen back on his right knee and holds up his shield for protection against the warrior attacking from the right who brandishes a spear in his left hand. On the right, a quiver and two palm branches. Above and below, rouletted border. (57.1006)

Max. L. of bezel 1-1/16 in (.027 m) Inner D. 13/16 in (.021 m)

History:
purchased from Arthur Sambon, Paris, 1926.
Notes:
The type is known in Crete but these two rings find their closest comparisons in rings from Mycenaean Greece (*CMS*, vol. 1, nos. 16 and 127 from Mycenae; no. 219 from the Vaphio Tomb; see also Boardman, *GGFR*, plate 153)

Bronze and Gold Fibula 234
Greek, 8th century B.C.

Large bow fibula, the bow inlaid with two strips of gold. The catchplate is incised with three fish within a hatched border. (54.2467)

Max. H. 4-1/4 in (.108 m) Max. L. 7-3/16 in (.183 m)

History:
acquired at André Emmerich Gallery, New York, 1965

Herbert A. Cahn, *Early Art in Greece,* Exhibition at
Publications:
André Emmerich Gallery, Inc., May 7-June 11, 1965, New York, p. 36, no. 103; Philip P. Betancourt, "The Age of Homer," *Expedition,* vol. 12, no. 1, 1969, p. 7, no. 20
Notes:
The large size and the gold applied to the bow make this an unusual fibula. The shape places it in Blinkenberg's Attic-Boeotian Type VIII 4-6; compare the incised fish on the catch plate with his VIII 4i from Crete and VIII 6g from Boeotia (Christian S. Blinkenberg, *Fibules Grecques et Orientales,* Copenhagen, 1926, pp. 161-176).

Gold Trappings from a Warrior's Burial 235
Greek, last quarter of 6th century

The following five gold objects were used in the burial rituals of a warrior whose bronze helmet of Illyrian/Thracian type was found with them. They have been compared to the famous finds at Trebenischte (Yugoslavia) and were subsequently proved to have come from a similar grave at Chadkidike in northern Greece. The condition of these trappings is similar to other finds from Trebenischte—they all share the reddish discoloration of the gold, which probably results from heating it to a little below a dull red heat at which point the iron impurities present in the metal cause a purple film to develop on the surface. Since we know that burial customs in this semi-barbarous fringe of the civilized world involved burning the body of the deceased in full paraphernalia on a pyre, the reddish discoloration is explained. When most of the body was consumed, what remained of the bones and funerary equipment was placed in a grave and it is from just such secondary burials that the mask shown here and the Trebenischte masks come.

Traces of mud, insoluble salts, and a reddish deposit appear on the mask, nose, and long diadem.

a. Mask made of a sheet of gold that was first hammered, then pressed over a matrix, perhaps the face of the deceased warrior. There are no signs of tooling on the surface. The mask is slit at the nose, the metal bent upward; five pairs of holes around the slit indicate that the separately made nose piece was attached by five stitches. Of each pair of holes one was made from the back and one from the front in the way a needle passes when one sews. An additional pair of holes is on the forehead, and a hole and a torn hole are on either side of the mask. (57.1944)

H. 6-13/16 in (.175 m) W. 5-13/16 in (.148 m)

b. Nose made of a triangular sheet pressed and folded to fit over the nose of the deceased. The five pairs of holes correspond exactly

to the holes on the mask. (57.1944)

H. 3-13/16 in (.097 m)

c. Diadem, a ribbon-shaped sheet decorated with a stamped double guilloche pattern, a hole at either end. It is the right length to stretch from ear to ear and probably served to hold the mask in place. (57.1945)

L. 11-9/16 in (.294 m) W. 15/16 in (.024 m)

d. Diadem or Pectoral, a lozenge-shaped sheet with a stamped rosette and leaves, within a border of circles/running spirals between lines, a hole at either end. (57.1947)

L. 6-1/2 in (.165 m) H. 2-11/16 in (.068 m)

e. Ring, a strip of gold bent round to form most of a circle, the edges bent inward. (57.1946)

Max. D. 1-1/8 in (.029 m)

History:
purchased from Hesperia Art, Philadelphia, 1964, with a bronze helmet of Illyrian/Thracian type (57.2456)
Publications:
Dorothy Kent Hill, "AIA Meets in Seattle," *Archaeology,* vol. 18, no. 1, p. 64, illus.; D. K. Hill, "A Helmet Tomb Group of the Trebenischte Type," *AJA,* vol. 69, 1965, p. 169 (paper abstract); D. K. Hill, "Helmet and Mask and a North Greek Burial," *JWAG,* vol. XXVII-XXVIII, 1964-5, pp. 9-15; Franz J. Hassel, "Ein archaischer Grabfund von der Chalkidike," *JRGZM,* vol. 14, 1967, pp. 201-205
Notes:
A few years after Miss Hill's publication of the helmet and gold, Franz-Josef Hassel published five objects in Mainz and revealed that they came from the same grave as the objects acquired by the Walters—a tomb at Chalkidike in Northern Greece—thus confirming Miss Hill's hypothesis. For a discussion of the purple film on the gold see R. W. Wood, "The Purple Gold of Tutankhamon," *British Journal of Archaeology,* vol. 20, no. 62, 1934, p. 63.

Earrings 236-254

Boat Earring 236
Greek, 5th century B.C.

Boat earrings are one of the basic types in the Archaic and Classical periods, infrequent in the Hellenistic period. They are most common in their simpler forms. This example is fairly early in the series and may date to the 5th century B.C.

Hollow, boat-shaped earring encircled at the center and two ends with twisted wire between smooth wires. Suspended from the center, a globule and a granule. The solid tapering gold wire that pierced the ear is preserved above. (57.1626)

Max. H. 11/16 in (.018 m)

History:
collection of Henry Walters before 1931; Mrs. Henry Walters, purchased from Joseph Brummer, 1941
Notes:
for the type see Higgins, *Greek and Roman Jewellery,* pp. 122-3, and 160; compare for example, an earring in London (*BMCJ,* no. 1659)

Boat Earring 237
Greek, 4th century B.C.

The boat is formed of two crescent-shaped sheets, joined, and elaborately decorated with strips of metal, globules, blue enamel, filigree and granulation.

On one side the main part of the crescent is divided horizontally by a row of ivy leaves set end to end, with a tiny Herakles knot in the center. From this row of ivy spring tiny shoots with ivy leaves or clusters of corymboi, the fruits of the ivy, on their ends. Traces of blue enamel remain in some of the leaves. On the other side in the center are spiraling tendrils connected at intervals with horizontal lines; two palmettes, and clusters of granules. The two ends of the crescent narrow to form hollow "horns" decorated at their bases with circles of twisted wire, and rising in five tiers, marked with donut-shaped disks worked on their outer edges to resemble twisted wire. Between each disk a strip of metal is placed over the core. A narrow metal strip runs along the entire outside edge of the crescent and is decorated with "spurs" made of granules of approximately the same size placed one on top of the other. In the hollow of the crescent set between two slightly curved sheets masking the join of the two halves, is a sphinx, its body made in two halves and worked in repoussé. A length of twisted wire forms its tail. A separate sheet forming the front leg and wing, worked in repoussé to show details of the leg and of feathers on the wing, is attached to either side of the body of the sphinx. For additional support, there is a sheet between the wings. The wire that presumably pierced the ear emerges from one end of the boat attached to a disk that serves as a lid for the open tube, and which is decorated with circles of smooth and twisted wire. There is a tiny filigree leaf above the lid, and the wire terminates at the other end in a duck's head.

The earring was discussed by Berta Segall who saw a combination of Greek, Phoenician and Egyptian motifs that suggest a date slightly before 320 B.C., and a workshop possibly in Alexandria. The fully modeled sphinx and the elaborate and different decoration of each side of the earring make this an unusual and rare ornament. (57.1733a)

H. with wire 1-3/16 in (.03 m) L. 7/8 in (.022 m)
Weight 4.18 grams

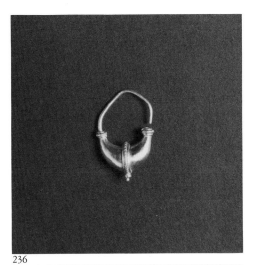

236

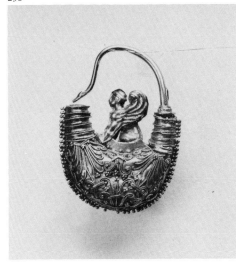

237

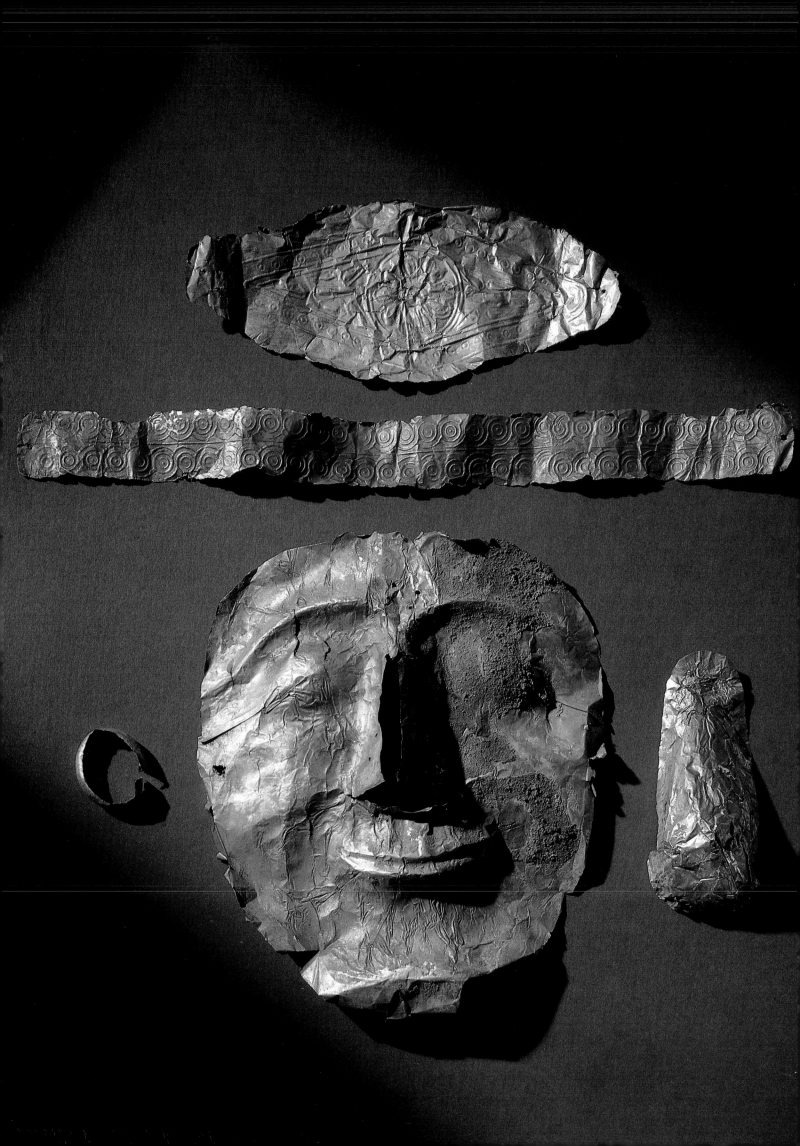

History:
collection of Henry Walters before 1931; Mrs. Henry Walters (sale, New York, Parke-Bernet Galleries, December 2, 1943, lot 524)
Publications:
Art Collection of Mrs. Henry Walters, New York, Parke-Bernet Galleries, 1943, pp. 90-91 illus.; Berta Segall, "The Problem of Phoenician Artisans in Egypt," *JWAG,* vol. IX, 1946, pp. 97-101; Dorothy Kent Hill, "From Alexander to Augustus," *BWAG,* vol. 7, no. 5, 1955, illus.; Stella G. Miller, *Two Groups of Thessalian Gold,* University of California Press, Berkeley and Los Angeles, 1979, plate 3f
Notes:
compare the earrings in the Stathatos collection (Amandry III, nos. 154-5) and a pair from Homolion Grave B now in the Volos Museum (Stella Miller, see above)

Pair of Hoop Earrings with Bull's Head Pendants 238

Greek, 5th century B.C.

Suspended from a loop is a bull's head attached to a biconical bead decorated with a row of granules around its equator, triangles of granulation pointing away from the equator on either side. In the center of one side of the bead is a globule surrounded by tiny granule triangles forming the heart of the eight-petaled flower formed by the larger granule triangles. The bull's head emerges from a collar made of two rows of granules on the other side of the bead. The head is carefully modeled in repoussé, ears and horns separately made and attached, details of eyes, nostrils, mouth, skin and forelock chased and engraved. The hoop, which is probably modern, is a tapering hollow gold tube, the lower half spirally wound with wire. One end of the hoop terminates in a loop with a globule attached; the other end is coiled around the loop.

The type probably evolves from a simpler shield-shaped earring type found at Olbia and dated to the second half of the 6th century B.C. (57.589-590)

Max. L. of pendant 5/8 in (.016 m) H. of entire earring 1-1/2 in (.038 m)

History:
acquired before 1931
Notes:
for the Olbia earrings see *AA,* 29, 1914, p. 243, fig. 61; an earring of similar type in Berlin dated to Roman times is probably earlier than Greifenhagen suggests (Greifenhagen, *Berlin* I, plate 23, 12)

Disk and Pendant Earrings: Pyramids 239

Western Greek, 4th-3rd century B.C.

One earring is an imitation of the other. The original earring consists of a hollow pyramid decorated with tiny triangles of granulation at the base and along the top. On the imitation, the triangles are worked in repoussé to form bosses. A loop at the top of the pyra-

mid interlocks with a wire twisted to form the suspension loop and the hook that pierced the ear, the whole attached to the back of a disk made of two circular sheets. The front of the disk is worked in repoussé to form concentric ridges and decorated with a circle of twisted wire and a circle of granules. A round garnet is set in the center. On the imitation disk, both circles are of twisted wire. On one side of the original disk is a small loop, with a short chain made of elongated figure-eight loop-in-loop wires like the necklaces nos. 257, 258, 259. Four cylindrical gold beads are threaded onto the chain. It appears that the chain and beads from the other side of the original disk were removed and attached to the imitation disk.

An inverted pyramid is one of the earliest types of earring pendants, known from the 7th century B.C., but inverted pyramids attached to disks are thought to begin in the 4th century B.C. (57.1671-2)

Max. H. 1-9/16 in (.04 m)

History:
collection of Henry Walters before 1931; Mrs. Henry Walters; purchased from Joseph Brummer, 1941
Notes:
for the type see Higgins, *Greek and Roman Jewellery,* p. 126; compare earrings from Tarento (Hadaczek, *Ohrschmuck,* p. 31, fig. 51) and from the François Tomb at Vulci (Franz Messerschmidt, *Nekropolen von Vulci,* Berlin, 1930, p. 107, fig. 82)

Disk and Pendant Earrings: Amphorae 240

Greek, 3rd century B.C.

The amphorae are made of a garnet bead held between gold neck and base. The handles are made of twisted wires bent into an S-curve. A loop at the mouth of the amphora interlocks with a coiled wire attached to a disk made of two circular sheets. A large round garnet edged with twisted wire is in the center. A suspension loop is attached above; the hook that pierced the ear is missing. Amphora pendants evolved from pyramidal pendants and are fairly common in the late Hellenistic period. (57.610-611)

Max. H. 1-7/16 in (.036 m)

History:
acquired before 1931
Notes:
for the type see Higgins, *Greek and Roman Jewellery,* p. 166; a similar pendant from Vulci dated to the 3rd century B.C. is in London (*BMCJ,* no. 1977, plate XXXVIII)

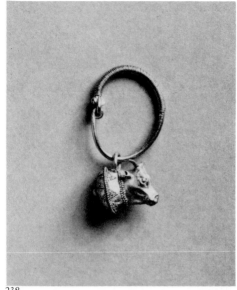

238

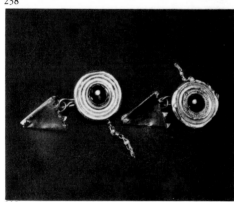

239

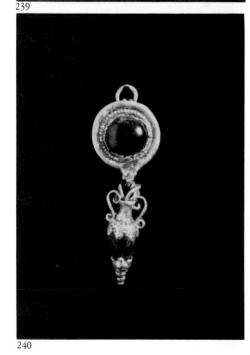

240

Facing: The gold trappings from a warrior's burial (no. 235)

Disk and Pendant Earring: Eros 241

Greek, 4th-3rd century, B.C.

The figure of Eros is cast solid, facial features chased. The wings are made of separate sheets, incised on the front to look like feathers. The mantle is yet another sheet, crinkled to look like cloth, draped over Eros' arms and hanging loose on either side. In his right hand Eros holds a torch. The figure is depicted as if coming in for a landing, the toes of one foot just touching the ground. A loop attached to the back of the head interlocks at right angles with a loop attached to a disk. The disk is a circular sheet, the edges turned up, twisted wire along the top of the edge; the resulting cavity is filled with a five-petaled rosette, and three double spirals. The ear wire is attached to the back of the disk. Eros figures, frequently solid cast, are one of the most popular earring pendants especially during the 4th-3rd centuries. (57.1496)

Max. H. 1-1/4 in (.032 m)

History:
acquired before 1931
Notes:
Hadaczek, *Ohrschmuck,* pp. 41 ff., and *BMCJ,* nos. 1858-1916; for the disk compare an earring in Krakow (Jerzy Kubczak, "Bijouterie Antique de l'ancienne collection Czartoryski a Cràcovie," *Archeologia,* vol. XXV, 1974, p. 65, fig. 10) dated 4th-3rd century B.C.

Disk and Pendant Earrings: Erotes 242

Greek, 3rd century B.C., or Italian, late 19th century

The ear wire is concealed by a concave disk filled with a triple tiered rosette and edged with plain and beaded wire, and at the serrated border with a tongue pattern outlined in wire. Above is a palmette with acanthus leaves and flanking stars mounted on wires. Below are two ivy leaves masking the pendant mechanism. The pendant Eros, wings displayed, wears double bandoliers with tassels and a medallion at the crossing, and carries a torch and mussel shell. The figure stands on a doubly flanged podium. Traces of enamel remain in the acanthus leaves, stars, and the bandolier medallion. One earring has incrustation on the face of Eros, on the disk and palmette. (57.1498-9)

H. 2-5/16 in (.058 m)

History:
purchased from Michel Abemayor, 1929
Notes:
An almost identical pair of earrings, formerly in the Guilhou collection, Paris (Catalogue vente Paris, Sambon-Canessa 1905, no. 97, plate VI) and more recently in the Lucerne art market (Auktion Kat. Ars Antiqua 7, November 1964, 148, plate XL) was published as genuine by Robert Zahn in 1930 (Zahn in *Schumacher-Festschrift,* Mainz, 1930, pp. 202-206, plate 22; 1-2).

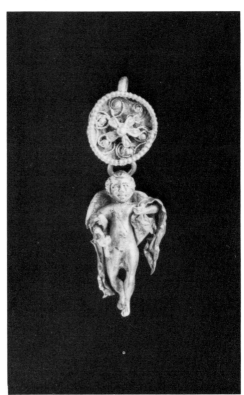

241

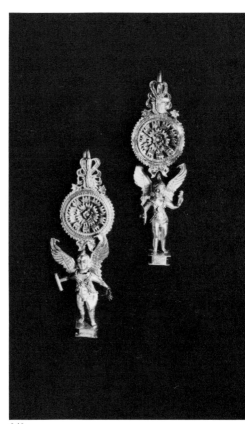

242

Pair of Earrings with Heads of Blacks 243
Greek, 3rd century B.C.

A negroid head, probably garnet, is set between a cup rosette and a cap of gold hair. The eyes are drilled and were once inlaid with colored glass. A gold pin runs through the head and cap and forms a suspension loop on top. The rosette at the base has a granule center and twisted wire petals. The cap of hair appears to have been made of wire coils which have been worn or polished almost smooth. One of the earrings shows signs of a modern repair at the base. The Greeks had long been fascinated by the peoples of Africa and represented them in every medium. (57.1562-3)

H. without loop 9/16 in (.014 m)

History:
acquired before 1931
Notes:
For the head and the rosette cup base, parallels in ancient times exist, most from Etruria, of the 3rd century, B.C. (Hackens, *Classical Jewelry,* no. 7.) One can add to his list of examples of the type a group of similar earrings also of the 3rd century from Yugoslavia (V. Bitrakova, "Zlatni Nakit iz Helenističke Nekropole kod Crevejnce," *Archeološki Radovi I Rasprave,* IV-V, Zagreb, 1967, plate I).

Top Part of an Earring 244
Western Greek, 3rd-2nd century, B.C.

The top part of an earring from which three pendants were once suspended, is a crescent-shaped sheet with an ivy leaf above. The crescent is edged on the bottom with thick twisted wire; on the top with very fine twisted wire. At each "horn" are tiny granule triangles, and a wire circle, probably once inlaid with enamel. In the center is a crescent-shaped garnet in a dog-tooth setting. Below are rows of smooth and braided wire; above are three granule rosettes. The ivy leaf is edged with a strip of metal, the top incised to resemble twisted wire; the inlay is missing. At the tip of the ivy leaf are two granules. Behind are a smaller crescent and triangle formed of sheets and strips which serve to raise the front up and away from the hook that pierced the ear lobe. The hook forms a loop from which a central pendant was once suspended. On each side of the crescent are parts of loops for the lateral pendants. (57.1886)

H. (not including wire) 7/16 in (.011 m) L. 1/2 in (.012 m)

History:
bequest of Mrs. Breckenridge Long, 1959
Notes:
Compare earrings from Vulci, most of them 3rd to 2nd century B.C. (*BMCJ* nos. 1678, 1681; Franz Messerschmidt, *Nekropolen von Vulci,* Berlin, 1930, fig. 82). An amphora, triangle, cone or enamel-dipped animal might have been suspended from the center of the earring. Western Greek in type: compare the pair once in the F. L. von Gans collection from Sardinia (Zahn, *Galerie Bachstitz,* p. 9, no. 26B, plate 4)

Earring Pendant: Sphinx 245
Greek, 2nd-1st century B.C.

The pendant consists of three elements: base, sphinx, and headdress. The trapezoidal base is made of three sheets of metal for top, sides, and bottom, the joins masked with twisted and smooth wires, the sides by wire colonnettes. The crouching sphinx is hollow, worked in repoussé and adorned with a necklace and double bandoliers made of smooth and twisted wire and rows and clusters of granules. Below the breast is a rectangular box setting for a garnet. The legs are strips of metal separately applied. The wings, also separately applied, consist of several sheets of metal of different shapes, the edges raised to hold stones or enamel inlays, placed close together to resemble feathers. Only one of the inlaid stones is preserved, a garnet on the sphinx's right wing. The wings are supported in back by a tubular strut that runs between them. The headdress is a large round setting for a stone, now missing; flanked by four smaller settings, garnets preserved in the lower two, and above an Isis crown consisting of a round setting with garret-shaped settings. The feathers and disk headdress, or Isis crown, appears frequently in jewelry of the 2nd-1st century B.C. in the eastern Mediterranean. (57.1490)

Max. H. 1-15/16 in (.049 m) Max. L. 1/2 in (.013 m)

History:
acquired before 1931
Notes:
Sphinxes seated on pedestals are known from Theodosia (Crimea) (*ABC,* plate XII a, 2), Amphipolis (Northern Greece) (*BCH,* vol. 83, 1959, p. 710, fig. 2), and Kerch (South Russia) (Gleb Sokolov, *Antique Art on the Northern Black Sea Coast,* Leningrad, 1974, p. 45, no. 26), but none as elaborate as the Walters example. The lavish inlay accords with a date in the 2nd-1st century B.C.

243

244

Hoop earrings with animal-head finials originated in Greece at the time of Alexander the Great, about 330 B.C. They may have developed from a simple tapered hoop with a knob finial at the larger end, a type known in Macedonia as early as the fifth century. With Alexander's conquests, the repertory of motifs opened up, and the variety of animal heads, especially the Persian lion-griffin (no. 248) is evidence of the eclectic nature of Hellenistic art.

The hoop is generally formed of coiled wires or worked in repoussé to give the impression of coiled wires sometimes elaborated with thin twisted wires (nos. 248, 252); or the hoop may consist of a flaring tube spirally wound with wire (no. 247) or left plain (no. 249). The point of the tapering end was thrust through the earlobe into the loop at the animal head. The animal head could be worn upside down or right side up.

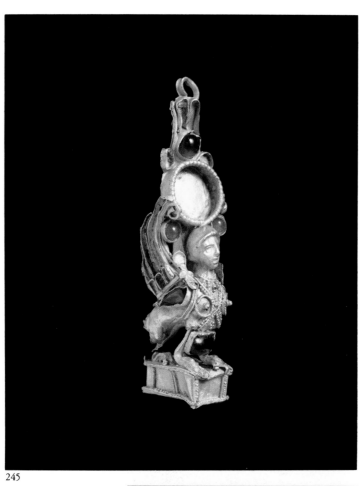

245

Pair of Hoop Earrings: Lion's Heads 246
Greece, 4th-3rd century B.C.

Four hollow tapering wires spirally wound around each other narrow to form the pin of the earring at one end, and widen at the other to fit into a collar of seven leaves, chased to resemble a lion's mane; encircled by plain and twisted wires. The lion's head is worked in repoussé and chased. The eyes and ears are hollowed out, the mouth has a hole in the center for attaching the pin.

Lion heads are the most common finials on hoop earrings. Many examples can be cited, most dated by tomb groups to the 4th-3rd centuries B.C. (57.581-2)

Max. L. 3/4 in (.019 m)

History:
acquired before 1931
Notes:
For the type see Higgins, *Greek and Roman Jewellery,* p. 162

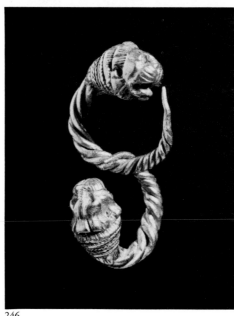

246

Hoop Earring: Lion Heads 247
Western Greek, 4th-3rd century, B.C.

Hoop of plain wire wound around a tapering gold core terminating in large and small lion heads. The small lion head holds a thin wire in its mouth that hooks into the loop held by the large lion head. Both heads are worked in repoussé and chased; the inlaid eyes of the large head are missing and the small head has been crushed. The collar of the small head is a plain tube, that of the large head is a gold sheet with nine leaves and three large ivy leaves outlined in smooth

wire, encircled by smooth and twisted wires. Contemporary with the single lion-head hoops but apparently a western Mediterranean specialty. (57.1665)

Max. L. 13/16 in (.021 m)

History:
collection of Henry Walters before 1931; Mrs. Henry Walters; purchased from Joseph Brummer, 1941
Notes:
Examples are known from Cumae, Taranto. and Capua (Higgins, *Greek and Roman Jewellery,* p. 163). An example in Brooklyn is from Ithaka (C. R. Williams, New York Historical Society, *Catalogue of Egyptian Antiquities. Gold and Silver Jewelry and Related Objects,* New York, 1924, pp. 149-50, nos. 86-7).

Hoop Earring: Lion-Griffin 248
Greek, 4th-3rd century B.C.

Hollow tapering hoop worked in repoussé to form ridges that resemble the spirally wound wire of other hoop earrings of this type. Fine twisted wire is wound round the hoop in the valleys of the ridges. At the small end of the hoop is a collar of sheet gold, terminating in a conical cap edged with twisted and smooth wire. The hoop expands at the other end into a collar of thirteen leaves edged by twisted wire; and a band decorated with double spirals rendered in twisted wire decorated with clusters of granules; and edged by twisted and smooth wires. The lion-griffin head is worked in repoussé in two halves, left and right and chased; ears, teeth and crest were separately made and applied. Two holes remain where the griffin horns once were.

Probably contemporary with the lion head hoop, the lion-griffin head hoop introduces an Achaemenid motif into the Hellenistic repertory. This type is less widespread than the lion head hoop. (57.1732)

Max. L. 1-1/8 in (.028 m)

History:
collection of Henry Walters before 1931; Mrs. Henry Walters (sale, New York, Parke-Bernet Galleries, December 2, 1943, no. 524)
Publications:
Art Collection of Mrs. Henry Walters, New York, Parke-Bernet Galleries, 1943, p. 91
Notes:
Higgins suggests this is a Cypriot creation; the type is also known in South Russia (Higgins, *Greek and Roman Jewellery,* p. 162).

Hoop Earring:
Antelope or Goat Head 249
Greek, 4th-3rd century B.C.

Plain tubular hoop tapering to pin, attached to the collar made of a gold sheet edged on either side by a twisted wire between smooth wires. Emerging from the collar is

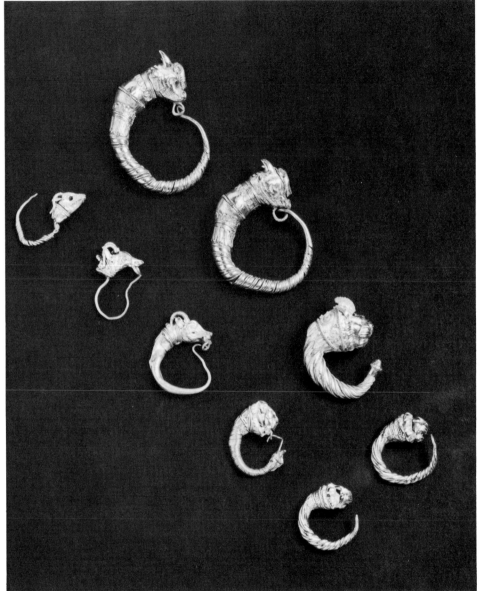

246-252

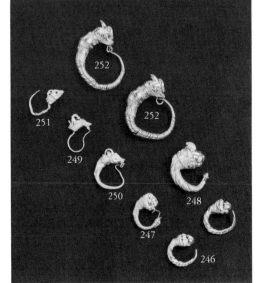

Key

an antelope or goat head, worked in repoussé and chased, horns and ears and the loop at the chin for attachment of the pin separately made and applied, one glass eye still preserved in place.

Hoops with antelope or wild goat heads are another frequently found type; known in the west, but the majority come from the eastern Mediterranean. Because the gazelle is a native of Egypt, it has been suggested that the type is an Egyptian creation. (57.1693)

Max. L. 3/4 in (.019 m)

History:
collection of Henry Walters before 1931; Mrs. Henry Walters; purchased from Joseph Brummer, 1941

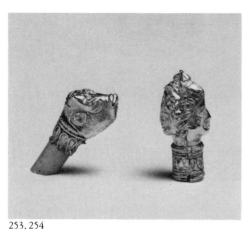

253, 254

255

Hoop Earring:
Antelope or Goat Head 250
Greek, 4th-3rd century B.C.

Hollow hoop tapering to pin at one end, widening at the other and fitted into a collar of sheet gold, cut to form three triangles that are outlined with smooth wire, encircled above the triangles and at the animal head by a twisted wire between smooth wires, the ends of these six wires wound together underneath. The head is worked in repoussé and chased; ears, horns, mustache, and loop for attachment of the pin separately made and applied. Both inlays for the eyes are missing. (57.1607)

Max. L. 15/16 in (.023 m)

History:
collection of Henry Walters before 1931; Mrs. Henry Walters; purchased from Joseph Brummer, 1941

Hoop Earring:
Antelope or Goat Head 251
Greek, 4th-3rd century B.C.

Hoop consists of two spirally twisted gold wires wound together and tapering to form the pin of the earring. The hoop is attached to a collar of sheet gold cut to form four rounded leaves outlined by twisted wire. A plain and twisted wire separate the collar from the animal head. The head is hollow, worked in repoussé, fur indicated by chasing; the horns and ears applied separately. The eyes were once inlaid. (57.1658)

Max. L. 7/8 in (.022 m)

History:
collection of Henry Walters before 1931; Mrs. Henry Walters; purchased from Joseph Brummer, 1941

Pair of Hoop Earrings:
Bulls' Heads 252
Greek, 2nd-1st century B.C.

Two rounded strips and two pairs of twisted wire are carefully wound together over a core to form the hoop that tapers at one end to form the ear wire. Elaborate collar formed of nine and a half long leaves edged with twisted wire, circles of smooth and twisted wire, and a hollow bead with twisted wire in the center held by rows of small leaves. The collar fits into a bull's head worked in repoussé, the hair chased. The horns and ears are not made separately and the eye was never inlaid. On the forehead is a drop-shaped garnet in a box setting edged by twisted wire. Around the setting at the nostrils is a garland made of four disks circled and partially connected by twisted wire. The loop at the bull's chin is plain on one earring, twisted on the other. (57.1730-1)

Max. L. 1-3/8 in (.035 m)

History:
collection of Henry Walters before 1931; Mrs. Henry Walters (sale, New York, Parke-Bernet Galleries, December 2, 1943, lot 522)
Publications:
Art Collection of Mrs. Henry Walters, New York, Parke-Bernet Galleries, 1943, pp. 90-91 (illus.)
Notes:
A similar earring from Egypt lacks the garnet on the forehead (Theodor Schreiber, *Die Alexandrinische Toreutic*, Leipzig, 1894, p. 305, fig. 29). Other bull's head hoops come from Egypt and Cyprus suggesting that this is again an eastern type (Higgins, *Greek and Roman Jewellery*, p. 162, and Georg Karo, "Die griechisch-römischen Altertumer in Museum zu Kairo," *AA*, vol. XVI, 1901, pp. 211-212, fig. 8). The addition of the garnet is typical of the later Hellenistic period, perhaps 2nd-1st century B.C.

Two-faced Finial 253
Western Greek, 4th-3rd century B.C.

Two gold sheets worked in repoussé over the same mould to form two female heads and necks, then placed back to back, twisted and smooth wire added around the base, two tiny twisted filigree spiral earrings that work for either face added to the sides.

A finial such as this probably served as one of the end decorations for spiral earrings of a type not represented in the Walters. (57.1635)

H. 11/16 in (.018 m) D. of base 1/4 in (.006 m)

History:
collection of Henry Walters before 1931; Mrs. Henry Walters; purchased from Joseph Brummer, 1941
Notes:
For the type see Hadaczek, *Ohrschmuck*, p. 15, fig. 24. Similar finials with a single human head are known from Metapontum in the 4th century (Breglia, *Napoli*, plate XIII, 1 and 4-5, nos. 75-7). Both single head finials and two-faced pendants are represented in the Santa Eufemia (Calabria) Treasure of the early 3rd century B.C. (*BMCJ*, nos. 2114-2116).

Calf-head Finial 254

Greek, 4th-3rd century B.C.

Two sheets worked in repoussé over the same mould, joined in the center. Around the neck, twisted and smooth wire and nine palmette fronds. Details of the calf's head chased and engraved. A hole where its mouth should be. May have served as one of the finials of a spiral earring just as no. 253. (57.1688)

H. 9/16 in (.014 m) D. 1/4 in (.006 m)

History:
collection of Henry Walters before 1931; Mrs. Henry Walters; purchased from Joseph Brummer, 1941
Notes:
The finial was formerly attached to an ivory pin (WAG 71.1096). For a Cypriot calf-head pendant of similar type see Münzen and Medaillen AG, *Werke Antiker Goldsmiedekunst*, Basel, 1970, no. 75.

Pegasus Protome 255

Greek, 4th century B.C. ?

Two sheets, each cut and worked in repoussé to form the foreparts of pegasus above a triangular pediment, edged with twisted wire, with granules in the corners. Details of mane and wings chased and engraved. Between the two pegasoi on the bottom is a sheet; between heads, wings and body are spurs formed of tubes of metal.

This tiny ornament may have decorated the top of a pendant or a mill wheel fibula. (57.1733 b)

L. at base 5/16 in (.008 m)

History:
collection of Henry Walters before 1931; Mrs. Henry Walters (sale, New York, Parke-Bernet Galleries, December 2, 1943, lot 524)
Publications:
Art Collection of Mrs. Henry Walters, New York, Parke-Bernet Galleries, 1943, p. 91
Notes:
compare the pendants in the Stathatos collection (Amandry I, no. 42); and the mill wheel fibula from a late 4th-century tomb at Sedes, near Salonica (*Ephemeris Archaiologike,* 1937, p. 881 sketch)

Gold Horse Pendant 256

Greek, 4th century B.C.

The horse is made in two halves, each worked in repoussé probably over a mould; the seam is visible down the center. The ears, forelegs, tail were separately made and fitted into the body. The suspension ring attached to a plug, was fitted into the horse's back. Details of the eyes, nostrils, mouth, ears, legs, hooves, mane and tail are chased.

The famous earring with Nike driving a two-horse chariot in the Boston Museum provides a parallel for this horse pendant. The horses are made similarly and the modeling is very fine on both pieces. The date is probably also the third quarter of the 4th century. (57.1728)

Max. H. 15/16 in (.024 m) Max. L. 1-3/16 in (.03 m)

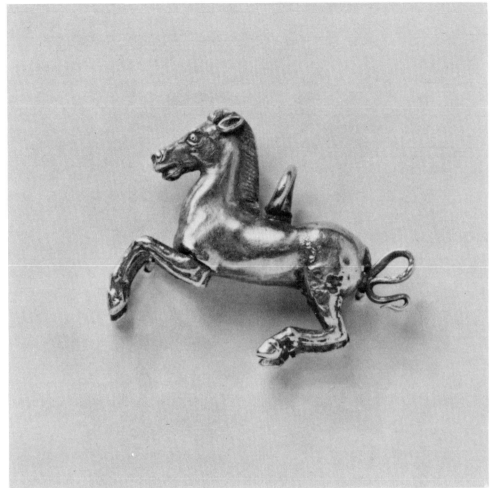

256

History:
collection of Henry Walters before 1931; Mrs. Henry Walters (sale, New York, Parke-Bernet Galleries, December 2, 1943, lot 517)
Publications:
Art Collection of Mrs. Henry Walters, New York, Parke-Bernet Galleries, 1943, pp. 90-91 (illus.)
Notes:
for the Boston earring see Museum of Fine Arts, *Illustrated Handbook,* Boston, 1964, pp. 72-3

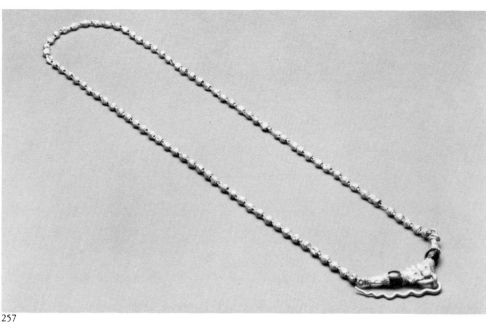

257

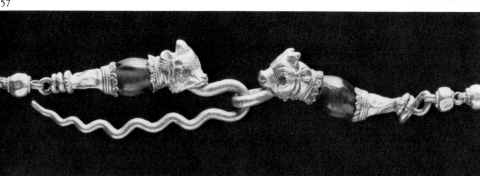

257 detail

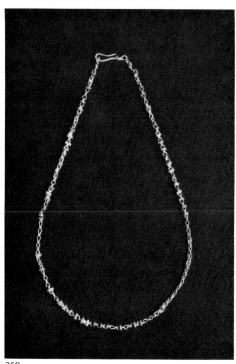

259

Necklaces 257-260

Gold and Garnet Necklace 257
Greek, 4th-3rd century B.C.

Composed of eighty-five hollow gold beads, the openings edged with twisted wire. The beads are threaded onto a chain made of double loops of wire constricted in their centers and twisted so that the end loops are in perpendicular planes. The bulls' head finials have a "collar" consisting of a garnet bead held between gold cups encircled by smooth and twisted wire and a row of tongues. Each collar terminates in a gold cone then a ring of twisted wire, and is attached to the chain by coiled, hollow wire. The forelock and mane of the bull are chased; the inlay of the eyes is missing. One bull holds in its mouth the hook, the other the loop.

Chain necklaces threaded with gold or garnet beads and ending in animal head terminals were popular throughout the Hellenistic period. As with hoop earrings, lion's heads are the most popular terminals. (57.598)

L. of finials 3/4 in (.019 m) Total L. 19-5/16 in (.49 m)

History:
collection of Jean Lambros et Giovanni Dattari (sale, Paris, Hôtel Drouot, June 17-19, 1912, no. 572)
Publications:
Jean Lambros et Giovanni Dattari collection, Paris, 1912, p. 62

Gold and Garnet Necklace 258
Greek, 4th-3rd century B.C.

Nineteen hollow gold beads, the openings edged with twisted wire; alternate with sixteen garnet beads all threaded onto a chain made like no. 257. The finials are in the form of lion-griffin beads, the horns and crest separately made and attached. Compare the hoop earring no. 248. The lion-griffin finials have a collar of twisted and smooth wires, then a truncated conical garnet bead, and a plain gold capsule at the end. The finials are attached to the chain with wire triangles. One head holds the hook in its jaws, the other the loop. (57.1540)

L. of finials 11/16 in (.018 m) Total L. 16-9/16 in
(.42 m)

History:
purchased from Dikran Kelekian, 1911; an old record
says "from Pontus"

Notes:
for the lion-griffin terminals and for the type of chain,
compare a necklace from Capua of the 3rd century B.C.
in London (*BMCJ*, no. 1966, plate XXXVII)

Gold and Glass Necklace 259
Greek, 4th-3rd century B.C.

The chain is made like nos. 257, 258. White
and brown disk-shaped glass beads are
threaded onto the chain; many are missing.
The short length suggests that this was
intended for a child. (57.1547)

L. 11-1/2 in (.29 m)

History:
acquired before 1931

Gold Necklace 260
Greek, 3rd century B.C.

One hundred and three spool-shaped beads
with loops rigidly set at right angles to one
another at either end, each attached to its
neighbor. Antelope-head finials made of
sheet gold worked in repoussé; horns and
ears applied separately, details of the horns
and face chased. Collar consisting of cones
of sheet gold, with wire twisted around
them that once held a stone. One antelope
holds the hook, the other the loop. (57.583)

Estimated L. of complete finial 9/16 in (.015 m)
Total L. of necklace 18-1/8 in (.46 m)

History:
acquired 1913

Notes:
similar necklaces in London (*BMCJ*, no. 1976) and in
the Stathatos collection (Amandry I, no. 250) have been
dated to the 3rd century B.C.; another, with lynx head
terminals is from Vulci (*BMCJ*, no. 1977, plate XXXVIII)

Gold Disk 261
Greek, 4th-3rd century B.C.

Round sheet worked in repoussé with some
surface chasing. Central boss surrounded
by eight creatures: lion, deer, scorpion,
human figure (?), genitalia (?), lizard (?),
bird (?), snake (?). Two circles of dots worked
from the back surround the animals. The disk
is edged with twisted wire. On the back, a
metal strip forms a loop for threading onto
a chain. (57.1650)

D. 1/2 in (.013 m)

History:
collection of Henry Walters before 1931; Mrs. Henry
Walters; purchased from Joseph Brummer, 1941

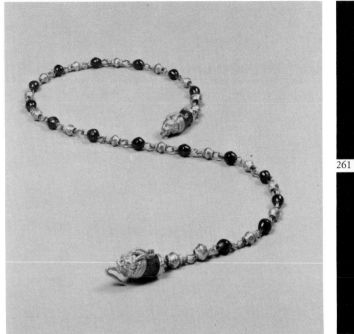

261

262

258

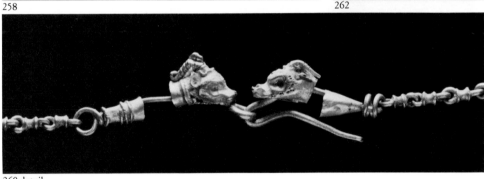
260 detail

260

Gold and Garnet Disk 262

Greek, 3rd-2nd century B.C.

Round sheet with circles of twisted, braided, and smooth wire forming the border; and a fourteen petaled filigree palmette with a garnet center in a serrated box setting. On the back, a ribbed tube for threading on a chain. (57.603)

D. 11/16 in (.017 m)

History:
acquired before 1931.
Notes:
Disks with loops or tubes on the back were threaded onto the chains of necklaces or diadems. Compare for example, a diadem in Berlin of the early second century B.C. (Greifenhagen, *Berlin* I, plate 14).

Gold Cage Bead 263

Greek, 3rd-2nd century B.C.

Sheet rolled into a cylinder, rectangular window cut out and edged with smooth and twisted wire. The window is filled with a network of wire with granules fixed over points of contact. Narrow strips of metal reinforce the ends of the cylinder. (57.1583)

L. 3/4 in (.02 m)

History:
acquired before 1931
Notes:
Cage beads wholly made of a wire network and with closed ends form a necklace in the Virginia Museum, Richmond (Hoffmann and Davidson, *Greek Gold*, no. 43, p. 126, fig. 43, where other examples are cited; it is called Northern Greek and dated to the first half of the 3rd century B.C.).

265 detail

265

Diadems 264-265

Hinged Gold Plaques 264
Greek, 4th-2nd century B.C.

The plaques, which may be part of the central ornament of a diadem, are composed of two sheets; one flat, and one worked in repoussé. The rectangular and U-shaped elements are hinged together horizontally. On the upper plaque are two lyre volutes, edged with twisted and smooth wires, palmettes and rosettes within; circles, ivy leaves and rosettes outside. The rosettes and palmettes have petals and fronds made of gold leaf and are edged with twisted wire. The ivy leaves, circles, centers of the lyre volutes, and the large rosette were once inlaid. The seven small rosettes have granules at their centers. The upper sheet of the lower plaque is worked in repoussé to form the bust of a woman in high relief, her hair swept back beneath a diadem, wearing a chiton and himation. Her features are quite distinct, and show evidence of chasing. On either side of the bust are a circle and an ivy leaf, once inlaid; and a rosette with a granule center. Both plaques are edged with a narrow gold strip, and twisted and smooth wires. On the back, traces of five loops remain; there are two hinges on one side of the rectangular plaque. (57.1414)

W. 1-9/16 in (.04 m) 2-9/16 in (.065 m)

History:
purchased from Gruel, Paris, 1928
Publications:
Randall, "Jewellery Through the Ages," p. 75; *The Dark Ages*, no. 120, illus.
Notes:
The two plaques may be part of the central ornament of a diadem such as one from a tomb at Kyme (Aeolis) of the 4th-3rd century B.C. in London (*BMCJ*, no. 1632, plate XXIX). Compare also a diadem in Berlin of the early 2nd century B.C. (Greifenhagen, *Berlin* I, plate 14).

Gold and Garnet Diadem 265
Greek, 3rd century B.C.

The diadem consists of a central Herakles knot flanked by two openwork straps joined to the knot by hinges. This type of diadem was worn over a high coiffure, the two straps tied at the back with a ribbon, like most ancient diadems and many necklaces. The Herakles knot would be the centerpiece with the two pendants falling over the forehead.

The sinuous curves of the Herakles knot symbolized the union of Zeus and Rhea as snakes—on the Walters diadem the snakes are preserved. The motif has a long history in Egypt, but owes its great popularity to its adoption by Alexander and his successors as a trade mark. The Herakles knot was also believed to function as an amulet and to be especially effective in healing wounds.

The knot is constructed from sheet gold

263

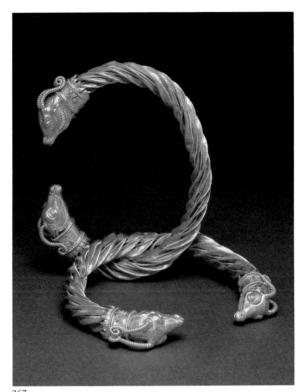
267

turned up at the edges with twisted and smooth wires fastened to the outside to form open channels in which are set ten dark red garnets. Twelve rosettes separate the garnets; four of the rosettes undoubtedly once held gem stones while the other eight are less elaborate. The ends of the knot are held by two "collars" consisting of smooth and twisted wire and a row of pointed leaves. At the four corners of the knot are tiny gold wire spirals ending in snakes' heads. The collars are hinged to the straps which are bordered at the inner terminals with a narrow strip of gold sheet decorated with filigree tongues, some still inlaid with green enamel. The straps are constructed of three long strips of gold that meet at the ends and terminate in long loops. The central strip of each strap has twelve rosettes with garnet centers; and lyre scrolls and palmettes inlaid with green and blue enamel. The lateral strips are decorated with leaves and spirals, with a filigree rosette where they meet and

at the ends of the terminal loops as well. Two multiple chain pendants are attached to the Herakles knot. The pendants consist of a large drilled garnet bead held between two rosette cups, with a sheaf of petals below, and three short loop-in-loop chains, two of which end with a small garnet held between rosette cups, a tiny rosette attached to the bottom, while the third ends in a gold bead with a tiny square, the corners folded over on the bottom. All are hooked to the chain by a long stem of spirally wrapped wire. (57.1541)

L. of central element: 1-9/16 in (.039 m) W. of arms: 7/8 in (.022 m) Total L. 17-3/4 in (.451 m)

History:
collection of Canessa (sale, Paris, Hôtel Drouot, May 11-14, 1903, lot 259, "found in Macedonia"); collection of E. Guilhou (sale, Paris, Hôtel Drouot, March 16-18, 1905, lot 82)
Publications:
Collection d'Antiquites Grecques et Romains Canessa, Paris, 1903, plate IX, II; *Catalogue des Objets Antiques et du Moyen-Age Collection de M. Guilhou,* Paris, 1905, plate VIII, pp. 16-17; Berta Segall, "Realistic Portraiture in Greece and Egypt," *JWAG,* 1946, p. 65; Randall, "Jewellery Through the Ages," p. 75, fig. 3
Notes:
The Walters diadem, with its openwork straps, is related to a series of openwork diadems the earliest of which in the Stathatos collection in Athens is dated to the beginning of the Hellenistic period (Amandry I, no. 217). The other three are dated to the 3rd century B.C. (Amandry III, p. 244, figs. 144-6, and Hoffmann and Davidson, *Greek Gold,* no. 3, p. 60). Compare also a diadem from Melos in London with straps consisting of three gold ribbons, the central ribbon ornamented with eleven and twelve rosettes (*BMCJ,* no. 1607, plate XXVII). According to Miss Segall, the "rich sumptuous style" of the Walters diadem suggests a date late in the reign of Ptolemy I, or in the early years of Ptolemy II, about 280 B.C., therefore fairly early in the series.

Bracelets	266-7

Bronze and Silver Bracelet 266
Greek, 5th century, B.C.

A solid bronze hoop, circular in section, is plated with silver. The open ends overlap, and are decorated with rings, cross hatchings, and a leaf. (54.601)

Max. D. 3-7/16 in (.088 m)

History:
acquired before 1931
Notes:
compare two bracelets from Cyprus (Einar Gjerstad, *The Swedish Cyprus Expedition,* vol. II, 1935, p. 326, plate LX, 13 and *BMCJ,* no. 607)

Pair of Bracelets 267
Greek, 4th century B.C.

A wide tube of sheet gold folded into six flanges forms the hoop which is twisted into a spiral and bent round to form each bracelet. Twisted wire is laid in the valleys and gathered at the ends of the hoop under the antelope

head finials which are detachable. The antelope heads are made in two halves, worked in repoussé, and chased. The horns, made of thick twisted wire are inserted separately. A strip of metal forms the "collar" of the finial and is decorated with three seven-frond palmettes, bordered above with a twisted and a smooth wire, below by a twisted wire between two smooth wires. A row of pointed leaves marks the transition from finial to hoop. (57.2021-2)

L. of finial 1-1/8 in (.029 m) Max. D. of hoop 2-15/16 in (.075 m)

History:
probably from Western Asia Minor; offered to the Metropolitan Museum of Art with the group described under "Notes" in 1948 by H. von Aulock; later collection of Ake Wiberg (Apertin, Sweden); (sale, London, Christie, Manson & Woods, December 5, 1973, lots 140 and 141); said to have been found in Anatolia (Stronach, infra)
Publications:
(57.2021) Pierre Amandry, "Orefèvrerie achéménide," *AK,* vol. 1, 1958, p. 15, note 51, plate 12, no. 34; (both) Hoffmann and Davidson, *Greek Gold,* no. 57; *Antiquities and Primitive Art,* London, Christie, Manson & Woods, 1963, pp. 34-5, plate 6; Dorothy Kent Hill, "Greek Gold Bracelets," *BWAG,* vol. 26, no. 7, 1974; David Stronach, *Pasargadae,* Oxford, 1978, p. 174, nos. 10-11
Notes:
A pair of gold bracelets of spirally twisted wire with detachable antelope head finials come from the Pasargadae Treasure, and belong to the same series as the Walters pair. They are discussed as a group by David Stronach (supra, pp. 173-5). The Walters bracelets are dated by him to the second half of the fourth century B.C.

The two bracelets were found in a group with an oval centerpiece from a diadem (Hoffmann and Davidson, *Greek Gold,* no. 5; sale catalogue, Christie, Manson & Woods, April 30, 1974, lot 170, plate 9), a pair of bracelets with Herakles knots (Hoffmann and Davidson, *Greek Gold,* no. 54; sale catalogue, Christie, Manson & Woods, July 10, 1974, lot 235), a necklace with spearheads (sale catalogue, Christie, Manson & Woods, April 30, 1974, lot 171, plate 9), two chains, a finger ring (Pierre Amandry, A Review of Hoffmann and Davidson, *Greek Gold, AJA,* vol. 71, p. 203), and a pair of earrings now in the Metropolitan Museum of Art (Andrew Oliver, Jr., "Greek, Roman and Etruscan Jewelry," *BMMA,* May 1966, p. 273, figs. 8-9, accession number 48.11.2, 3).

Rings	268-280

Swivel Scarab Ring 268
Greek, 6th century B.C.

Most archaic Greek gems were carved in the form of a scarab beetle. The type is ultimately of Egyptian origin and is thought to have passed to the Greeks via the Phoenicians probably on the island of Cyprus, which served as a crossroads for the eastern Mediterranean. The intaglio design and careful articulation of the beetle suggest a date in the early 6th century.

Silver hoop, green basalt scarab. The hollow, round hoop, narrows to pass through the scarab; the shoulders are spirally wound with wire. The parts of the scarab's back are carefully articulated. Intaglio design:

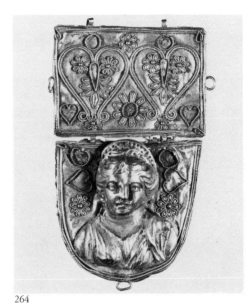

264

266

centaur to right with raised right arm holding a club (?), one complete lion to right, head turned back, and the foreparts of a second lion above the first; line border. (42.157)

L. of scarab 11/16 in (.018 m) D. 13/16 in (.02 m)

History:
collection of Newton-Robinson (sale, London, Christie, Manson & Woods, June 22, 1909, lot 14); said to be from Dali, Cyprus; purchased from Dikran Kelekian, 1909

Publications:
Catalogue of the Collection of Engraved Gems...formed by Charles Newton-Robinson, London, Christie, Manson & Woods, 1909, p. 7

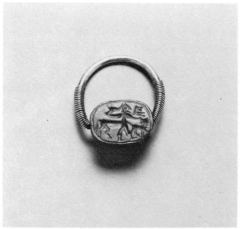

268

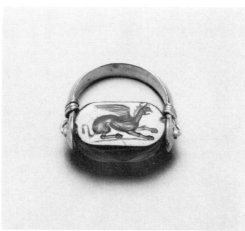

269

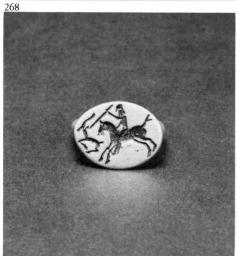

274

275

276

Swivel Scarab Ring 269
Greek, 5th century B.C.

Gold hoop, sard scarab. The hollow hoop is triangular in section, and has disk terminations. Wire is passed through the disks and scarab and wound round the shanks. The scarab is schematically modeled. Intaglio: crouching griffin on simple ground line, no border. (42.124)

L. of scarab 11/16 in (.018 m)

History:
collection of Morrison (sale, London, Christie, Manson & Woods, June 29, 1898, lot 58); collection of Newton-Robinson (sale, London, Christie, Manson & Woods, June 22, 1909, lot 7); purchased from Dikran Kelekian, 1909

Publications:
The Morrison Collection, London, Christie, Manson & Woods, 1898, p. 11; Burlington Fine Arts Club, *Exhibition of Ancient Greek Art,* London, 1904, p. 208, plate 110, M 130; *Catalogue of the Collection of Engraved Gems...formed by Charles Newton-Robinson,* London, Christie, Manson & Woods, 1909, p. 6 (illus.)

Notes:
Comparable griffins are found on Greek and Greco-Persian gems of the 5th century B.C., see Furtwängler, *AG,* plate IX, no. 58, plate XI, nos. 27 and 41. The fact that the scarab is not meticulously modeled suggests that it is Greek rather than Etruscan. On the modeling of scarabs see John Boardman, *Archaic Greek Gems,* London, 1968, pp. 13-15.

Four Gold Rings 270-3
Greek, 6th-4th century B.C.

These four rings are of a standard type popular from the Late Archaic period: not 270 with its leaf-shaped bezel and rounded hoop is the typical Archaic form and remains the only usual shape to the middle of the 5th century; 271-3 with ovoid bezels and flat or concave hoops are variations of this type, and may date as late as the end of the 4th century.

270. Round hoop, flat leaf-shaped bezel. Hoop and bezel made in one piece. (57.1637)

Max. L. of bezel 9/16 in (.015 m) Inner D. 5/8 in (.016 m)

271. Hoop concave inside, convex outside. Pointed oval bezel made of two flat sheets seamed together. Hoop and bezel made separately. (57.1640)

Max. L. of bezel 1-1/16 in (.027 m)

272. Hoop flat inside, slightly rounded outside; flat ovoid bezel. Hoop and bezel made in one piece. (57.1644)

Max. L. of bezel 13/16 in (.02 m)

273. Hoop concave inside, convex outside; flat ovoid bezel. Hoop and bezel made in one piece. (57.1669)

Max. L. of bezel 15/16 in (.023 m)

History:
collection of Henry Walters before 1931; Mrs. Henry Walters; all four purchased from Joseph Brummer, 1941
Notes:
Boardman, *GGFR*, pp. 212-214 types I-IX; no. 273, probably the latest of the four, can be compared with a silver ring from Marion in Cyprus found in a tomb with early Hellenistic pottery, late 4th century, B.C. (Einar Gjerstad, *The Swedish Cyprus Expedition,* vol. II, 1935, plate LXIV, no. 30).

Bronze and Silver Ring 274
Greek, 5th century B.C.

Hollow hoop, rounded outside, slightly ridged inside, spreading shoulder. On the oval bezel are a hunter on horseback with a Persian cap, brandishing a spear, chasing an antelope. A hunt on horseback was the favorite recreation of Persian nobility. The type of ring and its style are, on the other hand, typically Greek. The question with all such Greco-Persian works is their origin. Was it made by Greeks working at the fringes of the Persian empire, Persian craftsmen taught by Greeks, or Greeks influenced in their taste for subject matter by purely Persian works of art? It has been suggested that this ring belongs with a group made by local, "barbarian" Anatolian craftsmen in imitation of the so called Greco-Persian gems. The date is probably the second quarter of the 5th century B.C. The metal is a bronze and silver alloy. (57.1007)

L. of bezel 7/8 in (.022 m) Inner D. 13/16 in (.02 m)

History:
collection of Newton-Robinson (sale, London, Christie, Manson & Woods, June 22, 1909, lot 44); purchased from Dikran Kelekian, 1909
Publications:
Burlington Fine Arts Club, *Exhibition of Ancient Greek Art,* London, 1904, no. 085, plate CX; *Catalogue of the Collection of Engraved Gems...formed by Charles Newton-Robinson,* London, Christie, Manson & Woods, 1909, p. 13 (illus); M. E. Maximowa, "Griechisch-persische Kleinkunst in Kleinasien nach den Perser Kriegen," *AA,* 1928, p. 675, no. 3; Boardman, *GGFR,* pp. 322 and 357, plate 992

270-273

277

278

Gold and Garnet Ring 275

Greek, 4th-3rd century B.C.

Hoop slightly rounded outside, flat inside; shoulders square. The stepped oval bezel has a rinceau pattern between raised gold borders. The garnet is strongly convex and is cut in intaglio with Eros wearing a sash and holding a torch in his lowered hand. (57.1021)

L. of bezel 3/4 in (.019 m) Inner D. 3/4 in (.019 m)

History:
purchased from Dikran Kelekian, 1911

Gold and Agate Ring 276

Greek, 4th-3rd century B.C.

Hoop slightly rounded outside, flat inside; shoulders square and very slightly flared; the oval bezel in two degrees: an outer flat gold border, and an inner concave border with a pattern of chevrons, lines and dots engraved on it. The slightly convex agate cut in intaglio shows Eros riding on a swan. (42.856)

L. of bezel 3/4 in (.019 m) Inner D. 11/16 in (.018 m)

History:
collection of Henry Walters; Mrs. Henry Walters; purchased from Joseph Brummer, 1942
Notes:
Rings with incised patterns on the bezel are known from Italy to South Russia and can be dated on the basis of tomb groups to the 4th-3rd century B.C. See *BMCR*, nos. 91, 362, and 707, and Greifenhagen, *Berlin* I, plate 13, 3-5 for further references.

Gold Relief Ring 277

Greek, 4th-3rd century B.C.

Hoop flat inside, low ridge outside. Rounded oval bezel decorated with bust of Athena in high relief. She wears a triple-crested helmet pushed back on her forehead and a chiton with aegis. (57.1027)

Max. L. of bezel 15/16 in (.023 m) Inner D. 3/4 in (.02 m)

History:
collections of Robinson; Wyndham Cook
Publications:
Cecil H. Smith and C. Amy Hutton, *Catalogue of the Collection of Wyndham Francis Cook*, II, London, 1908 p. 5, no. 1, plate 1
Notes:
A relief ring of this type was found in a 4th-3rd century tomb at Santa Eufemia near Monteleone (Calabria) (*BMCR*, no. 224). Stylistically, the Athena bust is close to a medallion from an early 3rd-century tomb near the Quarantine Road at Kerch (*ABC*, plate XIX, 3). Dorothy Hill noted a resemblance to moulds from a potter's kiln at Chersonese—these moulds appear to have been made by taking impressions from metal, stone, or clay. The style points to the second half of the 3rd century B.C. when medallions in high relief were in fashion for adorning the bottoms of silver vessels and were imitated in clay (Minns, *Scythians and Greeks*, p. 364, fig. 265, I.4).

Gold and Garnet Ring 278

Greek, 3rd-2nd century B.C.

Hoop slightly rounded outside, flat inside; square shoulders. Garnet flat, cut in intaglio with the bust of Isis to right, with long ringlets, a diadem or wreath with lotus flower over her forehead. The individualized features suggest that this is a portrait of a Ptolemaic queen, perhaps Arsinoe, as Isis. (57.1022)

L. of bezel 11/16 in (.018 m) Inner D. 5/8 in (.016 m)

History:
purchased from Dikran Kelekian, 1911
Notes:
for a list of other gems of this type see John Boardman and Marie-Louise Vollenweider, *Catalogue of the Engraved Gems and Finger Rings,* Ashmolean Museum, Oxford, 1978, p. 82, no. 290; for the type ring compare for example a ring from Zakinthos (Zante) in London (*BMCR*, no. 396)

Gold and Garnet Ring 279

Greek, 3rd century B.C.

Broad hoop, rounded outside, flat inside, square shoulders. Oval bezel, wide border, convex stone. Intaglio: head of Dionysos wearing ivy wreath. (57.1699)

Max. L. of bezel 1-5/16 in (.033 m) Inner D. 13/16 in (.021 m)

History:
collection of Morrison (sale, London, Christie, Manson & Woods, 1898, lot 255 "said to be from Tarsus"); collection of Guilhou, 1912, purchased from Jacob Hirsch, 1942
Publications:
The Morrison Collection, London, Christie, Manson & Woods, 1898, p. 32, plate II; Furtwängler, *AG,* vol. III, p. 167, fig. 117; Seymour de Ricci, *Catalogue of a Collection of Ancient Rings formed by the late E. Guilhou,* Paris, 1912, p. 40, no. 268, plate V; Sir Arthur Evans, *An Illustrated Selection of Greek and Greco-Roman Gems,* Oxford, 1938, no. 76; Dorothy Kent Hill, "Some Hellenistic Carved Gems," *JWAG,* vol. VI, 1943, p. 66, figs. 2 and 4; Marie-Louise Vollenweider, "Das Bildnis des Scipio Africanus," *Museum Helveticum,* Basel, from 1944, vol. 15, fasc. 1, 1958, p. 30, no. 32
Notes:
The ring is one of a group put together by Marie-Louise Vollenweider who sees a resemblance in the portrait to Ptolemy IV Philopater (221-203) who often was represented as Dionysos (see above, supra, Marie-Louise Vollenweider, "Das Bildnis des Scipio Africanus," *Museum Helveticum,* vol. 15, no. 1, 1958, p. 30, no. 32). Both Miss Vollenweider and Miss Hill date the ring to the 3rd century B.C.

Greek, 2nd-1st century B.C.

Elaborate swivel hoop attached with spurs to mouldings projecting downward from the stepped bezel. Garnet set so that a gold flange covers the edges of the stone. Deeply cut intaglio: portrait head with ΑΓΟΛΛΩΝΙ 'of Apollonios' below the neck, either the signature of the gem carver or the name of the owner. (57.1698)

Max. L. of bezel 1-1/8 in (.028 m) Inner D. 11/16 in (.018 m)

History:
collection of Morrison (sale, London, Christie, Manson & Woods, 1898, lot 261 "said to be from Kerch"; collection of E. Guilhou; purchased from Jacob Hirsch, 1942

Publications:
The Morrison Collection, London, Christie, Manson & Woods, 1898, p. 33, plate II; Furtwängler, *AG,* vol. I, plate LXIII, 36; *ibid,* vol. II, pp. 285-6; *ibid,* vol. III, p. 163; Seymour de Ricci, *Catalogue of a Collection of Ancient Rings formed by the late E. Guilhou,* Paris, 1912, no. 202, p. 32, plate IV; Sir Arthur Evans, *An Illustrated Selection of Greek and Greco-Roman Gems,* Oxford, 1938, no. 65, plate IV; Dorothy Kent Hill, "Some Hellenistic Carved Gems," *JWAG,* vol. VI, 1943, p. 62, figs. 2 and 3; D. K. Hill, "Gem Engraving in Greece and Rome," *BWAG,* vol. 13, no. 4, 1961; D. K. Hill, "Gem Pictures," *Archaeology,* vol. 15, no. 2, 1962, p. 124, fig. 6; Gisela M. A. Richter, *Engraved Gems of the Greeks and Etruscans,* London, 1968, p. 168, no. 677, illus.

Notes:
It was suggested in the Morrison sale catalogue that the portrait is of Asandros, king of the Bosphorus (47-16 B.C.) on the basis of comparisons with coins of Pontus. Miss Richter disagreed with this identification, suggesting that the style and the fleshy physiognomy resemble the Ptolemaic rulers more closely. The name Apollonios is a common one, and as Furtwängler points out, if the name is the signature of the gem cutter, he is not the same Apollonios as the artist of other gems who signs in a different style (Furtwängler, *AG,* vol II, p. 286). For the hinged hoop compare a ring also once in the Jacob Hirsch collection (Adolf Greifenhagen, "Antiker Goldschmuck in Amerikanischem Privatbesitz," *Pantheon,* vol. XXV, 1967, pp. 82 and 85, figs. 6-7); two rings in the British Museum (*BMCR,* nos. 844-5); and a ring from Pelinna now in the Volos Museum (Stella Miller, *Two Groups of Thessalian Gold,* University of California Press, Berkeley and Los Angeles, 1979, plate 26 a, b; Pel. J2 dated to the second half of the 2nd century B.C.

279, 280

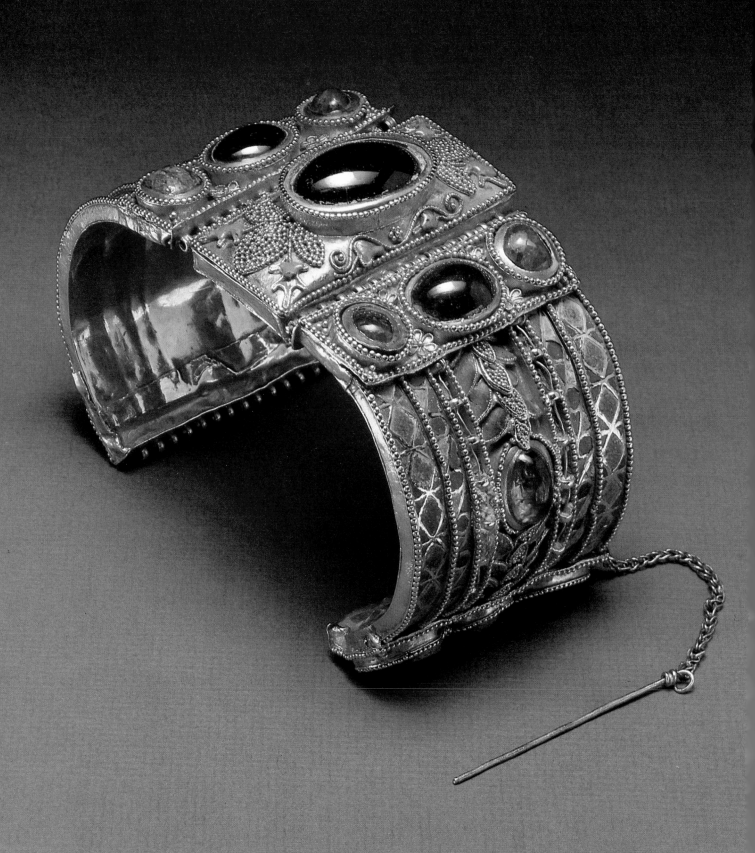

The Olbia Treasure

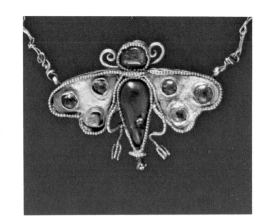

In the spring of 1891, Russian peasants, digging a plot of land near Olbia, a small town in the Crimea that was once an ancient Greek colony, came upon an ancient stone-faced tomb chamber in the midst of which were the remains of a bronze-footed wooden couch and the skeleton of a woman. She had been lavishly decked with jewelry: a wreath, gold and garnet earrings, two necklaces one with a butterfly pendant, two gold rings, and a silver medallion of Aphrodite with two Erotes. A small gold coin to pay Charon to ferry her over the river Styx in the Underworld had been placed in her mouth. Lying nearby were a multitude of gold ornaments, once probably sewn to her garments, a bronze mirror, a bone spoon, a clap lamp and various pieces of pottery, including a lead-glazed terracotta mug.

This discovery was reported in a Russian publication of 1894 that illustrated the butterfly necklace, the earrings, the lead-glazed mug and other pottery and gold ornaments. A later Russian report published in 1907 provided the additional information that the tomb had also contained a pair of silver cups, a silver ladle, a distaff, and a lead-glazed pitcher. The second report also described how the antiquities were dispersed: they were purchased from the peasants who found them by a local antiquities dealer who in turn sold them to a Moscow collector named Postnikov. Then, in a bizarre turn of events, archaeologists from St. Petersburg (Leningrad), to whom Postnikov showed his Olbia treasures, challenged their authenticity and despite published arguments to the contrary cast such serious doubts on their genuineness that Postnikov decided to sell them.

Apprehensive of his ability to do so in Russia he sold them (or at least some of them) to the London dealer Spink. It was from Spink that J. P. Morgan bought the silver cups, ladle, and distaff, now in the Wadsworth Atheneum, Hartford, and the lead-glazed pitcher, now in the Metropolitan Museum. The lead-glazed mug never left Russia and is in the Pushkin Museum, Moscow. A British scholar, E. H. Minns, reported seeing the butterfly necklace for sale at Spink in the early years of this century, no doubt sent to London by Postnikov with the silver from Olbia. The disposition of the rest of the jewelry and pottery is not known.

In the 1920s Henry Walters purchased the butterfly necklace, not from Spink however, but from the Bachstitz Gallery of The Hague, acquiring it together with a group of gold ornaments all alleged to have been found at Olbia. This Olbia group, or "Olbia Treasure" as it has come to be known belonged to a Frankfurt industrialist, F. L. von Gans, and was part of a large collection of ancient jewelry and other antiquities he began assembling after 1912 the year he had presented his first collection of antiquities to the Berlin Museum. In a folio catalogue of the second collection prepared for the Bachstitz Gallery in 1921, Robert Zahn, the assistant director of the antiquities department of the Berlin Museum reported that Gans had obtained his Olbia pieces from another collector, Peter Mavrogordato, and that Mavrogordato in turn had acquired the greater part of the group in the art market in 1913. And indeed a German archaeological report of 1913 illustrates much of the jewelry later published in the Bachstitz catalogue, and describes it as having come from a tomb excavated not long before at Olbia. As confirmation of the provenance the author of this report stated that he had re-excavated the tomb and had gleaned a gold ornament identical to ornaments alleged to have come from it (no. 57.391). No mention was made of a tomb discovered in 1891, and none of the jewelry illustrated in the 1913 report is pictured in the earlier Russian accounts. Without consulting unpublished Russian archaeological sources it seems impossible to determine for certain whether the jewelry purchased by Mavrogordato in 1913 actually came from the tomb discovered in 1891 or from another burial in the same necropolis opened only a short time before 1913. Even Zahn recognized the problem in his comments in the 1921 Bachstitz catalogue: he considered the association likely but not incontrovertible.

The butterfly necklace that was the principal ornament of the 1891 tomb and is the star of the "Olbia Treasure" today, must have been acquired directly from Spink in London by Peter Mavrogordato who was well acquainted with the circumstances of its discovery and surely recognized the object for what it was.

The Olbia Treasure in the Walters Art Gallery is representative of jewelry found in South Russian burials: a blend of native and Greek styles one would expect to find in a region where generations of Greek colonists had lived side-by-side with local inhabitants who still retained their own non-Greek language and customs.

Andrew Oliver, Jr.

Facing: Gold bracelet (no. 283)
Above: Detail of Butterfly Necklace (no. 281)

Greek, 1st century B.C.

Five colored inlays in elaborate gold settings form the center portion of the necklace: blue-green glass in the two rectangular settings and the two outer oval ones, and a violet stone in the center oval, a modern replacement for the original blue-green glass inlay known from a 19th-century description and photograph. The pendant butterfly has an emerald for its head, a blue stone for its body, and gold wings spotted with an emerald and inlays of red, white and green glass. The flanking pendants have ancient round emeralds and modern teardrop shaped blue stones, the latter being replacements for flat inlays of pinkish glass; the satellite beads are modern replacements for lost stones. Chains link the pendants to one another and to the outermost oval stones. The extremities of the necklace are formed by two lynx heads with rock crystal beads as necks and braided chains ending in loops. The animals' heads and four large settings have flexible hinges secured by toggle pins. The flanges of the settings are ornamented with granulation, small inlays of brown glass, and flower blossoms of gold sheet.

Elaborate diadems or necklaces featuring centerpieces of inlaid stones, pendant chains and beads, and beaded chains go back to third and second century Greek jewelry. As this object was found on the neck of the deceased it may properly be considered a necklace and not a diadem. The bold geometric forms and the importance given to the colored inlays foreshadow the style of the Roman empire—provincial style from the fringes of the Greek world on its way to becoming cosmopolitan Roman taste. In conceiving the necklace the jeweler has drawn widely from his repertory: lynx heads are at home on hoop earrings, the pendants flanking the butterfly are inspired by pendant elements of earrings, the oval and rectangular cushion inlays are taken from rings. The finished effect is dramatic but gaudy, the workmanship is competent but on close inspection a trifle coarse. (57.386)

L. 12-7/8 in (.327 m)

History:
found in a tomb at Parutino near Olbia in South Russia in 1891, in what was probably the burial ground of ancient Olbia; acquired from local dealers in antiquities by a Moscow collector, Postnikov; sold by Postnikov around the turn of the century to the London dealer Spinks and seen there by an English classical scholar, E. H. Minns; collection of F. L. van Gans; purchased by Henry Walters between 1921 and 1931

Publications:
A. V. Oreshnikov, "Remarks on antiquities found at Parutino in 1891," (in Russian), *Drevnosti,* XV:2, 1894, pp. 1-13, plate I:2, Minns, *Scythians and Greeks,* p. 406; Zahn, *Galerie Bachstitz,* pp. 28-9, 32-3, plate 25; Patricia Cowles, "Jewelry," *BWAG,* vol. 5, no. 4, January 1953, 2, ill.; Barbara Pfeiler Lippitz, "Späthellenistische Goldschmiedearbeiten," *AK,* 15, 1972, p. 108, plate 31 bottom

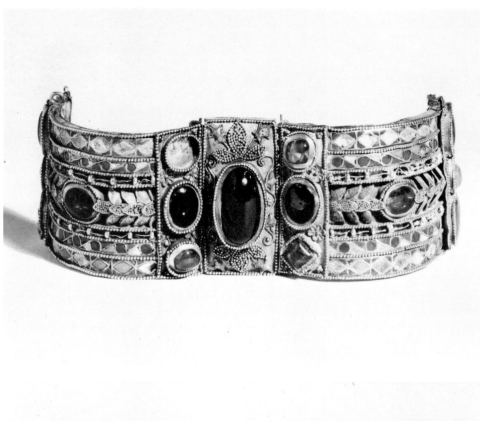

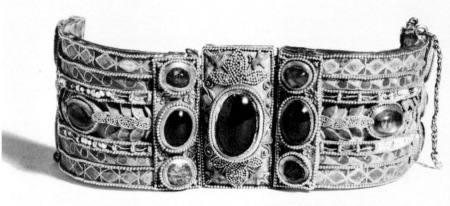

283

Notes:

Butterflies occur as pendants on other necklaces: one in the Köfler collection, also from Olbia (Hoffmann and Davidson, *Greek Gold,* p. 142, no. 51, ill.), another in Leningrad from Chersonesus, South Russia (Minns, *Scythians and Greeks,* p. 407, fig. 295), and yet another in the British Museum reported to be from Italy (Higgins, *Greek and Roman Jewellery,* plate 58).

Necklace 282

Greek, 1st century B.C.

Made of gold, the necklace has an oval blue stone (possibly a replacement for the original), flanked by two green stones, all three in box settings hinged and secured with toggle pins. Below is a cruciform assemblage of two garnets and two green stones, also in box settings and hinged in the same manner. Chains to steady the pendant run to the settings flanking the oval one and are secured by toggle pins ornamented with tiny rock crystal beads. The rest of the necklace, comprising pairs of green stones, garnets and pearls, is ancient but probably did not belong originally to the centerpiece of mounted stones. (57.385)

L. 15-9/16 in (.396 m)

Publications:

Zahn, *Galerie Bachstitz,* pp. 29, 33, plate 26; Barbara Pfeiler Lippitz, "Späthellenistische Goldschmiedearbeiten," *AK,* 15, 1972, p. 108, plate 31

Notes:

Robert Zahn, who first published the necklace, suggested that the centerpiece was once hinged to the braided chains with dog head finials erroneously attached to the cosmetic jar (no. 286). This seems likely. Such an arrangement would correspond not only to the design of the great butterfly necklace (no. 57.386) but also to that of a diadem in Athens from Thessaly (*AK,* 15, 1972, p. 108, plate 30:1), another in Leningrad from Artjukhov's barrow on the Taman peninsula, South Russia (Higgins, *Greek and Roman Jewellery,* p. 169, fig. 27), and the center portion of a necklace in the Cleveland Museum of Art (*Echoes from Olympus,* University Art Museum exhibition, Berkeley, 1974, no. 192, ill.).

Pair of Bracelets 283

Greek, 1st century B.C.

Each of these gold bracelets has a centerpiece and two curved arms hinged together. The arms are articulated and when shut can be secured by a pin that passes through intermeshing loops. All the members have a gold sheet backing folded up at the side to hold in place the decorative elements. The two centerpieces have box settings for an oval stone or glass inlay (present stones are modern replacements) surrounded by a floral design done in granulation and wire which includes oak and ivy leaves of green enamel. The curved arms have end pieces slipped on like sleeves, each end piece ornamented with three oval or circular stones in box settings. The sleeves flanking the centerpieces have oval garnets (?) flanked

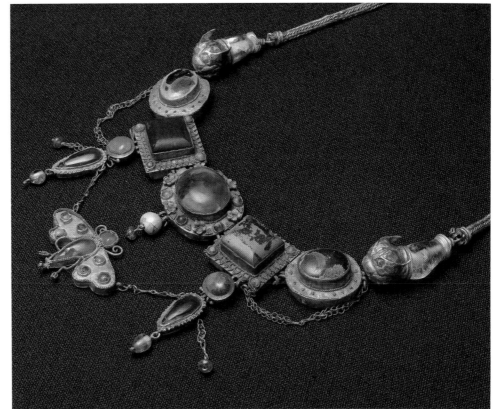

281

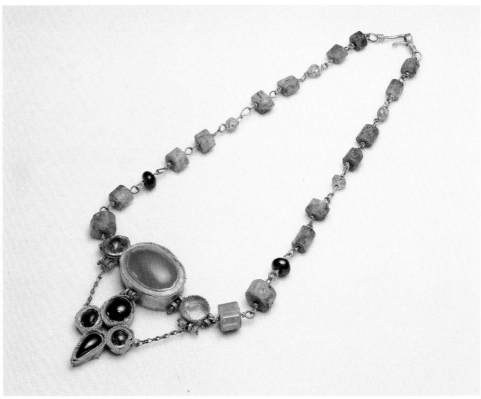

282

by green stones; the outer sleeves have round turquoise stones flanked by oval red ones, but many of the stones look like modern replacements. Elsewhere the arms are decorated with bands of cloisonné work: red, blue and turquoise inlays in diamond, triangular, and round settings. In the center, overlapping leaves of granulation and turquoise meet at a box setting. Flanking the leaves are troughs with pearls held in place by a wire running through loops. Major elements of the decoration are outlined with beading. (57.375-376)

W. 2-1/8 in (.053 m) D. 3-1/8 in (.079 m) 57.375

W. 2-1/8 in (.053 m) D. 2-7/8 in (.073 m) 57.376

History:
acquired by Peter Mavrogordato in the summer of 1913 with the story that they had come from a tomb discovered shortly before at Olbia; collection of F. L. von Gans; Robert Zahn (see publications) was unable to confirm positively that they were found with the butterfly necklace in the tomb opened at Olbia in 1891

Publications:
Zahn, *Galerie Bachstitz,* pp. 27-28, 32-33, plate 24; *The Dark Ages,* p. 33, no. 68, ill. (57.376); C. R. Morey, "Art of the Dark Ages: A Unique Show," *The Art News,* February 20, 1937, 13, ill. (57.376); Patricia Cowles, "Jewelry," *BWAG,* vol. 5, no. 4, January 1953, 2 ill. (57.376); Philippe Verdier, *Russian Art,* The Walters Art Gallery, 1959, no. 1, ill. (both); Ross, *Migration Period,* p. 21; Randall, "Jewellery Through the Ages," p. 497, fig. 8 (57.376); Barbara Pfeiler Lippitz, "Späthellenistische Goldschmiedearbeiten," *AK,* 15, 1972, p. 117, plate 31

Notes:
Hinged bracelets with toggle pin clasps, commonplace in Roman and early Byzantine jewelry, originated in the late Hellenistic period. They were either a flexible open hoop (Hoffmann and Davidson, *Greek Gold,* pp. 159 ff., no. 56, ill.), or composed of a centerpiece and curved, articulated arms as here. Related to the Walters bracelets conceptually are a bracelet in the National Museum, Athens, found in Thessaly (*AK,* 15, 1972, plate 33:2-3) and another from the collection of Lord Melchett, London, sold in the Basel art market in 1958 and said to have been found on the island of Mykonos (Münzen und Medaillen, Auktion XVIII, November 29, 1958, lot 155). But whereas the bracelets from Thessaly and Mykonos are in the mainstream of Greek jewelry, the Olbia bracelets are a hybrid of Greek and outlandish styles.

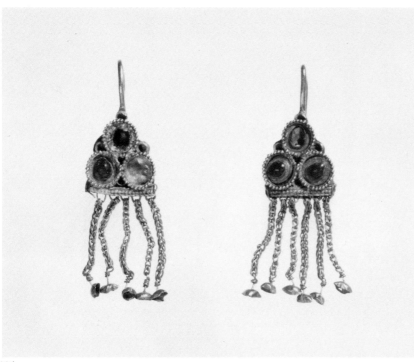

284

285

Pair of Earrings 284
Greek, 1st century B.C.

Made of gold, the earrings have three flanged settings with brown stones, each set within a bead-edged frame, displayed against a roughly triangular sheet on the back of which the ear wire is attached. A pin concealed behind the transverse bar below the settings secures six pendant chains. Crumpled caps at the ends of the chains once covered the tops of glass beads which have long since disintegrated and are missing. Some of the brown stones and one of the pendant chains is also missing. (57.382-383)

L. 2-1/4 in (.058 m)

History:
said to be from Olbia, South Russia
Publications:
Zahn, *Galerie Bachstitz,* pp. 29-30, 33-34, plate 25:D
Notes:
Two pairs of earrings in the Medieval Department of the Metropolitan Museum of Art, both said to be from Olbia, share the same scheme of design: stones mounted in a triangular arrangement, pendant chains below (22.50.5-6; 22.50.7-8; sale cat. American Art Gallery, New York, Chmielowski collection, February 24, 1922, lots 692-3). The Walters earrings are also related to the earrings actually found with the butterfly necklace (57.386) (*Drevnosti,* XV:2, 1894, pp. 1 ff., plate I:1) and to another pair from Kerch, South Russia (*Otchet,* 1903, p. 45, fig. 62).

Ring 285

Greek, 1st century B.C.

The gold ring has an oval garnet set in the bezel and gently sloping shoulders. (57.723)

D. 13/16 in (.021 m)

History:
said to be from Olbia, South Russia
Publications:
Zahn, *Galerie Bachstitz,* p. 30, plate 26 F
Notes:
A similar ring is in the British Museum (Higgins, *Greek and Roman Jewellery,* p. 175, plate 53:F); others have been found in Artjukhov's barrow on the Taman peninsula, South Russia, Eretria, Greece (G. A. Papavasileos, *Peri ton en Euboia archaion taphon,* Athens, 1910, p. 57, plate 14:14), Ancona, Italy (*NSc,* 1902, p. 460, fig. 29), and Delos, Greece (*BCH,* 89, 1965, plate 22:a- ; *BCH,* 92, 1968, pp. 554-555). Their context suggests a date in the first century B.C.

Cosmetic Jar 286

Pontic, 1st century B.C.

A cap fits snugly over this high necked gold jar. Pairs of twisted wire circle the shoulder and base of the neck, as well as the top and bottom edges of the cap. Two pairs of coiled wires further ornament the shoulder, front and back. The cap has four blue-enameled leaves arranged in a quatrefoil design around a garnet set within a ring of twisted wire. Pairs of gold loops on cap and bottle can be aligned to receive suspension chains. The braided chains currently attached, featuring loops at one end, dogs' heads at the other, are ancient but did not originally belong to the jar. (57.380)

L. with chain 6-1/2 in (.165 m)

Publications:
Pharmakowski, "Russland," p. 255, fig. 29; Zahn, *Galerie Bachstitz,* pp. 30, 34, plate 27:J
Notes:
The earliest published photograph shows the jar without chains. Robert Zahn noticed that the chains probably belonged with the centerpiece of the necklace illustrated elsewhere in this catalogue (no. 282). The jar probably contained perfume or a cosmetic like the small gold container called a *phykion* listed among necklaces in the temple inventories of Delos, which Marjorie Milne was convinced was a rouge container (*AJA,* 43, 1939,

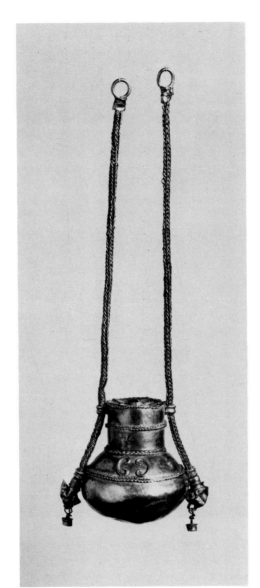

286

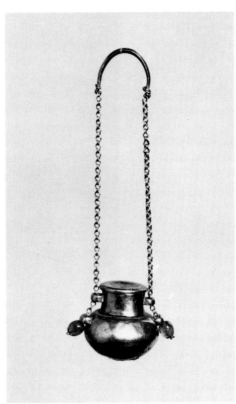

287

pp. 251, 254). Other cosmetic jars of this design, sometimes ornamented with garnets, have been found in the Black Sea area (Zahn, *Galerie Bachstitz*, p. 34; *Otchet*, 1902, 83, fig. 184; *Huitième Congres International d'archéologie classique*, Paris, 1963 [1965], p. 430, plates 102:3, 103:1; Pfeiler, *Römischer Goldschmuck*, p. 79, plate 22).

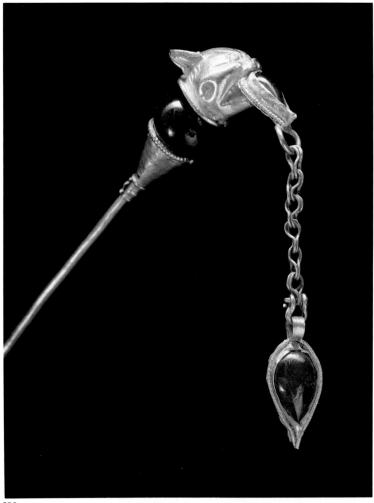

290

288

Cosmetic Jar 287

Pontic, 1st century B.C.

A cap fits snugly over the cylindrical neck of the gold jar. Two pairs of loops on cap and jar are aligned to receive the suspension chains. Green stones keep the chains from slipping loose, while a horseshoe-shaped bar at the top fits comfortably over one's finger. (57.381)

Publications:
Zahn, *Galerie Bachstitz*, pp. 30, 34, plate 27:K

Two Pendants 288

Pontic, 1st century A.D.

Each gold pendant is composed of two cylinders side-by-side, closed at the bottom, open at the top. They are lined with a row of granules and have two loops for suspension. (57.377-378)

L. 1/2 in (.014 m)

Publications:
Pharmakowski, "Russland," p. 255, fig. 78; Zahn, *Galerie Bachstitz*, pp. 30, 34, 35, plate 26:H

Pin 289

Greek, 1st century B.C.

The head of the gold pin is missing but the moulding that kept what were probably its composite elements securely in place is still preserved. Three loops soldered to the pin retain three pendant cylinders which may or may not belong. The original photograph of the cylinders shows them without the pin. Two of the cylinders are ornamented with wire, the third has a stone bead jammed in its bottom. (57.379)

L. 2-7/8 in (.074 m)

Publications:
Pharmakowski, "Russland," p. 255, fig. 78 (cylinders alone without the pin or stone); Zahn, *Galerie Bachstitz*, pp. 30, 34-35, plate 27:G (as presently assembled)
Notes:
No other pin like this is known. Although the original photograph shows the undecorated cylinder without the stone bead, there may once have been a stone of some sort on the Walters pendant because rock crystal stones occur on pendant tubes of a necklace in Berlin (Greifenhagen, *Berlin II*, 1975, p. 53, plate 42:6-7).

Pin 290

Greek, 1st century B.C.

The top of the gold pin is a finely modeled
lynx head. A small moulding on the shaft of
the pin keeps the garnet bead and conical
collar from slipping off. One setting with a
tear-drop garnet is firmly fixed in the lynx's
mouth by a pin the extremity of which is
looped. Chained to the loop is a second
tear-drop garnet. (57.384)

L. 7-1/2 in (.171 m)

History:
said to be from Olbia, South Russia
Publications:
Zahn, *Galerie Bachstitz,* p. 30, plate 27:E
Notes:
Robert Zahn, who first published this object, con-
sidered it to be the fragment of a lynx head earring made
up as a pin, but I see no reason to doubt that the various
elements were made expressly as components of a pin.
Many Greek pins have a tassel or chain at the head
serving a functional or ornamental purpose, as for
example pins in the British Museum (Higgins, *Greek
and Roman Jewellery,* plate 53:H), Hamburg (Herbert
Hoffmann and Vera von Claer, *Antiker gold — und
silberschmuck,* Mainz, 1968, p. 159, no. 100 ill.), and
Leningrad, the latter from Artjukhov's barrow in
South Russia (Minns, *Scythians and Greeks,* fig. 321)

289

Dress Ornaments 291

Pontic, 1st century B.C.

The gold ornaments are pierced for sewing
to clothing. (57.388)

H. 1/2 in (.014 m)

History:
from Olbia; collections of Peter Mavrogordato; F. L.
von Gans
Publications:
Zahn, *Galerie Bachstitz,* pp. 31, 35, plate 29
Notes:
other ornaments like these have been found in South
Russia (*Otchet,* 1896, fig. 347)

291

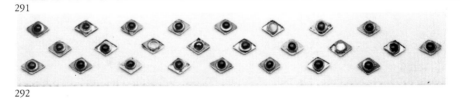
292

Dress Ornaments 292

Greek or Pontic, 1st century B.C.

In the center of the diamond-shaped gold
ornaments are round settings containing
either garnets or dark green glass. Those
with garnets have brown glass inlaid in the
surrounding space while those with green
glass have dark blue glass in the correspond-
ing space. Some of the stones and inlays have
fallen out. On the back are tiny loops for
sewing the ornaments to clothing. (57.391)

3/8 in x 5/8 in (.01 m x .016 m)

History:
from Olbia; one of the ornaments was picked up by an
archaeologist, Pharmakowski, in a tomb at Olbia, shown
him by a local farmer, Philippov, where the others
were said to have been found; collections of Peter
Mavrogordato; F. L. von Gans
Publications:
Pharmakowski, "Russland," pp. 254-255, no. 2, fig.
78; Zahn, *Galerie Bachstitz,* pp. 31, 35, plate 28

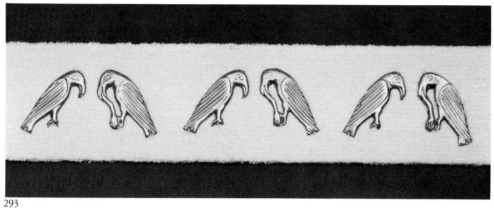

293

294

295

Dress Ornaments 293

Greek or Pontic, 1st century B.C.

There are six pairs of gold plaques done in repoussé relief, showing facing birds of prey, one devouring a fish. The plaques are pierced at the birds' bills, tails, wings and feet suggesting they were sewn on clothing as ornaments. Robert Zahn (see publications) considered the birds Black Sea eagles, often represented on the coinage of Pontic cities. (57.387)

H. 1-3/8 in (.036 m)

History:
from Olbia; collections of Peter Mavrogordato; F. L. von Gans
Publications:
Pharmakowski, "Russland," pp. 254-255, no. 2, fig. 78; Zahn, *Galerie Bachstitz*, pp. 31, 35, plate 30

Dress Ornaments 294

Greek or Pontic, 1st century B.C.

The diamond-shaped gold ornaments are pierced at each end allowing them to be sewn on clothing. Their original arrangement is not known. (57.389)

1/4 in x 3/8 in (.06 m x .01 m)

History:
from Olbia; collections of Peter Mavrogordato; F. L. von Gans
Publications:
Zahn, *Galerie Bachstitz*, pp. 31, 35, plate 30
Notes:
other ornaments like these have been found in South Russia (*Otchet*, 1896, fig. 346)

Dress Ornaments 295

Greek or Pontic, 1st century B.C.

The twenty-six circular gold ornaments are pierced for attachment to clothing. (57.390)

D. 5/16 in (.08 m)

History:
from Olbia; collections of Peter Mavrogordato; F. L. von Gans
Publications:
Zahn, *Galerie Bachstitz*, p. 31, plate 30

Belt Buckle 296

Greek or Pontic, 1st century B.C.

The gold buckle has a flange on three sides ornamented with beading and an egg-and-dart pattern. A slot and knob on the remaining side must have engaged part of the belt allowing it to be cinched and fastened. Robert Zahn (see publications) noticed traces of leather or cloth on the back, none of which are visible today. Boldly represented in repoussé relief with details added by engraving is a griffin, that creature of Greek imagination said to guard the gold of Central Asia. The second-century-A.D. Greek geographer, Pausanias, quoting an earlier authority, said

that griffins were like lions with wings and beak of an eagle. (57.373)

1-3/8 in x 2-9/16 in (.036 m x .066 m)

History:
from Olbia; collections of Peter Mavrogordato; F. L. von Gans
Publications:
Pharmakowski, "Russland," pp. 254-255, no. 5, fig. 78; Zahn, *Galerie Bachstitz,* pp. 31, 35, plate 28:L; *The Dark Ages,* p. 33, no. 69, ill.

Belt Ornament 297
Greek or Pontic, 1st century A.D.

The gold ornament is made of heavy, beaded wire. It must have formed the end piece of the tongue of the belt for which the belt buckle (no. 296) also served. The belt would have been secured to the ornament through the rectangular opening at one end. (57.374)

L. 1-1/2 in (.039 m)

History:
from Olbia; collections of Peter Mavrogordato; F. L. von Gans
Publications:
Pharmakowski, "Russland," pp. 254-255, no. 4, fig. 78; Zahn, *Galerie Bachstitz,* pp. 31, 35, plate 28
Notes:
a comparable tongue ornament for a belt was found with a buckle of different design from that at the Walters at Tsvetno, South Russia (*Otchet,* 1896, 88, fig. 352)

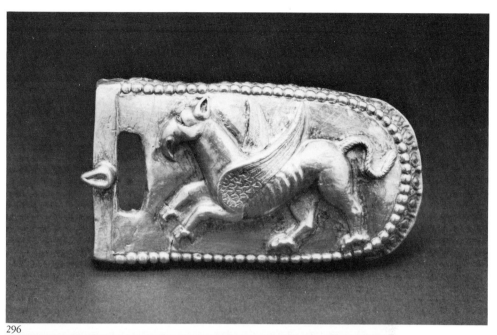

296

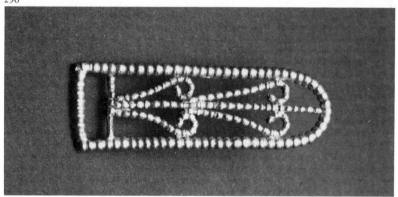

297

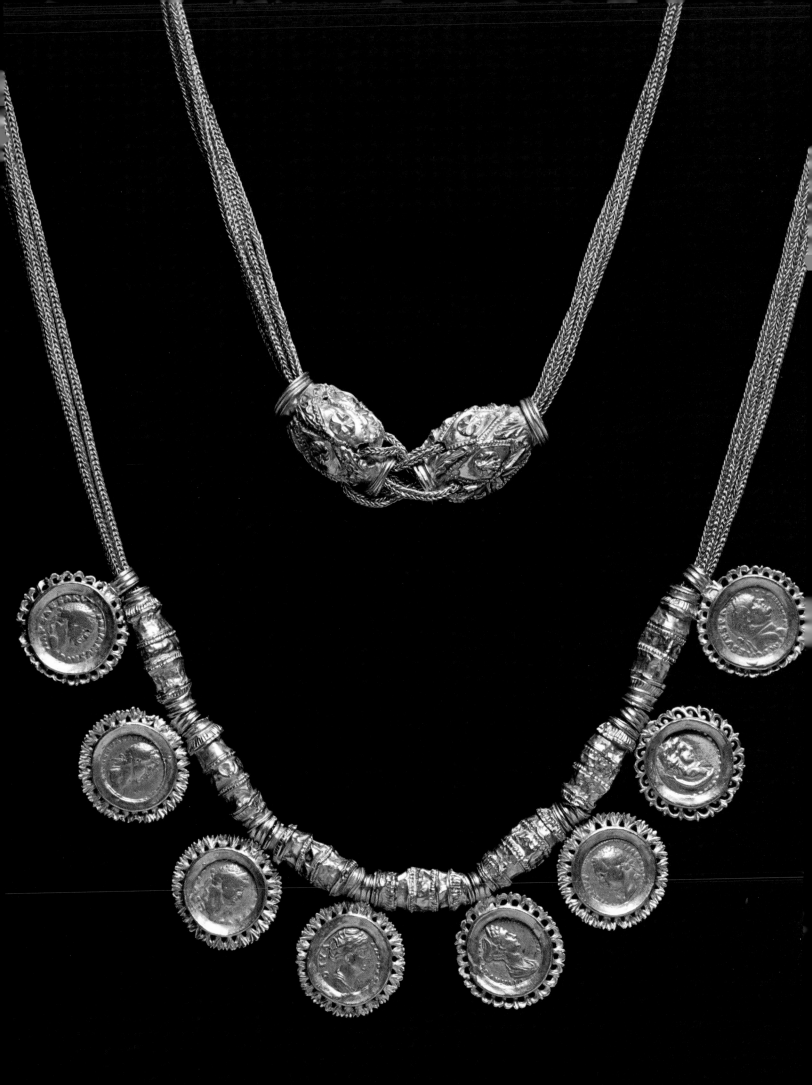

Roman Jewelry

In his *Natural History* compiled in the 70s of the 1st century A.D. the encyclopedist Pliny attributed the origin of the Roman fashion for pearls and gems to the spoils of the victories of Pompey the Great in the East more than 130 years earlier. Pliny also drew attention to the extravagant feminine taste for gold jewelry. Previously Roman law had restricted its use: in the 3rd century B.C. a woman could wear no more than half an ounce of gold; and only senators and knights were allowed gold rings. But the rules were gradually relaxed. The romanization of Etruria, and the assumption by Rome of political power in the Mediterranean world beginning with Magna Graecia (southern Italy and Sicily) in the late 3rd century B.C. and Greece proper, Asia Minor, Syria, and Egypt in the 2nd and 1st centuries B.C. brought Italians into contact with countless new customs, among them jewelry.

Although the fashion and propriety of wearing jewelry developed through exposure to the East, Roman jewelry is a peculiar blend of the eastern taste for colored stones with the Etruscan predilection for the use of flattened gold sheets to create abstractly contoured surfaces and volumes. Tertullian, a Christian writer flourishing about A.D. 200, remarked perceptively, yet sarcastically because he was condemning the practice of wearing jewelry in the first place, that stones and gold mutually enhanced one another (*On Female Dress* VI). That is the essence of Roman jewelry. Of course, not all pieces exhibit this feature but the tendency is evident in the earliest comprehensive view we have of Roman jewelry, contemporary with Pliny, namely that recovered from the ruins of houses at Pompeii and Herculaneum and such neighboring villas as the one at Boscoreale overwhelmed by the A.D. 79 eruption of Mount Vesuvius.

Well-to-do Romans had long vacationed in the Bay of Naples at the famous sea side resorts of Baia, Puteoli, Neapolis, and Herculaneum and so we may assume that the jewelry found through modern excavation at the Vesuvian sites is representative of what was fashionable in the capital. But Roman jewelry was not limited to Rome and its environs, or even to Italy. We must also consider as Roman jewelry the products of the goldsmiths' guilds in Alexandria and Antioch and other cities where these craftsmen practised their trade; Roman jewelry widely exported and found today in all parts of the Empire from Britain and the Spanish provinces in the west to Arabia Nabatea, Syria, and Cappadocia (central Asia Minor) in the East; jewelry made in the closing decades of the Roman Republic in the 1st century B.C. and in three and a half centuries of the Roman Empire proper, from the accession of Augustus as Emperor in 27 B.C. to the transfer of the capital to Constantinople in A.D. 330 by Constantine the Great shortly after his conversion to Christianty. During this period the emulation of Italian Roman life by provincial cities of the Empire had a homogenizing effect on the material culture of the Mediterranean world. Jewelry from one region is difficult to distinguish from that of another.

Burying jewelry with the deceased seems not to have been so common a custom as in earlier centuries; nevertheless, numerous Roman tombs excavated in modern times have revealed sets of jewelry interred with the body: for a woman, earrings, bracelets, one or even two necklaces, occasionally with pendants, one or more rings, and frequently a wreath perhaps worn only in death; gold rings, often heavy ones, have been found in association with male burials. Much of the Roman jewelry in the Walters collection must originally have come from such burials. Some pieces, however, are likely to be spoils from treasure troves. In times of peril, or for safekeeping, the family jewels might be secreted in a jar, perhaps even with a collection of gold or silver coins, never for some reason to be recovered by their original owner. One pair of earrings is reported to have come from the ruins of a house near Vesuvius.

Likenesses of women wearing jewelry of the very sort that has actually survived are seen in mosaics and wall paintings from Pompeii and Herculaneum and among funerary portraits from the Fayuum in Egypt such as the one shown here. They serve to remind us that the earrings, necklaces, bracelets, and rings that follow were once personal possessions of real people worn next to the skin and treasured for a lifetime.

Andrew Oliver, Jr.

Facing: Coin Necklace (no. 328). **Above:** Egyptian Mummy Portrait of the Roman Period showing a woman wearing earrings and a necklace. (W. 32.5)

298

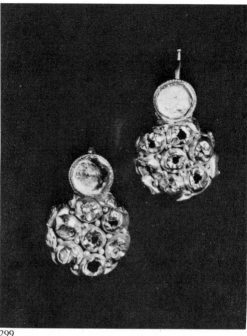

299

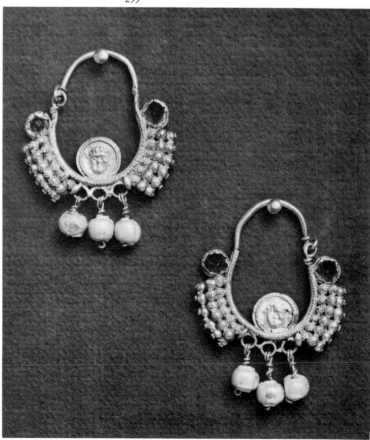

300

A disk, earwire, and pendant formed the basic Roman earring. The disk, or in many instances a mounted stone, concealed the S or hoop-shaped earwire attached to its back side; the pendants were rigidly or flexibly secured to an extension of the earwire, to the disk itself, or to a transverse bar at the bottom of the disk.

Flattening his gold into thin sheets to gain maximum effect from the metal, the goldsmith built individual parts into composite geometric designs. Greek antecedents of this style can be seen in earrings in the form of disks with pendant amphorae, but recognizable shapes such as model vases disappeared in Roman jewelry in favor of pure geometric ornament which emphasized the shimmering metal. Realistic renderings of human figures and animals, or their heads, do not occur except in certain "old fashion" pieces of the 1st century A.D.

Mounted stones, especially garnets, green beryls, and pearls become increasingly dominant components. In the midst of a commentary on pearl oysters, the Roman encyclopedist Pliny says, in an aside, that even the oyster's ability to close itself could not protect it from women's ears (*Natural History,* IX, 55, 111).

A simple disk and crossbar with pendant pearls (no. 298), common at Pompeii, exemplifies discreet Roman taste of the first century A.D. By the 3rd century this type of earring had developed into a showy version with emphasis on a large openwork disk (no. 307). Another Pompeian type, consisting of a large hemisphere below a small disk, was relatively light in weight despite the large area of gold it displayed. Sometimes the hemisphere had scores of raised bumps or was wired with small stones; or occasionally, as in no. 299, the earring was formed from composite elements roughly arranged as a hemisphere.

A rich series of earrings, generally dated to the 2nd and 3rd centuries, featured a cluster of small balls for the pendants, some resembling grapes (no. 302), and often dripping with granules. The different varieties must be indicative of regional styles that are difficult to identify today. A less common type of earring displayed a fan-like arrangement of ornament around the perimeter of a hollow hoop (no. 300). This design, with origins in Persian jewelry, had a subsequent history in Byzantine jewelry (see no. 387).

Earring 298

Roman, 1st century A.D.

A simple, lightweight gold earring composed of a crossbar, two pendant pearls, and a small disk partially concealing the ear wire, of a type found in great quantity among the ruins of Pompeii. (57.1670)

L. 1-1/16 in (.027 m)

History:
collection of Henry Walters before 1931; Mrs. Henry Walters; purchased from Joseph Brummer, 1941
Notes:
similar earrings from Pompeii are in Naples (*NSc*, 1914, p. 208, fig. 4 - Breglia, *Napoli*, p. 60, nos. 359-360, plate 26:5; Essen, Villa Hügel, *Pompeji, Leben und Kunst in den Vesuvstädten*, exhibition catalogue, 1973, p. 121, no. 148, ill.)

Pair of Earrings 299

Roman, second half of the 1st century A.D.

Seven crumpled hemispheres are placed in front of a second zone of nine hemispheres, which in turn are mounted on a flattened ring, all made of gold. Granules appear between the hemispheres. In back, the opening of the ring is crossed vertically and horizontally by two struts of twisted wire. Above, partially concealing the ear wire, is a bead-edged box setting filled with a glass inlay. (57.1914 a, b)

L. 1-7/16 in (.036 m)

History:
collection of E. Guilhou (sale, Paris, March 16-18, 1905, lot 165); purchased from the collection of Fred Werther, 1962
Publications:
Catalogue des objets Antiques et du Moyen-Age...collection de M. Guilhou, Paris, 1905, p. 27; Arthur Sambon, "La Banlieue de Pompei," *Le Musée*, III, 1906, pp. 160, 211, fig. 37
Notes:
Related are a pair of earrings in the Nicosia Museum from Polis (ancient Marion), Cyprus, with similar glass inlaid disks, but below, instead of a circular cluster of hemispheres, two vertical rows of them flanking rows of twisted wire (*BCH*, 89, 1965, p. 234, fig. 5; Pfeiler, *Römischer Goldschmuck*, p. 63, plate 18:3-4). A simpler variant of the Polis type is represented among the finds from Eleutheropolis, Palestine, now in Athens, thought to date from the late 1st or early 2nd century A.D. on account of associated coins (*JIAN*, 10, 1907, p. 251, nos. 343-344, plate VII:14).

Also related to the Walters earrings are the extensive series of earrings in the form of one large hemisphere surmounted by a disk, found in such quantity at Pompeii and Herculaneum that we must conclude they were in fashion at the time of the A.D. 79 eruption of Vesuvius and not old family pieces (Breglia, *Napoli*, p. 59, nos. 255-346, plate XXX). A pair of this type in Athens from the same Eleutheropolis find mentioned above, has disks inlaid with glass as on the Walters pair (*JIAN*, 10, 1907, p. 251, nos. 333-334, plate VII:7).

Pair of Earrings 300

Roman, 2nd century A.D.

A thick wire hoop, one end wound around the other for the clasp, forms the framework of each gold earring. The decoration is aligned in one plane around the outer edge of the hoop: at each side is a conical garnet in a flat-backed setting; at the bottom are three pearls hung from rings; between the pearls and garnet are four rows of balls, six to a row, the center row concealing the fourth behind it. Hoops and balls are liberally sprinkled with granulation on the front side only. Within the hoop is a disk with the face of Eros framed by twisted wire. (57.1552-3)

L. 1-1/2 in (.038 m)

History:
acquired before 1931
Notes:
Although no exact parallels are known, the pair seems related to earrings excavated from a 2nd century Nabataean tomb at Mampsis in the Negev (*Archaeology*, 24, 1971, 169 ill.). Others, like the Mampsis pair, are in the Rhode Island School of Design (Hackens, *Classical Jewelry*, pp. 113-115, nos. 50-51 and footnote 1-3 for further examples).

Pair of Earrings 301

Roman, 3rd century A.D.

A shield-like disk, with twisted wire at the edge and a granule in the center conceals the hoop-shaped ear wire. The rigid pendant is an inverted pyramid of four hollow balls, the front three ornamented with wire spirals and topped by an almond-shaped garnet; the whole gold assemblage is dripping with granules. (57.1522-3)

L. 1-1/4 in (.031 m)

History:
acquired before 1931
Notes:
a comparable pair was formerly in the Thomas Barlow Walker collection (sale, New York, Sotheby Parke Bernet, September 26-28, 1972, lot 241, ill.)

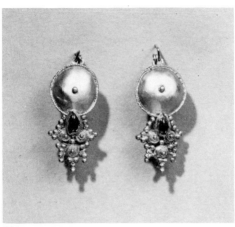

301

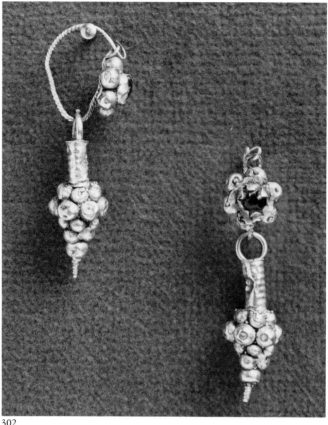

302

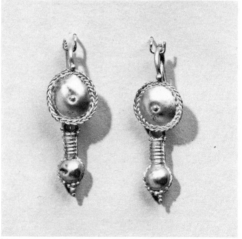

303

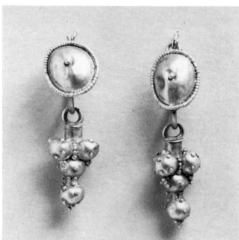

304

Pair of Earrings 302

Roman, 2nd or 3rd century A.D.

The ear wire of twisted square wire has a shield formed by six hollow balls framing a garnet in a serrated setting. The pendant is a grape-like cluster of hollow balls dotted with garnets and connected by a corrugated tube to the ring attachment. Pollux, a 2nd century A.D. scholar, reported that some earrings were called "grape" earrings (*Onomasticon* V, 97). Perhaps these gold earrings are of this kind. (57.612-3)

L. 1-5/8 in (.042 m)

History:
acquired before 1931
Notes:
Similar pendants occur on earrings found at Kerch in South Russia (*Otchët*, 1903, p. 50, fig. 87) and on others now in Berlin (Greifenhagen, *Berlin I,* p. 46, plate 23:14-15).

Pair of Earrings 303

Roman, 2nd or 3rd century A.D.

The S-shaped ear wire has a convex shield in front, dotted with a granule and edged with two sets of two wires wound together. A corrugated tube and hollow ball form each pendant, the whole gold assemblage outlined with three twisted wires; a ring attachment at the top and granules below. (57.614-5)

L. 1-5/8 in (.041 m)

History:
acquired before 1931
Notes:
Related earrings are in the Newark Museum (accession numbers 50.1721 a-b; D. L. Carroll, "Ancient and Exotic Jewelry in the Museum's Collections," *The Museum,* Newark, n.s. 19, 1967, p. 19, fig. 20)

Pair of Earrings 304

Roman, 2nd or 3rd century A.D.

The ear wire has a convex shield dotted with a granule and edged with beaded wire. The pendant has a cluster of hollow balls dotted with granules and connected by a hollow tube to the ring attachment. All made of gold. (57.616-7)

L. 1-1/4 in and 1-3/8 in (.036 m and .037 m)

History:
acquired before 1931
Notes:
Similar pendants occur on earrings from South Russia in the Decorative Arts Museum, Prague (I. Ondřejová, "Beiträge zum antiken Schmuck," *Acta Universitatis Carolinae-Philosophica et Historica,* 1970, p. 115, nos. 14-15, fig. 3), and on a pair of earrings in the Brooklyn Museum (accession number 05.466.1-2).

Pair of Earrings 305

Roman 2nd or 3rd century A.D.

A convex shield covers the ear wire formed by four wires twisted together. The extremities are merged together to fashion a hook and eye clasp. The rigid pendant has a corrugated tube as its core. The upper section pierces two rectangular sheets kept apart by twelve struts of beaded wire. The lower section is flanked by four strips coiled at each end, their outer edges lined with beading. The strips are separated at the top by four balls, and joined at the bottom by one, all dotted with granule clusters. These gold earrings are exceptionally heavy. (57.1520-1)

L. 1-5/8 in and 1-3/4 in (.041 m and .044 m)

History:
acquired before 1931
Notes:
At least two similar earrings formerly in the de Clercq-Boisgelin collection are said to come from the eastern Mediterranean, one "from Gebel" the other, "from Tortose" (A. de Ridder, *Collection de Clercq*, catalogue vol. VII; premier partie: *Les Bijoux*, Paris, 1911, p. 101, nos. 559-560, plate III).

Pair of Earrings 306

Roman, 2nd or 3rd century A.D.

The gold earrings are similar to no. 305. The wire hoop has a beaded, tear-drop shield set with a conical garnet. The "vase" or "lantern" shaped pendant is made of two hollow hemispheres slipped over a cylindrical core and kept apart by nine struts of twisted wire. Granules dot the sheet gold; "handles" ornament the tube below the ring attachment. (57.1545-6)

L. 1-5/16 in (.033 m)

History:
acquired before 1931

Earring 307

Roman, 3rd century A.D.

In this gold earring the ear wire is largely concealed by a convex disk of openwork with cut out triangles and crescents surrounding a pearl threaded across a cavity at the center. On the back two struts in a cruciform arrangement support the ear wire. The crossbar engages three pendants once set with conical stones: the left red garnet is probably original, the center one modern, the right is missing. Below, a faceted green bead is flanked by two pearls. (57.1675)

L. 1-7/16 in (.037 m)

History:
collection of Henry Walters before 1931; Mrs. Henry Walters; purchased from Joseph Brummer, 1941
Notes:
Earrings with similar cut out disks have been found at Villardu, near Lyons, France (Greifenhagen, *Berlin II*, p. 63, plate 50:3), at Pleven, Bulgaria (*Arkheologiya*, 1973, part 2, p. 51, fig. 4), and elsewhere in contexts datable to the 3rd century A.D.

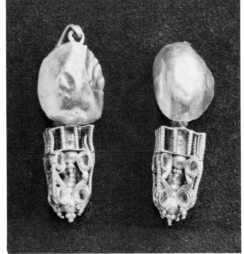

305

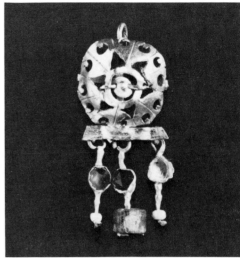

307

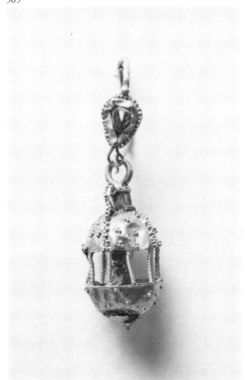

306

Three types of necklace were predominant in the Roman period: 1) necklaces of multiple gold leaf ornaments linked together; 2) necklaces of colored stones, either pierced and threaded on gold links or set in mounts which were secured together; 3) necklaces in the form of tightly braided or open loop chains, with openwork wheels or more ambitious relief medallions as part of the hook and eye clasps. Threaded beads were sometimes introduced as isolated elements in necklaces of the first and third types (no. 325).

Emerald beads, hexagonally faceted, were usually linked directly to one another (nos. 282, 311). Garnets and other stones such as obsidian and carnelian, cut with fourteen sides (double cubes with beveled corners), were strung with sets of links, or a flattened link having a particular shape such as a "knot of Herakles" or square knot (no. 322). Beads of this distinctive cut were introduced as early as the 1st century B.C. and lasted until at least the mid-3rd century A.D.

Most pendants on chain necklaces were probably considered gold luck charms, though of course pendant gold coins were a display of material wealth (no. 328). The pendants ran free or were fastened to a link. Medallions with heads of Medusa boldly rendered in repoussé relief served as *apotropaic* or evil-averting devices. A lady in a portrait from the Fayuum, now in the British Museum, seems to be wearing such a medallion.

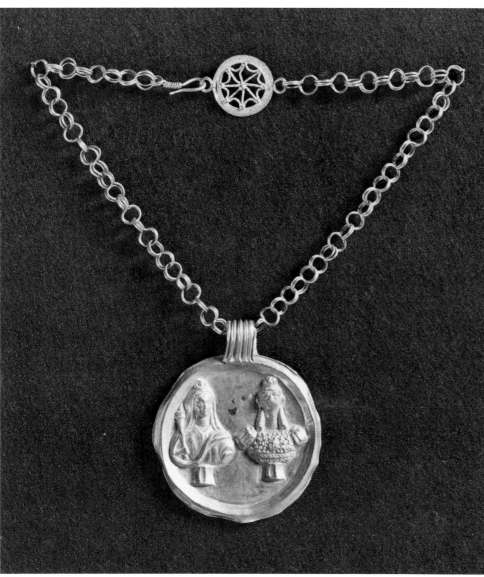

308

Necklace and Pendant 308

The Necklace: 1st or early 2nd century A.D.
The Pendant: 1st century B.C.?

The links of the chain of this gold necklace are double loops, pinched and given a 90° turn at the center. An openwork disk, fashioned as a wheel with twisted wire spokes and dotted with granules, forms part of the hook and eye clasp. The gold pendant, which may not have originally belonged with the necklace, shows in repoussé relief two Egyptian deities in Graeco-Egyptian guise, both represented as sculptured busts on pedestals: Isis as Demeter with a crescent emblem on her veil and carrying a torch; Haroeris ("The Elder Horus") as a falcon-headed man wearing the armor of a Roman legionary, including a breast plate sporting the face of Medusa. (57.539)

L. of necklace 14-1/2 in (.368 m)

Max. D. of medallion 2-11/16 in (.068 m)

History:
acquired before 1931
Notes:
A comparable necklace in the British Museum came from a 2nd century A.D. context at Backworth, England (*BMCJ*, p. 318, no. 2738, plate LXI; Pfeiler, *Römischer Goldschmuck*, p. 71, plate 19), while another in Athens, found at Eleutheropolis, Palestine, should date prior to A.D. 138 (*JIAN*, 10, 1907, plate VII:2). A comparable pendant showing Aphrodite on a goat was excavated in a late 2nd or early 1st century B.C. context at Delos (*BCH*, 89, 1965, plate XXIII:c-d; *BCH*, 92, 1968, pp. 557-564). Isis and Haroeris on the Walters pendant were considered healers and saviors suggesting that the object was a good luck charm.

Pendant 309

Roman, 1st century B.C.

A bust of the Graeco-Egyptian deity, Zeus-Serapis, whose colossal statue by the Greek sculptor Bryaxis for the Serapeion at Alexandria inspired a host of spin-off representations, is shown here in gold repoussé relief. The image is framed by a thick wire hoop terminating at the bottom in a pair of globules. A corrugated tube allowed the pendant to be strung on a necklace. (57.1524)

Max. D. 1-3/4 in (.044 m)

History:
acquired before 1931
Publications:
Brooklyn Museum, *Pagan and Christian Egypt*, January 23 - March 9, 1941, no. 129
Notes:
A pendant of comparable design showing Aphrodite on a goat was excavated in a 2nd century B.C. context at Delos (*BCH*, 92, 1968, pp. 565-566, fig. 23). The frame is a shorter crescent terminating in globules, the horns are farther apart than are the ends of the hoop on the Walters pendant.

Pendant 310

Roman, 1st century A.D.

A gold pendant in the form of a round box. The centerpiece, worked in repoussé, shows a bull felled by a lion and lioness. Details of the animals are chased. The side of the pendant has a broad wire braid and is edged with twisted wire. The swivel ring must have served for suspension, but the function of two strip-metal loops on the back is unclear. (57.587)

H. 3/8 in (.009 m) D. 1-1/8 in (.029 m)

History:
acquired before 1931
Notes:
A Roman date is suggested by the braided wire which occurs on other Roman jewelry (Pfeiler, *Römischer Goldschmuck*, plates 8, 10:2, 17; Museum of Fine Arts, *Pompeii A.D. 79*, Boston, 1978, vol. 2, p. 132, no. 40).

309

310

311

315

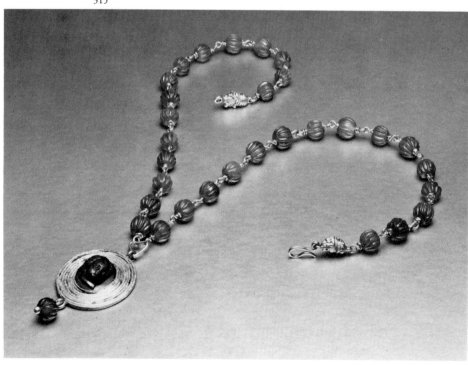

312

Necklace 311

Roman, 1st century A.D.

As presently constructed the gold necklace must be considered a pastiche. The linked green stones are from one ancient necklace, the flattened links from another, the pendant probably from a third. The hook and disk clasp, however, may well belong to the flattened links. (57.525)

L. 14 in (.356 m)

History:
acquired before 1931
Notes:
A necklace in the Benaki Museum, Athens, combining seven green stones with a chain of flattened links is perhaps also a pastiche (Berta Segall, *Museum Benaki Athen. Katalog der Goldschmiedearbeiten,* Athens, 1938, pp. 92-3, no. 109, plate 31).

Beads Strung as a Necklace 312

Roman, 1st century A.D. ?

The necklace is a pastiche. The carnelian beads are ancient and strung on modern gold links. The lion-head finials comprising the hook and eye clasp are reused from Greek earrings. The child's head boldly carved in a carnelian stone is set in a gold setting, which may or may not be ancient. (57.1864)

L. 21-3/16 in (.537 m) D. of medallion 1-1/4 in (.031 m)

History:
purchased from Hugo Weissmann, Boston, 1957
Publications:
Dorothy Kent Hill, "An Ancient Necklace," *BWAG,* IX:7, April 1957
Notes:
Related to the pendant is a boy's head carved in high relief on a carnelian dated to the 1st century B.C. in Oxford (J. Boardman and M.L. Vollenweider, *Catalogue of the Engraved Gems and Finger Rings,* Ashmolean Museum, Oxford, 1978, pp. 104 ff., no. 358, plate LIX).

Two Necklaces 313

Roman, 1st and 2nd century A.D.

As presently assembled, the gold necklace is a pastiche. One half is formed by a loop-in-loop chain with corrugated collars and a pendant crescent. The other half has flattened links bent double and pinched. Linking the two are a pair of lyre-volute attachments and a button disk edged with plain and beaded wire, which do not necessarily belong to either necklace. (57.1542)

L. of loop-in-loop chain 12-1/2 in (.316 m)

L. of flattened link chain 13 in (.33 m)

History:
acquired before 1931
Notes:
Flattened links of this type are found on a chain from Herculaneum in Naples (Breglia, *Napoli,* no. 490, plate 31:1); button disks appear on necklaces from Pompeii (Breglia, *Napoli,* nos. 504 and 480, plate 32:2, 4) and on a bracelet from Naucratis, Egypt in the British Museum, dated to the 1st century A.D. (Pfeiler, *Römischer Goldschmuck,* p. 72, plate 14:2); the loop-in-loop chain necklace appears to be later in date.

Necklace 314

Roman, 1st or 2nd century A.D.

The gold necklace has a quadruple loop-in
loop braided chain with corrugated collars.
As openwork disk, edged with two twisted
square wires, is filled with square wires
arranged in spiral designs. Granules dot the
spirals. A pendant has a hexagonal green
stone bead threaded below a corrugated
tube. (57.517)

L. 14-5/8 in (.371 m)

History:
acquired 1913
Notes:
Similar necklaces are in the British Museum (*BMCJ,*
no. 2720, plate LVIII and no. 2735 - Pfeiler, *Römischer
Goldschmuck,* plate 12); a similar bead pendant occurs
on a necklace in the Medieval Department of the Metro-
politan Museum of Art (accession no. 17.190.1643; W.
Dennison, *A Gold Treasure of the Late Roman Period,*
University of Michigan Studies, vol. XII, Studies in Early
Christian Art, part II, 1918, p. 101).

Necklace with Medallion 315

Roman, 2nd century A.D.

Flattened gold links, folded double and
pinched at one end, form the chain. The gold
medallion features a Medusa head done in
repoussé relief. The head is framed by a
separately made ring, its join to the relief
partially concealed by a continuous chevron
pattern, fashioned from corrugated strips.
Four hollow hemispheres dot the border.
(57.523)

D. of medallion 2-5/8 in (.067 m)

History:
acquired before 1931
Publications:
Dorothy Kent Hill, "Mass Production in Antiquity, its
Significance for the Modern Collector," *Gazette des
Beaux Arts,* series 6, vol. 25, February 1944, pp. 65-76,
ill. page 71
Notes:
An almost identical medallion was once in the London
art market (sale, London, Sotheby & Co., November
26, 1968, lot 58). Other large medallions are in the
British Museum (Higgins, *Greek and Roman Jewellery,*
plate 57:B), and the Royal Ontario Museum, Toronto
(*Bulletin of the ROM,* 1953, 31, no. 58, plate 10).

Necklace with Medallion and Pendant 316

Roman, 2nd century A.D.

The necklace has a loop-in-loop chain of
squared appearance, enhanced by square
corrugated collars. The medallion, edged
with beaded and plain wire, features a Medusa
head. The pendant is in the form of a bust
of the Graeco-Egyptian deity, Isis. All are
made of gold. (57.521)

L. 13-3/4 in (.349 m)

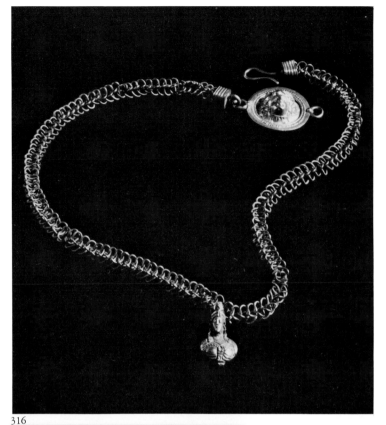

316

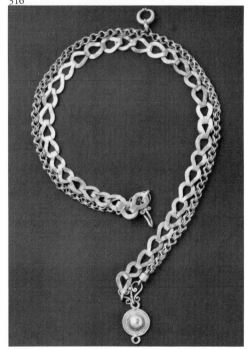

313

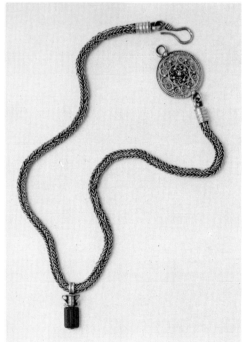

314

History:
collection of F. G. Hilton-Price
Publications:
A Catalogue of the Egyptian Antiquities in the Possession of F. G. Hilton-Price, London, 1897, p. 115, no. 1178, ill. opposite page 116

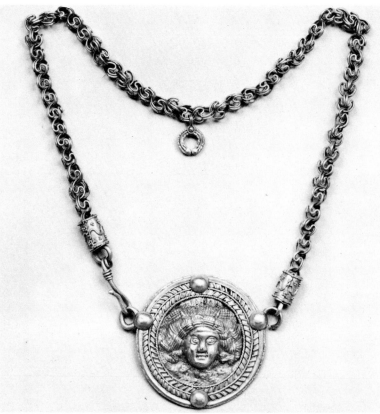

317

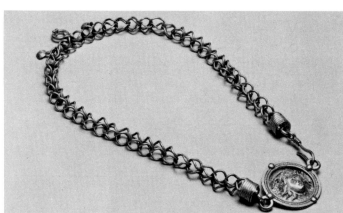

318

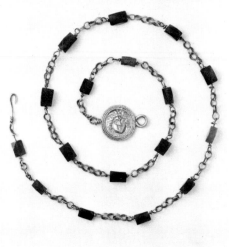

319

Necklace and Medallion 317

Roman, 2nd century A.D.

The gold necklace has intentionally bent figure-eight links. The collars are ornamented with wire and granulation. A gold crescent pendant is secured to one of the links. The medallion features a winged head of Medusa done in repoussé relief. The head is framed by a ring of twisted square wire and a chevron pattern formed by a ring of plain wire flanked by corrugated strips. Four hollow hemispheres dot the border. The workmanship is rather coarse. (57.520)

L. 16-1/4 in (.411 m) D. of medallion 1-7/8 in (.048 m)

History:
purchased from Khawam, Cairo, 1929

Necklace and Medallion 318

Roman, 2nd century A.D.

The gold necklace has an open, loop-in-loop chain with corrugated collars. Three tiny gold pendants are looped into links of the chain: a crescent flanked by two pendant busts of the Graeco-Egyptian deity Isis. The medallion features a head of Medusa, wings in her hair, done in gold repoussé relief. Framing the head is a border of plain and beaded wire dotted with four granules. (57.516)

Max. L. with medallion 15-1/16 in (.382 m)

D. of medallion 1-1/16 in (.027 m)

History:
purchased from Dikran Kelekian; said to be from Fayuum, Egypt
Notes:
A similar medallion was once in the New York art market (sale, New York, Sotheby Parke Bernet, November 20-21, 1975, lot 654). The chain is similar to that of a necklace in the British Museum (*BMCJ*; no. 2736, plate LX).

Necklace 319

Roman, 2nd century A.D.

The gold necklace has seventeen polygonal garnets graduated in size, each stone alternating with two figure-eight links. A disk, forming part of the hook and eye clasp, features a Medusa head in repoussé relief. (57.1555)

L. 17-3/16 in (.437 m)

History:
acquired before 1931

Necklace 320

Roman, 2nd century A.D.

Twelve polygonal garnets and two cylindrical ones alternate with groups of figure-eight gold links. The palmette ornament between the hook and eye clasp, though ancient, does not belong to the necklace; nor does the "peach-pit" pendant. (57.1557)

L. 16 in (.406 m)

History:
acquired before 1931

Necklace 321

Roman, 2nd century A.D.

Twelve polygonal beads of a milky green stone alternate with sets of flattened gold links. (57.1554)

L. 14-3/4 in (.375 m)

History:
acquired before 1931

Necklace 322

Roman, 2nd century A.D.

The gold necklace has eighteen flattened "Knot of Herakles" links, alternating with hexagonal green stones and spherical blue beads, some of which are missing. A red sard stone, set in a crimped gold setting shows in intaglio the bust of a youth. The gold disk shows Eros leaning on an arrow near Aphrodite, who crouches as she does in the statue by the Greek sculptor Doidalsos. Neither the sard nor the disk need have belonged originally to the necklace. (57.1549)

L. 15 in (.38 m)

History:
acquired before 1931
Notes:
Flattened, "Knot of Herakles" links occur on another necklace in the Walters (no. 323) and on a necklace in the British Museum from Tortosa, Syria (*BMCJ,* p. 316, no. 2730, plate LX).

Necklace 323

Roman, 2nd century A.D.

Fourteen polygonal beads of obsidian (?) alternate with flattened, "Knot of Herakles" gold links. A pomegranate-like pendant of carnelian is threaded at the center. The lyre-volute member of the hook and eye clasp is modern. (57.1556)

L. 14 in (.355 m)

History:
acquired before 1931
Notes:
see no. 323

320

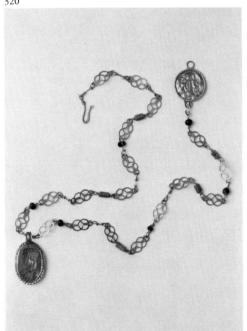

322

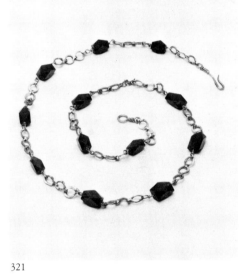

321

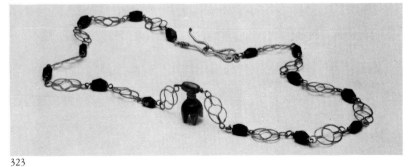

323

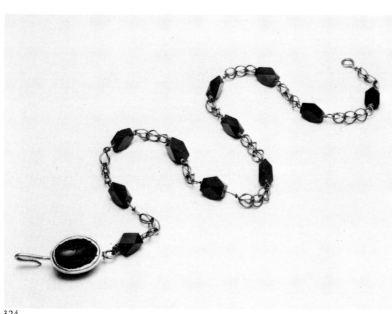

324

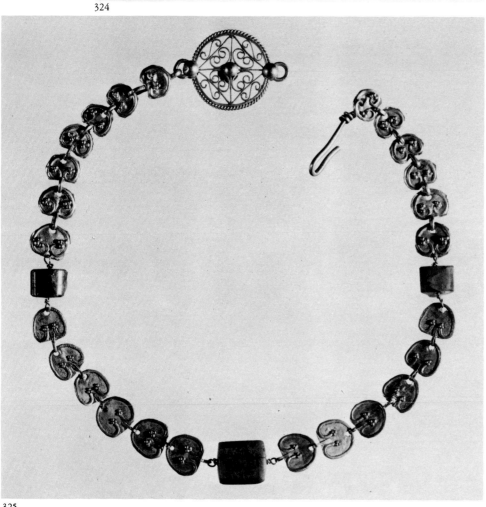

325

Necklace 324

Roman, 2nd century A.D.

Eleven polygonal beads of red carnelian strung on modern gold links. The hook of the clasp features a carnelian showing in intaglio Athena and Hermes. (57.1550)

L. 14 in (.355 m)

History:
acquired before 1931

Necklace 325

Roman, 2nd or 3rd century A.D.

Gold leaves, edged with flattened wire and dotted with clusters of granules are graduated in size and linked in groups with three green stone beads. An openwork disk, punctuated with three hemispherical caps, forms parts of the hook and eye clasp. (57.524)

L. 14-1/2 in (.368 m)

History:
acquired before 1931
Publications:
Byzantine Art, no. 427, plate LVIII
Notes:
Originally considered to be 5th or 6th century A.D. work, the necklace more likely dates from the 2nd or 3rd century A.D. Beads interspersed among gold elements of necklaces have an early history in Roman jewelry. A necklace from Orbetello, Italy (dated to the 1st century A.D. only because of the superficial resemblance of its leaves to those on a necklace from Pompeii) has leaves grouped with green glass prismatic beads (*NSc,* 1958, p. 42, fig. 10).

Nevertheless, isolated beads separated by short lengths of braided chain occur on necklaces from more firmly dated 2nd or 3rd century A.D. contexts, for example one from near Tyre, Lebanon (*Bulletin du Musée de Beyrouth,* XVIII, 89, F 401, plate XIX, 2nd or 3rd century), others in the British Museum from Beaurains, France (P. Bastien and C. Metzger, *Le trésor de Beaurains,* Wetteren, 1977, p. 165, plate IV, of the late 3rd century).

Necklace 326

Roman, 3rd century A.D.

The gold necklace has a loop-in-loop braided chain with serpent head terminals. The openwork disk, forming part of the hook and eye clasp, has a spoked center and several concentric zones of S volutes. It is edged with twisted wire and liberally dotted with granules. (57.515)

Total L. 25-1/8 in (.638 m)

D. of disk 1-9/16 in (.039 m)

History:
purchased from Khawam, Cairo, 1929
Notes:
Related necklaces are in the Royal Ontario Museum, Toronto (*Bulletin of the ROM,* 1953, p. 31, no. 61, plate 10), and formerly the Gans collection (Zahn, *Galerie Bachstitz,* no. 34, plate 9), the former said to be from Egypt.

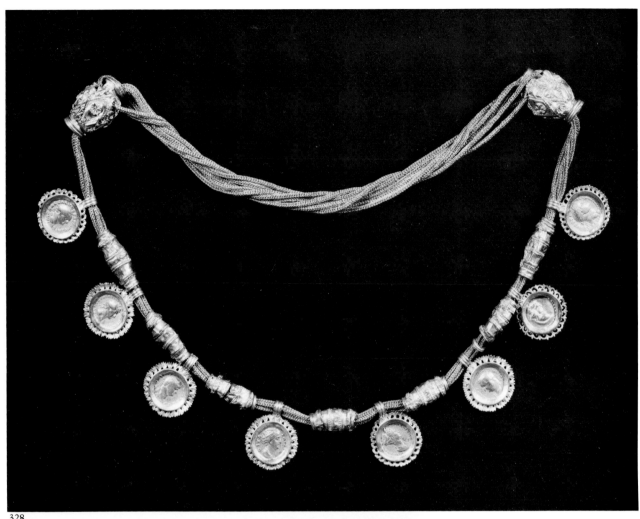

328

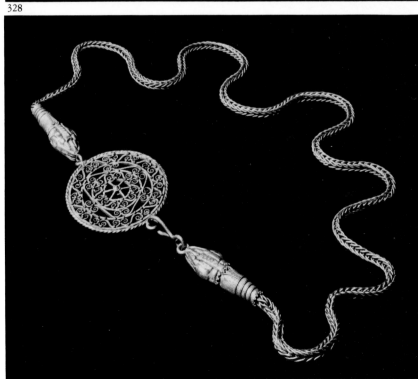

326

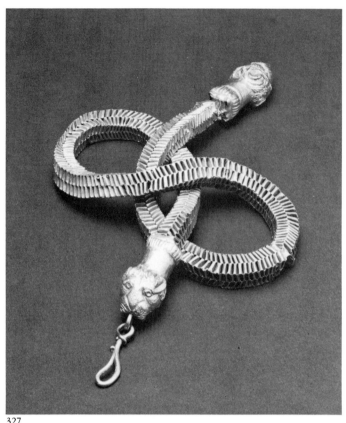

327

329

Necklace 327
Roman, 4th century A.D.

Four strips of gold foil are folded and continuously interlocked to form the flexible chain of this gold necklace. The lion head finials are modeled from single sheets. The novel method of folding gold foil is contemporary with the general acceptance of the codex format for manuscripts, which also involved folding sheets, instead of using the simpler roll. (57.588)

L. 16-1/16 in (.408 m)

History:
acquired before 1931
Publications:
Catalogue vente Rollin et Feuardent, June 9-10, 1898, (Tyskiewicz collection), 65, no. 176, plate XXI, said to have been bought by Auguste Salzmann at Macri (ancient Telmessos in Lycia, southwest Turkey)
Notes:
A necklace formerly in the Gans collection has a chain of identical construction (Zahn, *Galerie Bachstitz,* 11, no. 33, plate 8). Lion head finials of related design are found on a necklace formerly in a German private collection (Zahn, *Schiller,* no. 112, plate 58), and another from Carthage in the British Museum (O. M. Dalton, *Catalogue of early Christian Antiquities and Objects from the Christian East,* British Museum, London, 1901) both necklaces datable to the 4th century A.D.

Necklace with Pendant Coins 328
Roman, early 3rd century A.D.

The gold necklace is composed of four braided chains. They are gathered together and, after passing through two large beads, cross over to the opposite bead where the ends are secured. The ends of the chains are fitted through holes crudely punched into the sides of the beads and are fastened by buttons inside. The overlapping chains give the impression that part of the necklace has eight chains. The length of the necklace can be adjusted by sliding the chains through the beads, thereby altering the amount of overlap. Bringing the beads together lengthens the necklace; moving them apart shortens it. The beads are faceted and ornamented with rosettes, palmettes, and scallop shells. Collars keep the open ends from fraying.

Seven gold coins (*aurei*) are mounted in frames with cut-out borders; an eighth pendant, second from the right, is actually a pair of disks, or bracteates, set back-to-back to resemble a gold coin. Seven tubular spaces keep the pendants separated. The coins show the portraits of Vespasian, Nerva, Domitian, the Elder Faustina, Marciana, Vitellius, and (skipping the disk with busts of Luna and Sol) Vespasian again.

As Cornelius Vermeule has shown, the practice of mounting coins became increasingly common in the third century A.D. (Cornelius C. Vermeule, "Numismatics in Antiquity," *Swiss Numismatic Review,* 54, 1975, pp. 5-32). Inflation under the Severan emperors during this period and the result-

ing lighter weight of new coins caused the intrinsic value of the earlier and heavier *aurei* of the 1st and 2nd centuries to rise above their face value. Older *aurei* were prudently withdrawn from circulation and hoarded as bullion. For this reason and also because of their historic significance, they were occasionally mounted for display in jewelry as medals.

On the Walters necklace the coins range from Vitellius, A.D. 69, to the Elder Faustina, wife of Antonius Pius, deified after her death in A.D. 140-141. Hers is the least worn. The coins were probably mounted and the necklace made up in the early 3rd century. (57.1600)

Total L. 36 in (.914 m) D. of coin 1-1/16 in (.027 m)

History:
said to be from Egypt; collections of Adolph Schiller; Henry Walters before 1931; Mrs. Henry Walters (sale, New York, Parke-Bernet Galleries, May 2, 1941, lot 1313)

Publications:
Zahn, *Schiller,* no. 111, plate 61; R. Zahn, "Die Sammlung Schiller," *Pantheon,* 3, 1929, p. 130, ill.; *The Mrs. Henry Walters Art Collection,* New York, Parke-Bernet, 1941, p. 420, ill.; Christa Belting-Ihm, "Spätrömische Buckelarmringe mit Reliefdekor," *JRGZM,* 10, 1963, p. 108, footnote 44, plate 18:1-2

Notes:
A similiar necklace, in the Metropolitan Museum of Art, with five coins ranging in date from A.D. 168 to 227, is said to have been found at Memphis, Egypt (accession number 36.9.1; Cornelius C. Vermeule, 1975, pp. 16-18, no. 26, ill. nos. 2-3). Another with four coins ranging in time from ca. A.D. 140 to 238 is in the Kunsthistorische Museum, Vienna (Robert Forrer, *Reallexikon,* 1907, p. 518, plate 134:1). Yet another with similar quadruple chains, a pair of beads, and spacers, but without pendant coins was found in association with 3rd century unmounted coins in the Hadra cemetery, Alexandria, giving credence to the alleged Egyptian provenances of the Walters and Metropolitan necklaces (E. Breccia, in *Le Musée Gréco Romain,* 1925-1931, 29, plate XXI, fig. 78). A quadruple chain, two beads, and spacer without mounted coins is in a private collection in Germany (*Antiken aus Rheinischem Privatbesitz,* Bonn, 1973, p. 257, no. 414, plate 185). Three mounted coins of the Valerians, senior and junior of the years 254-256 and two beads but no chains, found at Rabakovacsi, Hungary, are in the National Museum, Budapest (E. B. Thomas in *Studien zur Geschichte und Philosophie des Altertums,* ed. J. Harmatta, Budapest, 1968, pp. 343-346, figs. 7 and 9).

Three Spacers from a Necklace 329
Roman, 3rd century A.D.

The three gold profiled tubes served as spacers on a necklace similar to no. 328 to keep the pendants separate from one another. Two are paired, one is a singleton. The smooth areas seem to have been worked on a lathe; the patterns are chased. No seams are visible. (57.602, 57.604, 57.605)

L. 1-3/16 in, 1-15/16 in, 2 in (.03 m, .05 m, .051 m)

History:
acquired before 1931

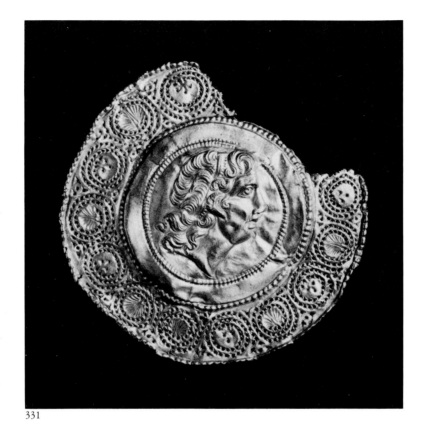
331

Belt or Gorget 330
Roman, mid-4th century A.D.

A magnificent gold medallion of Constantius II (337-361) is mounted in an openwork frame. The Emperor wears a cloak over his cuirass, pinned at the shoulder by a fibula, and a jeweled diadem with tassels like those on the medallion's frame. He holds an orb with the figure of Victory offering a wreath. The inscription reads DN CONSTANTIUS MAX AUGUSTUS (Dominus Noster, Constantius, Maximus Augustus), "Our ruler Constantius, greatest Augustus." On the reverse, the Emperor stands as charioteer in a six horse chariot and is offered wreaths by two Victories. The inscription reads DN CONSTANTIUS PF AUGUSTUS (Dominus Noster, Constantius, Pius Felix Augustus), "Our ruler, Constantius, patriotic, blessed Augustus." In the exergue, under the chariot, is an assemblage of wreaths, palm branches, and bags of coins, flanked by the letters MN, mint marks of the city of Nicomedia in Asia Minor. Joined and secured in modern times by a quintuple link strap (on the analogy of a short length of similar strap on the right of the medallion) is a mounted gold *aureus* of the elder Faustina. (57.527)

D. of Constantius medallion 3-3/16 in (.8 m)
L. of belt 7-1/2 in (.19 m)

Publications:
J. M. C. Toynbee, *Roman Medallions, Numismatic Studies,* 5, 1944, p. 119, n. 49, p. 173, n. 57, plate XXI; *Byzantine Art,* no. 421, plate LIX; *The Bulletin of the Cleveland Museum of Art,* 34, 1947, ill. page 223; Glanville Downey, "The Art of New Rome in Baltimore," *Archaeology,* I, 1948, p. 23, fig. 7; Philippe Verdier, "The Riches of Byzantium," *Apollo,* 84, December 1966, ill., page 459; Cornelius C. Vermeule, "Numismatics in Antiquity," *Swiss Numismatic Review,* 54, 1975, p. 28, no. 53

Pendant 331
Roman, 4th century A.D.

The upper border and attachment that once secured this gold pendant to a necklace are missing. A diademed portrait of Alexander the Great framed by two beaded mouldings is shown in repoussé relief. Surrounding the portrait is a wreath border made by punching through the gold sheet with a sharp tool. The edge is rolled back and crimped to form beading. Alexander wears around his ear the ram's horn of Ammon. This Egyptian god, who was equated by the Greeks with Zeus, had a cult and oracle at the Siwa oasis in eastern Libya. Alexander visited the place, and some ancient writers say he was even deified by the oracle thus accounting for the many portraits showing him with the ram's horn attribute. (57.526)

D. 3-11/16 in (.094 m)

History:
purchased from Dikran Kelekian, 1928
Publications:
S. P. Noe, "Bibliography of Greek Coin Hoards," *Numismatic Notes and Monographs,* no. 78, New York, 1937, p. 14, no. 6; M. C. Ross, "Notes on Byzantine Gold and Silversmith's Work," *JWAG,* 18, 1955, pp. 63-65, fig. 9
Notes:
The Walters medallion recalls three pendants now divided between the Louvre and the Dumbarton Oaks collection, Washington, D.C., each with a gold coin of the 320's and with an openwork wreath border (sale, London, Christie, Manson & Woods, October 19, 1970, among lots 197-200; Cornelius C. Vermeule in the *Swiss Numismatic Revue,* 54, 1975, pp. 27-28, ill. 9). Similar openwork occurs on a pair of 4th century bracelets divided between the St. Louis Art Museum and the Berlin Museum (Greifenhagen, *Berlin I,* fig. 62 and plate 55:7), and on another bracelet of this date in the British Museum (*BMCJ,* no. 2817, plate LXV).

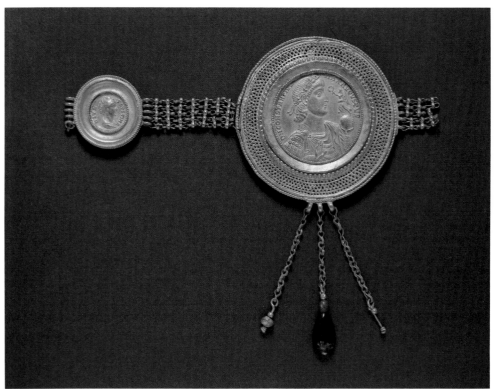

330 front

Bracelets 332-336

Two kinds of Roman bracelets were developed from versions used earlier in the Greek world: solid hoop bracelets in the form of serpents (no. 332), frequently seen on Roman funerary portraits from the Fayuum, and perhaps originally a Ptolemaic specialty; and hinged, strap bracelets of the sort exemplified by the pair from Olbia (no. 283). Instead of being made of a solid bar, hoops were also fashioned from a number of hollow tubes spirally wound together and capped at each end with serpents' or lions' heads (no. 335). On some examples a mounted stone is displayed between the heads. On others the mounted stone stands alone without head finials; a Roman mosaic from Antioch shows a servant girl bringing a pair of such bracelets on a tray to her mistress (*AJA,* XLII, 1938, p. 213, fig. 8).

Other varieties of Roman bracelets, including those fashioned from simple chains, from gold links, or from mounted stones linked together, are not represented here.

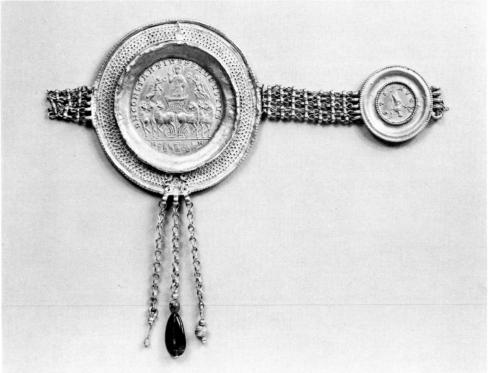

330 back

Two Bracelets 332
Roman, 1st century A.D.

The gold bracelets are in the form of serpents, heads and tails modeled in a life-like manner, with skin indicated by cross-hatching, but the rest of the hoop left plain. Leaf-shaped ornament and clusters of dots mark the termination of the cross-hatching. The bracelets are not a matched pair: one (57.529) is heavier, having a thicker rod for the loop, and a looser cross-hatched pattern. (57.528-9)

57.528 Inner D. 2-9/16 in (.065 m) Outer D. 3-1/4 in (.082 m)

57.529 Inner D. 2-3/8 in (.06 m) Outer D. 3 in (.077 m)

History:
acquired before 1931
Notes:
Pairs of similar bracelets have been found at Pompeii,
(Breglia, *Napoli,* nos. 831-832, plate 36:6 and II), and
at Boscoreale near Pompeii (Foundation Piot, Monu-
ments et Mémoires, 5, 1899, pp. 265-267, nos. 110-111,
fig. 57); other examples are in the British Museum
(Higgins, *Greek and Roman Jewellery,* p. 187, plate
61:E), the collection of Norbert Schimmel (O. M. Mus-
carella, ed., *Ancient Art, The Norbert Schimmel Col-
lection,* 1974, no. 71, ill.), and the Benaki Museum,
Athens (Berta Segall, *Museum Benaki Athen, Katalog
der Goldschmiedearbeiten,* 1938, pp. 115 ff., nos. 171-
174, plates 37-38).

Pair of Bracelets 333
Roman, 1st century A.D.

The gold bracelets are in the form of cursorily
rendered serpents. The hoops are flattened
depriving the reptiles of the life-like ap-
pearance of no. 332. Skin is indicated on the
outer, angled surface of the bracelet by cross-
hatching, and on the inner chamfered edges
by chevrons in imitation of the natural
appearance of a serpent's body. (57.534-5)

Max. D. 2-3/4 in and 2-13/16 in (.071 m and .072 m)

History:
collection of Giovanni Dattari (sale, Paris, Hôtel
Drouot, June 17-19, 1912, lot 573)
Publications:
Collection Jean Lambros et Giovanni Dattari, Paris,
1912, p. 62
Notes:
Bracelets of this flattened design were also made with
a serpent's head at each end (Zahn, *Schiller,* p. 87, plates
48-49 - Munzen und Medaillen Auktion, XVIII, Novem-
ber 29, 1958, lot 160).

Pair of Bracelets 334
Roman, 1st century A.D.

The extremities of the hoops take the form
of cursorily rendered serpents. Their heads
are boldly modeled; the skin is indicated on
the outer, angled surface by cross-hatching
only behind the head and at the undulating
tail. The inner faces of these gold bracelets
are flat and undecorated except for a few
cross strokes toward the heads. The small
size would be appropriate only for a child.
(57.536-7)

Max. D. 1-7/8 in and 2 in (.048 m and .05 m)

History:
collection of Giovanni Dattari (sale, Paris, Hôtel
Drouot, June 17-19, 1912, lot 573)
Publications:
Collection Jean Lambros et Giovanni Dattari, Paris,
1912, p. 62

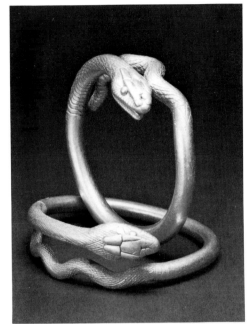

332

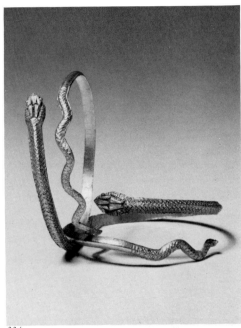

334

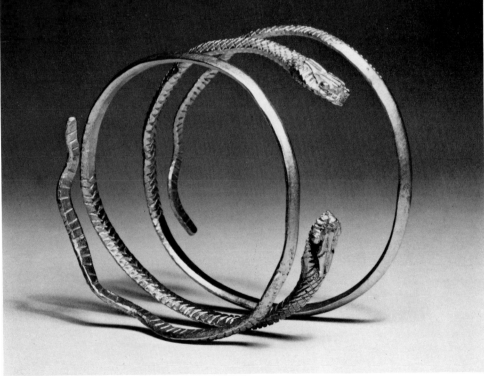

333

Bracelet 335

Roman, 2nd or 3rd century A.D.

The gold bracelet originally had two lion heads each biting one side of the ball that remains in the mouth of the preserved head. The hoop is formed by nine hollow tubes wound along a gold core. The ends are capped by a cylindrical collar with beaded mouldings. A toggle pin secures the collar to a similar collar in the back of the lion's head. (57.579)

Max. D. 3-5/8 in (.092 m)

History:
source not known, but probably from Egypt; acquired before 1931
Notes:
The location of the mate to this bracelet, once in the Kennard collection (Burlington Fine Arts Club, *Exhibition of the Art of Ancient Egypt,* London, 1895, p. 127, no. 81, plate 26; sale catalogue, Sotheby, July 16-19, 1912, lot 427, plate VII) and later in the Gans collection (Zahn, *Galerie Bachstitz,* no. 50, plate 15) is not known.

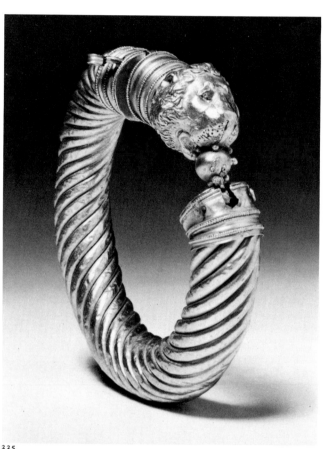

335

Bracelet 336

Roman, 1st century A.D.

The ends of the hollow gold hoop overlap and are secured to one another by lengths of wire issuing from the extremities which are coiled around the adjacent part of the hoop. (57.1088)

Inner D. 1-1/8 in (.029 m) Outer D. 2-7/16 in (.062 m)

History:
acquired before 1931
Notes:
A pair of similar bracelets is in Berlin (30219.502; Greifenhagen, *Berlin II,* p. 42, plate 36:3).

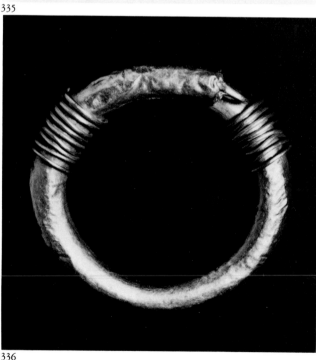

336

Rings 337-356

Rings were worn both by men and women on any finger except the middle, although the fourth finger of the left hand was the most favored. They served a variety of functions. Some had a practical use as signets whereby individuals sealed letters and documents such as wills with their own distinctive devices; others were a mark of dignity or rank, a custom apparently adopted from the Etruscans; for women rings might be a token of betrothal. Rings were also purely ornamental, and were often collected for the gems they displayed.

Such an extensive variety of rings has come down to us from the Roman world that it is difficult to mention more than a few basic kinds. Serpent rings, like serpent bracelets, are a legacy of the Greek world to early Roman taste (nos. 337, 338). Signet rings with a stone cut in intaglio and set into the bezel continued without abrupt changes in style from Greek versions (nos. 342, 343, 345). Sometimes the device was cut directly into the gold bezel of the ring (nos. 346, 347, 351).

Hoops were substantial (no. 347) or slender (no. 350). They could be round in section (no. 345) but more often the outer face was round (no. 342) or angled (no. 341) while the inner face was flat. In many rings of the 3rd century A.D. the lower part of the hoop was distinguished and set off from the broad shouldering of the upper part (no. 352). Rings were surely worn more constantly than other jewelry. Commenting on the natural wear of material things, the 1st century B.C. Latin poet and philosopher, Lucretius, observed that as the years go by the ring on the finger becomes thin beneath by wearing (*De Rerum Natura,* I, 312).

Ring in the form of a Serpent· 337
Roman, 1st century B.C. or A.D.

The inner face of the gold ring is flat allowing it to fit snugly against the finger; the outer face is slightly convex. The snake's skin is rendered at head and tail by curving rows of short strokes. Broader strokes mark features along the side of the head and at the very tip of the tail. The eyes are hollowed as if once inlaid with colored glass. (57.1539)

H. 1-7/16 in (.037 m) D. 3/4 in (.02 m)

History:
purchased from Michel Abemayor, 1930
Notes:
Comparable rings have been found at Pompeii, Naples Museum, Pfeiler, *Romischer Goldschmuck,* 28, plate 4:3) and Cyprus, Nicosia Museum (Angeliki Pierides, *Jewellery in the Cyprus Museum,* Cyprus, 1971, p. 44, plate XXIX:7). Another was once in a German private collection (Zahn, *Schiller,* no. 3, plate 51:3). Serpent rings of this general type flourished as far back as the 3rd century B.C.

Ring 338
Roman, 1st century A.D.

The gold ring has a serpent's head at each end of the hoop, the heads turned back against their necks. Skin and details of the heads are crudely indicated by short strokes and cross-hatching. (57.1538)

H. 1-1/8 in (.028 m) Outside D. 1 in (.025 m)

History:
purchased from Michel Abemayor, 1930

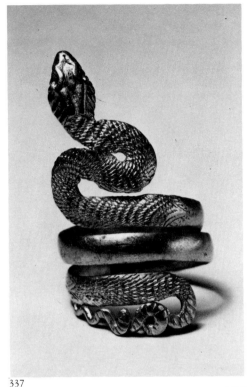

337

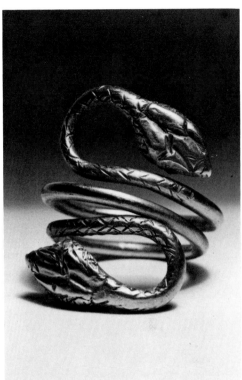

338

339 340

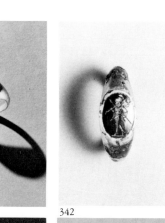

341

342

344

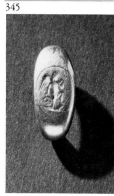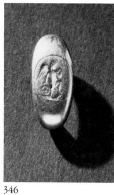

345

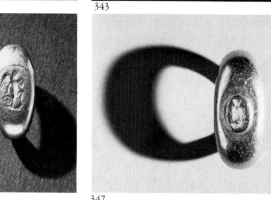

343

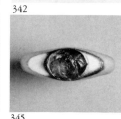

346

347

Ring 339

Greek or Roman, 1st century B.C.

The gold hoop is rounded on the outer face, flat on the inner; the shoulder is sloping, flared at the top, with the edges of the bezel turned in to secure the stone, a convex garnet. The intaglio design shows Nike holding a lyre. (42.143)

L. of bezel 5/8 in (.015 m) Inner D. 11/16 in (.017 m)

History:
collection of Morrison (sale, London, Christie, Manson & Woods, June 29, 1898, lot 258); purchased from Dikran Kelekian, 1909
Publications:
The Morrison Collection, London, Christie, Manson & Woods, June 29, 1898, p. 33
Notes:
for the general shape of the hoop and bezel compare a ring in the British Museum (*BMCR,* no. 398, plate XII)

Ring 340

Roman, 1st century A.D.

The gold ring has a slender hoop, rounded on the outer face, flat on the inner and a small oval bezel inlaid with a green stone. (57.1639)

Inner D. 5/8 in (.016 m)

History:
collection of Henry Walters before 1931; Mrs. Henry Walters; purchased from Joseph Brummer, 1941
Notes:
compare a ring in Berlin (Greifenhagen, *Berlin II,* plate 58:25-26)

Ring 341

Roman, 1st century B.C. or A.D.

The gold hoop is angled on the outer face, flat on the inner. The convex, oval bezel is one piece with the ring. Represented in intaglio is a crayfish or some other crustacean. (57.1605)

Inner D. 9/16 in (.014 m)

History:
collection of Henry Walters before 1931; Mrs. Henry Walters; purchased from Joseph Brummer, 1941
Notes:
Rings of this design but with convex stones set in the bezels are more common (e.g. British Museum, *BMCR,* no. 391, plate XII).

Ring 342

Roman, 1st century A.D.

The ring, fashioned of gold plated bronze, has an oval red stone set in the bezel. Represented in intaglio is the god of war Mars, wearing a crested helmet and carrying a spear and a trophy (captured armor on a pole). (57.1638)

Inside D. 5/8 in (.016 m) Outside D. 15/16 in (.023 m)

History:
collection of Henry Walters before 1931; Mrs. Henry Walters; purchased from Joseph Brummer, 1941
Notes:
Representations of Mars in this guise are common (e.g. Metropolitan Museum of Art, Gisela M. A. Richter, *Catalogue of Engraved Gems, Greek, Etruscan and Roman*, 1956, no. 296; *Ancient Gems from the Collection of Burton Y. Berry*, 1968, p. 65, no. 119).

Ring 343
Roman, 1st or 2nd century A.D.

The ring appears to be of gold foil wrapped over a light weight core. The carnelian intaglio gem, set flush with the face of the ring, shows Fortuna holding a cornucopia and a ship's steering oar. (57.1985)

Interior D. 11/16 in (.017 m) Exterior D. 1 in (.025 m)

History:
gift of Dr. and Mrs. Robert Fox, 1969; acquired by them in Istanbul

Ring 344
Roman, 1st century A.D.

A slender ring with a small bezel engraved with a palm branch. (57.1615)

Interior D. 7/16 in (.014 m)

History:
collection of Henry Walters before 1931; Mrs. Henry Walters; acquired from Joseph Brummer, 1941
Notes:
A similar ring in the National Museum, Belgrade is part of the Tekiya treasure (D. Mano-Zissi, *Les trouvailles de Tekiya*, Belgrade, 1957, p. 71, plate III:5)

Ring 345
Roman, 1st or 2nd century A.D.

The gold ring has an oval hoop, round in section, with an amethyst stone set into the bezel. Represented in intaglio are a leopard and Eros beside a krater. (57.1019)

Max. Interior D. 11/16 in (.018 m)

History:
said to be from Bath, England; collection of Newton-Robinson (sale, London, Christie, Manson & Woods, June 22, 1909, lot 124a); purchased from Dikran Kelekian, 1909
Publications:
Catalogue of the collection of engraved gems ... formed by Charles Newton-Robinson, London, 1909, p. 30
Notes:
Similar rings are in the British Museum (*BMCR*, no. 410, plate XII, no. 450, plate XIII)

Ring 346
Roman, 3rd century A.D.

The gold ring has an elliptical hoop, broadening at the shoulders, and a flat-topped oval bezel. Represented in intaglio on the bezel within an engraved circle is the figure of Eros holding a ball, one leg on a rock. A length of wire is coiled on the hoop. (57.1020)

Max. Interior D. 5/8 in (.016 m)

History:
purchased from Dikran Kelekian, 1911

Ring 347
Roman, 3rd century A.D.

The gold ring has a heavy elliptical hoop and a broad flat bezel with an oval ledge in the center. Represented in intaglio on the ledge is a bust of the Graeco-Egyptian deity, Zeus-Serapis. (57.1526)

Max. Interior D. 11/16 in (.018 m)

History:
acquired before 1931
Notes:
A ring of this general shape (but with a different bezel) in the British Museum was found at Tarsus, Turkey, together with coins of the early 3rd century A.D. (*BMCR*, no. 188, plate V).

Ring 348
Roman, 3rd century A.D.

The gold ring has an elliptical hoop, broadening at the shoulder, and a broad oval bezel. Within the bezel is a ledge with the representation of a lion and star inlaid in niello. (57.1527)

Max. Interior D. 5/8 in (.016 m)

History:
acquired before 1931
Notes:
A similar representation of a lion and star occurs on a ring in Berlin (Greifenhagen, *Berlin II*, plate 64:14).

Ring 349
Roman, 1st or 2nd century A.D.

A child's gold ring. The dotted Greek inscription reads ΑΥΞΑΝΕ, "grow." (57.1863)

History:
purchased from John Khayat, New York, 1956
Notes:
A gold ring with an inscribed bezel of similar shape came from a late 1st century A.D. tomb near Tyre, Lebanon (*Bulletin du Musee de Beyrouth*, XVIII, 81, F 426, plate XVIII). Others are in Berlin (Greifenhagen, *Berlin II*, p. 83, plate 61:12-13) and the Metropolitan Museum of Art (Gisela M. A. Richter, *Catalogue of Engraved Gems, Greek, Etruscan and Roman*, 1956, p. 120, no. 598, plate LXV).

Ring 350
Roman, 2nd or 3rd century A.D.

The gold ring has a thin flat band with a conical red stone set in the bezel. (57.1618)

Interior D. 9/16 in (.014 m)

History:
collection of Henry Walters before 1931; Mrs. Henry Walters; purchased from Joseph Brummer, 1941
Notes:
Rings of related design are in the Berlin Museum (Greifenhagen, *Berlin II*, plate 60:25-26) and the British Museum (*BMCR*, no. 785, plate XX).

348

349

351

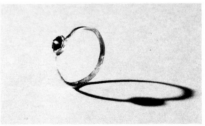

350

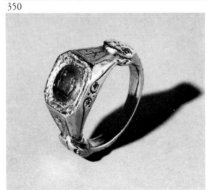

352

Ring 351

Roman, 1st century A.D.

The gold ring has a thin hoop and an oval bezel engraved with a dolphin. (57.1915)

Interior D. 5/8 in (.016 m)

History:
purchased from the collection of Fred Werther, 1962

Ring 352

Roman, 3rd century A.D.

Gold serpent heads back-to-back on the lower hoop grasp the massive polygonal shouldering of the upper part. A round carnelian intaglio is set flush in the square bezel. A torch and a trident are engraved on the outer faces of the shoulder, stems with leaves on the sides. The intaglio shows a reclining figure, possibly Dionysos. (57.1114)

Interior D. 3/4 in (.019 m)

History:
purchased from Dikran Kelekian, 1926
Publications:
Byzantine Art, no. 507
Notes:
Although no exact parallel is known, rings of this general design with polygonal shoulders are fairly common (e.g. British Museum, *BMCR,* no. 551, plate XVI).

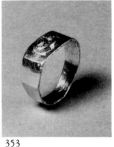
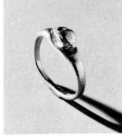

353 354

355

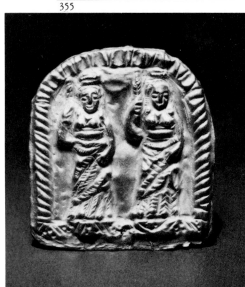

356

Ring 353

Roman, 3rd or 4th century A.D.

The gold ring has a flat, octagonal hoop with blue glass inlaid in a raised oval setting. (57.1606)

Interior D. 5/8 in (.016 m)

History:
collection of Henry Walters before 1931; Mrs. Henry Walters; purchased from Joseph Brummer, 1941
Notes:
Rings of this design are in the British Museum (*BMCR,* no. 822, plate XXI), Berlin (Greifenhagen, *Berlin II,* plate 60:3-4), and elsewhere (Higgins, *Greek and Roman Jewellery,* p. 191).

Ring 354

Roman, 1st or 2nd century A.D.

Slender hoop with an object represented almost in the round by gold foil over glass (?) on the bezel: a snail shell (?) or bird (?). (57.1616)

Interior D. 9/16 in (.014 m)

History:
collection of Henry Walters before 1931; Mrs. Henry Walters; purchased from Joseph Brummer, 1941

Wedding Ring 355

Roman, 3rd or 4th century A.D.

The hoop is a flat hexagonal gold band ornamented with openwork containing on the back a Latin inscription, DVLCIS VIVAS, "Live sweetly." The bezel is elongated in a fingernail-like projection, giving an indication of where it might have been worn. Two blue and white cameo stones are inlaid in raised settings, an oval one on the overhang with a splendid representation of a ship, and an almond-shaped one with a Greek inscription, EYTYXI, "Good Luck." (57.1824)

History:
said to have been found in France; collections of Alessandro Castellani (sale, Rome, March 17-April 10, 1884, lot 924); E. Guilhou (sale, London, Sotheby & Co., November 9, 1927, lot 406); Joseph Brummer (sale, New York, Parke-Bernet Galleries, May 12, 1949, lot 254); purchased 1949
Publications:
Catalogue vente à Rome, Alessandro Castellani Collection, March 17-April 10, 1884, ill., p. 120; *CIL,* XIII, 3, 1901, 631, no. 10024, 63 (the inscription); S. de Ricci, *Catalogue of a Collection of Ancient Rings formed by the late E. Guilhou,* Paris, 1912, p. 58, no. 439, plate VII; *Catalogue of the Superb Collection of Rings formed by the late Monsieur E. Guilhou,* London, Sotheby & Co., November 9, 1937, plate XIV; *Byzantine Art,* no. 501; *The Notable Art Collection...of the late Joseph Brummer,* New York, Parke-Bernet, May 12, 1949, p. 58, illus.
Notes:
Rings of similar design with wedding inscriptions are in the Musée d'Art et d'Histoire, Brussels and the Rothschild collection, Paris (*Archaeologia Aeliana,* 4 ser. XXVI, 1948, pp. 139-142, plate V:2-3). A simpler wedding band is in the Corbridge Museum, England (*Archaeologia Aeliana,* 4 ser. XIII, 1936, pp. 310-319, plate XXV).

Plaque 356

Roman, 3rd century A.D.

Two female figures holding torches, perhaps deities, are represented rather crudely in gold repoussé relief. There is a hatched border at the sides, cursory "egg-and-dart" pattern at the rounded top, and dotted zigzags at the bottom. A corrugated loop on the back served as the attachment. (57.530)

H. 1-7/16 in (.036 m) W. 1-3/8 in (.034 m)

History:
collection of Giovanni Dattari (sale, Paris, Hôtel Drouot, June 17-19, 1912, lot 575)
Publications:
Collections Jean Lambros et Giovanni Dattari, Paris 1912

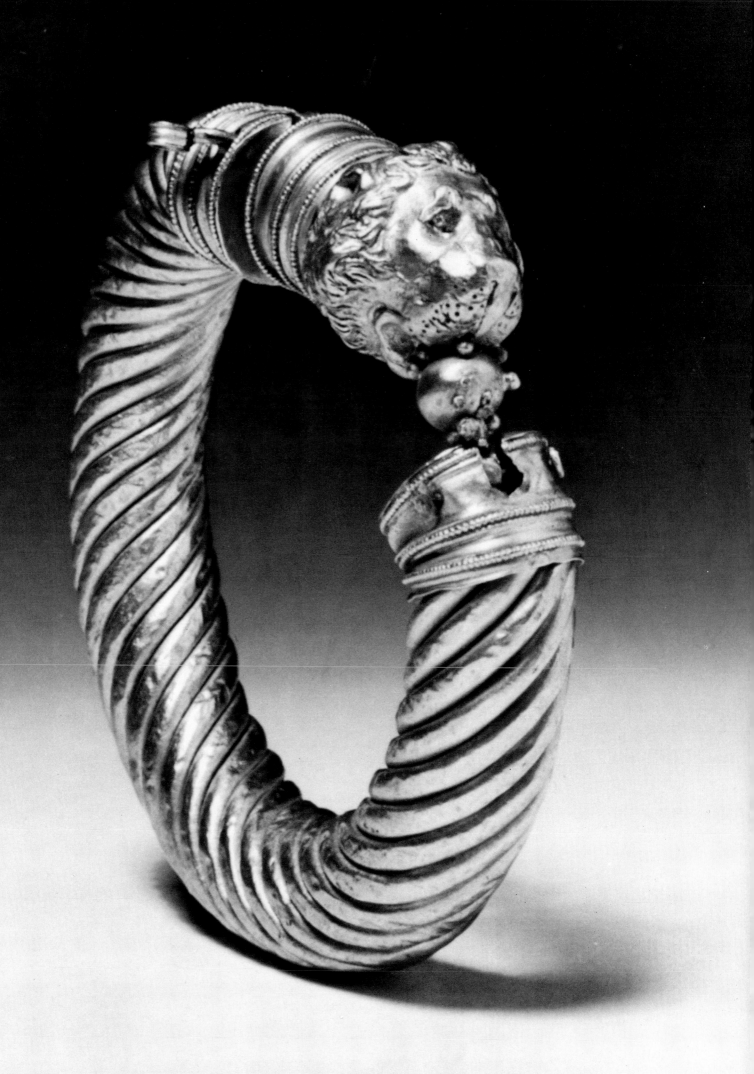

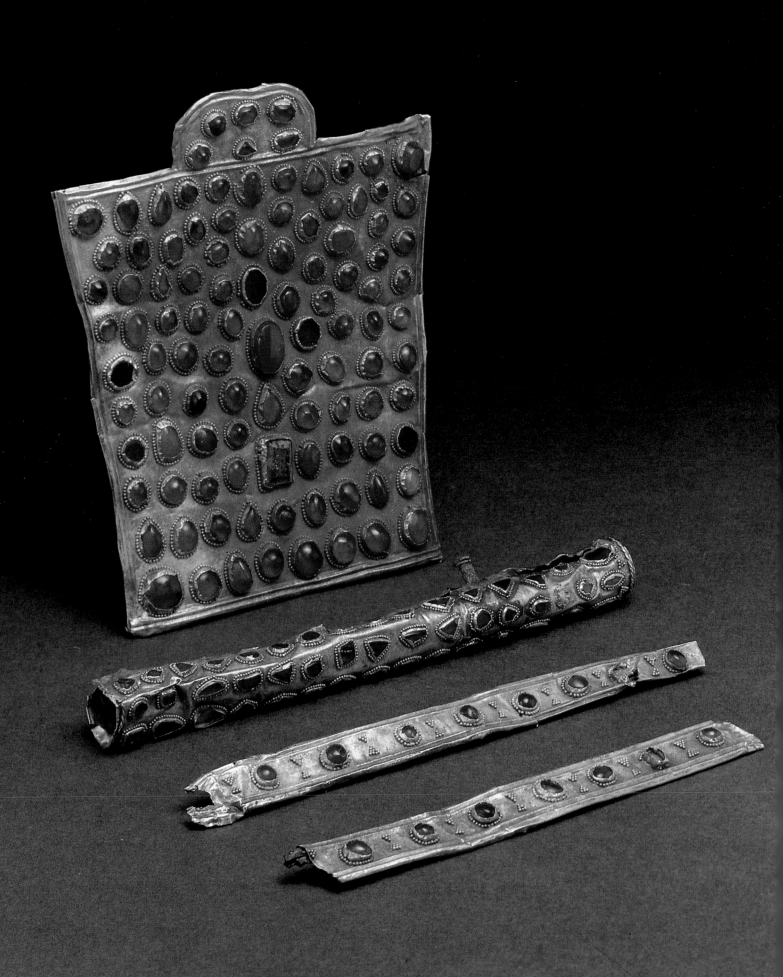

Migration Jewelry

The hordes of Asian horsemen that overran the Roman Empire were originally a mixture of agricultural and nomadic herding tribes. Their way of life necessitated carrying their wealth with them and wearing it as a badge of rank. Hence jewelry became both a practical means of decoration and an indication of wealth and position. The ultimate explosion of migrations in the 4th century, caused the agrarian peoples to imitate their herding neighbors, and, for a period of centuries, jewelry became the bullion, the badge of office, and the normal ornament of the Huns, the Goths, the Vandals, and the many other tribes of central and western Asia who were gradually forced from their lands and turned towards the fertile areas of Europe.

The descent of the Huns from Central Asia in the 4th century was the major force which compelled the tribes located north of the Black Sea, in west Russia, and in eastern Europe to begin a series of migratory wars that continued until the 10th century. The pressure of tribe against tribe caused the ultimate breakdown of all the frontiers of the Roman Empire, as well as a complex history of tribal alliances, warfare, and treachery.

The earlier systems of political checks and balances of the Romans both in the east and west had kept the Germans out of Gaul and the Asian tribes in relatively settled areas beyond the limits of the eastern empire. Trade with Roman colonies north of the Black Sea brought the nomadic horsemen into contact with Graeco-Roman jewelry traditions, and allowed them to set up standard trade routes with India to acquire garnets, almandines, and other precious stones to create their ornaments. By the time of the attacks of the Huns, the major tribes such as the Avars, Goths, Alans, Sarmations, Burgundians, and Lombards had all established traditions of ornament and jewelry. It decorated their horses and themselves in daily life and was carefully buried with them in their graves.

Our modern knowledge of these great tribal migrations is in part based on the great sagas and epic poems of oral literature, but more solidly depends on the excavations of thousands of graves across Europe. Traces of a powerful tribe like the Visigoths may be followed from south Russia, then into Rumania and Greece, over into Italy, down the west coast and up the eastern one, across southern France, where the tribe remained for the larger part of a century, and finally into Spain, where they settled. With this great migration went the traditions carried from the original homeland, many of which were altered to some extent by time and artistic development, and partly by the acceptance of allies and other cultures along the route.

Barbarian style included several different elements, which stemmed from far flung sources. Of major importance was the "animal style" of Central Asia, which had some relation with Persian and Near Eastern traditions. A rich source of techniques came from the Graeco-Roman world, as Greek craftsmen had begun producing rich gold jewelry north of the Black Sea, as early as the 4th century B.C. Such techniques as chip carving, filigree, granulation, and inlay with precious stones and glass pastes were well known. They were adopted rather differently by the various tribes, and many were abstracted and turned into linear patterns. Color was particularly favored by many barbarians, and a polychrome style, quite different from that of Greece and Rome, was developed, employing the use of inlays, stones, glass pastes, and enamel.

The simplicity of Hunnish work contrasts sharply with the jewelry of the Franks, where abstracted birds, geometric designs, interlace, animal heads, glass inlays, and Christian griffins show a myriad of influences. The materials changed as new territories were conquered. The round Frankish fibulae from the Rhineland were of gold and filigree, while the great buckles from the Frankish graveyard at Tabariane in Aquitaine were plated with tin engraved with interlace.

Particularly spectacular and varied is the Hunnish jewelry which was found at various sites from Russia to Hungary and lower Austria. It includes four pieces lavishly decorated with almandines and garnets, which probably formed the ornaments of an important warrior (no. 361). These include the chamfron for the horse studded with 106 jewels, the handle for the warrior's whip, with both gems and granulation, and two strips of harness ornament decorated *en suite*. These examples of 4th century style are succeeded by three circlets for the upper arm decorated with large garnets that date from the early 5th century and relate to others found in Russia. The third Hunnish group is all of silver and has parallels in finds from northern Austria.

The Langobards of north Italy settled in lands rich with tradition, neighboring powerful Byzantine strongholds. It is hardly surprising that their jewelry reflects these civilizing influences, and their earrings, for instance, are close imitations of Byzantine style. The most unusual example is a gold medallion, originally decorated with a band of pearls, which has as its center a portrait of a man in cloisonné enamel (no. 392). This is closely related to the well-known Castellani Brooch in the British Museum, and both imitate the regalia of the emperor. The Walters piece is said to have been found at Commachio, a town near Ravenna.

The Franks were the first of the tribes to be Christianized. Their King, Clovis, was baptized in 498, and various of the other tribes joined either the Aryan or the Catholic Church. The cross, therefore, begins to appear as an ornament in Frankish jewelry and the drinking griffin of the pierced belt buckle in this collection is paralleled on early Christian altar frontals from Italy and Byzantium. On some Burgundian buckles, there is a representation of a head with a cross above it, representing "the Holy Face," as illustrated here (no. 388).

Other types of symbols, such as the eagle, which was common to both Frankish and Visigothic jewelry, undoubtedly had mythic significance. Among the most striking examples of the polychrome style are a pair of Visigothic eagle fibulae, found in Spain, which are subdivided into compartments filled with glass pastes of green and blue, garnets, white meerschaum, and small cabochon crystals (no. 402). Worn as a pair with pendant stones from their tails, they must have made a noble effect.

Square-headed brooches were introduced into England by the invasions of the Angles and Saxons. Nearly identical types can be found on the continent, but there is an interesting progression of changes that takes place in the jewelry forms in England, as old forms degenerated, were elaborated, or altered. The new waves of tribal immigrants, as recorded by the Venerable Bede, helped to keep fresh the connections with continental patterns.

The last phases of European migratory activity are connected with the Vikings. Their jewelry included torques and rings of twisted wire, which descend in concept from the earliest Celtic jewelry of the Middle Bronze Age. The heavy silver torque to be worn around the upper arm (no. 413), while Viking in origin, was appropriately found in Ireland where its warrior owner was buried.

Richard H. Randall, Jr.

Facing: The jeweled garniture of a Hunnish warrior (no. 361)

Two Ribbon Armlets 357

Scottish, Middle Bronze Age, about 1000 B.C.

The two torques for the upper arm were excavated together in Morayshire in 1857. They are made of ribbons of sheet gold twisted in an even corkscrew pattern, and they join with hook-and-eye clasps. They stand at the beginning of a tradition of Celtic jewelry which continued in Scotland and Ireland into the 8th century and as late as the 10th century A.D. with the Vikings. (57.1847-8)

D. 4 in (.102 m) and 4-5/8 in (.117 m)

History:
collection of Sir William Gordon Cumming; purchased New York, 1953
Publications:
Philippe Verdier, "Gold from Ancient Ireland," *BWAG*, April 1954, vol. 6, no. 7, (called Irish); John M. Coles "The 1857 Law Farm Hoard," *The Antiquaries Journal*, vol. 48, pt. II, pp. 169 ff., pl. 46, nos. 26 and 27

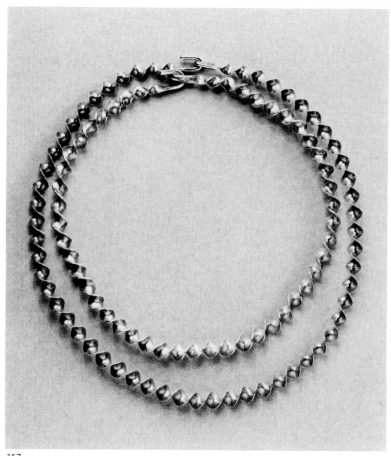

357

Fibula 358

Gallo-Roman, 1st century B.C.-1st century A.D.

Found in France, this circular bronze fibula relates to a number of others found in various parts of the Roman Empire, often in Roman campsites and forts. The round body of the fibula narrows towards the opening, where the ends are recurved and terminate in flattened buttons. The button ends are treated with hatched decoration, and the pin is filed with transverse lines at its upper end. (54.2480)

W. 1-5/8 in (.042 m)

History:
purchased in Paris, November 1970
Notes:
A similar fibula was excavated at Dangstetten in the fort of the Roman XIX Legion, occupied between 15-9 B.C. (Karlsruhe, Badisches Landesmusem, *Neue Römische Ausgrabungen in Baden-Würtemberg*, December 1972-March 1973, p. 11)

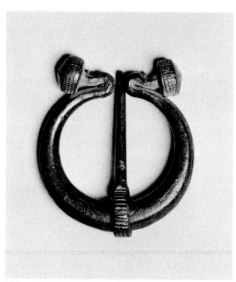

358

Torque 359

Celtic, 4th-2nd century B.C.

A bronze torque for the neck, engraved with La Tene designs near the opening. The bronze thickens toward the opening, and the flattened terminals expand abruptly and are engraved with striations. Broken in half in ancient times. (54.2502)

D. 4-15/16 in (.125 m)

History:
found in the Scheldt River; collection of Hugo Olse; gift of Mrs. Carol L. Brewster, 1973

Buckle 360

Hunnish, 4th century A.D.

The heavy gold inlaid plate is divided into
eight cloisons set with garnets. There are two
reetangular cloisons on the tongue which
are similarly inlaid. The tongue terminates
in an animal head with garnet eyes. (57.449)

L. 2-1/8 in (.054 m)

History:
acquired 1927
Publications:
Ross, *Migration Period*, p. 30; *Romans and Barbarians*,
no. 151

Jeweled Garniture 361

Hunnish, 4th century

The trappings of an important Hunnish
horseman are represented by these four
ornaments of sheet gold, set with carnelians
and other stones in granulated settings.

The large slightly expanding oblong
plaque, set with 102 stones has embossed
borders, and a small half oval projection at
the top. The gold borders are turned over a
sheet of copper, of which fragments remain.
There are seven bronze rivets, which pro-
ject from the back, and the lower two retain
portions of a second layer of copper. The
plaque was mounted on some material still
thicker, as the longest rivet projects 3/4 inch,
though it is bent at about its mid-point. The
plaque has been called a portion of a crown,
but is more probably the chamfron of a horse.

The cylindrical tube served as the handle
of a whip and its ends are decorated with
twisted gold wires and triangles of granula-
tion. One end is closed. There is a bronze rivet
to affix it to the shaft.

Two strips of gold set with a single row of
carnelians have similar borders turned over
copper. The stones are divided by double
triangles of granulation. Each is broken and
bent at the ends. These are probably either
harness or scabbard mounts. (57.1050, 57.1060,
57.1051-2)

Whip handle: L. 5-3/4 in (.146 m) 57.1050

Chamfron: L. 4-7/8 in (.124 m) 57.1060

Mounts: L. 5-1/4 and 4-15/16 in (.133 m and .125
m) 57.1051-2

History:
purchased from Arnold Seligmann, Rey and Co., 1929
Publications:
Byzantine Art, no. 841; Richard Winston, "The Bar-
barians," *Horizon*, vol. XII, no. 3, 1970, p. 73, colorplate

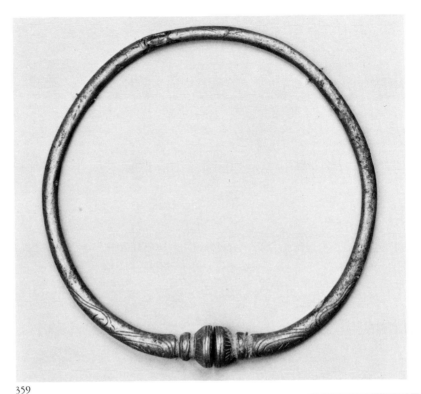

359

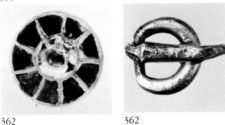

362 362

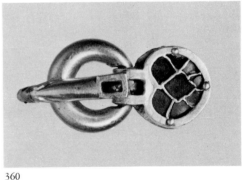

360

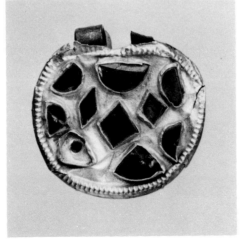

362

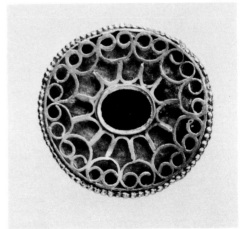

362

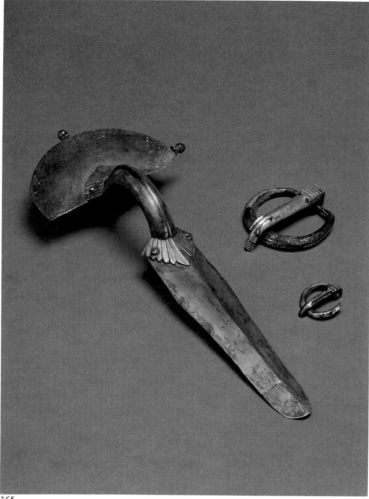

365

Two Fibulae, a Buckle Plate, and a Buckle 362

Hunnish, probably from South Russia, 4th-5th century

Presumably found together, this group comprises a gold buckle; a buckle plate of gold backed with bronze, set with odd shaped pieces of carnelian; a wheel fibula set with garnets and a central carnelian; and an oval fibula of openwork in gold, originally set with carnelian, of which only the central inlay remains. (57.557A, 57.557B, 57.556, 57.558)

a. Buckle L. 3/4 in (.019 m) 57.557A; b. Plate L. 1-1/4 in (.032 m) 57.557B c. Wheel fibula L. 3/4 in (.02 m) 57.556 d. Oval fibula W. 1-1/2 in (.038 m) 57.558

History:
acquired 1929
Publications:
Ross, *Migration Period,* p. 36

Pair of Armlets 363

Hunnish, probably from South Russia, early 5th century

The tubular gold hoops narrow toward the central ornaments, which are set with garnets in a cross pattern, centered on one large stone. The reverse of each central section is decorated with patterns of twisted gold wire. Related pieces were found at the sources of the Soudza River, and are in the Hall of Armor in the Kremlin, Moscow. (57.1080-1)

W. 4 in (.102 m) and 4-1/2 in (.114 m)

History:
acquired in Paris from Daguerre, 1928
Publications:
Ross, *Migration Period,* p. 38

Armlet 364

Hunnish, probably from South Russia, early 5th century

Tubular armlet of gold with a cinquefoil clasp, composed of four hemispheres decorated with granulation and a central domical garnet. The reverse sides are decorated with twisted gold wire, and the attaching collars and surfaces between the spheres are granulated. The pin is a modern replacement. (57.1082)

W. 4-1/2 in (.114 m)

History:
acquired in Paris from Daguerre, 1928
Publications:
Ross, *Migration Period,* pp. 38, 40

364

367

Fibula and Two Buckles 365

Hunnish, probably from Lower Austria, first half of the 5th century

Purchased as a group, the find compares to others from Loa an der Thaya in Lower Austria, and includes two silver buckles with filed ornament on the base of the tongues. The silver fibula has a wide semi-circular head with three knob ornaments (one missing), a long foot with a central ridge, and palmette ornaments attached on each side of the bow by rivets. (57.1878-80)

Large buckle L. 1-3/4 in (.044 m) Small buckle L. 7/8 in (.022 m) Fibula L. 7 in (.178 m)

History:
acquired 1959
Publications:
Ross, *Migration Period*, p. 42

Six Buckles 366

Hunnish, probably from Russia, early 5th century

Probably from the same find, the group includes a silver buckle set with pastes, a bronze gilt buckle lacking its tongue; a bronze gilt buckle, its plate framed with four rivets; a silver buckle plate with a bird-head finial, a bronze buckle with two red paste inlays, and a silver buckle set with a single garnet. (57.658, 54.1918, 57.659, 57.656, 53.24, 57.657)

a. L. 1-3/8 in (.035 m) 57.658　b. L. 1-1/8 in (.028 m) 54.1918　c. L. 1-3/4 in (.044 m) 57.659　d. L. 2-1/8 in (.054 m) 57.656　e. L. 1-1/4 in (.032 m) 53.24　f. L. 2-1/4 in (.057 m) 57.657

History:
acquired in Paris from Sambon, 1930
Publications:
Ross, *Migration Period*, p. 44

Gold Fibula 367

Hunnish (or Ostrogothic), about 400 A.D.

This highly stylized horse-head fibula derived from Roman prototypes uses dots to suggest the texture of a horse's coat and looped filigree for the mane. The catch-plate has an incised zig-zag decoration. (57.482)

L. 1-3/8 in (.035 m)

History:
acquired from Joseph Brummer in 1927
Publications:
Ross, *Migration Period*, p. 46

366

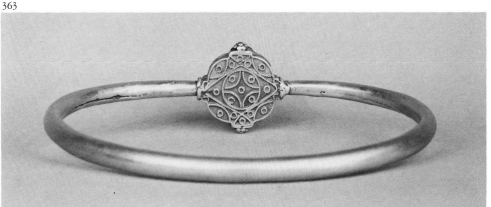

363

363 inside

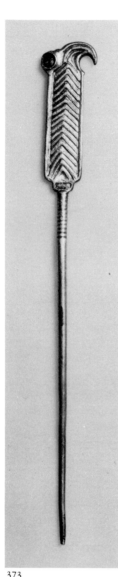

373

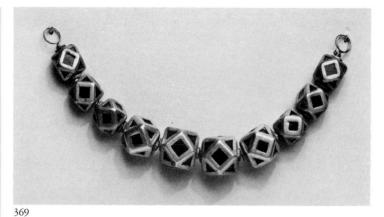

369

371

372

368

Earring 368
Gothic, late 4th century

Formed of two twisted strands of gold wire within four plain strands, terminating in a classical capital formed of wire and granulation, the earring is surmounted by an onyx bead and has a loop catch. Similar granulation is found in the second treasure of Szilagy-Somlyo, now in Budapest. (57.1821)

D. 2 in (.05 m)

History:
collection of Baron von Haersolte; Joseph Brummer (sale, New York, Parke-Bernet, May 12, 1949, part III, lot 250); acquired 1949
Publications:
Helmut Schlunk, *Kunst der Spätantike im Mittelmeerraum,* Berlin, 1939, no. 85; Ross, *Migration Period,* p. 48; cf. Nandor Fettich

Ten Graduated Polyhedral Beads 369
Ostragothic, found at Olbia, 5th century

The gold polyhedral beads are set with garnets similar to many earrings of the period found in South Russia. These must have formed part of a necklace. (57.1746)

W. from 1/4 to 3/8 in (.006 to .009 m)

History:
collection of Joseph Chmielowski (sale, American Art Gallery, February 23-25, 1922, lot 710); Henry Walters; Mrs. Henry Walters (sale, December 1-4, 1943; lot 537); purchased from the Hammer Galleries, 1945

Fibula and Buckle 370
Ostragothic, from Rumania, 5th century

Found with glass beads at Nagy-Varad, Grosswardein (now Oradea) in 1876, the fibula is incised with animal faces and S-scrolls along the bow and animal heads at the terminals, and is inlaid with four garnets. The plate of the buckle is framed with carved and gilt scrolls, and is centrally inlaid on a dotted field with four leaf-shaped garnets around a garnet within a circle of green paste. (57.664-5)

Fibula - L. 2-5/8 in (.065 m) Buckle - L. 4 in (.101 m)

History:
purchased before 1931
Publications:
Archaeologiai Értesitö, vol. 14, 1880, pp. 79-80; Joseph Hampel, *Der goldfund von Nagy-Szent-Miklos,* Budapest, 1886, fig. 119; for complete references Ross, *Migration Period,* p. 50

Gold and Garnet Ring 371
Ostrogothic?, 5th century

Gold ring decorated with transverse incised lines, and set centrally with a circular garnet. A similar ring is in the Bargello, Florence. (57.1603)

D. 5/8 in (.016 m)

History:
acquired 1941

Bird Fibula 372
Frankish, 6th century

A silver gilt small bird-shaped fibula with the beak missing, similar to one found in a Frankish grave at Cologne. (57.1834)

L. 1-1/8 in (.028 m)

History:
gift of Alastair Bradley Martin, 1949
Publications:
Ross, *Migration Period,* p. 58

Hair Pin 373
Frankish, 5th century

The bird terminal of this silver gilt pin has a serrated body, inlaid eye (stone missing), and a curved beak. It resembles a pin found at Chaffois (Doubs), now in the museum at Besançon, France. (57.1833)

L. 5-3/8 in (.137 m)

History:
collection of Joseph Brummer (sale, New York, May 12, 1949, lot 276)
Publications:
Ross, *Migration Period,* p. 58

Hollow Polyhedral Gold Ornament 374
Ostrogothic, 5th century

Shaped as a half cube with truncated front corners, the foremost five faces are pierced with trellis patterns filled with traces of red, green, and white glass paste. There is a central cross in the front face. The back and sides are plain gold with a gold sheathed slot passing from one side to the other for mounting. (57.1820)

D. 1/2 in (.013 m)

History:
when purchased in Rome, the piece was said to have been found in Ravenna; Joseph Brummer (sale, New York, May 12, 1949, lot 246)
Publications:
Ross, *Migration Period,* p. 52

Bronze Buckle 375
Gallo-Roman or Helvetic, 4th century

A massive bronze buckle with animal-headed finials. The plate is pierced with figure eights, and the loop and tongue develop opposing volutes. (54.2346)

L. 3 in (.076 m)

History:
collection of Joseph Brummer (sale, New York, May 12, 1949, lot 278)
Publications:
Ross, *Migration Period,* p. 54; *Romans and Barbarians,* no. 168

375

Gold Plated Bronze Ring 376
Frankish, 6th century

The bezel is formed of stepped squares, the upper face being incised with a sunburst in imitation of an intaglio setting. The hoop, which is broken, develops a strong median ridge as it approaches the bezel. (57.1679)

D. 1-1/4 in (.03 m)

History:
collection of Henry Walters; Mrs. Henry Walters; acquired from Joseph Brummer, 1941
Publications:
Ross, *Migration Period,* p. 60

374

376

Pin with Bird Terminal 377
Frankish, late 6th century

The plain silver pin terminates in a stylized bird, which is overlaid with gold foil and divided into compartments set with thin garnets over cross-hatched gold foil. Similar pieces have been found in France near Arras (Champagne) and at Herpes (Charente) and are in the Museum fur Vor-und-Frugeschichte, Berlin. (57.1883)

L. 6-1/2 in (.165 m)

History:
acquired Carlebach Gallery, 1959
Publications:
Ross, *Migration Period,* p. 62

377

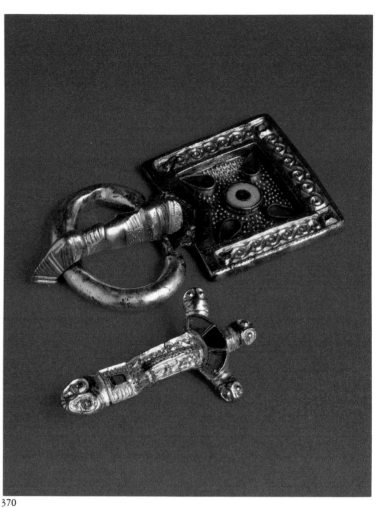

370

Digitated Fibula 378

Frankish, second half of 6th century

The gilt bronze plate has incised geometric patterns and from it radiate five knobs inset with red glass pastes. The bow is bordered with inscribed spirals and set with three garnets; the stem is a restoration. (54.2444)

L. 3-1/2 in (.090 m)

History:
acquired 1959
Publications:
Ross, *Migration Period,* p. 60

Digitated Fibula 379

Frankish, about 600 A.D.

From the bronze and gilt plate extend seven knobs alternately inlaid with garnets or nielloed with concentric circles. The plate is divided into three triangular sections and the body of the piece into two with cross-hatched decoration. The raised borders are treated with niello in zigzag or lozenge patterns, and the median band with a series of concentric circles joined with a continuous line. Broken and repaired; end of stem restored. (54.2443)

L. 4-3/8 in (.111 m)

History:
acquired from the Carlebach Gallery, 1959
Publications:
Ross, *Migration Period,* p. 66; Robert G. Calkins, *A Medieval Treasury,* Ithaca, 1968, p. 113, no. 21

Bow Fibula 380

Frankish, probably from Lorraine, about 600 A.D.

The fields of the fibula are carved with interlace ornament, bordered with flat strips inlaid with zigzag borders in niello. The plate has an undulating border and the fibula terminates in a stylized animal head. Traces of gilding over the whole piece. (54.2445)

L. 4-1/8 in (.105 m)

History:
acquired Carlebach Gallery, 1959
Publications:
Ross, *Migration Period,* p. 68

381

382

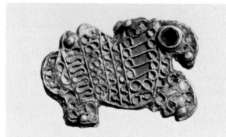

383

Circular Fibula 381

Frankish, about 600 A.D.

The bronze body is overlaid with a sheet of silver decorated in repoussé, and set with red pastes and a domical central green paste bead. The design is of a Maltese cross with palmettes between the arms. Iron pin missing. (57.1884)

D. 1-5/8 in (.04 m)

History:
acquired Carlebach Gallery, 1959
Publications:
Ross, *Migration Period,* p. 68

Peacock Fibula 382
North Frankish, 7th century

The bronze body is overlaid with sheet gold decorated with filigree of twisted gold wire. It is set with three red stones on the body, and a blue stone for the eye. The concept perhaps derives from Gallo-Roman bird jewelry. (57.570)

H. 1-1/8 in (.028 m)

History:
acquired by Henry Walters before 1931
Publications:
Ross, *Migration Period,* p. 70

Animal Fibula 383
Frankish, 7th century

The bronze base plate with its pin is faced with sheet gold attached by gold rivets. The animal body is decorated with filigree of twisted wire, and the eye set with a red glass paste. A pair of related fibulae were found at Monceau (Oise) France. (57.571)

L. 1-3/8 in (.035 m)

History:
purchased by Henry Walters before 1931
Publications:
Ross, *Migration Period,* p. 70; and cf. C. Boulanger, "Le Cimetière Mérovingien de Monceaux," *Bulletin Archéologique,* 1908, pp. 328 ff., pl. 29, no. 4

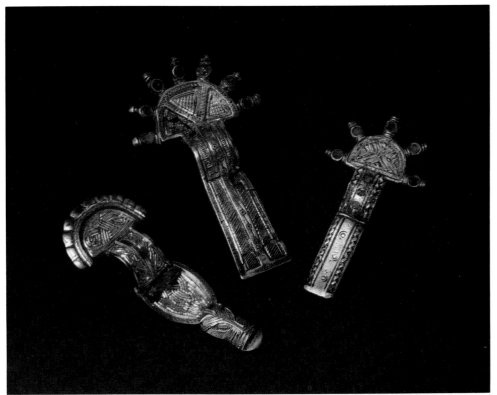

378, 379, 380

Round Fibula 384
Frankish, Northern France or Rhineland, 7th century

The bronze backing is overlaid with gold treated with filigree circles and three interlaced knots in filigree. There are five triangular pastes around the outer portion and three small ones on the central boss. The pin is missing. (57.1825)

D. 1-3/4 in (.044 m)

History:
collection of Joseph Brummer (sale, New York, May 12, 1949, lot 269)
Publications:
Ross, *Migration Period,* p. 72

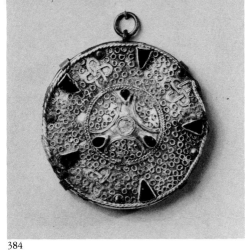

384

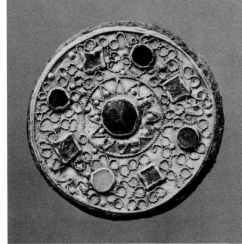

385

Round Fibula 385
Frankish, probably Rhineland, 7th century

The gold face is inlaid into a bronze disk, and is decorated with filigree and set with eight glass pastes in red, blue, and green around a larger central blue paste. (57.1714)

D. 1-3/4 in (.044 m)

History:
gift of H. Kevorkian, 1947
Publications:
Ross, *Migration Period,* p. 72

Frankish, Acquitaine, 7th century

The obverse of the buckle, tongue, and plate
are incised with interlaced strapwork against
a hatched ground and plated with tin. There
are eight graduated bosses at the sides of the
plate, and five pierced tangs on the reverse
for fastening. The buckle was excavated in
the cemetery of Tabariane, commune of
Teilhet (Ariege) in France in 1908. (54.2350)

L. 7-1/8 in (.18 m)

History:
collection of Joseph Brummer (sale, New York, May 12,
1949, lot 280)
Publications:
Robert Roger, "Cimetière Barbare de Tabariane," *Bulle-
tin Archéologique,* 1908, p. 319, pl. 21; Ross, *Migration
Period,* p. 74; Robert G. Calkins, *A Medieval Treasury,*
Ithaca, 1968, p. 113, no. 22

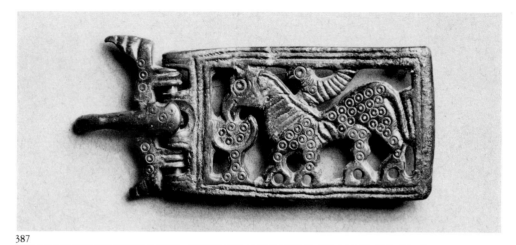

387

Bronze Buckle with a Griffin 387
Frankish, 7th century

The buckle is broken, and part of its loop is
missing. The bronze plate is pierced with a
griffin drinking from a fountain, the surface
treated with linear designs and punched
circles. It relates to one found in Picardy
though the majority of the type have been
found in Burgundy and Switzerland. (54.2343)

L. 4 in (.10 m)

History:
collections of Victor Gay; Joseph Brummer (sale, New
York, May 12, 1949, lot 278)
Publications:
Herbert Kühn, "Dei Germanischen Greifenschnallen
der Völkerwanderungzeit," *Ipek,* 1934, pp. 77 ff., no. 30.
Byzantine Art, no. 859; Ross, *Migration Period,* p. 76;
Romans and Barbarians, no. 175

388

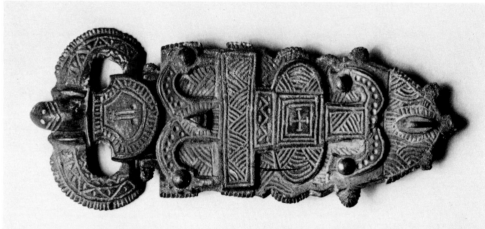

389

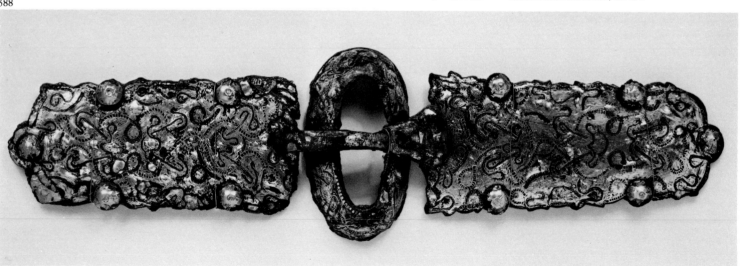

Buckle and Plate 388
Frankish, Burgundian type, 7th century

The bronze buckle plate is formed of two sections, a decoratively shaped one riveted with bosses on top of the lower one. The surface is incised with formal geometric patterns, with a cross in the center. The tongue is incised with a human face and has an animal terminal. The buckle loop has serrated edges and geometric incisions. (54.2347)

L. 5-7/8 in (.149 m)

History:
collection of Joseph Brummer (sale, New York, May 12, 1949, lot 278). The buckle loop at one time became separated but was reunited to the piece by gift of Ernest Brummer in 1964.
Publications:
Byzantine Art, no. 855; Ross, *Migration Period,* p. 82

Buckle with Two Plates 389
Burgundian, 7th century

A massive Burgundian iron buckle; its two large plates are overlaid with silver decorated with interlace patterns. Each plate has five bosses overlaid with gold, and certain areas of each design are gilded. (52.276)

L. 13-3/4 in (.350 m)

History:
collections of E. de Lorey; Joseph Brummer (sale, New York, May 12, 1949, lot 319)
Publications:
Byzantine Art, no. 861; Ross, *Migration Period,* p. 86

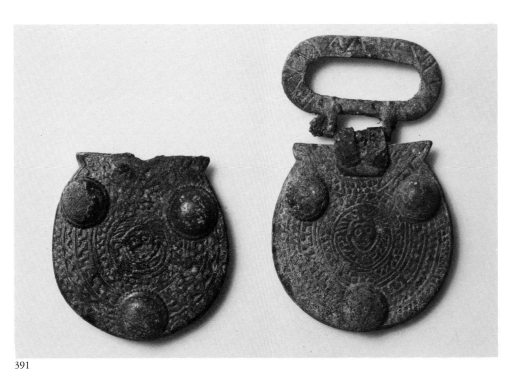

391

Buckle and Plate 390
Frankish, 7th century

Bronze buckle, its tongue decorated with incised lines, with a square plate divided into cloisons set with garnets and blue stones, some of which are lacking. (54.424)

L. 2-3/4 in (.070 m)

History:
acquired by Henry Walters from Daguerre, Paris, 1930
Publications:
Byzantine Art, no. 851; Ross, *Migration Period,* p. 80

390

A Buckle and a Buckle Plate 391
Burgundian, 7th century

Bronze buckle and plate with the tongue missing. The plate has three bosses and three tangs for attachment on its reverse side. It is incised with bands of concentric ornament centering on a human face surmounted by a cross, which represents the face of Christ. The second plate is very similar but omits the cross from the central face. Its buckle loop and tongue are lacking. Both are said to have been found in France. (54.2344-5)

L. 3-5/8 in (.092 m) and 2-1/4 (.057 m)

History:
collection of Joseph Brummer (sale, New York, May 12, 1949, lot 278)
Publications:
Byzantine Art, no. 859 b; Ross, *Migration Period,* p. 84

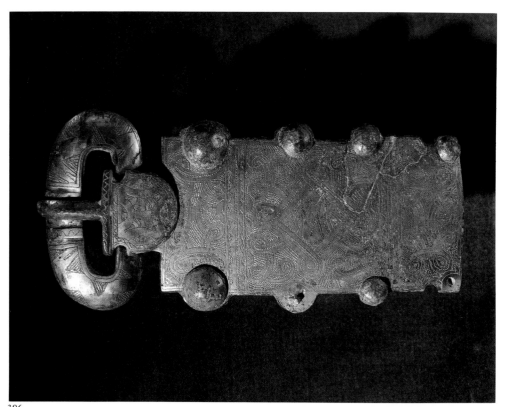

386

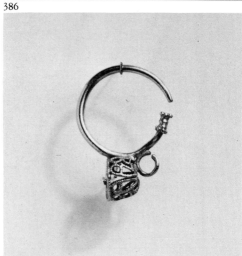

396

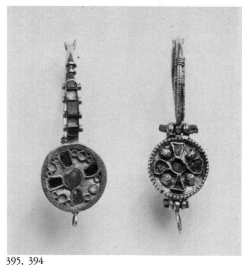

395, 394

Brooch with a Man's Bust in Enamel 392

Langoboard or Byzantine, 7th century

Said to have been found at Comacchio, near Ravenna, the jewel recalls the Castellani Brooch in the British Museum. It is formed of a gold disk, decorated concentrically with a beaded border, a ring of braided wire, a ring of repoussé hemispheres, and a circle of loops for the attachment of pearls. In the center is the bust of a man, wearing earrings, which is highly stylized and carried out in red, blue, and white cloissoné enamel. There are three loops at the base for pendant chains and jewels. This brooch relates to five others published by Ross which appear to be Langobard imitations of the Imperial regalia, each of them supplied with three decorative chains and jewel pendants. Each is somewhat different in workmanship, but the present example relates very closely to a pair of earrings found at Senise, and now in the National Museum, Naples, with similar heads in enamel within a ring of pearls. (44.255)

D. 1-1/2 in (.038 m)

History:
acquired by Henry Walters before 1931
Publications:
J. Werner, "Die Byzantinischen Scheibenfibeln von Capua and ihre Germanischen Verwandten," *Acta Archeologica,* 1936, pp. 57 ff., and fig. 2; Herbert Kühn, "Wictige Langobardische Funde in Amerikanischen Sammlungen," *Ipek,* vol. 12, 1938, p. 180, pl. 58; Franz Rademacher, *Fränkische goldscheibenfibeln aus dem Rheinischen landesmuseum in Bonn,* Munich, 1940, p. 53; Helmut Schlunk, "The Crosses of Oviedo," *Art Bulletin,* March 1950, vol. 32, no. 1, p. 96, note 36; Ross, *Migration Period,* p. 88; Marvin C. Ross, "Some Langobard Insignia," *Allen Memorial Art Museum Bulletin,* Oberliń, vol. 21, no. 3, Spring 1964, pp. 142 ff., fig. 2

Three Crosses 393

Langobard, 7th-8th century

Found in many Langobard cemeteries, these sheet gold crosses are so fragile that they must have been grave jewelry sewn to the garments of the deceased, as suggested by the holes at the edges for attachment. (57.1771-3)

a. Plain sheet gold H. 1-7/8 in (.047 m) b. Stamped with interlace H. 3 in (.075 m) c. Stamped with borders of circles and dots H. 2-3/4 in (.07 m)

History:
collection of Morrin; gift of Mrs. Nelson Gutman, 1946
Publications:
Ross, *Migration Period,* p. 90

Three Gold and Paste Earrings 394-6
Langobard, 7th century

394. The front decorated with a cross in red pastes, which are also used along the edges of the forepart of the hoop (mostly missing). The back is a hemisphere of wire openwork and the hoop is long and ovoid. (57.476)

L. 2 in (.05 m)

History:
acquired from Joseph Brummer, New York, 1927

395. The front is decorated with a cross in green pastes, with four gold bosses between the arms. The back is a gold hemisphere with filigree decoration, and there is a ring at the bottom for a pendant. Circular hoop. (57.475)

L. 2 in (.05 m)

History:
acquired from Joseph Brummer, New York, 1927

396. Circular hoop with a delicate openwork wire decoration, orginally set with a pearl, now missing. (57.1662)

L. 1-3/8 in (.035 m)

History:
collections of Henry Walters before 1931; Mrs. Henry Walters; acquired from Joseph Brummer, New York, 1941
Publications:
Ross, *Migration Period,* pp. 92-94

S-Shaped Fibula 397
Langobard, end of 6th century

The cast bronze plate ends in eagles' heads. The eyes and body areas, which were once inlaid with glass pastes, are now missing. The remainder of the fibula which is treated with interlace, is overlaid with gold. Similar finds from San Giovanni, Cividale in Italy suggest a date at the very end of the 6th century. (54.2440)

L. 1-3/8 in (.035 m)

History:
acquired 1958
Publications:
Ross, *Migration Period,* p. 94

Monogram Ring 398
Langobard, 7th century?

A bronze ring, formerly gilt, with the mongram I N (?) and a cross. The hoop is broken. (54.2264)

D. 1 in (.025 m)

History:
acquired in Brescia; gift of Marvin C. Ross, 1942

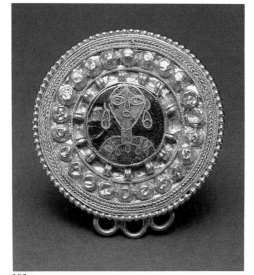

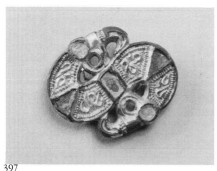
397

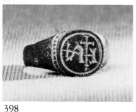

392

398

393

Two Small Gold Rings 399-400

Langobard, 7th century

399. Hoop made of a zigzag wire between two larger plain wires, probably for a child. Set with two pearls and an emerald. (57.1604)

D. 5/8 in (.016 m)

400. Hoop made of two serrated gold wires and a plain wire, probably for a child. Set with two pearls and a blue stone. (57.1642)

D. 3/8 in (.009 m)

History:
collections of Henry Walters before 1931; Mrs. Henry Walters; acquired from Joseph Brummer, New York, 1941
Publications:
Ross, *Migration period,* p. 96

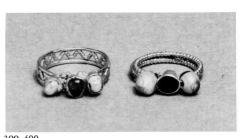

399, 400

Animal Dress Ornaments 401

Langobard, 7th century

The foreparts of two lion-like animals are pierced with holes as if to be sewn to garments. The hindquarters are missing. Made of stamped sheet gold, they are related in technique to the crosses of Langobard workmanship found in many graves. (57.1822a, abd, b)

L. 1-3/4 in (.044 m) and 1-1/2 in (.038 m)

History:
collections of Marc Rosenberg, who purchased them in Rome; Edgar S. Apolant; Joseph Brummer (sale, New York, May 12, 1949, lot 251)
Publications:
Herbert Kühn, "Ein Langobardisches Tierpaar aus Gold," *Ipek,* 1941-42, p. 262; Ross, *Migration Period,* p. 98

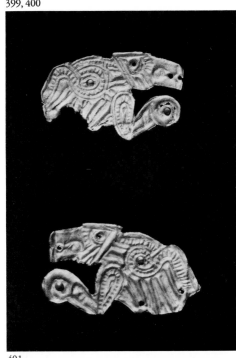

401

Eagle Fibulae 402

Visigothic, second half of the 6th century

This large and well-preserved pair of fibulae, found at Tierra de Barros (Badajoz), is noted for the fluid lines which contrast with the majority of eagle fibulae from Spain (see no. 403). They are made of a bronze core, overlaid with sheet gold, and inlaid with blue and green stones and garnets. The raised boss in the center is inset with a cabochon crystal, and the eye of the bird with an amethyst set in a circle of meerschaum. The brows are inset with blue stone, somewhat fractured in one bird, as are many stones in their bodies. Originally each eagle had attachments at the tail for three pendants. The pins are lacking. They are a reversed pair. (54.421-2)

L. 5-5/8 in (.143 m)

History:
purchased by Henry Walters from Daguerre, Paris, 1930
Publications:
O. von Falke, "Zur Wiedereröffnung der Walters Art Gallery in Baltimore," *Pantheon,* vol. 18, 1936, p. 346; J. Martinez Santa-Olalla, "Westgotische Adlerfibeln aus Spanien," *Germania,* vol. 10, 1936, pp. 47 ff.; G. Thiry, *Die Vogelfibeln, Rheinische Forschungen zur Vorgeschichte,* III, Bonn, 1939, no. 16, pl. 16; H. Kühn, "Die Grossen Adlerfibeln der Völkerwanderungszeit," *Ipek,*

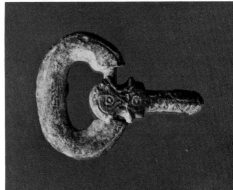

404

1939-40, p. 134, and pl. 58; Ramón Menéndez Pidal (edit.). *Historia de España,* III, España Visigoda, Madrid, 1940, p. 122, fig. 45; J. Martinez Santa-Olalla, "Nuevas Fibulas Aquiliformes Hispanovisigodas," *Archivo Español Archeologia,* vol. 14, 1940-41, p. 36; H. Schlunk, "Arte Visigodo," in *Ars Hispaniae,* II, Madrid, 1947, p. 309, fig. 326; W. Holmquist, *Germanic Art,* Stockholm, 1955, pl. 15; Ross, *Migration Period,* p. 100

Eagle Fibula 403

Visigothic, 6th or early 7the century

A typical example of the Visigothic eagle brooch, in this case made of bronze and divided into small cloisons inset with garnets, blue stones, and mother-of-pearl. There is a central shield-like boss, and the eye was a large inlay. Many of the stones are missing, as is the pin. Found at Herrera de Pisuerga, province of Palenica, Spain. (54.423)

L. 4-1/4 in (.108 m)

History:
collection of Meto (?); purchased by Henry Walters from Seligmann, Paris 1910
Publications:
J. Martinez Santa-Olalla, "Sobre Algunos Hallazgos de Bronces Visigóticos en España," *Ipek,* 1931, pp. 58 ff. and fig. 1; H. Zeiss, *Die Grabfunde aus dem Spanischen Westgotenreich,* Berlin, 1934, pp. 19, 104, 194, pl. 6, no. 3; G. Thiry, *Die Vogelfibeln, Rheinische Forschungen zur Vorgeschichte,* III, Bonn, 1939, p. 68, pl. 4, no. 22 (erroneously attributes Walters Art Gallery example to Museo Nacionale, Madrid); J. Martinez Santa-Olalla, "Nuevas Fibulas Aquiliformes Hispanovisigodas," *Archivo Español Archeologia,* vol. 14, 1940-41, pl. 3, fig. 7; cf. H. Kühn, "Die Grossen Adlerfibeln der Völkerwanderungszeit," *Ipek,* 1939-40, pp. 136 ff., and esp. p. 136 and pl. 59 (7); *L'Art Mérovingien* (exhibition catalogue), Brussels, 1954, p. 43, pl. 27; two more examples formerly in the von Diergardt collection and now in the Römisch-Germanisches Museum, Cologne; Ross, *Migration Period,* p. 102

Bronze Buckle 404

Visigothic, 7th century

Small buckle, perhaps a boot buckle, with cast linear decoration on the loop and tongue. Many similar examples have been found in Visigothic tombs. (54.2306)

L. 1-1/2 in (.038 m)

History:
gift of Mrs. George Seligmann, 1946
Publications:
Ross, *Migration Period,* p. 102

Pair of Earrings 405

Visigothic, 6th century

Said to have been found in Estramadura, these large earrings are formed of seven stones and pearls mounted in gold collars with stamped foliate designs in thin gold on the back of each setting. They have large hoops with one ball finial for suspension, and three amethyst pendants (one replaced) each with a green glass bead on the gold wire. (57.560)

H. 4-7/16 in (.113 m) each W. 1-11/16 in (.043 m) each

History:
purchased from Daguerre, Paris, October 10, 1930
Publications:
Byzantine Art, no. 854; Metropolitan Museum of Art, Cloisters, *Spanish Medieval Art,* New York, 1954, no. 2; Randall, "Jewelllery Through The Ages," p. 496, fig. 6b
Notes:
The workmanship was called Byzantine by Marvin Ross, but is nearly identical in treatment to the Crown of Recesvinto, the votive crown, and a pair of earrings of Visigothic workmanship in the Archaeological Museum, Madrid.

Great Square-Headed Brooch 406
Anglo-Saxon, 6th century

The brooch is of gilt bronze, its surfaces somewhat rubbed. The head-plate is decorated with a mask around which is a U-shaped panel filled with abstract ornament, and framed with two heavy raised borders and a band of roping. The bow is of the two grooved type and continues into a strong median ridge along the foot-plate. The lozenge-shaped foot-plate has three masks and bands of scroll surrounding the central lozenge. The descending animals flanking the bow have been reduced to scrolls and spirals. Unusual is the addition of three crescent-shaped panels with scroll designs on the outer extremities of the lozenge. (54.2508)

L. 5-1/2 in (.040 m)

History:
William Eadkins (sale, London, Sotheby, May 21-25, 1891, lot 585); Pitt Rivers Museum, Farnham, Dorset; purchased in New York, 1975
Publications:
Nils F. Aberg, *The Anglo-Saxon in England,* Uppsala, 1926, p. 69, no. 110; E.T. Leeds, *A Corpus of Early Anglo-Saxon Great Square-Headed Brooches,* Oxford, 1949, pp. 39-40, no. 59a
Notes:
The find site is unknown and the most closely related example, probably from East Anglia, is that from Londesborough, Yorkshire. (Leeds, no. 59)

Pin with Ring and Chain 407
Irish, 6th century

Part of a group intended to be attached to a garment, this short silver pin is complete with its ring and chain. Very few such pins have survived intact. Found in Dunshaughlin Crannog in 1867. (57.1831)

L. 3-1/8 in (.079 m)

History:
collections of Robert Day of Cork (sale, London, Sotheby, May 19-22, 1913, lot 485); William Randolph Hearst; Joseph Brummer (sale, New York, May 12, 1949, lot 276)
Publications:
Ross, *Migration Period,* p. 108

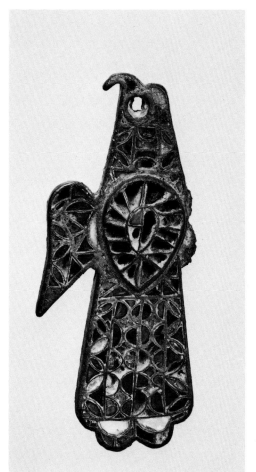

403

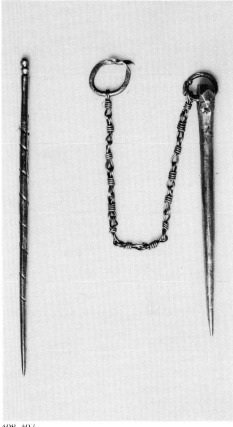

408, 407

409

410

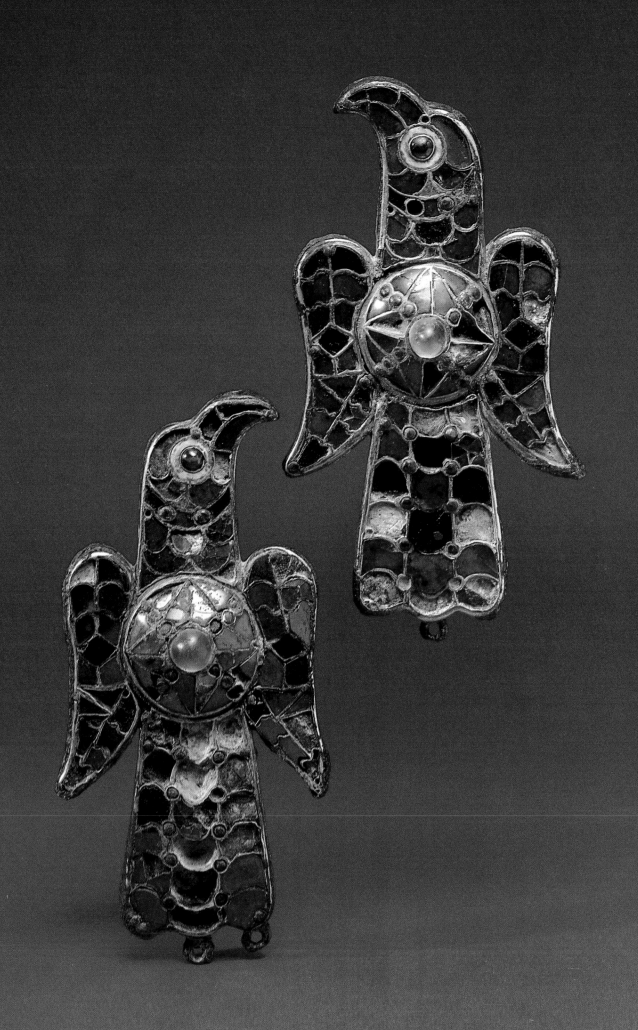

Irish, 6th-8th century

Found in a County Galway crannog, this unusually elegant pin has a double knob head and a spiral line around the pin for decoration. (57.1832)

L. 4 in (.102 m)

History:
collections of Robert Day of Cork (sale, London, Sotheby, May 19-22, 1913, lot 458); William Randolph Hearst; Joseph Brummer (sale, New York, May 12, 1949, lot 276)
Publications:
Ross, *Migration Period,* p. 110

Bronze Pin 409

Irish, 6th-8th century

An interesting form is displayed in this elegantly tapering pin with two collars and a finial curved back in a spiral. Found at Armagh in 1886. (54.2340)

L. 9 in (.228 m)

History:
collections of Robert Day of Cork (sale, London, Sotheby, May 19-22, 1913, lot 355); William Randolph Hearst; Joseph Brummer (sale, New York, May 12, 1949, lot 276)
Publications:
Ross, *Migration Period,* p. 112

Bronze Hand-Pin 410

Irish, 7th century

A hand-pin with five pellets at the top of the head, and a panel of interlace beneath. Found in the Craigywarren Bog at Toome, County Antrim. (54.2370)

L. 8-5/8 in (.22 m)

History:
collection of Robert Day of Cork (sale, London, Sotheby, May 19-22, 1913, lot 357 and plate XVII); acquired 1950
Publications:
R.A. Smith, "The Evolution of the Hand-Pin in Great Britain and Ireland," *Opuscula Archaeologica Montélio Septuagenaru Diceta,* Stockholm, 1913, pp. 281, ff., fig. 16

Bronze Pennanular Brooch 411

Irish, 6th-7th century

The bronze ring is hatched to imitate wire binding for half its circumference, and then is flattened and carved with scrolling plant ornament. The head of the pin is decorated with three deeply cut ovals, and the pin is incised with linear ornament on its faceted central section. Such brooches were worn on the left shoulder. They developed from Roman models but were greatly elaborated in Ireland. (54.2341)

L. 5 in (.127 m)

History:
collections of Robert Day of Cork; William Randolph Hearst; Joseph Brummer (sale, New York, May 12, 1949, lot 277)
Publications:
H.E. Kilbride-Jones, "The Evolution of the Pennanular Brooches with Zoomorphic Terminals in Great Britain and Ireland," *Proceedings of the Royal Irish Academy,* vol. 43, 1935-37, pp. 379 ff.; Ross, *Migration Period,* p. 114; Randall, "Jewellery Through The Ages," p. 497, fig. 7

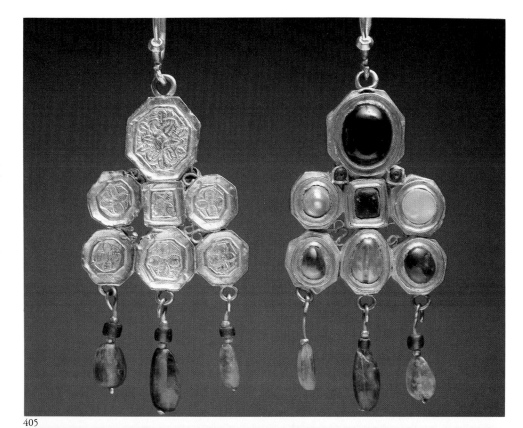

405

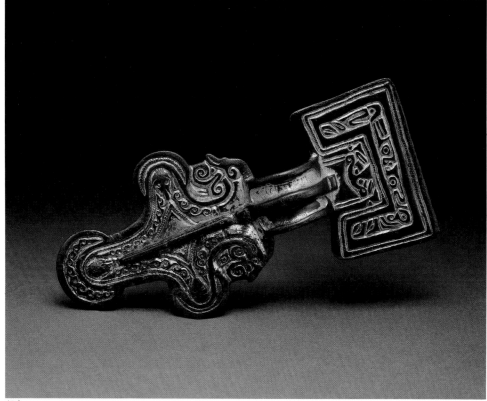

406

Facing: Pair of visigothic eagle fibulae (no. 402)

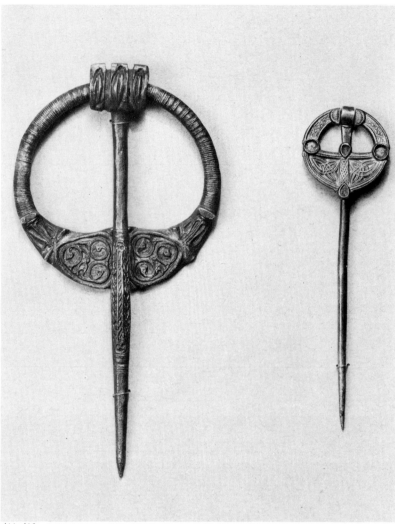

411, 412

413

Small Bronze Pennanular Brooch 412
Irish, 8th-9th century

The head of the brooch is pierced with a half circle, and the remaining surface is ornamented with interlace. There were originally four inlaid stones, now missing. Found in Balinderry Crannog, County Westmeath. (54.2342)

L. 3-7/8 in (.098 m)

History:
Robert Day of Cork (sale, London, Sotheby, May 19-22, 1913, lot 384 and pl. XVII); William Randolph Hearst collection; Joseph Brummer (sale, New York, May 12, 1949, lot 277)
Publications:
Ross, *Migration Period,* p. 114

Silver Armlet 413
Viking, 7th-8th century

A massive armlet of thick twisted silver strands found at Fenit, County Kerry, Ireland. (57.1599)

D. 4-3/4 in (.120 m)

History:
Robert Day of Cork (sale, London, Sotheby, May 19-22, 1913, lot 452, and pl. XIX); William Randolph Hearst collection; gift of members of the Board of Trustees, 1941
Publications:
Ross, *Migration Period,* p. 116 (called Irish)

Silver Ring 414
Viking, 6th-8th century

Composed of two strands of thick silver wire twisted together to form a single strand, such rings were called "ring money." It is said to have been found in Ireland along with other specimens. (57.1850)

D. 1 in (.025 m)

History:
collection of Alastair Bradley Martin; gift of Ralph M. Chait, 1954
Publications:
Ross, *Migration Period,* p. 118 (called Irish)

Bronze Box Brooch 415
Viking, 11th century

Cast bronze with a basketry design, the brooch is a typical Viking pattern and was found at Böda, Öland, Sweden. The pin is missing and several areas of the background are broken through the front surface. In the center is an ornament of superimposed squares with a highly polished central circle. (54.2373)

D. 2-3/8 in(.06 m)

History:
purchased from James Graham, New York, 1952
Publications:
Ross, *Migration Period,* p. 118

Hoard of Gold Ornaments 416
Hispano-Moresque, late 10th century

Said to have been found at Madinat al-Zahra, near Cordova, which was plundered by the Berbers in 1000, the group of forty-five pieces consists of the ornaments for a belt,

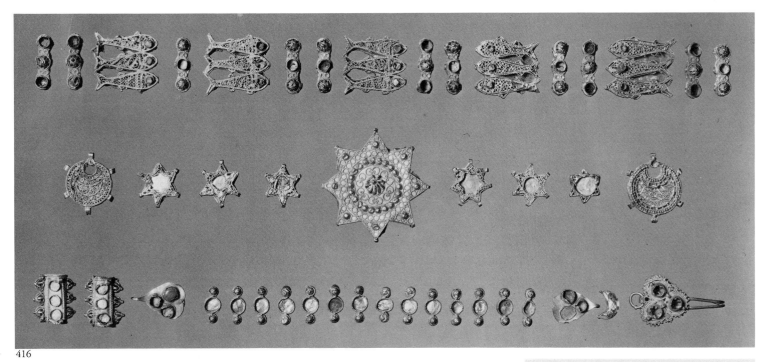

416

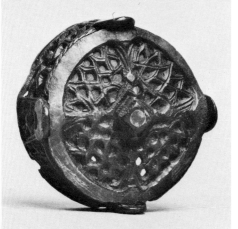

415

414

a fillet, pendants, dress ornaments, and parts of a necklace of gold with filigree, enamel, and stones.

The belt ornaments feature designs of three fish in filigree on a sheet gold ground. The eyes are inlaid with small cabochon pastes, many of which have deteriorated or are missing. Between the fish were pairs of tiny plates set alternately with two openwork bosses of filigree and a cabochon paste, or two cabochons and one boss.

The fillet is somewhat similar in design with small plates, composed of three circles, the small outer ones with filigree bosses and the larger central one with a cabochon setting for stones, all of which are lacking. The clasp is formed of two heart-shaped plates set with three cabochon settings, one of which retains a turquoise.

There are seven pendants or dress ornaments of which the six smaller examples are six-pointed stars covered with granulation with a central cloisonné enamel, one of which survives in a slightly deteriorated state and shows a small bird in four colors. The larger pendant is an eight-pointed star decorated with filigree and gold beads. There is a central openwork boss within a surround of S-shaped filigree, which is framed with a circle of gold beads. The outermost surround is of filigree rings, and the points of the stars have a gold bead on a ground of filigree rings.

Two circular openwork ornaments have six loops and were apparently to be sewn to a garment. Their designs are based on enamel crescents inset into a larger crescent of filigree. One of the enamels has survived in a fragmentary state and is decorated with a pattern of interlace in cloisonné enamel.

Two tubular beads and a hook are apparently from a necklace. The beads are divided into four zones longitudinally, set alternately with three cabochon stones and three openwork bosses of filigree. The stones are lacking. The long hook of two gold wires is soldered to the underside of a trilobate plate ornamented with granulation and three settings for cabochon stones.

Two other hoards of gold jewelry from Spain are in the Victoria and Albert Museum and one from Loja (Granada) in the Instituto de Valencia de don Juan, Madrid. The second of these can be dated by coins found with it to not later than 1009. (57.1596.1-45)

Belt: H. of fish 1 in (.026 m) H. of plates 7/8 in (.0225 m) Fillet: Average H. 9/16 in (.0145 m) Pendants: Small, H. 3/4 in (.019 m) Large, H. 1-15/16 in (.049 m) Dress Ornaments: H. 1 in (.026 m) Tubular Beads: H. 9/16 in (.020 m) Hook: L. 1-11/16 in (.043 m)

History:
purchased 1929
Publications:
Marvin C. Ross, "An Egypto-Arabic Cloisonné Enamel," *Ars Islamica,* vol. VII, Pt. 2, 1940, p. 165; M. Gómez-Moreno, *Ars Hispaniae,* vol. III, Madrid, 1951, pp. 338-341, fig. 401; Philippe Verdier, "Gold Work of the Umaiyads," *BWAG,* vol. 9, no. 4, January 1957, p. 3, ill.

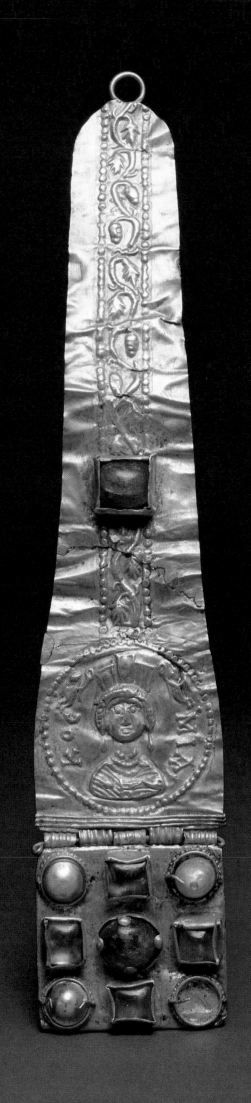

Byzantine Jewelry

From the point of view of jewelry, no empire was ever richer in traditions than that of the Byzantines. As the ultimate heirs of the territories and peoples of the East Roman Empire, after the Emperor Constantine moved the capital to Constantinople in 330, the Byzantines inherited the great lands of Greece, Egypt, the entire Near East, parts of Russian Asia, the littoral of North Africa, and the skills that went with them. The great cities of the empire—Constantinople, Alexandria, Antioch, and Athens—could call upon the immense wealth of Asia, Africa, and Europe for inspiration, and upon the lands themselves for trained craftsmen.

Naturally, there existed within the Byzantine Empire not a single stylistic tradition but a conflict between the classical realistic tradition, established when Greece dominated the Mediterranean, and an abstract tradition, which came ultimately from Persia and the East via the trade routes. Neither approach ever completely dominated the arts of the Byzantines, and both styles existed side by side or co-mingled in various new forms.

The jewelry of the Empire reflects both traditions; for instance, the cameos and coins remain, for the most part, in the Hellenistic tradition, (nos. 466, 467), while a gold belt buckle and a pierced plaque to be sewn to a court costume totally follow a patterned and abstract eastern tradition (nos. 431, 432, 419). Among the new developments in Constantinople was the art of cloisonné enameling, with hieratic figures in brilliant colors floated on a gold ground, recalling the great art of mosaic, which was brought to its height in the decoration of the palaces and churches of Byzantium.

One of the important monuments for the study of the imperial use of jewelry is San Vitale in Ravenna with its famous mosaics completed in 547, which show a procession led by the Emperor Justinian and his Empress Theodora. The empress is dressed in a rich textile woven of gold threads, studded with pearls and gems. On her head is a crown of gold, enamel, and stones; around her neck a series of pearl, enamel and gem necklaces; and her earrings have long drops of pearls. Justinian wears a diadem and a large brooch with triple pendants, the special insignia of the emperor. This jeweled splendor became part of the ritual of the Byzantine court, and was duly imitated not only by the courtiers but in all the capitals and dependencies of the empire.

There survive a number of imperial ornaments such as the dress ornament in the present exhibit, a gold disk decorated in cloisonné enamel with a cross and two orbs representing the east and west empires (no. 419). Amongst the Langobard jewelry one finds an enameled brooch for a lesser ruler, which imitates the triple pendant brooch of the Byzantine emperor (no. 392). A pendant from a court crown is made of sheet gold and stones, embossed with a symbolic figure of the cosmos (no. 421), and in a diadem of regal quality the cabochon stones are set against abstract grounds of pierced gold.

Rings of great weight and extraordinary workmanship were given as formal badges of recognition by the emperor to important servants of the state. An example is of massive gold with three-dimensional leopards supporting the bezel, in which an intaglio shows the figure of Victory (no. 425). It is thought to have been a present to a victorious general, of whom there were many, in the long defensive wars of the Byzantines to safeguard their empire.

Cloisonné enamel was often used in Byzantine jewelry for pendants of saints or for tiny religious medallions on earrings, where the chief decoration was gold filigree. Sickle-shaped earrings of filigree, with projecting triangles of filigree and pearls, became a frequent ornament of ladies of the empire, though the Alexandrians seemed to have favored long drops of several pearls. The effects of color and glitter were achieved by the use of myriad colored stones in necklaces, alternating with pierced golden discs and clasps. A rare moment of humor is to be seen in the necklace of repoussé gold ducks and pearls that originated in Coptic Egypt in the fifth century. (no. 436).

Among the rings is a fine gold marriage ring of distinguished simplicity with the symbolic clasped hands (no. 426). A late signet ring bears engraved heraldic lions and religious inscriptions but is set with a gem of classical origin showing the figure of Pan. Most extraordinary is a gold ring decorated in niello with eight scenes of the life of Christ on a miniscule yet readable scale (no. 427). It relates to a number of others, considered to be marriage rings, the most famous of which is that in the British Museum.

While the Byzantine Empire controlled the lands of the eastern Mediterranean in political fact, it also fostered many cultures and artistic styles within its varying but immense borders. In the Balkans, one finds a strong leaning toward the animal style in bracelets with silver reliefs. Some combine repoussé and niello decoration, though the one shown here (no. 458) shows a procession of mythological beasts in simple relief. An earring with a pair of entwined birds (no. 457), identical to one found in Hungary, shows the same technique. Other regions, like South Russia, imitate the fine technique of Byzantine cloisonné enameling, where the earrings relate in shape and form to the silver one from the Balkans, but are of gold decorated with inset pairs of birds in enamel.

Even after the fall of Constantinople in 1253, the influence of Byzantine style continued unabated in various corners of the empire including Greece, the Balkans, South Russia, and isolated monasteries like Mount Sinai. One of the richest examples of Byzantine work is the reliquary pendant of the Metropolitan Arsenius of Serres (no. 460), which was probably produced on the Island of Chalke in the 16th century. The case of the reliquary is decorated on the back and inside with elegant niello decoration and lavish inscriptions. The interior is shaped to contain four relics and a small finely made gold and niello reliquary cross with pearl decoration, which is somewhat earlier in date. The front of the pendant is set with cabochon jewels, on a ground of filigree, with a sapphire cameo of the Virgin and Child as a centerpiece. The cosmopolitan tradition of this pendant combines eastern Christian iconography, Greek goldsmithing, pagan gem settings, and the most current of European niello design. Like many earlier examples, it shows the polygot traditions of the great eastern empire, which continued long after its demise.

The Byzantine tradition was carried west into Europe by the Crusaders and, periodically, by other means such as trade and intermarriage from the time of Charlemagne onwards. The Princess Theophano, daughter of the Byzantine Emperor Romanus II, for example, married the German Emperor Otto II in 972 and brought with her as dowry marvelous creations from the Byzantine Empire. The ivory triptych in the Walters from the church of Altotting was perhaps a gift of Theophano. Textiles and other products were received through trade, and affected the styles of Carolingian France, Ottonian Germany, and the peninsula of Italy. Few actual remnants of this exchange exist, but there are vessels of imperial quality in the treasures of San Marco in Venice and the royal French collection, now in the Cabinet de Medailles in Paris. Two such vessels are to be found in America, the serpentine bowl of Suger's chalice for St. Denis, in the National Gallery of Art and the agate Rubens Vase in the Walters Art Gallery, which is decorated in the late Roman tradition with satyrs and vine leaves. Of jewelry there is little enough evidence, as gems and enamels tended to be reset, and the goldsmith's work was sent to the crucible.

Richard H. Randall Jr.

Facing: Pendant from a crown (no. 421)

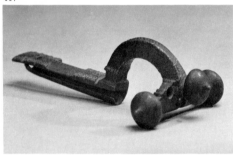

417

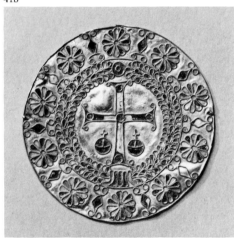

418

419

Fibula 417
Byzantine, 4th century

Gold crossbow fibula, the bow inlaid with a niello inscription VIVAS/VIATOR (Good Luck/Traveler). The top of the bow has a vine-scroll in niello, which contains a small bird. The crossbar with bead finials has been broken and repaired. The pin is missing. Gold fibulae with inscriptions seem to have been special gifts, and several are identified as gifts from Constantine and other emperors. The present inscription has been shown by Van Buchem to be a Christian motto referring to the afterlife. (57.562)

L. 2 in (.05 m) W. 1-3/4 in (.044 m)

History:
purchased by Henry Walters from Daguerre, Paris, 1924
Publications:
Byzantine Art, no. 465; Marvin C. Ross, "Notes on Byzantine Gold and Silversmith's Work," *JWAG,* vol. 18, 1955, pp. 66-67, figs. 11, 12; H.J.H. van Buchem, "Viator vivas," *Archeologie en Historie (Festschrift für H. Brunsting)* 1973, pp. 263-270

Fibula 418
Byzantine, 5th century

A bronze crossbow fibula of the three-knobbed type, cast with formal pattern on the stem, and striations on the bow. The head is pierced with two holes flanking the central knob. The pin is missing. The type is well known from find sites in Pannonia (Hungary). (54.2263)

L. 4-1/16 in (.103 m) W. 2-3/8 in (.06 m)

History:
purchased at Gimbel Brothers, 1941; gift of Marvin C. Ross
Publications:
H.J.H. van Buchem, "Bemerkungen zu den Dreiknopf-fibeln des vierten Jahrhunderts," *Bulletin Antieke Beschaving,* Jaargang, vol. 48, 1973, pp. 143-157

Dress Ornament 419
Byzantine, second half of the 5th century

The gold disk is decorated with patterns of palmettes, a wreath, and the central cross in filigree, which is filled with blue enamel. The central cross has scrolled ends, is decorated with five circles, and is flanked by two tripartite globes surmounted with crosses. The disk is pierced with four holes for attachment to a garment. Much of the enamel is lacking.

The imperial cross flanked by tripartite globes indicates that this is an imperial dress ornament to be sewn to the chiton. The orbs represent the two empires, East and West, and the co-emperorship, thus placing the date in the second half of the 5th century. (44.304)

D. 2-9/16 in (.065 m)

History:
collection of Madame X (Behague ?), (sale, Paris, Hotel Drouot, November 5, 1925, lot 84)
Publications:
Byzantine Art, no. 458; Philippe Verdier, "Notes sur trois bijoux d'or de Walters Art Gallery," *Cahiers Archéologiques,* vol. XI, 1960, pp. 121-122; ill; Klaus Wessel, *Die Byzantinische Emailkunst,* Recklinghausen, 1967, p. 40, no. 1; Angelo Lipinsky, *Oro, Argento, Gemme e Smalti,* Florence (Olschki), 1975, pp. 427-428

Diadem 420
Byzantine, 5th century

The diadem is formed of ten thin gold rectangular panels, pierced with basket and foliate patterns, of which the end two have rounded corners. Each panel was originally set with five stones or pearls, but only the central amethysts, alternating with green felspar, have survived. The panels are pierced with holes for sewing to a headband of either cloth or leather. (57.549)

L. 12-1/4 in (.311 m) W. 1 in (.025 m)

History:
collection of Gilhou, Paris (sale, Paris, July 16-18, 1905, lot 272, pl. X)
Publications:
Byzantine Art, no. 419; Deer, "Mittelalterliche Frauen-kronen," p. 447, fig. 49g
Notes:
Deer and others have accepted the theory that this is a diadem, and have illustrated similar pieces in use. Étienne Coche de la Ferté in *Bijoux du Haut Moyen Age,* Lausanne (Payot), 1962, pl. IV rejects the evidence and interprets this piece and two others as jeweled collars rather than diadems.

Pendant from a Crown 421
Byzantine, 6th century

A strip of thin gold embossed with a running vine and a medallion of a female personification (*tyche*) with a fortified headdress of a city of the Empire, with the inscription KOC/MIA, and two flying Victories. Below is a hinged square section set with a cross of cabochon stones and four pearls (all replacements). A square mounted cabochon ornaments the center of the running vine. Suspension loop at the top. (57.546)

H. 6-3/4 in (.171 m) W. 1-1/2 in (.038 m)

History:
purchased from a dealer in Smyrna; collections of Bachstitz; Ludwig von Gans
Publications:
R. Zahn, "Sammlungen der Galerie Bachstitz, II," *Antike Kunst,* La Haye, 1921, no. 100, pp. 43-44, pl. 19; Paul Friedländer, *Documents of Dying Paganism,* Berkeley, 1945, p. 28, no. 10; *Byzantine Art,* no. 457; Philippe Verdier, "Notes sur trois bijoux d'or Byzantin de Walters Art Gallery," *Cahiers Archéologiques,* vol. XI, 1960, pp. 125-129, ill.; Deer, "Mittelaltarliche Frauenkronen," p. 446, fig. 59h

Bracelet 422
Byzantine, 5th-7th century

Bracelet of tubular gold swelling to ridge on one side, with a simulated fastener of five ribs embossed on the opposite side. (57.1844)

D. 3 in (.076 m)

420

History:
purchased 1951
Notes:
Part of a group of three bracelets, two of which are now in the Royal Ontario Museum, considered to have been Mycenaean (*BMCJ*, pl. VIII, nos. 800 and 801). More recently the attribution was altered to Byzantine on the basis of bracelets from the Treasure of Mersine. (cf. Nikodim P. Kondakov, "Trésors Russes (et Byzantins) Enfouis," *Russkie Klady*, 1896, vol. 1; and André Grabar, "Un Médaillon en or provenant de Mersine en Cilicie," *Dumbarton Oaks Papers*, vol. VI, fig. 2, no. 10)

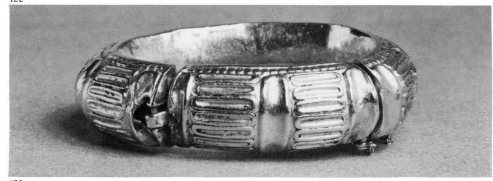

422

Bracelet 423
Byzantine, 6th-8th century A.D.

Made of half round tubular gold, the bracelet is decorated with bands of raised loops, divided by plain indentations. There is a roped border, and the small hinged section of the bracelet is secured by a pin. (57.1737)

L. 2-7/8 in (.073 m)

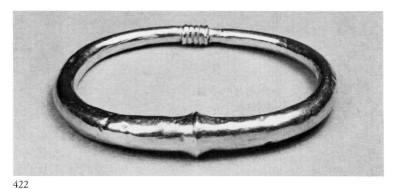

423

History:
gift of Mrs. Saidie A. May in memory of C. Morgan Marshall, May 1945
Publications:
Byzantine Art, no. 453; Christa Belting-Ihm, "Spätrömische Buckelarmringe mit Reliefdekor," *JRGZM*, 1963, p. 104, footnote 26

Pair of Ivory Bracelets 424
Coptic, 7th century?

Both are carved with crosses and stylized patterns; one also has human figures and the other fish. Each one is cracked. (71.1128-9)

D. 3-7/8 in (.098 m)

History:
purchased from the estate of Dikran Kelekian, 1951

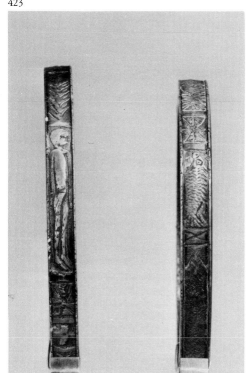

424

Ring 425

Byzantine, 4th century

Massive gold ring with almost freestanding leopards on each side of the loop supporting a high bezel with indented edges. The bezel is set with a niccolo, the blue surface being cut with a Victory in intaglio in black. Rings of this type are thought to have been imperial presents to important military figures, and that their weight (this one weighs 89.95 grams) indicated the importance of the recipient. Several related rings are set with coins of emperors of the 3rd and 4th centuries. Here the Victory figure implies a gift to a successful general. (57.542)

H. 1-1/4 in (.032 m) W. 1-3/4 in (.044 m)

Publications:
The Dark Ages, no. 79; *Byzantine Art,* no. 506; Marvin C. Ross, "Notes on Byzantine Gold and Silversmith's Work," *JWAG,* vol. 18, 1955, pp. 65-66, fig. 10; Randall, "Jewellery Through the Ages," p. 76, fig. 5c

425 side

425 top

426

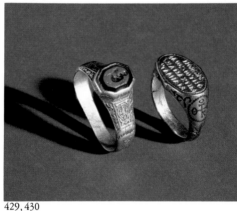

429, 430

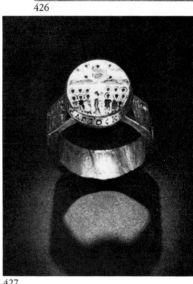

427

Marriage Ring 426

Byzantine, 6th century

The ring is cast in gold with a wide convex band with beaded borders. The circular bezel has clasped hands in relief within two circles of beading. (57.1715)

H. (bezel) 5/8 in (.016 m)

History:
gift of Mrs. Saidie A. May, November 6, 1942
Publications:
Byzantine Art, no. 508, pl. 65; The University of Notre Dame, *The Arts of Christian Antiquity,* Notre Dame, 1957, no. 26

Ring 427

Byzantine (Egypt?), 6th century

Gold ring with a wide octagonal hoop, each face of which is inlaid with a scene from the life of Christ in niello. The large oval bezel carries the scene of the Ascension, and around the edges is the Greek inscription ΑΓΙΟϹΑ • ΑΓΙΟϹ • ΑΓΙΟϹ • ΚΥΡΙΟϹ • ϹΑΒΑWΘ (Holy, holy, holy, the Lord God of Hosts). The seven scenes on the hoop begin at the right of the bezel, and show the Annunciation, the Visitation, the Nativity, the Adoration of the Kings, the Baptism, the Crucifixion, and the Marys at the Tomb. Some niello is lacking. (45.15)

D. 7/8 in (.022 m)

Publications:
Byzantine Art, no. 513; Philippe Verdier, "An Early Christian Ring with a Cycle of the Life of Christ," *BWAG,* vol. 11, no. 3, December 1958, pp. 1-2, ill.
Notes:
The ring reflects an early cycle of the life of Christ as seen on the ampullae of Monza and Bobbio. Three rather similar rings in the British Museum, Palermo, and Dumbarton Oaks all incorporate marriage scenes and are thus considered marriage rings. This example, however, was more likely for a prelate.

Ring 428

Byzantine, 6th-7th century

Plain gold hoop with a high bezel treated with a row of fleur-de-lys in high relief. The bezel is inset with a disc nielloed with a cross within a wreath. (57.1582)

W. 1-3/8 in (.034 m)

Publications:
Byzantine Art, no. 509

Gold Seal Ring 429

Byzantine, 9th century

The bezel is inscribed in Greek in reverse with four lines, which translate "Lord, protect thy servant Michael, the imperial mandator." The shoulders are decorated with vine scrolls and the inscription BOHO(EI) in niello. (57.1053)

D. 15/16 in (.023 m)

History:
F. A. Harman Oates (sale, London, Sotheby, February 1929, lot 14); purchased from Léon Gruel, 1929
Publications:
Marvin C. Ross, "Two Byzantine Nielloed Rings," in *Studies in Art and Literature for Belle da Costa Greene,* 1954, p. 170, figs. 136a, 137a, 138a

Signet Ring 430

Byzantine, 12th century

The gold hoop is deeply incised with ornament, and on the shoulders are rampant lions within pointed ovals. The collar is inscribed with the words of Psalm 26 "Lord, my light and my saviour, whom shall I fear?" The Roman sard intaglio depicts Pan. (57.1580)

D. 1-1/16 in (.027 m) L. of bezel 1/2 in (.013 m)

History:
purchased by Henry Walters before 1931
Publications:
Byzantine Art, no. 518, pl. 65

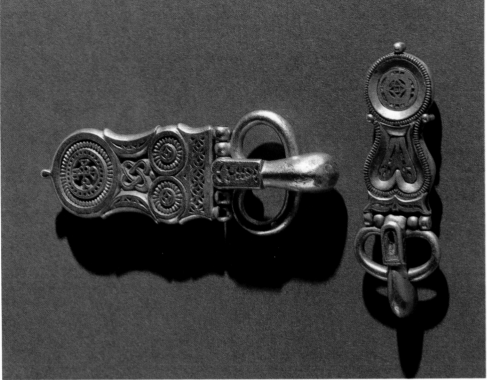

431, 432

428 top

428 side

Buckle 431

Byzantine, 5th-6th century

Gold buckle with deeply chased designs on the tongue and belt plate, including a large beaded circle with a Greek monogram, an interlace, and a pair of smaller beaded circles. (57.545)

L. 3-1/8 in (.079 m) H. 1-1/8 in (.028 m)

History:
said by the dealer Kouchakje to have been found near Hamah in Syria
Publications:
Byzantine Art, no. 468, pl. 66; The University of Notre Dame, *The Arts of Christian Antiquity,* Notre Dame, 1957, no. 24; Randall "Jewellery Through the Ages," p. 76, fig. 5b

Buckle 432

Byzantine, 7th century

Small gold buckle with beaded edges. The round and lyre-shaped sunken areas are pierced with geometric designs which reveal an underlayer of white meerschaum. (57.1891)

H. 13/16 in (.02 m) L. 2-3/8 in (.06 m)

Publications:
Herbert Kühn, "Wictige Langobardische Funde in Amerikanischen Sammlungen," *Ipek,* vol. XII, 1938, p. 179, pl. 59, fig. 5; *Byzantine Art,* no. 469, pl. 66; Cooper Union Museum, *Enamel,* New York, 1954, no. 15

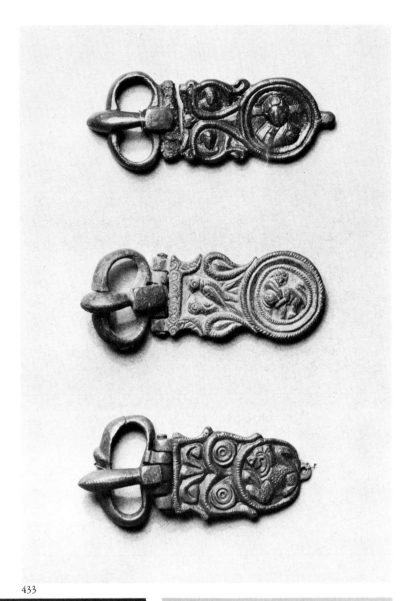

433

434

435

Three Buckles 433

Byzantine, 6th century

Three bronze buckles of the same size and form, each cast with a different pattern: a) with two saints within scrolls and a medallion of Christ; broken in two pieces b) with a pair of birds and Samson and the Lion within a medallion c) with scrolls and a lion within a medallion. (54.2330-2)

L. each 2-3/4 in (.070 m)

History:
Joseph Brummer (sale, New York, April 21, 1949, lot 258)

Pendant Cross 434

Byzantine, 6th century

Small gold pectoral cross of Roman form with splayed ends, set with five cabochon garnets. Tubular ring for suspension. (57.1734)

H. 1-3/16 in (.030 m) W. 7/8 in (.022 m)

History:
collection of Henry Walters, prior to 1931; Mrs. Henry Walters (sale, New York, December 2, 1943, no. 514); gift of C. Morgan Marshall and David Rosen, 1943
Publications:
Byzantine Art, no. 441, pl. 61

Pectoral Cross 435

Byzantine, 10th-11th century

Hollow cross of sheet gold, each arm with a rounded end, emphasized with three bosses and a pierced cross. The central medallion has a roped border, within which is a standing figure of Christ on one side, and a bust of Christ on the other, carried out in blue, red, and green cloisonné enamel. The surfaces are slightly crushed, and the lower arm is bent. (44.153)

H. 2-3/16 in (.056 m) W. 1-7/16 in (.037 m)

History:
purchased by Henry Walters from Leon Gruél, Paris, 1928
Publications:
Byzantine Art, no. 442; Charles Diehl, *Byzantium: Greatness and Decline,* New Brunswick, N.J., 1957, p. 227

Necklace of Ducks 436

Coptic, 4th-5th century A.D.

The necklace is composed of ducks separated by pearls on twisted gold wires. The ducks are stamped of thin repoussé gold in two halves and joined. The clasp is formed of two oval plates of gold stamped with concentric circles and ending in hooks. (57.1727)

L. 1 ft. 10-5/8 in (.575 m)

History:
said to be from Nazareth; gift of Robert Garrett, October 11, 1943
Publications:
The Brooklyn Museum, *Pagan and Christian Egypt,* New York, 1941, no. 132; Marvin C. Ross, "The Genesis and Development of Coptic Art," *Bulletin de la Société d'Archéologie Copte,* 1941, p. 49; *Byzantine Art,* no. 425; *BWAG,* vol. 12, no. 3, December 1959

Necklace 437

Byzantine (Syria), 5th century

Simple necklace formed of a gold wire with a boss at each end. Fastened by a hook and eye. (57.600)

D. 5-3/4 in (.146 m)

History:
purchased from Sheik Ismael, "Sheik of the Pyramids," 1930

Necklace 438

Byzantine, 5th-6th century

Narrow necklace of eight plasma beads separated by pairs of flat openwork diamond beads of gold. Simple loop and hook fastener of gold. (57.1683)

L. 14-3/4 in (.375 m)

History:
collection of Henry Walters; Mrs. Henry Walters; purchased from Joseph Brummer, 1941
Publications:
Byzantine Art, no. 429

Necklace 439

Byzantine, 5th-6th century

Necklace of alternating stones and small pearls strung on gold wire. There are nine pink quartz beads, three of glass, and thirteen pearls. The clasp is formed of two circular openwork disks with Greek crosses and leaves. (57.544)

L. 16-3/8 in (.416 m)

Publications:
Byzantine Art, no. 429

Portion of a Necklace 440

Byzantine, 6th-7th century

Part of a necklace or a long pendant with two coins of the east Roman Emperor Maurice (582-602), two blue stone beads, and a gold biconical bead. The pendant cross is gold incised with circles on the four arms and with a central quatrefoil in which is set a blue glass bead. (57.541)

L. 7-7/16 in (.189 m)

Publications:
Byzantine Art, no. 423

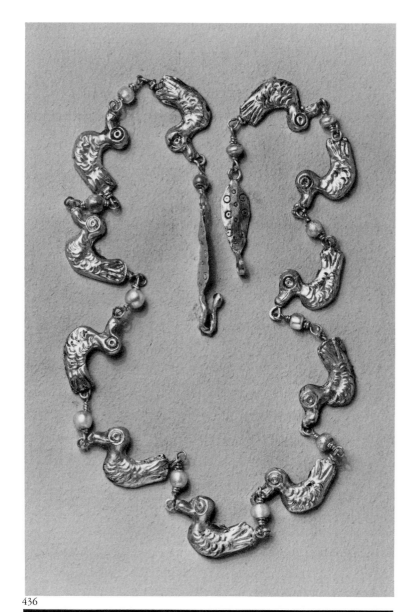

436

437

441

440

Necklace 441

Byzantine, 7th century

Necklace with a chain of circular links, interrupted with three plasma beads set between biconical gold beads. The central ornament is set off with two pearls. The catch is formed of two beaded circles filled with wire openwork. (57.1817)

L. 14-1/2 in (.368 m)

History:
Joseph Brummer (sale, New York, May 11, 1949, part II, lot 9), as Egyptian

Two Pairs of Earrings 442-3

Byzantine, probably from Egypt, 4th-5th century

Simple loops with a single pendant made of gold spacers and four small baroque pearls. (57.594-5, 57.592-3)

L. 2-1/2 in (.064 m) 57.594-5
L. 2-15/16 in (.074 m) 57.592-3

History:
purchased as a group from Sheik Ismael, Cairo, 1930
Publications:
Marvin C. Ross, "A Byzantine Treasure in Detroit," *The Art Quarterly,* vol. 22, no. 3, Autumn 1959, p. 231, figs. 5 and 7

Earring 444

Byzantine, Empire, 5th-6th century

Gold earring set with a sard cut in intaglio with Herakles and a goat. The frame of the stone is a series of petal shapes with traces of colored paste, and below is a gold crossbar with pendant pearls on twisted wires. (57.623)

H. 1-5/8 in (.04 m) W. 1-1/16 in (.026 m)

Publications:
Byzantine Art, no. 440

Earring 445

Byzantine (Syrian or Egyptian) 5th-6th century

Small ball shaped earring with hemispheres of granulation covering the surface. Plain hoop for the ear. (57.586)

L. 15/16 in (.023 m)

History:
purchased September 27, 1913

Earring 446

Byzantine, 6th century

A hoop earring with three pendant plaited chains, each terminating in a hollow gold cross and pendant amethyst. The crosses have striated surfaces, and a central cell, which was originally filled with green vitreous paste, now largely missing. (57.1729)

L. 3-3/4 in (.095 m)

History:
collection of Khawam?; purchased from Dikran Kelekian; Mrs. Henry Walters (sale, New York, Parke Bernet, December 2, 1943, lot 519); purchased 1943
Publications:
Byzantine Art, no. 479

439, 446

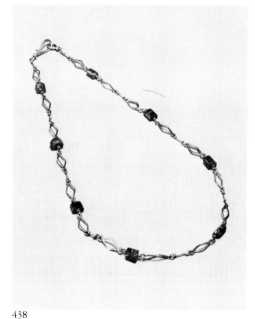

438

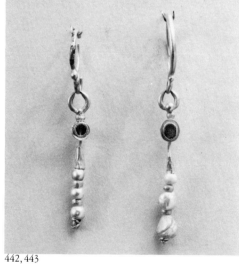

442, 443

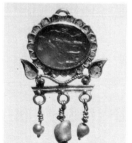

444

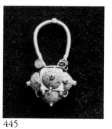

445

447

448

449

Pair of Earrings 447
Byzantine, 6th century

Loop earrings with three pendants of small chain links, ending in a small baroque pearl. (57.575-6)

H. 3-1/16 in (.077 m)

History:
purchased from Sheik Ismael, Cairo, 1930
Publications:
Marvin C. Ross, "A Byzantine Treasure in Detroit," *The Art Quarterly,* vol. 22, no. 3, Autumn 1959, p. 231, figs. 5 and 7

Pair of Earrings 448
Byzantine, 6th century

Crescent-shaped earrings with a hollow gold body decorated with filigree. Plain loop for the ear. (57.1570-1)

W. 1-3/8 in (.035 m)

History:
purchased from Dikran Kelekian, Paris, December 16, 1926

Pair of Earrings 449
Early Byzantine, 6th century

The outer edge of the hollow hoop is lined with granules. A convex shield, dotted in the center, is situated at one end of the hoop; a rigid ring ornament is attached to the bottom. The hoop and granules are completely worn through on one side exposing their interiors. (57.606-7)

Notes:
Similar earrings have been found in Sicily together with coins of the Emperor Tiberius II (A.D. 578-582) (*Byzantinische Zeitschrift* 19, 1910, p. 464, no. 3, pl. II:1, p. 474, fig. 16). Related earrings are in Berlin (Greifenhagen, Berlin II, 65, pl. 51:11) and the Dunbarton Oaks Collection, Washington, D.C. (Ross, Dumbarton Oaks II, 1965, 66, no. 85, pl. 48).

Pair of Earrings 450
Byzantine, 10th century

The earrings are made of semi-circular bands of cloisonné enamel, now largely deteriorated, above which are roundels showing busts of Christ and the Virgin. The borders are done in triangles of granulation and small circlets of gold wire. The surface is decorated with three gold balls, and two larger ones were the terminals of the loops, both of which are missing. (44.300-1)

L. 1-3/8 in (.034 m)

History:
purchased from Daguerre, Paris, 1926
Notes:
for dating see H. Schlunk, "Eine Gruppe Datierbarer Byzantinischer Ohrringe," *Berliner Berichte,* vol. 61, Heft 3, 1940, pp. 42-47, fig. 5

Pair of Earrings 451
Byzantine, 6th century

From a central semicircle decorated with filigree spring five radial bars. The bars expand slightly, are decorated with filigree borders and granulation, and terminate in openwork filigree patterns. (57.1574-5)

L. 2 in (.05 m)

History:
purchased from Dikran Kelekian, Paris, December 16, 1926
Publications:
Byzantine Art, no. 478a, pl. 64

Pair of Earrings 452
Byzantine, 10th century

The gold circular loop is decorated with filigree of braided wire on its inner face and with alternating triangles of granulation and filigree balls terminating in small pearls. A gold button ornaments the catch. (57.1587-8)

D. 2-9/16 in (.065 m)

History:
purchased before 1931
Publications:
Byzantine Art, no. 478a; Deer, "Mittelaltarliche Frauenkronen," p. 448, fig. 59e

Pair of Earrings 453
Byzantine, 11th century

The body is a rectangular openwork panel decorated with filigree and granulation, with a lower row of six pearls and a central filigree pendant with a blue stone (one missing). (57.1572-3)

W. 1-5/16 in (.033 m)

History:
purchased from Dikran Kelekian, Paris, December 16, 1926
Publications:
Byzantine Art, no. 487a, pl. 64

Gold Earring 454
South Russian, 11th century

A large loop decorated with three openwork balls of filigree, separated by two circles of filigree. The plain half loop is hinged and secured with a pin. (57.1823)

D. 1-3/4 in (.044 m)

History:
Joseph Brummer (sale, New York, May 12, 1949, lot 253)
Publications:
Byzantine Art, no. 485, as Langobard, 7th century

451, 452, 453

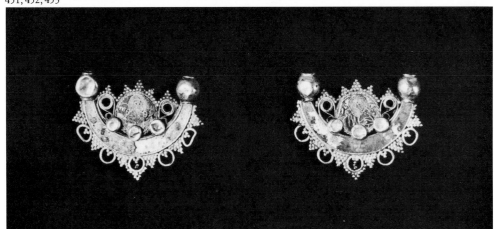

450

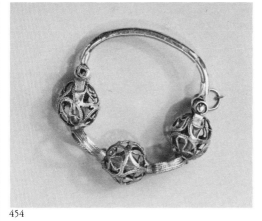

454

Two Earrings 455-6

Russian (Kiev) 11th-12th century

455. Large gold crescent shaped earring (*kolt*) formed of two shaped discs with a simple loop at the top for the ear. Decorated on the front with addorsed birds divided by a small spade-shaped tree in cloisonné enamel of red, green, blue, and off-white. The back is divided into small geometric areas of enamel. (44.297)

W. 1-15/16 in (.049 m)

456. Crescent shaped earring (*kolt*) of electrum, formed of two shaped discs with two ring attachments for the ear loop. Decorated on the front with two addorsed birds separated by geometric designs in cloisonné enamel of red, green, blue, and white. The back was divided into geometrically shaped areas of enamel, which are now missing, and several of the openings have been enlarged. (44.302)

W. 1-7/8 in (.048 m)

History:
456 only, said to have been found in Constantinople; purchased from Daguerre, Paris, 1925
Publications:
Byzantine Art, no. 828; Ross and Downey, "An Emperor's Gift," p. 30, footnote 28; Philippe Verdier, *Russian Art,* Baltimore, 1959; Tamara T. Rice, *A Concise History of Russian Art,* New York, 1963, p. 95, pl. 76; Randall "Jewellery Through the Ages," p. 76, fig. 6a
Notes:
Ross surmised that while these earrings are of Kiev workmanship, they were common to the Byzantine world and stemmed from earlier Constantinopolitan models.

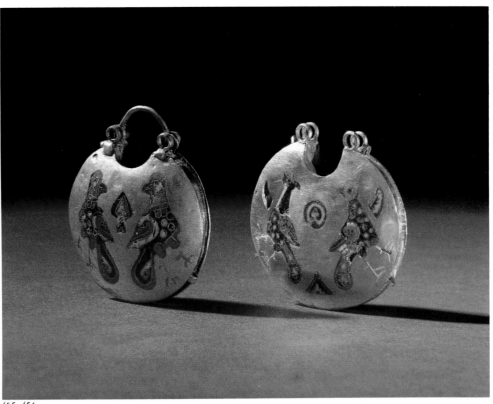

455, 456

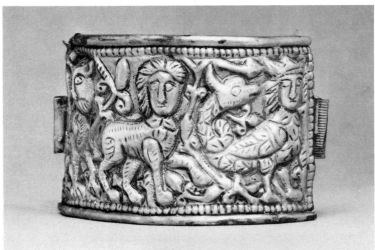

458

457

Earring 457

Byzantine (Balkan ?), 12th century

A silver crescent shaped earring embossed on the front with a gilt pair of intertwined birds within a beaded circle. The outer borders of applied wire include a band of triangular and circular ornaments, two loops of twisted wire, and an outer beaded border. The ear loop was attached to paired rings at the top, one of which is lacking. The back is embossed with the identical design, and is deeply dented. (57.1073)

H. 2-1/4 in (.057 m) W. 2-5/16 in (.059 m)

History:
said to have been found in Constantinople; purchased from Joseph Brummer, 1920s
Publications:
Byzantine Art, no. 490; Ross and Downey, "An Emperor's Gift," pp. 22 ff., fig. 5
Notes:
A nearly identical earring is in the National Museum, Budapest without a history. Ross surmised that these were either made in Constantinople or inspired by Constantinopolitan work.

Bracelet 458

Byzantine (Balkan) 12th century

Half of a silver bracelet embossed with a procession of animals and mythical beasts. From left to right are a lion, a sphinx, and a harpy with dragon tail, divided by tendrils and plants. Beaded border with a plain outer turnover. A cylindrical central section of hinge at each side, one of which has been repaired. (57.710)

H 2 in (.05 m) W. 2-7/8 in (.073 m)

History:
said to be from Yugoslavia, purchased from Joseph Brummer
Publications:
André Alföldi, "Études Sur Le Trésor De Nagyszentmiklós, I." *Cahiers Archéologiques,* vol. V., 1951, p. 132, pl. IV, no. 7; Ross and Downey, "An Emperor's Gift," p. 30, fig. 10

Pendant Seal 459

Byzantine, 12th century ?

A small racquet-shaped silver seal with a ring for suspension. The broad end is shaped like a cockle shell and is carved with the standing Madonna with a kneeling monk at her feet. The inscription translates "Mother of God, Theotoke, help thy servant John." (57.1008)

L. 1-1/8 in (.028 m)

History:
purchased from Joseph Brummer, New York, 1925
Publications:
Byzantine Art, no. 447; Ross and Downey, "An Emperor's Gift," p. 32, fig. 14

Reliquary Pendant and Cross 460

Byzantine (Greek), 16th century

The jewel is formed of a hinged reliquary case with compartments for six relics and a small pectoral cross. The front of the gold pendant has a large amethyst cameo of the Virgin and Child set within a border of cabochon emeralds, rubies and pearls against a ground of filigree. The back is decorated with similar filigree set with a large green stone in the center, a circle of six cabochon rubies, and outer circle of green stones, rubies, and pearls. The outer edge of the pendant has a border of fifteen pearls in filigree settings. The hinge is broken.

The inner face of the back-plate of the reliquary is decorated in niello with a floral pattern surrounding the spaces for the relics. The small cross from the reliquary is of gold with a figure of Christ in niello on a hatched ground with inscriptions. There are two pearls on either side of the suspension loop.

The inscription translates: "Arsenius, the most holy metropolitan of Serres and hyper-timos (and) substituting for (the metro-politan of) Cesaria-Capadocia, God be helper." There are three other conventional religious inscriptions in Greek. On the

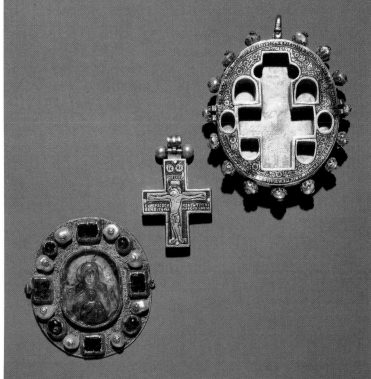

459

460

edges of the pectoral cross is a second inscription to the same Arsenius, translated: "Dedicated by the most holy Metropolitan of Serres, Arsenius, to the monastery of the Holy Trinity called Esoptron on the Island of Chalke." The Metropolitan Arsenius, who is known from three other inscriptions, was Metropolitan of Serres in the mid-16th century. (57.1511a, b, c)

H. 3-1/8 in (.079 m) W. 2-13/16 in (.071 m)

Cross: H. 2-1/16 in (.052 m)

History:
purchased by Henry Walters before 1931
Publications:
Byzantine Art, no. 448; Marvin C. Ross and Basil Laourdas, "The Pendant Jewel of the Metropolitan Arsenius," *Essays in Honor of Georg Swarzenski,* Chicago, 1952, pp. 181-184

Bronze Pectoral Cross 461

Byzantine (Palestine), 7th century

The front of a pectoral cast in bronze with the figure of the Virgin, and the busts of four saints in the cross arms. It was hinged at the top, and one loop of the hinge remains. In excavated condition. (54.2308)

H. 3-5/8 in (.092 m)

History:
purchased 1946
Publications:
The University of Notre Dame, *The Arts of Christian Antiquity,* Notre Dame, 1957, no. 12

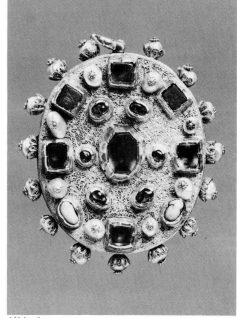

460 back

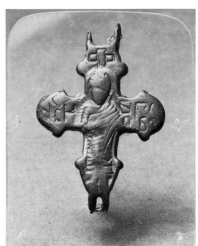

462

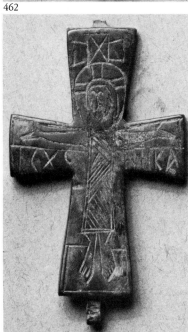

464

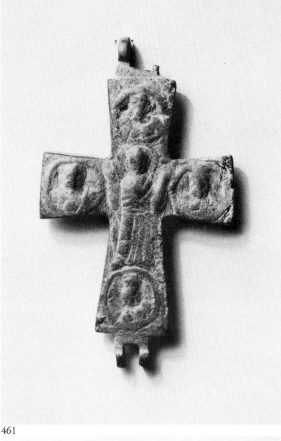

461

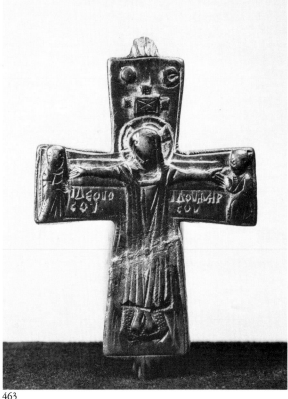

463

Bronze Pectoral Cross 462

Byzantine (possibly Syrian), 6th-7th century

A small pectoral cast with the figure of the standing Christ with a cross above his head and inscriptions, now worn, in each arm of the cross. The cross was hinged at the top; the back is missing. (54.2352)

H. 2-1/16 in (.052 m)

History:
Joseph Brummer (sale, New York, May 12, 1949, lot 288)

Bronze Pectoral Cross 463

Byzantine, 6th-7th century

The front of a cast cross with the figure of the crucified Christ wearing the colobium, with the busts of the Virgin and St. John in the cross arms, and the sun and moon above. Inscribed below the arms of the cross. Back missing; the cross repaired. (54.59)

H. 3-5/16 in (.084 m)

History:
purchased by Henry Walters from Joseph Brummer, 1925
Publications:
Dallas Museum of Fine Arts, *Religious Art of the Western World,* Dallas, 1958, no. 86, ill. p. 9
Notes:
for the reverse of a similar cross, see Collection Hélène Stathatos, catalogue, Strasbourg, pl. VI, no. 62.

Bronze Pectoral Cross 464

Byzantine, 11th century

The front is engraved with a stylized figure of the crucified Christ wearing the colobium. It was hinged at the top and the back is lacking. (54.2368)

H. 3-1/8 in (.079 m)

History:
purchased from A La Vielle Russie, New York, 1949

Bronze Pectoral Cross 465

Byzantine, 11th century

The front of the cross is engraved in a highly stylized manner with the praying Virgin with the Christ Child between ángels; the reverse with a medallion bust of a saint. The cross is hinged on the suspension ring to reveal a cavity for a relic, and is secured at the base by a tripartite latch. (54.2367)

H. 4-3/4 in (.12 m)

History:
purchased at A La Viella Russie, New York, 1949

Cameo of St. Irene 466

Byzantine, 11th-12th century

A garnet bead carved in high relief with the full-length standing figure of St. Irene whose name is inscribed on either side of her. The bead is centrally drilled, and somewhat worn at each end. (42.1436)

L. 3/4 in (.019 m)

History:
purchased at the Joseph Brummer (sale, New York, May 12, 1949, lot 232)
Notes:
A second bead of similar size with the bust of St. Procopius was in the collection of San Giorgi, Sangiorgi, Rome.

Cameo Pendant 467

Italo-Byzantine, 13th century

A sardonyx cameo finely cut in high relief in upper tawny brown layer on a white ground. The cameo shows the bust of a Hohenstaufen Emperor, rendered full face with crown of laurels, armor, and paludamentum. The gold mount is probably modern. (42.1428)

H. 1 in (.025 m)

History:
collection of John Hunt, Dublin; purchased 1946
Publications:
Byzantine Art, no. 553; Hans Wentzel, "Die vier Kameen in Aachener Domschatz," *Zeitschrift für Kunstwissenschaft,* vol. VIII, nos. 1-2, 1954, p. 9, fig. 26; G. Kaschnitz-Weinberg, Bildnisse Friedrichs II, Von Hohenstaufen," *Mitteilungen des Deutschen Archäologischen Instituts Römische Abteilung,* vol. 62, 1955, pp. 50-51, pl. 21 (2); The Metropolitan Museum, *The Year 1200,* New York, 1970, no. 335, p. 325, ill.; Württembergisches Landesmuseum, *Die Zeit der Staufer,* Stuttgart, 1977, vol. 1, no. 861, pp. 677-678, vol. 2, fig. 635

Virgin and Child Pendant 468

Byzantine, 18th century

The Virgin nursing the Christ Child is carved in high relief on a square of steatite with cut corners. There are two holes for suspension. The inscription is illegible. (41.231)

H. 1-1/16 in (.027 m) W. 1-3/16 in (.030 m)

History:
collection of Henry Walters; Mrs. Henry Walters; Joseph Brummer; gift of Miss Julia R. Rogers, 1941

466

467

468

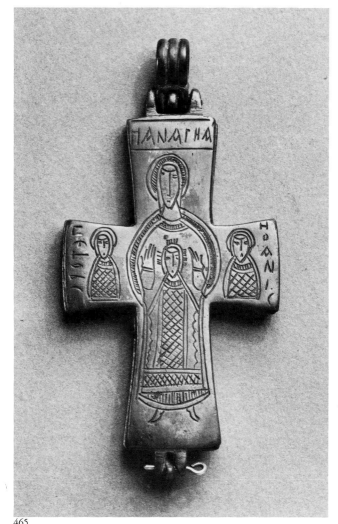

465

Above: In the border of a page from a German Book of Hours made for Cologne in the early 16th century are a series of gold and enamel jewels. Shown as if suspended by gold chains from small gold pins, they include a quatrefoil pendant in gold and stones, a yellow enameled pansy brooch, two trefoil jewels in gold and stones and in gold, pearl, and enamel, probably referring to the Trinity, and a pectoral cross inlaid with five stones. The border is further filled with pearls and tiny pendants suspended from fine chains, and elsewhere in the manuscript are rosaries of coral and pearls. The border surrounds a miniature of the Mass of St. Gregory. (W 10.437, folio 63 verso) **Facing:** Two 15th-century ladies choosing jewelry in a goldsmith's shop, shown in a marginal miniature from a Flemish Book of Hours, about 1490. (W 439)

Medieval Jewelry

In the later Middle Ages, from the 12th to the 15th centuries, jewelry was worn sparingly by both men and women. Medieval costume was relatively simple, often of heavy wool, and a brooch or clasp at the neck was the chief ornament of the period. In addition there were occasional belt buckles of precious and gilt metal, and a large variety of finger rings of silver and gold.

The materials were carefully selected, as every precious stone was seen in the light of its special properties and amuletic value. Many stones were thought to have certain protective significance, such as the sapphire so often used in bishops' rings. The sapphire, according to the lapidary tradition, made its wearer beloved of God and man, in addition to protecting him from injury, fraud, and terror. The green toadstone, which was thought to be found in the forehead of the toad, was believed to cure dropsy, and the amethyst to prevent drunkeness.

More exotic materials like unicorn's horn, coral, and ancient flint arrowheads, which were called "serpent's tongues," were suspended around the neck or used in jewels for their prophylactic value. Each of these materials was thought to be useful in detecting poison, but some had other traits as well. Coral was a general protection against disease and was sometimes related to strengthening the heart. Its use as an amulet around the necks of children probably led to the habit of using it for teething in the Renaissance and later. An early depiction of it may be seen around the neck of the Christ Child in the Madonna and Child by Barnaba da Modena, dated 1367, in the Staedel Institute, Frankfurt.

In addition to the materials themselves, there was great faith in the protective quality of inscriptions, particulary religious ones. Many brooches and rings bear Gabriel's salutation — "Ave Maria," the name of JESUS, or the INRI inscription from the Crucifixion. The names of the three kings—Caspar, Balthasar, and Melchior—were used to protect travelers, and also as a protection against epilepsy. The 1380 inventory of King Charles V reveals that he owned a brooch with their names. Naturally the name of a patron saint was often employed as a protective inscription.

The literature of the 14th and 15th century indicates that many magical words were recommended for engraving upon rings or jewelry. Each constellation and zodiacal sign was given a magic word, and certain words were employed to prevent specific diseases. As a charm against falling sickness the word *Ananazpata* was used, and against toothache the words *BURO Berto Berneto*. The word *AGLA* is thought to have had amuletic importance. It is usually interpreted as standing for *Atha Gebri Leilan Adonai* (Thou art mighty for ever, oh Lord), and is seen on the front of a tiny gold brooch (no. 471) in the Walters collection. However, the brooch has a double level of meaning, for on the back is the further inscription "Io fas amer e doz de amer," which can be translated "I am love and the gift of love." If the recipient's name was Anne or began with an A, which is likely, then there would be a third level of interpretation.

Certain medieval jewels were symbols or badges of office. Every bishop received a ring at his consecration, a tradition related to the use of papal rings as signs of authority. Messengers and marriage brokers wore emblems of their office, as can be seen on the figure in the background of the Merode Altarpiece, by the Master of Flemalle, at The Cloisters. In an account of 1420 the Duke of Burgundy pays a goldsmith for twenty silver badges of the arms of Burgundy to be worn by the knights and officers of his household.

Often such badges were made of lesser materials like lead, and many of these have been recovered from the River Seine and are now in such collections as the Cluny Museum and the Walters Art Gallery. Some indicate political affiliations and were worn as hat badges or attached to the costume. Others are signs of pilgrimages and indicate that the wearer had traveled to Santiago de Compostella or some other great religious shrine. The custom of wearing such pilgrim badges is recorded as early as 1183 in the Chronicles of Saint Denis where the badge of Our Lady of Puy is carefully described.

Necklaces were rather uncommon until the 15th century, as indicated both by representations and by inventories. An unusual example in gold and enamel formed "like the leaves and branches of May" is recorded in the French royal accounts for 1404. As the 15th century progressed a number of orders of chivalry, like the Order of the Golden Fleece of the Duke of Burgundy, were founded and elaborate collars were provided for the members. Simple gold chains for men are seen in Flemish portraits of the early to middle years of the century.

The hat badge became an accepted part of men's daily costume in the later 15th century, and the tradition continued into the 16th. Certain types of jewelry such as earrings are almost unknown, though they are referred to in the *Roman de la Rose,* written about 1300. The statue of St. Foy at Conques, curiously wears earrings, which may reflect the influence of Byzantium on the Crusaders. Bracelets, too, are virtually never mentioned and only a few have survived such as the one of heart-shaped links with the life of Christ in translucent enamel in the Residenz, Munich.

In the 13th century, the study of the classical past brought about an interest in cameos and engraved gems. They were often used to decorate reliquaries and shrines, and occasionally were incorporated in personal jewelry. The finest of those surviving is probably the Schaffhausen Onyx, a

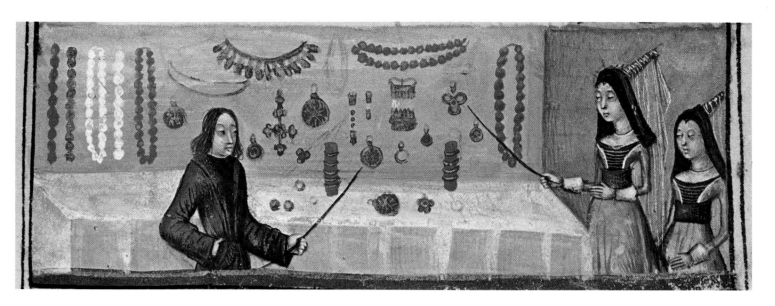

magnificent 1st century Roman cameo, in a German mounting of the mid-13th century. Another example is the lion and dog cameo, with a subject thought to be proof against epilepsy, mounted in a 14th century openwork leaf frame and now in the collection of the Victoria and Albert Museum.

A few superb medieval cameos exist, largely made for the Burgundian court, after the fashion of the antique. One is a ring with a portrait cameo of Duke Jean sans Peur of the early 15th century, and another is a large brooch with the portrait of the Burgundian courtier, Robert de Masmimes. In 1401 the Duke de Berry ordered several rings with his cameo portrait.

There is considerable information on the finest jewelry made for the kings of France and England and their nobility, because of the survival of their household accounts. Little of what is documented is preserved and the many minor jewels of the citizenry are less known and also have remained intact only by chance. The medieval jewels shown here were found in drains or mires where they were lost in medieval times. Most jewelry, because of its materials, was melted down in later times.

Crowns and royal insignia have survived somewhat better as they were often dedicated to shrines and cathedrals. The reliquary crown of Saint Louis, preserved in the Louvre, is replete with cabochon jewels, cast figures of angels in silver-gilt, and filigree. This standard of quality can be seen in the large religious ring, probably for an English bishop, with a bezel of openwork eagles and a religious inscription, which is set with a toadstone (no. 474). Another ring of nearly identical design and certainly by the same goldsmith is in the British Museum and was excavated at Cannington, Somersetshire.

Other religious jewels include rosary beads, which were made of ivory, jet, wood, precious metal, and gemstones. The boxwood paternostre beads of Flanders were famous and widely disseminated in the 15th century. What is unusually rare is a paternostre with two scenes in translucent enamel on gold (no. 479). This so-called "Spitzer" jewel opens to show the Entry into Jerusalem and "the Doubting Thomas" in multicolored enamel on gold. The exterior of the bead is not carved of boxwood as would have been usual but has two scenes modeled in wax set beneath rock crystals.

Equally remarkable is a pendant of the Virgin of the Immaculate Conception in opaque painted enamel (no. 478). The reverse depicts the head of the Emperor Augustus who saw the vision of the Immaculata in the sky. The pendant was produced about 1440 by the same school of Flemish enamelers who produced the "Monkey Cup" at The Cloisters and two related spoons. Other pendants of the 14th and 15th centuries in translucent enamel on silver and

gold are also known, but their fragility and material suggest that only a small proportion of what existed has survived.

The technique of encrusted enamel on gold, which became the standard for pendant jewels in the Renaissance, developed early in the 15th century. A number of them take the form of circular brooches or hat badges in low relief decorated with enamel. The surviving pieces are rather consistent in style and were made largely for the Burgundian court. There is a famous brooch with two figures in the round in the Kunsthistorisches Museum, Vienna, and a rare necklace with links in the form of enameled leaves in the Cleveland Museum of Art.

German traditions favored gold necklaces of massive scale, well illustrated in the Cranach portraits of Saxon princesses. Often three or four necklaces were worn at the same time. The German merchant class, however, wore simpler jewels of silver-gilt, often of large size, like the Virgin on the sickle moon within a garland of roses (no. 481).

Mother-of-pearl reliefs were worn both as ecclesiastical mantle clasps and secular pendants in Germany. The designs followed those by the Master E. S. and the Master of the Housebook and examples exist reflecting known prints. The invention of printing expanded the goldsmiths' horizon, and the advent of the 16th century saw a total change in the approach to jewelry design with the dissemination of master designs by major artists.

A new era of jewelry corresponding to the influx of gold from the Americas, changed entirely the modest medieval attitude toward jewelry.

Richard H. Randall, Jr.

French (Paris), second quarter of 14th century

These three clasps or morses for copes or ecclesiastical vestments are of a coarse champlevé enamel on a thin copper ground. Their style relates to Parisian enamels of the period 1325-1350, which include the ewer and paten in Copenhagen, but more especially the figures surrounding the base of the silver gilt Virgin of Jeanne D'Evreux of 1339 in the Louvre.

The morses are all of the quatrefoil form, but with distinct variations in the projections between the arms of the quatrefoil, and the copper gilt body is enameled with blue, red, and white, in one instance the figure subjects being in engraved copper reserve. Two are pierced around the edge with holes to sew them to the garments, while the third was riveted.

a. Two bishops beneath trefoil arches are shown against a field of blue enamel with copper flowers with red enamel centers, and flank the Virgin and Child on the central narrow plate which swivels on the connecting pin. The bishops are surrounded by a series of monsters and grotesques in copper reserve against a red ground. Four cut rivets at the corners were used for attachment and most have been capped with cabochon jewels or other ornaments which have been lost. (44.251)

H. 6-1/8 in (.155 m) W. 6-1/2 in (.165 m)

History:
collections of P. Soltykoff (sale, Paris, April 8 - May 1, 1861, lot 212); F. Spitzer (sale, Paris, 1893, lot 281, pl. IX); Chalandon, Lyon; purchased from Daguerre, Paris, 1927

b. Decorated with the Annunciation, the Virgin and Gabriel being similarly placed against a blue ground with copper and red flowers, in this case under triple arches. The surrounding red enamel areas have six dragons in copper reserve, but the copper gilt borders are treated with punched patterns and incised leaves. The central plate and pin are lacking and the pin restored. (44.115)

H. 5-9/16 in (.141 m) W. 5-1/8 in (.130 m)

History:
collection of Chalandon, Lyons; purchased from Daguerre, Paris, 1927

469a

c. The third clasp employs three colors of enamel and is a simple quatrefoil. Two candle-bearing angels with white enamel details beneath trefoil arches, flank the Virgin and Child on the plate decorating the pin. They are surrounded with dragons in lozenges of red enamel, divided by triangles of red enamel with central white flowers. Three areas of the border have been broken away, including the dragon figure beneath the angel in the left valve, and much enamel is missing. (44.325)

H. 5-1/4 in (.133 m) W. 5-7/16 in (.138 m)

Publications:
Marie-Madeleine S. Gauthier, *Émaux du Moyen Age Occidental,* Fribourg, 1972, p. 379, no. 146; The Rhode Island School of Design, *Transformations of the Court Style,* Providence, February 1977, no. 26, p. 79

Clasp for a Cope or Secular Garment 470
French (Limoges), late 13th century

While most morses or mantel clasps that have survived from the middle ages are clearly of ecclesiastical origin, this example could as well have served to fasten a cloak or secular garment. It is carefully made with a series of holes around the border to sew it to a garment. The original pin, which would have had a large head to make it easy to remove, is missing and has been replaced by a modern one.

The field of each valve is decorated with three cabochon gems in floral settings and a series of large and small stylized flowers carved in intaglio from the copper. The field is blue enamel, leaving the copper gilt flowers in reserve. The entire clasp is framed in a filed roped border within an outer border of incised petals. (44.16)

H. 3-5/16 in (.085 m) W. 4-1/4 in (.108 m)

History:
collection of Victor Gay (sale, Paris, March 23, 1909, lot 35); purchased from Daguerre, New York, 1924

471, 472, 473

474

478

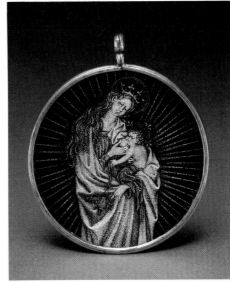

478

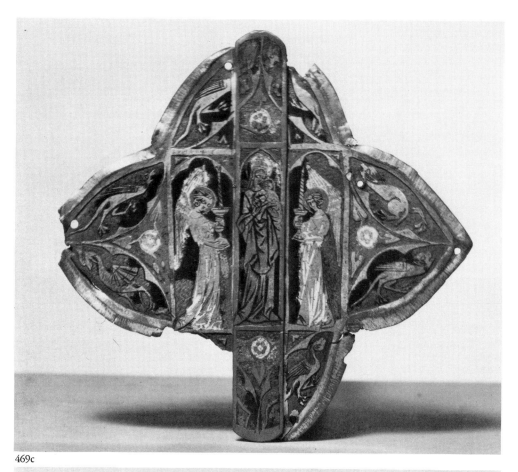

469c

470

A-Shaped Brooch 471
English, 13th century

Shaped as an A and made of gold and stones, the brooch is hatched and engraved with the magical word AGLA which is interpreted "Atha Gebri Leilan Adonai" (Thou art mighty for ever, O Lord). On the reverse is inscribed "Io fas amer e doz de amer" (I am love and the gift of love). (57.1987)

H. 5/8 in (.015 m)

History:
collections of Warne, England, about 1830; Victor Gay, about 1887; John Hunt, Dublin; purchased 1969
Publications:
Victor Gay, *Glossaire Archéologique*, Paris, 1887, vol. 1, p. 1

Brooch 472
English, 13th century

This tiny gold and sapphire brooch is formed of a ribbed ring, inscribed on the inner face AVE MARIA. On one side of the ring emerge a pair of praying hands, while the other has a raised mount for a single sapphire. (57.1988)

L. 1 in (.025 m)

History:
collection of John Hunt, Dublin; purchased 1969

Silver Ring Brooch 473
English, 14th century

Found at Clitheroe, Lancashire in a drain in the 19th century, this ring brooch is inscribed IESUS with the ground cross-hatched between the letters. Shaped tongue. (57.1990)

D. 1 in (.025 m)

History:
collection of John Hunt, Dublin; purchased 1969

Prelate's Ring 474
English, 13th century

A bishop's gold and malachite ring of unusual quality, the malachite probably intended to represent "toadstone", a green stone said to be found in the head of a toad, which was believed to cure many afflictions. The hoop terminates in animal heads, and is inscribed AVE MARIA GR/ATIA PLENA D/. (Hail Mary Full of Grace). The bezel is pierced with a band of openwork eagles, and there is an upper border engraved with floral ornament. (57.481)

H. 1-1/4 in (.031 m) W. 1-1/4 in (.031 m)

Notes:
A nearly identical ring, set with a sapphire, was excavated at Cannington, near Bridgewater, Somerset in 1924 and is in the British Museum (Ormonde M. Dalton, "A Medieval Gold ring found at Cannington," *Antiquaries Journal*, vol. V, 1925, pp. 298-299; Charles C. Oman, *British Rings 800-1914*, London, 1974, plate 26a).

Stirrup Ring 475
English, 13th century

This elegant gold stirrup-shaped ring, set with a small sapphire, was found near Bottesdale, Suffolk. (57.1986)

L. 1-1/8 in (.028 m)

History:
collections of Warne, England, about 1830; John Hunt, Dublin; purchased 1969

Silver Thumb Ring 476
English, 14th century

Shaped with eight raised facets, which are inscribed IHESUS N in gothic letters. (57.1989)

D. 1-1/16 in (.027 m)

History:
collection of John Hunt, Dublin; purchased 1969

Signet Ring 477
German, about 1500

Gold ring with faceted hoop, engraved at the shoulders with a man and woman in late medieval secular dress. Between them on the hoop is plant ornament, now much damaged, and on the facets of the hoop is engraved gothic foliage. The octagonal bezel has a cabled border, and the signet displays a shaped tilting shield charged with a rampant lion with a billet (or flute) in his mouth, surmounted by the initials +S+K+, within a cabled border. (57.2050)

D. 1 in (.026 m)

History:
collection of Melvin Gutman (sale, Parke-Bernet, May 15, 1970, Part V, lot 121); purchased from Mrs. Ruth Blumka, January 1979

475

476

477 side

477 top

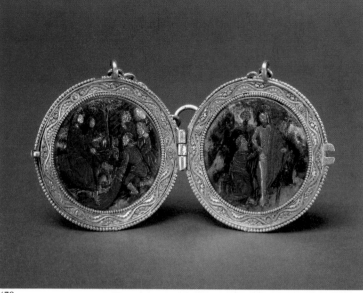

479

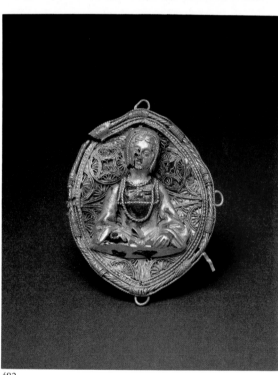

482

Pendant with the Virgin and Child 478
Flemish, about 1420

A silver pendant enameled on one side with the head of the Emperor Augustus and on the other with his vision of the Virgin and Child on the sickle moon. The painted enamel relates to the Monkey Cup at The Cloisters, New York, and to two spoons in the Victoria and Albert Museum, London, and the Museum of Fine Arts, Boston, respectively, all of which are decorated with secular subjects. The figures are in grisaille with gold details, against a ground of midnight blue. The edges of the pendant are gilt. (44.462)

D. 2 in (.050 m)

History:
collection of F. W. B. Massey-Manwaring; purchased from Harding, London, before 1931
Publications:
Steingräber, *Alter Schmuck,* p. 62, fig. 94; Philippe Verdier, "A Medallion of the 'Ara Coeli'," *JWAG,* vol. XXIV, 1961, p. 9 ff.; *Europäische Kunst um 1400,* Vienna, 1962, no. 495; Willy Burger, *Abendländische Schmelzarbeiten, Berlin, 1930, p. 163;* The Walters Art Gallery, *The International Style,* Baltimore, 1962, no. 136

Pendant with Translucent Enamel 479
Probably North France, about 1470

Two scenes in translucent enamel on silver ornament the interior of a hinged gold locket. The left hand scene is the Entry into Jerusalem where the artist has employed purple for Christ's robe and red, green, blue, and purple for the figures and background. The right hand scene is the Doubting Thomas carried out in the same colors. Both are set within a gold border engraved with a wavy line separating two patterns of plant ornament.

The exterior of the locket has two scenes framed by a roped garland of gold within two pearled borders. The scenes are carried out in brown wax, in imitation of boxwood, set against blue-painted backgrounds dotted with gold. The left scene is the Ecce Homo and that on the right, the Mourning over the Body of Christ. Both are covered with disks of rock crystal. (44.590)

D. 1-1/2 in (.038 m)

History:
collections of Passavant; Spitzer (sale, Paris, 1893, lot 1787); Henry Walters; gift of Mrs. John Russell Pope, 1943
Publications:
Frédéric Spitzer, *La Collection Spitzer,* III, (Bijoux), Paris, 1891, plate 1, no. 2

Pendant Crucifixion 480

German, late 15th century

A small cast pendant of silver gilt showing the Crucifixion, with Mary and John. The cross is of the rugged type with a ruby set at the foot and an architectural capital at the base and top, each attached to a striated ring. (57.654)

H. 2-3/8 in (.060 m)

History:
purchased before 1931

Virgin and Child in Glory 481

German, early 16th century

The Apocalyptic vision of the Virgin and Child in Glory, the so-called "Rosenkranz Maria," was a favorite subject of late Gothic Germany where it was to be seen in great cathedral chandeliers and miniature objects. The figure of the Virgin is depicted within an aureole of roses, her feet on the sickle moon, surmounting the world, and her head about to be crowned by angels; the entire vision seen against a glory of light. The present pendant jewel of cast silver with gilded details has a roped ring for suspension and another at the base for the attachment of a pendant. The emphasis on the necklace as the chief ornament of German women's costume at the period accounts for its large size. (57.1991)

H. 4-3/4 in (.012 m)

History:
collection of Melvin Gutman (sale, Parke-Bernet, April 24, 1969, lot 11); purchased from L. Blumka, New York, 1970

481

Dress Ornament or Hat Badge 482

Probably Spanish, about 1500

The figure of a lady is embossed in gold and set against a background of circles and semi-circles of filigree. There is a triple border of roping, the heavy outer rope being bound transversely at various points of its circumference. The lady's dress retains much red enamel, and other red fragments appear on the sill below her hands. Three of the four loops for attachments are preserved. (44.351)

H. 2-1/8 in (.053 m)

History:
said to have been bought in Boulogne-sur-Mer; purchased from Arnold, Seligmann, Rey, and Co., New York, 1926

Publications:
Steingräber, *Alter Schmuck*, p. 91, fig. 149; Randall, "Jewellery Through the Ages," p. 78

480

483

483

Pair of Hat Badges 483

Flemish, early 16th century

Made in the same workshop, these two silver hat badges with niello decoration show two different styles. One, with the Visitation group against a landscape, is based on a 15th-century model, and the other, with the Veronica's veil suspended from a dove, shows a more florid early 16th-century style. Each had three loops for attachments, two of which are lacking on the Visitation example. (45.1-2)

D. of each 1-7/8 in (.048 m)

History:
purchased before 1931

Sharpshooter's Prize Medal 484

Flemish (North Brabant), 16th century

This medal and bird pendant were the prize for the "king" of a Flemish shooter's guild—the Guild of Saint Anthony and the Holy Virgin of the town of Linden, North Brabant. The crowned silver parrot pendant is the symbol of the "king" of the guild, and it is suspended by silver chains from the guild's medal with the Tau of St. Anthony inscribed IHS beside the Virgin and Child, within an engraved border of flowers with the inscription "Sancta Maria Schot van Linden." Each chain passes through a pierced silver ball, and there is an openwork floral hook at the top for suspension. The hook and the bird bear 19th century French tax marks. (57.1933)

L. 10-3/4 in (.273 m) D. of medal 2-1/8 in (.053 m) L. of bird 3-3/4 in (.095 m)

History:
purchased from L. Blumka, New York, 1967
Notes:
a second example of the Linden prize is in the collection of Museum Vleeshuis (*Schatten van de Vlaanse Schuttersgilden,* Antwerp, 1966-67)

484

The Jewelry of the Renaissance

During the Renaissance the art of jewelry reached new levels of opulence and artistry, for prodigal expenditure on objects of personal adornment was matched by the genius of goldsmiths whose designs and skills mirrored in miniature the achievements of the age in painting and sculpture. Courtly patronage provided a consistent stimulus, with popes and kings competing for the services of such masters as Benvenuto Cellini and others, who adapted the medieval tradition of enameled goldwork to the taste for the glories of the classical past and for the exotic splendors of the New World. But although jewelry design was so much affected by the aesthetic inspired by antiquity, there was no attempt to revive archaeological styles or the ancient techniques of filigree and granulation. The change from the gothic style was principally expressed by deriving surface ornament from relics of Roman pattern called grotesques.

Grotesque motifs came to light in the early years of the 16th century, when enterprising artists explored the underground chambers of Nero's Golden House on the Esquiline, and those of other palaces, villas, and tombs in other parts of Rome and Naples. Because they were buried so far below ground level, such caverns were known as grottoes, and their stucco and painted decorations accordingly termed grotesques. Light hearted caprices combining festoons, caryatids, dolphins, masks, cornucopiae, thrysi, pelta shields, hybrids, animals, satyrs, putti, scrolls and volutes, they were adopted by Raphael and Guilio Romano and applied to the decoration of one of the great Vatican loggias which has ever since provided the most comprehensive array of classical ornament for generations of designers.

Something more substantial, however, was needed as a framework to enclose grotesque ornament, and this was invented in 1533-5 by another Italian, Rosso Fiorentino, as a means of framing the series of paintings on the walls of the Gallery of François I at the Palace of Fontainebleau. This device, called strapwork, was copied from strips of leather cut into unusual shapes and standing out in high relief. Taken up with enthusiasm, especially by the designers of the Low Countries and Germany, it underwent a further transformation under the influence of the oriental arabesque, a stylized plant ornament with winding stem imported into Venice by the Islamic makers of dama-

Facing: The Esterhazy Marriage Collar (no. 535)

scened brass, resulting in the broad scrolls of strapwork being drawn out into narrow and complex interlaced bands known as moresques.

This vocabulary of surface decoration composed of grotesques, strapwork, and moresques was used in decorative gem-set jewels, or was combined with figure subjects derived from classical and Christian iconography, to form ornaments of vari-colored enameled goldwork either in relief or wrought in the round. The sculptural and pictorial quality of such pieces as have survived reflects the high standing of the goldsmith and his close connection with other artists. Indeed some of the most celebrated names in renaissance art—Ghiberti, maker of the golden Doors of Paradise for the Florence Baptistery, and Verrochio, the teacher of Leonardo da Vinci—were also trained as jewelers. In this atmosphere craftsmen stretched their skills far beyond their traditional limitations, creating little masterpieces to rival those of their colleagues in the major arts. So just as the leadership in architecture, painting and sculpture came from Italy, so did fashions in jewelry, and portraits of courtiers from the cities of Venice, Florence, Ferrara, and Milan show that such jewels were made to be worn, enhancing the beauty of hands, hair, neck and wrists, and not to be kept in collectors' cabinets.

Just as the rich in other European countries had already imported Italian examples of the fine arts, so the new style of jewelry went abroad too, first to France. François I invited Benvenuto Cellini to set up workshops for gem engraving under the direction of Matteo del Nazzaro, while in recognition of their importance as symbols of monarchical glory, the king established the collection of French Crown Jewels. The arrival of Catherine de' Medici as the bride of the Dauphin (later Henri II) brought further Italian influence to France, and the style which resulted from this mixture of the French tradition with the Renaissance is exemplified in the beautiful engraved designs for jewels by Etienne Delaune and Pierre Woeiriot.

Because of the Wars of Religion in France the center of design shifted in the second half of the 16th century to the great trading towns of southern Germany—Augsburg, Nuremberg and Munich. Following the example of Albrecht Dürer, artists from these prosperous centers had studied and traveled in Italy, and like him some had close family links with the goldsmith's profession. Dürer had also demonstrated his interest by designing pendants, whistles and girdle ornaments, while artists, above all Cranach, faithfully reproduced jewelry in portraiture. The wealth of the banking and commercial families, led by the Fuggers of Augsburg created a demand for jewels on a scale that

encouraged artists to design for a large public. Pattern books were printed, some by Germans such as Virgil Solis (1514-1562) and Matthias Zundt (1498-1586), others by talented Flemings such as Hans Collaert of Antwerp and Theodor de Bry who settled in Frankfurt after 1570, all of them practical craftsmen with some experience of the problems involved.

A remarkable document of the splendor of German renaissance jewelry was compiled by Hans Mielich, who was employed by Duke Albrecht V of Bavaria to record the treasures of the House of Wittelsbach in an album of miniatures on vellum. Among the jewels thus illustrated are bracelets, the upper surfaces with the gems in strapwork frames contrasting with the flat backs decorated with interlaced moresques. In Prague under the patronage of the Emperor Rudolph II (1570-1612) jewelry of equal splendor was produced, epitomized by the Imperial crown made by Jan Vermeyen, now in the Vienna Treasury. At the far ends of Europe both the Hungarian and Spanish courts shared a similar passion for display in clothing and jewels, while across the Channel the extravagance of the Tudor household attracted a large colony of foreign goldsmiths and dealers.

Something of the character of the wonderful pieces supplied to Henry VIII and his children and listed in their inventories is revealed in the group of drawings for jewelry by the artist Hans Holbein, who entered the royal service in 1536. Confiscation of the accumulated contents of the church treasuries made quantities of bullion and precious stones available, and courtiers, enriched by grants of monastic lands, had money to spend on jewels, since there were comparatively few other outlets for investment. Queen Elizabeth inherited both the paternal passion for gold and gems as well as the sense of royal power and consistently used jewelry—coronets, necklaces, rings and pendants pinned to her ruff, bodice and sleeve, aiglets sewn on her entire dress—to convey a dazzling image of consecrated virginity and imperial authority. While some of the jewels associated with her are so emblematic that the original meaning has been lost, others refer to great events such as the defeat of the Spanish Armada, or contain her portrait.

The international demand, which encouraged artists and jewelers to travel, resulted in a style which became even more cosmopolitan with the diffusion of designs and fashions in dress from France, the Low Countries and Germany. In addition, the universal taste for classical culture constituted a common market for personal ornaments. Since heads of state were continually exchanging gifts of jewels, it is extremely difficult, in the absence of hall-

marks, to establish the place of origin of much surviving renaissance jewelry. Another issue is the problem of authenticity, for most pieces have been repaired, and, unlike the examination of paintings by X-rays, there is no scientific means of assessing the extent of such restoration.

Paradoxically the spirit of intellectual inquiry, which led to the classical revival and the development of this new style of goldwork, was also responsible for its eclipse, since interest in science brought about improvements in cutting precious stones culminating in the emergence of the diamond as the principal subject of jewelry. The change is best illustrated by a comparison of the portraits of Henry VIII, resplendent in jewels in enameled settings, and of Charles I, discreetly wearing one pearl-drop earring and the diamond-set Badge of the Garter. Although the transition comes almost imperceptibly, a key designer in the process is the Augsburg engraver Daniel Mignot, who around 1600 produced compositions based on the effect of stones juxtaposed into definite forms, independent of the settings. Consequently, the role of the goldsmith was further diminished, for with the elimination of figure work he had merely to provide settings as unobtrusive as was compatible with fixing the stones securely. Gems, which in the 16th-century jewel had been set table cut or *en cabochon*, as points of contrast, or for their decorative character, continued to assume more and more importance as the art of faceting was mastered, thus releasing all their fire and sparkle. A milestone was the invention of the rose cut form of faceting, displayed in the Lyte jewel given by James I in 1611 to a Somerset squire, who had traced the ancestry of the royal House of Stuart back to a refugee from the Trojan War. More encouragement came from the increased supply of diamonds on the market after the opening up of the mines of Brazil and of Golconda in Hyderabad, India. Another influence was Cardinal Mazarin, whose patronage of the lapidaries so stimulated progress that, by the end of the century, the brilliant cut with thirty-two facets had been discovered.

Because of the Thirty Years War, and threats of invasion from the Turks, Germany lost the prime position in jewelry design, and in the 17th century the lead came once again from France. The sense of luxury associated with the diamond accorded well with the concept of absolute monarchy as developed by Louis XIV, and he appeared at the fêtes of Versailles radiant and sparkling in diamond-set parures. Other monarchs used the same formula in order to present an image of transcendent magnificence, and insisted, in spite of complaints about the oppressive weight of such costumes, that

their ladies did the same. Mary of Modena, wife of James II of England, wore jewels valued "at a millions worth, which made her shine like an angel."

So much concentration on glitter meant that jewels could assume simple forms such as bows, stars, rosettes and knots, and the proliferation of them about the person is best described by John Evelyn in his poem "Mundus Mulieribus" published in 1690:

> Diamond buckles too,
> For garters, and as rich for shoo....
> A manteau girdle, ruby buckle,
> And brilliant diamond rings for knuckle....
> A saphire bodkin for the hair
> Or sparkling facet diamonds there;
> Then turquois, ruby, emerauld rings
> For fingers and such petty things
> As diamond pendants for the ears
> Must need be had, or two pearl pears
> Pearl necklace, large and oriental
> And diamond, and of amber pale.

The rococo style of the next century meant that few examples of this diamond jewelry survived remodeling, and information about baroque jewels tends to come either from pieces set with paste, crystals or marquesite, or engraved designs. Those of Gilles Legaré, court jeweler to Louis XIV, published in his *Livre des Ouvrages d'Orfévrerie,* in 1663, offer an invaluable record. They also illustrate the place of enamel in jewelry of this date, which although increasingly relegated to the edges and backs of the majestic gem-set parures represented, was still the prime means of decoration for watches and miniature cases. The adoption of the method invented by Jean Toutin of Chateaudun meant that their flat surfaces could be painted like pictures in floral designs or miniature versions of landscapes and history painting. Rings, slides for threading onto ribbons for wearing round the neck or as bracelets, could also be enameled in this way, so although almost banished from the settings of the grandest jewels, the technique of enamel, which the Renaissance goldsmith had inherited from his medieval predecessor and had brought to perfection in the sculptural jewel, was still, thanks to its renewal by Jean Toutin, holding its own amid the splendors of baroque art.

Diana Scarisbrick

Hat Badges

Hat badges, a popular fashion of the early 16th century, derived from earlier times. During the Middle Ages the retainers of feudal lords and princes often wore the heraldic devices of their masters on their headgear as a badge of livery. Medieval pilgrims imitated this fashion by wearing in their caps the leaden images of patron saints of the shrines they had visited. By renaissance times the hat badge, or *enseigne* as it was sometimes called, had become a favorite form of jewelry among men. The emblems, which had originally signified service or religious devotion, were transformed into more courtly ornaments, gold and disk-shaped, with designs embossed or cast in relief, chased and enameled, with either a pin or holes for attachment to the brim of the hat. Reflecting the personal choice of the wearer, they often had individualized inscriptions on devotional, classical, or emblematic themes.

By the second decade of the 17th century, the fashion for wearing jewelry on hats had expanded to include jeweled hat bands and aigrettes with the feathers of the panache imitated in clusters of diamonds and pearls. But now the emphasis was on stones rather than on the setting and the taste for figurative and emblematic designs had been superseded by a grandiose display of diamonds and rubies.

Hat Badge 485

English, 16th century

Enameled gold and jeweled hat badge with applied relief of the Fall of Adam and Eve, overhead ribbon with remainder of inscription in Roman capitals, LE...M. Inner border and tree base set with five table cut diamonds and three rubies in square collets framed in black arabesques alternating with raised cartouches of fruit and strapwork, the gems perhaps added later.

This is one of nine surviving examples of historiated English jewelry all related to key pieces in the British Museum, a girdle prayer book and hat badge, both with inscriptions in the vernacular. (44.266)

D. 2-3/16 in (.05 m)

History:
purchased from Seligman & Co., New York, 1905
Exhibitions:
Cleveland "Exhibition of Gold"
Publications:
"Exhibition of Gold," *BCMA;* John D. Farmer, *The Virtuoso Craftsman,* Worcester Art Museum, March 27 - May 25, 1969; Hugh Tait, "Historiated Tudor Jewellery," *The Antiquaries Journal,* vol. XLII, part II, 1962, pp. 226-246

Devotional Jewelry 486-513

During the Renaissance jewelry worn at the neck, or hanging from chains on the bodice and waist was accorded increasing importance. Following medieval precedent many pieces of jewelry were religious in character, and chief among them was the cross, for this symbol of Christian faith was considered a powerful talisman. Mary Queen of Scots seems always to have worn one. Rosaries were often extremely luxurious objects, set in gold and bejeweled. They were made in combinations of a variety of materials such as boxwood, jet, rock crystal, coral, amber, agate, and lapis lazuli. Surviving crosses come in an equally wide range of materials and many forms. The Danes and English adopted the Tau cross shaped like a T, symbol of St. Antony Abbot. Another severe form is the Latin cross, sometimes plain, but more often with the applied figure of Christ, scroll inscribed INRI above his head, skull and crossbones at his feet. Many are engraved with the symbols of the Passion. The Mannerist designs of Virgil Solis (1514-62) show a softening of the cruciform outline with fronts set with gems in raised lobed collets, and backs engraved with arabesques. The gem studded cross with hanging pearls was intended to equal the splendor of other jewels worn on the person and in the 17th century it attained great magnificence. The gold cross of Lorraine that Prince Charles presented to the Infanta during his Spanish Embassy was set with two rubies and huge diamonds, some of them rose cut, while the cross of Marie de Medici had a diamond set crown of thorns and nails, with three further diamonds hanging in heart-shaped pendants.

Reliquaries represent another large class of devotional jewelry, and crucifixes were sometimes fitted with containers for this purpose. Many were made of rock crystal, of pendant form, enclosing miniature representations of devotional images or decorated in *verre eglomisé,* a technique of painting glass in colors on a ground of gold leaf. Mary Queen of Scots went to her death with a rock crystal Agnus Dei pendant at her neck. Other popular subjects were the Sacred Monogram and the Vernicle, or Holy Face.

In addition to reliquaries and rosaries, book pendants containing miniature illuminated manuscripts were worn hanging from the belt. Gold and silver prayer books had been in use since Byzantine times, but this transformation into such personal ornaments was a renaissance innovation. Many are listed in Tudor inventories and there is a design for one with the initials TW by Hans Holbein in the British Museum. Among those belonging to Mary Tudor was "a Boke of golde garneshed wt litle rubies and Clasped wt oon litle Diamond." Queen

486

487, 488

485

489

490

491

492

Elizabeth wore a miniature book containing a copy of the last prayer of Edward VI in enameled golden covers set with a shell cameo, and in *Euphues and His England,* published in 1580, J. Lyly speaks of "the English damoselles who have thyr bookes tyed to their girdles." The book pendant shown in no. 512 is one of the finest examples of this type and can be compared with another made for the Holy Roman Emperor, Charles V. Badges of membership of religious societies, such as those shown in nos. 510, 511 also took the form of jewels. The excellent quality of insignia worn by members of the Sacred Inquisition and the Order of St. James of Compostela can be attributed to the Spanish sumptuary laws which encouraged expenditure on such pious emblems.

Although the importance of religion in the age of the Reformation and the Counter Reformation is mirrored in such jewelry, at the same time designers and goldsmiths combined their skills to make secular jewels equally expressive of the taste for classical learning and literature.

Rosary Bead 486
Spanish, 16th century

Jet rosary bead carved with conjoined heads of Christ and St. James, both bearded. Christ is crowned with thorns, St. James wears the pilgrim's hat with cockle shell, the badge of his shrine at Compostela.

Dealers' inventories at Compostela record large stocks of jet devotional objects for sale to pilgrims. Jet was easy to carve and it was believed that its brilliance could intercept the evil eye. (41.233)

H. 7/8 in (.022 m)

History:
gift of Marvin C. Ross, 1941

Crucifix 487
Spanish, 16th century

Enameled gold rock crystal crucifix with beveled arms terminating in mounts with strawberries and pansies and capped with red, green, and violet quatrefoils. The strawberries signify goodness, the pansies humility. Nimbed Christ attached to gold strips, jawless skull and crossbones below, added later. Suspension loop. Three hanging pearls missing. (44.511)

H. 3-7/16 in (.084 m) W. 2-3/16 in (.055 m)

Crucifix 488
Spanish, 16th century

Enameled gold rock crystal crucifix, the beveled arms terminating in mounts each with four white saltires and finials with studded sunbursts. Nimbed figure of Christ attached to gold strips, and at the back a relief of the Virgin and Child seated on a column with a black cross. Devotion to Our Lady of the Pillar derives from the tradition that she was transported by angels in 40 A.D. to advise St. James on his mission to Spain. Before returning to Palestine she asked that the marble pillar on which she stood should be enclosed in a church dedicated to her at Saragossa. Suspension loop. (44.436)

H. 2-9/16 in (.064 m) W. 1-3/8 in (.035 m)

Crucifix 489
Spanish, 16th century

Enameled gold rock crystal crucifix with beveled edges terminating in black and white mounts with raised quatrefoils and embossed winged heads of cherubim back and front, and applied figure of Christ with overhead scroll inscribed INRI. Suspension loop and hanging pearl (replacement). At present in beveled rock crystal case of book form intended to hang from the girdle with interior cross *botonée* and five oval reliquaries, perhaps symbolizing the Five Wounds. Silver gilt rimmed edges, and suspension loop with plaited silver thread tie. (44.576)

H. of crucifix 2-3/8 in (.06 m) W. of crucifix 1-7/16 in (.036 m)

H. of book 4-1/8 in (.105 m) W. 2-3/4 in (.069 m)

Crucifix 490
German ?, about 1600

Enameled gold cross of triangular section, the front with vine scrolls, the back with hammer, sponge, and other Instruments of the Passion. Applied figure of Christ crowned with thorns, overhead scroll inscribed INRI, skull at the base missing. Suspension loop. (44.425)

H. 2-3/8 in (.058 m) W. 1-1/4 in (.03 m)

Crucifix 491
Spanish, 16th century

Enameled gold cross of lozenge section, arms with fleurs-de-lis at the crossing, terminating in round finials (one missing), the front with Instruments of the Passion, the back with continuous paired scrolls. Applied nimbed figure of Christ crowned with thorns, overhead scroll inscribed INRI, and skull below. Bearded mask applied at the back. Three hanging pearls missing and all nails replaced. (44.435)

H. 2-1/8 in (.053 m) W. 1-1/2 in (.038 m)

Notes:
for a similar crucifix see Muller, *Jewels in Spain,* frontispiece, the bearded mask may refer to Adam

493

494

495

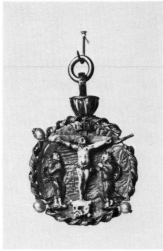

496

Crucifix 492
Spanish, 16th century

Enameled gold cross of quadrilobate section, fleurs-de-lis at the crossing, the front blue and green, the back with white chevrons, terminating in reeded finials. Applied nimbed figure of Christ crowned with thorns, overhead scroll inscribed INRI, jawless skull below. Three hanging pearls and two nails replaced. French control mark. Suspension loop. (44.437)

H. 3 in (.076 m) W. 1-15/16 in (.05 m)

Cross 493
Spanish, 16th century

Enameled gold and jeweled cross, the front set with table cut emeralds, seven in oblong collets, and four in triangular collets at the terminals; sides with arabesques on black ground, the edges of the frame embellished with open scrolls, the back with continuous black foliate scrolls terminating in triangles enclosing rosettes. Three hanging pearls and suspension loop. (57.1745)

H. 3-7/8 in (.098 m)

History:
purchased from Carl Schon, Inc., Baltimore, 1945
Publications:
Muller, *Jewels in Spain,* fig. 66, and p. 61, also fig. 65 (portrait of Maria of Austria wearing similar cross, by Antonio Moro, dated 1551)

Cross 494
Spanish or Hungarian, 17th century

Enameled gold cross *botonée,* the arms terminating in pairs of violet scrolls enclosing white dots and green quatrefoils, the front set with seven table cut crystals in oblong collets within a black filigree border, the back with a black cross enclosing white scrolls and quatrefoils. Three double hanging pearls and suspension loop. (44.485)

H. 2-7/16 in (.061 m) W. 1-1/4 in (.031 m)

Notes:
for a similar gem set cross see Muller, *Jewels in Spain,* p. 61, plate 68, illustrating the design by Ramon Carbo, dated 1612

Crucifixion Group 495
Flemish, 16th century

Enameled gold Crucifixion group, Christ applied to diapered cross, overhead scroll inscribed INRI, skull and crossbones below, the Virgin and St. John to each side, and two angels bearing chalices, which may refer to the devotion of the Precious Blood. (44.314)

H. 1-1/8 in (.023 m) W. 13/16 in (.02 m)

Crucifixion Group 496
European, 16th century

Enameled gold roundel with Crucifixion group, Christ crowned with thorns, overhead scroll inscribed INRI, skull and crossbones below, flanked by two disciples, applied to an escudo coin issued during the reign of Ferdinand and Isabella of Spain. Cable border pinned with four pearls (one missing), and suspension loop attached to fluted vase finial. (44.267)

H. 1-5/8 in (.042 m) W. 1-3/16 in (.03 m)

Pendant 497
European, 16th century

Silver and rock crystal oval pendant enclosing *verre eglomisé* Crucifixion group, and at the back, the Lamb of God, the frame with inner and outer edge serrated and cable border. Silver beads simulating hanging and pinned pearls. The triple suspension chain and loop are all replacements. (46.14)

H. 1-9/16 in (.04 m) W. 1-3/8 in (.036 m)

Pendant 498
Milanese, 16th century

Enameled gold oval pendant set with faceted rock crystal over *verre eglomisé* Crucifixion group within an octagonal border enclosing panels of arabesques, the back with vari-colored symmetrical scroll and foliate ornament centered on a vase of lilies, in pierced frame embellished with three applied quatrefoils. Suspension loop. The back of the heart-shaped cameo jewel associated with Mary Queen of Scots, now in the National Museum of Antiquities, Edinburgh, has an identical design of lilies and scrollwork. (46.24)

H. 2-3/8 in (.06 m) W. 1-7/8 in (.05 m)

Pendant 499
Spanish, 16th century

Enameled gold agate oval pendant enclosing *verre eglomisé* Crucifixion group and inscription from *Isaiah* 53, 5 in Roman capitals CUIUS LIVORE SANATI SUMUS (By whose wounds we are healed) in a black border of lozenges and bars, and at the back a similarly framed Virgin and Child, inscribed AVE SAN(CTA) MARIA MAT(ER) DEI, embellished with four openwork coronas over quatrefoils. Triple suspension chain and loop (replacements). Comparable pendants in the Victoria and Albert Museum came from the Treasury of the Virgin of the Pillar, Saragossa, and those in the Louvre given by Baron Davillier, were also purchased in Spain. (46.13)

H. 2-1/4 in (.06 m) W. 2 in (.052 m)

Pendant 500

Spanish, late 16th century

Gold rock crystal octagonal pendant enclosing a *verre eglomisé* scene of an apparition, and at the back a relic enclosed in a Gloria of alternate plain and wavy rays, in a filigree frame. Suspension loop. French control mark. (46.10)

H. 2-1/8 in (.054 m) W. 1-5/8 in (.041 m)

Pendant 501

Spanish, 17th century

Enameled gold oval pendant enclosing *verre eglomisé* paintings of the Battle of Clavijo and the Rest on the Flight into Egypt, in openwork frame of green, white, blue and black pods and shells. Suspension loop. While the subject of St. James routing the infidels at the Battle of Clavijo in 930 A.D. occurs frequently in Spanish art, the Flight into Egypt is less common. Here it is presented as a domestic idyll, perhaps the 17th-century counterpart of the serene Madonnas of the early Renaissance. (46.27)

H. 2-1/8 in (.054 m) W. 2 in (.052 m)

Lantern Pendant 502

Mexican and European, 16th century

Enameled gold rock crystal lantern pendant enclosing Crucifixion and Deposition scenes from the Passion minutely carved in boxwood on a ground of blue bird's feathers, the space between filled with smaller two-tiered panels of St. Veronica and the Flagellation, the Man of Sorrows, and Christ Carrying the Cross. Framed by baluster columns crowned with seed pearls, arabesque ornament above and below. Hanging pearl and suspension loop. It has been suggested that the wood carving in this pendant was the work of Mexicans under the patronage of Hieronymite missionary fathers from Spain. Sculpture Mexican, case European. (61.120)

H. 1-5/8 in (.04 m) W. 1-1/16 in (.026 m)

Publications:
Theodor Müller, "Das Altärchen der Herzogin Christine von Lothringen in der Schatzkammer der Münchner Residenz und Verwandte Kleinkunstwerke," *Zeitschrift für Bayerische Landesgeschichte*, bd. 35, heft 1, 1972

Pendant 503

Spanish, 16th century

Enameled gold and jeweled pendant with the crowned Virgin wearing a robe of white brocade and lined blue star-spangled mantle, the nimbed Infant Christ on her arm (his orb and her sceptre missing), within a mandorla with red wavy rays, and outer filigree frame set with diamonds in square collets in front, the back with colored flower-heads. At her feet are pairs of red flowers on high green

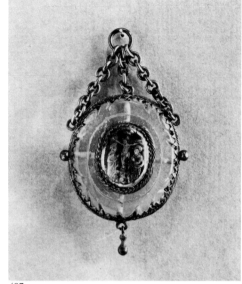

497

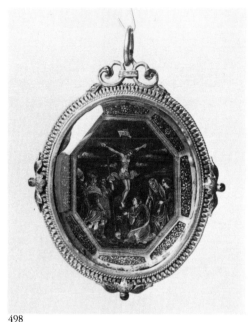

498

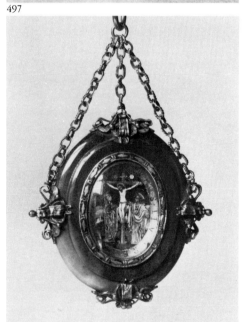

499

500

501

stems rising from an oblong reliquary with openwork diamond-set sides and hinged cruciform base. Scallop shell applied to the head of the Virgin at the back, and suspension loop. The figure of the Child perhaps added later. Comparable reliquaries have pendant figures of SS Francis, Jerome, Antony of Padua, and the Infant Christ, all miniature versions of monumental sculpture. (44.271)

H. 2-11/16 in (.07 m) W. 1-3/8 in (.035 m)

History:
purchased in Paris, 1927
Exhibitions:
Cleveland, "Exhibition of Gold"
Publications:
"Exhibition of Gold," *BCMA*

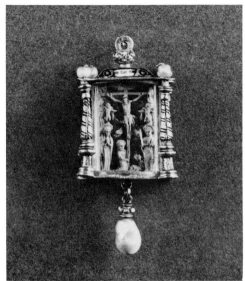

502 front

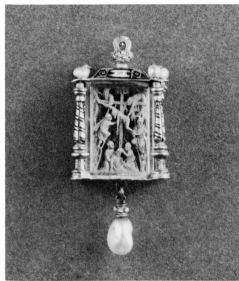

502 back

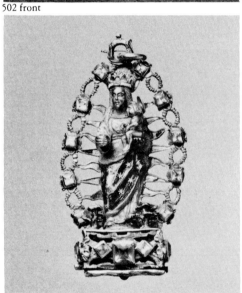

503

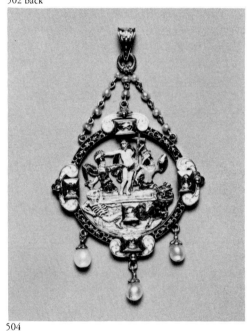

504

Medallion Pendant 504
European, about 1600

Enameled gold and jeweled medallion enclosing a vari-colored relief of the Resurrection, and below the crystal-set open tomb, the skeleton of death, and cloven hoofed Satan, the back *en suite,* with inscription in Roman capitals CIAS (CHRISTUS IESUS ASCENDANS SEPOLCHRO). The frame with silhouette ornament on a red ground is embellished with white open scrolls set with crystals in square collets. Three hanging chains interspersed with pearls attached to suspension loop, and three hanging pearls below. (44.414)

H. 3-1/8 in (.08 m) W. 1-7/8 in (.048 m)

History:
purchased from Seligman, Paris, 1906
Notes:
Yvonne Hackenbroch, in her article "Erasmus Hornick as a jeweller" (*The Connoisseur,* vol. 166, no. 667, September 1967, pp. 54-63) refers to similar medallions in New York, London, and Vienna as exemplifying the practice of using pewter models to meet the demand for Hornick's most successful compositions. The pieces reproduced in this way could then be incorporated into settings made to individual choice with gems and pearls, or enclosed in rock crystal cases.

Pendant 505
Augsburg, about 1600

Enameled gold and jeweled pendant, the openwork back-plate with white, green and red scrolls set in front with four table cut rubies in square collets, with raised cusped box collet below and triangular collet above similarly set. Applied relief of the enthroned Virgin and Child flanked by a pair of jubilant cherubim, the Virgin with punched mantle over her gold hair and a blue robe spangled with stars and crescents, holding a scepter, the Child with hand raised in blessing and clasping an orb. Crowning baldachino and crescent moon below are each set with table cut rubies in collets of different shapes, arranged round central raised diamonds. Forget-me-not with suspension loop above, and five hanging pearls. (44.263)

H. 4-1/8 in (.10 m) W. 3-1/16 in (.075 m)

History:
purchased from J. & S. Goldschmidt of Frankfurt, Paris, 1910

Publications:
Museum of Contemporary Crafts, *Enamels.* New York, September 18 - November 29, 1959, cat. no. 55

Notes:
Comparable with the pendant illustrated in Angéla Héjj-Détári, *Old Hungarian Jewelry,* Budapest, 1965, no. 31, where the enthroned Virgin and Child are placed in a gem set architectural frame in a more integrated composition than ours, in which pierced scrollwork combines less satisfactorily with sculpture.

Pendant 506

Spanish, about 1600

Enameled gold rock crystal oval pendant enclosing Annunciation group *en ronde bosse* above reliquary inscribed AVE MARIA GRASIA PLEN (A DOMINUS TECUM), framed in a garland of flowers and leaves. Pear-shaped emerald pendant and suspension loop. (44.426)

H. 1-7/16 in (.036 m) W. 1-1/16 in (.023 m)

Notes:
Two pendants illustrated in Muller, *Jewels in Spain,* figs. 200-201 contain Annunciation groups, though in different frames, suggesting that popular devotional subjects could be produced in quantity using interchangeable parts.

Pendant 507

Flemish ?, about 1600

Enameled gold rock crystal pendant enclosing Annunciation group *en ronde bosse* with overhead scroll inscribed on both sides AVE MARIA GRATIA PLENA, framed in a barbed cable border. Three double hanging pearls and suspension loop. (44.310)

H. 2-5/16 in (.06 m) W. 1-9/16 in (.04 m)

Pendant 508

Spanish, late 17th century

Enameled gold rock crystal pendant enclosing a pair of gilded angels venerating the Sacrament on an altar crowned with a baldachino framed with a continuous row of beads and cusped and studded filigree border enclosing trefoils attached to filigree octofoil joined to rosary of ebony beads, all in white with colored detail. (44.509)

H. 2-1/8 in (.055 m)

Notes:
for another example of this popular subject see Muller, *Jewels in Spain,* fig. 205

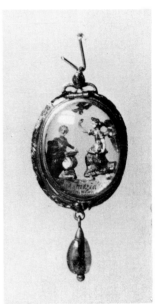

506

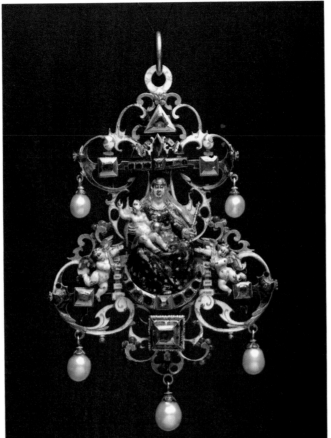

505

507

508

510

511

512 outside

512 inside

Tryptych 509
European, 17th century

Enameled gold oval tryptych enclosing six devotional scenes, the Annunciation, the Adoration of the Shepherds, the Agony in the Garden, the Last Supper, the Crucifixion and Resurrection, the central hinged frame with bead and reel ornament. Plain rims and clasp. Suspension loop.

The large demand for devotional objects in the Catholic countries could be met by the technique of painting on opaque white enamel, using compositions deriving from great masters diffused through engravings, and examples such as this represent the baroque counterpart of the medieval tryptych. (44.311)

H. of each miniature 2-11/16 in (.069 m)
W. of each miniature 2-3/8 in (.06 m)

Badge of the Order of St. Joseph 510
Spanish, 17th century

Enameled gilt metal oval pendant with convex faceted crystal over scene of the Death of St. Joseph, the back with the portrait of an ecclesiastic wearing the cap of a Doctor of Theology, framed in palm sprays and encircled with seraphim and angels declaiming his virtues, two of them by the portrait, and another holding up a rayed shield of arms. Plain rimmed frame with suspension loop. The Death of St. Joseph was the badge of brotherhoods dedicated to the service of the dying, since St. Joseph, who had died in the presence of Christ and the Virgin, was the patron saint of the terminally ill. The shield is charged with five gilt stars. (44.332)

H. 1-7/16 in (.037 m) W. 1-11/16 in (.027 m)

Badge of the Order of Santiago de Compostela 511
Spanish, late 17th century

Enameled gold and jeweled hinged green scallop shell set with two diamond sparks in a border of table cut emeralds in square gold collets with suspension loop and bow similarly set, all outlined in scallops with black detail on a white ground, the back green. Modern gold chain.

The scallop shell was the badge of the Order of Santiago of Compostela, which was founded in 1160 with the purpose of protecting the pilgrimage shrine of St. James at Compostela and ridding Spain of the Muslims. Contemporary portraits show how the badge hung from a ribbon passed through slots at the back of the bow. Other paintings show this insignia worn on official occasions such as attendance at the Inquisition, Velasquez, who was Court Chamberlain,

wore it while making the arrangements for the marriage of the Infanta with Louis XIV at the Isle of Pheasants in 1660. (44.592)

H. 2-11/16 in (.068 m)

History:
purchased from Carl Schon, Inc., Baltimore, 1945
Notes:
this piece compares with one published in Muller, *Jewels in Spain,* fig. 176, design by Ioseh Rosell dated 1671, and fig. 178, portrait of the Duke of Pastrana by Juan Carreño de Miranda

Book Pendant 512
European, 16th century

Enameled gold and jeweled binding enclosing a manuscript. The clasps, spine, and hinged covers in white silhouette strapwork, and set back and front with nine table cut rubies, eight in square collets, the ninth in central oblong collet in black channeled border. The double suspension chain is a replacement.

The manuscript was written for a lady and contains portrait heads of Christ and the Virgin, prayers addressed to the Virgin, the Regina Coeli hymn, and the Seven Psalms of the Virgin. It is signed by the scribe responsible for the greater part of the contents, Jacopo Romano, possibly the pupil of Giulio Romano, whose style it resembles. Closest in quality and size to ours is *La Protestacion del Emperador* or profession of Catholic faith, dated 1530, written in Spanish, perhaps for Charles V, and also bound in a gem-set white enameled case. (10.444)

7/8 in x 7/8 in (.022 m x .021 m)

Publications:
Baltimore Museum of Art, *The History of Bookbinding, 525-1950,* November 12, 1957 - January 12, 1958, cat. no. 674, plate VI
Notes:
for similar book pendants see Frederick Madden, *Privy Purse Expenses of the Princess Mary,* London, 1831, fol. 137b; Joan Evans, *A History of Jewellery, 1100-1870,* New York, 1953, plate XVII, no. 5, and p. 83; Muller, *Jewels in Spain,* p. 70 describes some containing portraits

Book Pendant 513
European, about 1600

Gilt metal book pendant perhaps used as a reliquary, to hang from the girdle or attach to a rosary. The covers are set with *verre eglomisé* panels of the Agony in the Garden, Moses and the Brazen Serpent, and inside, the Lamb of God with three nails, and St. Joseph of Arimathea. Pierced spine, clasp, and two suspension loops. (46.1)

H. 1-1/4 in (.013 m) W. 1 in (.025 m)

History:
purchased from Gruel, Paris

509 outside

509 inside

513

Besides expressing religious faith and secular intellectual themes, pendant jewels were designed in purely ornamental form. Among the drawings of Hans Holbein are a number of such jewels, and the published engravings of Mathias Zundt and Virgil Solis dating from the mid 16th century illustrate the fully developed renaissance style in elaborate gem-set pendants framed in caryatids and strapwork.

The gems used for this type of pendant, either *en cabochon* or table cut, may have had some additional esoteric significance since belief in the talismanic power of precious stones was still part of everyday life. While few of these survive there is a large representation of the type that succeeded them, with figure subjects enclosed in frames of architectural outline, illustrating a concept such as charity, victory, or the pleasures of hunting, music and poetry. In its final form this style has the architectural elements of the frame set with rows of gems, though these are always subordinate to the setting. Another challenge to the skill of the goldsmith was the introduction of baroque pearls into jewelry. The large irregular shapes inspired a group of pendants of which the Harpy Pendant (no. 520) with pearl torso is a splendid example. Pearls continued to suggest witty and sophisticated figures to the goldsmiths of Dresden well into the 18th century. The sculptural form of the pendant suited the design of animals and birds, the latter being a Spanish specialty, and also of some legendary hybrids—dragon, sphinx, and griffin. Appropriately in the age of the voyages of Sir Francis Drake and the Conquistadores the sea was another source of inspiration, both in the form of miniature ships complete with crew and passengers and also in a host of maritime creatures.

These large figured pendants took the place of the hat badge as the medium through which the virtuosity of the jeweler could be best displayed. They represent the summit of craftsmanship—hammering, casting, chasing, enameling, gem setting and foiling of the highest quality are combined to produce these miniature works of art. Although the allusions are sometimes obscure, the formula is always the same: gold, enamel, and gems are balanced together so that each element has an equal role in the composition. Further adornment is provided by the lustre of hanging pearls and the enameled backs matched by the quality of the gem-set suspension chains. Worn principally by women, pendants hung at the neck, shoulder, or bosom, or were pinned to the sleeve, where they could be seen from all sides as they dangled freely.

521, 522, 523

514

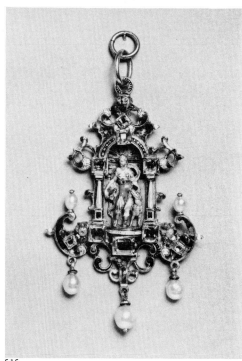

515

The international market for such jewels, the publication of designs for them, and the itinerancy of craftsmen makes provenance very difficult to establish, and there was no system of control marks. The wealth of the trading centers of South Germany, Nuremberg, Augsburg, and Munich, attracted such numbers of designers and craftsmen that traditionally the figurative pendant in architectural frame is ascribed to this area, and the style that led to its eclipse also originated there. Daniel Mignot, a Huguenot, published in Augsburg from 1596 to 1616 sets of designs for pendants in three parts—the foundation or back-plate with strictly symmetrical flat scrollwork with holes to which another plate, also with pierced decoration could be attached with screws, and a third section, sometimes enclosing a rosette completing the design. It was this multi-layered style studded with gems in high cusped box collets, which dispensed with figure work and led the way to the simplified gem-set pendants of the 17th century.

Locket 514
Italian, 16th century

Enameled gold and banded agate locket, the convex sides enclosing figures of Pyramus and Thisbe. He wears classical armor, and is seated by the fountain where he has discovered her bloodstained cloak, while she, thinking him dead, kills herself. Framed in a laurel wreath, and surmounted by a skull. Suspension loop. (44.474)

H. 1-7/16 in (.036 m) W. 1-1/16 in (.024 m)

History:
collection of Canessa, New York, February 1917, cat. no. 82

Notes:
Boccaccio in *De Mulieribus Claris* developed the tragedy of the Babylonian lovers Pyramus and Thisbe from the account in Ovid, *Metamorphoses* IV, pp. 57-168. The subject occurs in a set of engravings by Etienne Delaune (1519-1583); the nut-shaped locket form is found in a jewel in the British Museum, Waddesdon Bequest no. 184, enclosing figure of Moses holding up the tablets of the Law, and in a rosary in the Louvre, each bead containing enameled reliefs of events from the Gospel, illustrated in Joan Evans, *A History of Jewellery, 1100-1870,* New York, 1953, plate 38b. In 1546 Henry VIII gave Mary Tudor "a broche of thistory of Piramys and Tysbye wt a fayr table diamond in it" (Frederick Madden, *Privy Purse Expenses of the Princess Mary,* London, 1831, fol. 142b), and at a meeting of the Society of Antiquaries, Sir Augustus Wollastan Franks exhibited a locket with an enameled relief of this subject, recorded *Proc. Soc. Ant.* 17th December 1863.

Diana Pendant 515
South German, 16th century

Enameled gold and jeweled pendant with scrolled frame enclosing a shell-headed open arcaded alcove framed by baluster columns containing a statuette of Diana on rounded base. She is dressed for the hunt in boots, belted tunic, baldric and scarf, and carries hunting horn, bow and quiver, hound beside her. Set with four table cut diamonds and five rubies in square collets with two pearl finials pinned to outer C-scrolls, and three hanging pearls, all replacements. The back *en suite,* centered on alcove facade. Suspension loop. (44.442)

H. 2-5/8 in (.066 m) W. 2-1/16 in (.05 m)

Publications:
John D. Farmer, *The Virtuoso Craftsman,* Worcester Art Museum, March 27 - May 25, 1969, no. 60, illustrated; California Palace of the Legion of Honor, *The Triumph of Humanism, Renaissance Decorative Arts 1425-1625,* San Francisco, October 22, 1977 - January 9, 1978, cat. no. 97

Venus Pendant 516
South German, 16th century

Enameled gold and jeweled pendant with scalloped frame enclosing a shell-headed arcaded alcove containing a statuette of Venus, naked except for drapery over her arm and thigh, standing by a tree stump holding up an arrow, flanked by baluster columns supporting an arch and set with three table cut rubies and three emeralds in raised box collets with white serrated bases. The back colored *en suite* with black arabesques on the alcove facade. Hanging pearl and suspension loop. (44.441)

H. 2-1/4 in (.056 m) W. 1-9/16 in (.04 m)

Notes:
Venus is usually shown with Cupid, especially when she is holding his arrow, as here.

Deliverance Pendant 517
South German, 16th century

Enameled gold and jeweled double-sided pendant with scrolled frame enclosing two scenes from the Old Testament depicting deliverance from tyranny *en ronde bosse* in shell-headed open arcaded alcoves flanked by baluster columns, capitals and crowning baldachino, set back and front with three diamonds and two rubies or three rubies and two diamonds respectively. On one side the alcove contains a group of David taking aim at Goliath, and on the other Judith, sword in hand, places the head of Holofernes in a sack, helped by her maid. Raised box collet below set with a table cut ruby or diamond respectively, a mask beneath the diamond. Double suspension chain, loop and five hanging pearls, all replacements. (44.424)

H. 2-3/16 in (.053 m)

History:
collection of Frederic Spitzer (sale, Paris, 1893, *Catalogue des Objets d'Art),* no. 1840

Publications:
Burlington Fine Arts Club, *Catalogue of a Collection of European Enamels,* London, 1897, no. 244, plate LXVI (Mrs. J. E. Taylor)

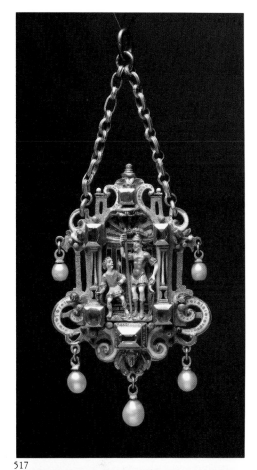

517

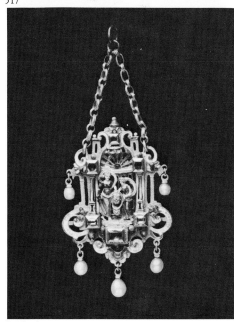

517 back

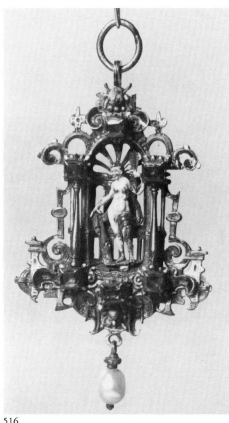

516

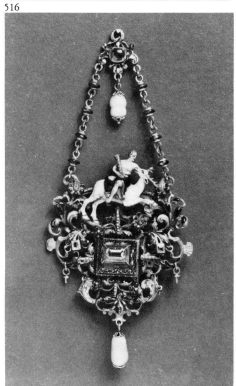

518

Notes:

This rare form with two sides containing figurative groups with related themes compares with a pendant in the Metropolitan Museum of Art, New York, where the subjects are Neptune, and two other maritime divinities. A detailed study of the Walters pendant is in the drawings of Reinhold Vasters, the Aachen goldsmith (Victoria and Albert Museum, E. 2847-1919), and illustrated in Charles Truman "Reinhold Vasters—The Last of the Goldsmiths," *The Connoisseur,* vol. 200, no. 805, March 1979.

Fortitude Pendant 518
European, 16th century style

Enameled gold and jeweled pendant, the openwork scrolled back-plate with vari-colored leaves, flowers and shells, the front set with a large table cut diamond in high cusped box collet, sides with black arabesques on a blue base, flanked by a pair of table cut diamonds in square collets. It is crowned with an allegorical figure in half relief of a bare breasted woman in red drapery clasping a column and riding a stag with head turned back, one antler now missing, perhaps she represents Fortitude. Two suspension chains interspersed with red and white beads attached to cartouche set with a cabochon ruby with double pendant pearl, another below (two pearls missing). (44.622)

L. 5 in (.127 m)

History:
collections of Frederic Spitzer (sale, Paris, 1893, *Catalogue des Objets d'Art,* lot 1819); Belle da Costa Greene, presented in her memory by the Trustees of the Morgan Library, 1951
Publications:
Cooper Union Museum, *Enamel, An Historic Survey to the Present Day,* New York, 1954, cat. no. 79; Museum of Contemporary Crafts, *Enamel,* New York, September 18-November 29, 1959, cat. no. 54
Notes:
A drawing of this pendant by Reinhold Vasters, the Aachen goldsmith, now in the Victoria and Albert Museum (E. 2801-1919) and another of the suspension chains (E. 2855-1919) confirms the impression that it has been assembled from various sources.

Vase Pendant 519
Italian ?, 16th century

Enameled gold rock crystal vase pendant flanked by two winged female terms, feet meeting at the base, their necklaces linked to hinged inner frame with red medallions alternating with green H-scrolls on a blue ground dotted with gold stars enclosing double sided convex oval center panel. Three suspension chains interspersed with vase shaped links hanging from cartouche attached to openwork stopper cover and diadems crowning heads of terms. Hanging pear-shaped emerald. French control mark. When complete the central panels contained *verre eglomisé* paintings, probably devotional; without them it is difficult to ascertain the date of the enameled frame. (44.477)

H. 4-13/16 in (.123 m) W. 1-13/16 in (.046 m)

History:
collections of Ernest Guilhou; Canessa, New York, February 1917, cat. no. 72
Notes:
A similar pendant in the Wernher collection at Luton Hoo, Bedfordshire, has a verre eglomisé painting of the Annunciation.

Harpy Pendant 520
Italian, 16th century

Enameled gold and jeweled harpy, her torso a baroque pearl, her head, shoulders, necklace, eagle's wings, fish tail, fins, and legs are chased and colored, the back *en suite.* Her tail, girdle, and diadem are set with table cut diamonds; the pendant brooch and fin are each set with a table cut ruby, all in square collets. Suspension loop and pendant emerald. (44.486)

L. 2-3/8 in (.06 m)

Publications:
Randall, "Jewellery Through the Ages," p. 498; Peter Stone, "Baroque Pearls, part III," *Apollo,* vol. LXIX, 1959, pp. 33, 107

Lion Pendant 521
European, 16th century

Enameled gold and jeweled lion passant, the body a baroque pearl, the mane, legs, and twisted tail chased, the collar set with table cut diamonds in square collets. Two hanging chains joined to a suspension loop in an enameled flower vase set with a table cut ruby and triangular diamond attached to pendant bunch of fruit and flowers, all replacements.

Although Muller ascribes this jewel to Spain, where the lion features in the Royal arms, it is a heraldic device in other places, notably Venice and Germany, and is used universally as a zodiacal sign and symbol of courage. This quality is conveyed by the threatening pose of the gold head and the muscular force of the baroque pearl body. (57.618)

H. 2-7/16 in (.062 m) W. 2 in (.05 m)

History:
collection of Canessa (sale, New York, February 1917, lot 73)
Publications:
Peter Stone, "Baroque Pearls," *Apollo,* vol. LXIX, 1959, p. 36, fig. VIII; Muller, *Jewels in Spain,* p. 93, fig. 144

Owl Pendant 522
European, 16th century

Enameled gold and jeweled owl *en ronde bosse,* feathers black and white, claws gripping openwork vari-colored triangular scroll base enclosing birds and leaves, the back *en suite,* set with a table cut tourmaline in raised central cusped box collet between two small table cut diamonds in square collets. The back of the owl's head is set with a table cut

ruby in an oval collet, the base with three table cut diamonds. Two suspension chains interspersed with stars set with table cut diamonds, the backs red, joined to openwork cartouche set with a cabochon ruby in oval collet with hanging pearl and table cut emerald in closed back fluted collet, two pearls and ruby below, similarly set, and another pearl.

The owl, emblem of Minerva, symbol of wisdom and discretion is listed in Covarrubias Orozco, *Emblemas Morales,* as a device suited for a great captain. This example, although the openwork base is not of the quality of the bird, illustrates the care given to match the decoration of the back to the front of pendants especially when designed to swing from the sleeve as here. (44.481)

H. 4-1/2 in (.11 m)

Publications:
Ada M. Johnson, *Hispanic Silverwork,* New York, 1944, p. 98, fig. 77; Muller, *Jewels in Spain,* p. 96, fig. 156

Camel Pendant 523
European, 16th century

Enameled gold and jeweled camel couchant, head erect, three legs drawn up underneath, the fourth stretched out in front, reticulated white coat, harness with black arabesques set with table cut rubies and crystals in square collets. Suspension chains, loop and hanging pearl, all replacements.

Because of its qualities of sobriety, endurance and patience, the walking or couchant camel was adopted as a heraldic device and personal emblem. The Cardinal of Ferrara, Ippolito d'Este, chose the camel couchant for his impresa, and in P. Giovio, *Dialoge dell'Imprese,* Lyons, 1559, this is interpreted as a warning to his lady that she should not try him too hard or like the camel he would rise and depart when the load was more than he could bear. (44.476)

H. 1-1/2 in (.037 m) W. 2 in (.05 m)

History:
collection of Canessa (sale, New York, February 1917, lot 75)
Publications:
Muller, *Jewels in Spain,* p. 93, fig. 145; Kirsten A. Piacenti, "Renaissance and Baroque Jewellery," *Apollo,* vol. CV, no. 184, June 1977, p. 25

Lion Pendant 524
German, 17th century

Ivory lion passant, the eyes and flank set with red glass simulating rubies, in gilt metal collets, hung from a pair of gold chains interspersed with pearls, joined to a flower head with six blue petals set with a pearl. Two hanging pearls and suspension loop. The hanging chains and setting are all replacements. (57.1231)

L. 3-3/8 in (.085 m)

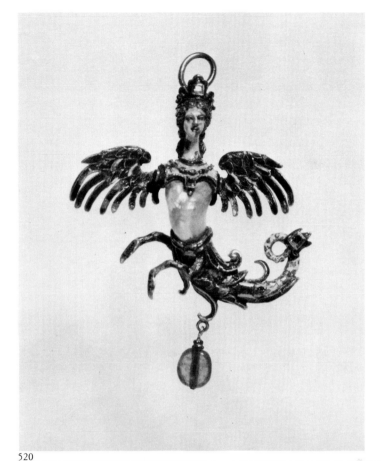

520

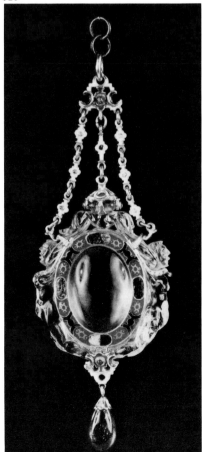

519

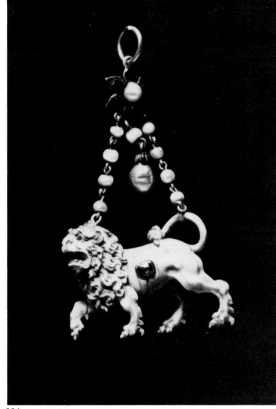

524

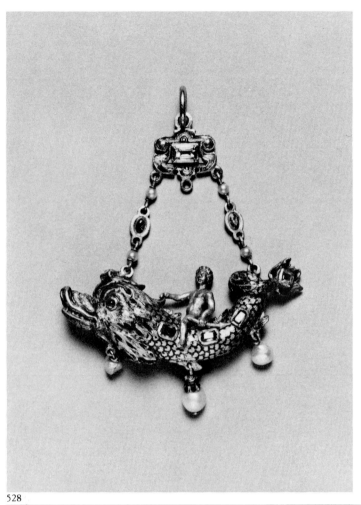

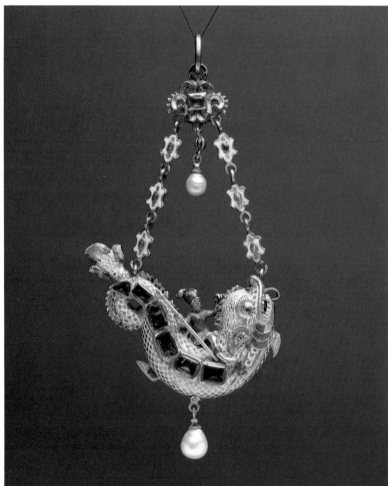

528

527

533 shut

533 open

Parrot Pendant 525
European, 16th century

Enameled gold and jeweled parrot, the breast a baroque pearl, perched on a wreath of red and green ivy leaves with pinned pearls for berries. Two suspension chains interspersed with pearls attached to crystal set rosette with hanging pearl, all replacements. The wreath added later, the parrot 16th century.

Bird jewels, which are found in most collections, include cockerels, eagles, pelicans, ostriches, swans, doves, peacocks, storks and owls. Some of them, like the eagle, have heraldic associations, others, like the pelican, a devotional significance, and the parrot represented the qualities of docility and eloquence. Furthermore, since the 14th century, the parrot had been a favorite pet in royal and papal households, symbolizing the rare, remote and exotic, and selling for high prices. Although most frequently occuring in Spanish jewelry, parrots are listed in inventories elsewhere, and "a juell of golde wherin is a parrot hanging" was one of the presents received by Queen Elizabeth on New Year's Day, 1578. (44.521)

H. 3-9/16 in (.09 m) W. 2 in (.041 m)

Negro Boy Pendant 526
German (Dresden), early 18th century

Silver jeweled and lacquered three-quarter length captive negro boy, hands manacled behind his back. He is armed with a baroque pearl helmet, cuirass, and double hanging pearl pyterges, the cuirass and helmet bordered with rose cut crystals in silver collets, with neck pendant and center of helmet border each set with a ruby. Black lacquer skin, eyes set with red glass, one ear hung with a painted pearl. Suspension loop.

Baroque pearl figurative jewelry, which went out of fashion with the renaissance pendant, was reintroduced by Johann Melchier Dinglinger (1664-1731) and a Huguenot, Ferbecq, both of them goldsmiths to Augustus the Strong in Dresden. Ferbecq is particularly noted for figures incorporating baroque pearls, combining as here renaissance ideas with the sophistication and humor of the 18th century. (57.887)

H. 2-1/4 in (.056 m)

Dolphin Pendant 527
Spanish, 16th century

Enameled gold and jeweled sea monster and rider. A warrior wearing boots, cuirass and shako, wielding a long spear, sits astride a sea monster, back arched in a deep curve, mouth, eyes, fins, scales, and gills with varicolored imbricated and guilloche patterns, and set with six table cut emeralds in oblong collets, the back *en suite*. Hanging pearl and two chains interspersed with red and white shields joined to double sided openwork cartouche with suspension loop set

with a table cut emerald, another hanging pearl below. (44.443)

H. 3-5/8 in (.092 m) W. 2-1/2 in (.065 m)

History:
purchased from A. Seligmann, Paris, 1929, reputedly from the collection of Baron Alfred C. Rothschild of London

Publications:
"Arte Colonial en Santo Domingo, Siglos XVI-XVIII," *Unin de Santo Domingo*, vol. LXXVI, no. 1, p. 36, fig. 42; Erwin W. Palm, "Renaissance Secular Jewellery in the Cathedral at Ciudad Trujillo," *Burlington Magazine*, vol. XCIII, no. 583, October 1951, p. 318, fig. 21; Ann Gabhart, *Treasures and Rarities, Renaissance, Mannerist and Baroque*, The Walters Art Gallery, Baltimore, 1971, p. 26; "Renaissance Objects Installed," *BWAG*, vol. 28, no. 2, November 1975, p. 3, fig. 4; Muller, *Jewels in Spain*, p. 87, fig. 133

Notes:
Muller suggests that this may represent Orlando and the Orca, or man-eating whale, from *Orlando Furioso*, Ariosto, Cantos IX and X.

Dolphin Pendant 528
European, 16th century

Enameled gold and jeweled pendant of a youth, wielding a javelin, astride a dolphin, the low slung back cross-hatched in black, and set with three table cut rubies, the twisted tail with a table cut diamond, all in square collets, the head with blue and green fins, the eye set with a cabochon ruby, the back *en suite*. Two suspension chains interspersed with seed pearls alternating with white plaques centered on red bosses simulating rubies joined to a cartouche set with a table cut diamond. Three hanging pearls and suspension loop. The youthful rider, Arion, who was thrown overboard and carried to safety by a dolphin became a symbol of the arts of music and poetry. (44.309)

H. 1-3/16 in (.03 m) W. 2-9/16 in (.065 m)

Notes:
Both Hans Brosamer and Heinrich Aldegrever adopted the dolphin subject for their designs for whistles, and a sardonyx cameo in the collection of the Duke of Devonshire at Chatsworth illustrates the same theme.

Amulet 529
European, 16th century

Silver gilt pendant spherical urn on a cylinder base with acanthus enclosing branch of white teething coral. Suspension loop.

Renaissance paintings often show adults and children with amulets of coral at the throat, sometimes in branches, or as bead necklaces, for, according to the lapidaries, coral had the power of frightening evil spirits and averting danger. Pliny, in his *Natural History*, Book XXXIII, attributes this to the origin of coral, which, having absorbed the blood of Medusa, obtained with it the power of turning all enemies to stone. (57.1992)

H. 2-3/4 in (.007 m)

History:
gift of Nicholas Landau, 1970

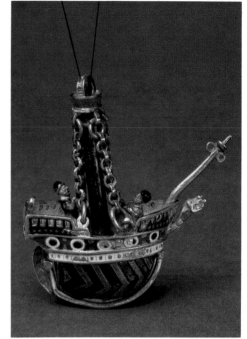

531

525

529 526

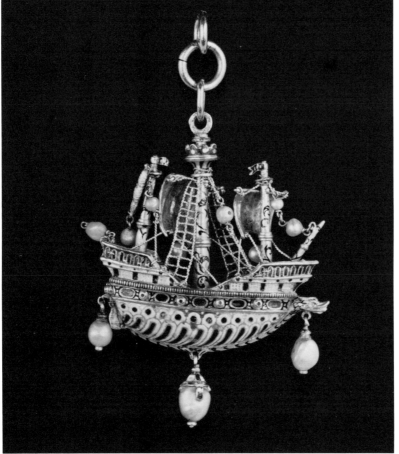

530

Ship Pendant 530
Venetian ?, 16th century

Enameled gold and jeweled ship pendant, the keel outlined with black chevrons, the hull with vari-colored imbricated and guilloche pattern, the gun deck set with table cut rubies and diamonds in square collets, the poop and forecastle with baluster railing, the back *en suite,* except for enamel simulating gems on gun deck. Main masts, bow sprit and deck with arabesque ornament, filigree rigging, some interspersed with pearls, and two sails billowing, mainsail set with a cabochon emerald in a cusped collet, two pennons flying. Suspension loop above the main top with three links attached, pearls hanging from sea monster figurehead, rudder and keel center. (44.475)

H. 2-11/16 in (.07 m) W. 2-1/16 in (.051 m)

History:
collections of Ernest Guilhou de Bayonne; Canessa (sale, New York, February 1917, lot 81)

Pomanders, Picks, and Other Accessories

Although magnificently disguised as jewelry, many renaissance pendants were designed to serve functional as well as ornamental purposes. Pomanders, scented balls of musk or ambergris placed in hinged and pierced metal containers to be sniffed as a protection against the plague or to counteract unpleasant smells, were used throughout this period because of the poor standards of hygiene. Lord Bacon even recommended them "for the drying of rheums, the comforting of the heart, and the provoking of sleep." At first in the shape of an apple or pear, hence the name "pomme d'ambre," they came as large single containers or in sets like beads. Mary Queen of Scots possessed two of these "accoutrements de senteurs," that is a double row of miniature pomanders encircling the head, with necklace, bodice chain, belt, rosary, and two pairs of bracelets. As a further refinement her earrings contained ambergris. Even more unusual is scented figurative jewelry carved from ambergris such as the pendant (no. 534) where the swarthy aromatic material endows the group of the woman and children with a decidedly exotic character.

Other accessories of a practical nature worn in this way were prayer books, mirror cases with brushes attached, whistles, tooth and ear picks, and in the 17th century these took the form of chatelaines with watches and miniature cases added. Occasionally objects served multiple purposes such as the combined pomander, case and mirror (no. 533) or the toothpick pomander (no. 532).

Toothpicks, in particular, took many shapes and forms. They were not just carried for hygiene and comfort but were worn at the

neck or from the waist as highly fashionable adornments, as in the Portrait of a Venetian, by Alessandro Oliviero, in the National Gallery of Ireland, and designs for them exist by Heinrich Aldegrever and Erasmus Hornick, the latter in the form of a mermaid, illustrated in Johanna Defrates, "Late Renaissance Jewellery" (*The Connoisseur,* vol. 190, no. 766, December 1975, figs. 2a and b, and 4a). Queen Elizabeth owned many, one of them a ruby and diamond-set dolphin, another like a pistol "a tothe picke of golde made gonne fation." The fashion came to an end with the use of aromatic wood picks and Shakespeare comments in *All's Well That Ends Well,* Act. I, Scene I: "Virginity like an old Courtier wears her cap out of fashion; richly suited but unsuitable, just like the brooch and the toothpick which we wear not now."

Ship Pomander 531
European, 16th century

Enameled gold ship pomander, the hinged hull with green and white chevrons encircled by white keel and dotted white border, blue rudder. Band of blue H-scrolls alternating with red centered white ovals, balustraded poop and forecastle decks above with pair of seated seamen on each side of green main mast hung with four chains. They wear red caps, blue breeches, and green shirts. Gold bowsprit and sea monster figurehead, and red main top with suspension loop. (44.464)

H. 1-5/8 in (.041 m) W. 1-5/8 in (.04 m)

Toothpick Pomander 532
German, 16th century

Enameled gold and jeweled pomander toothpick, the openwork convex front with pairs of ribbed black cornucopiae each enclosing a blue quatrefoil, set with four table cut rubies round a central diamond, all in square collets, the edges embellished with open scrolls and twin crested eagles' heads, with vari-colored feathers, the hinged back with black foliate scrollwork down plinth with front set with two table cut rubies linked to talon pick issuing from beak of lower crested eagle's head, with vari-colored feathers terminating in a domed boss. Two hanging pearls and suspension loop. (44.482)

L. 3-3/16 in (.081 m)

Publications:
California Palace of the Legion of Honor, *The Triumph of Humanism, Renaissance Decorative Arts 1425-1625,* San Francisco, October 22, 1977-January 9, 1978, cat. no. 101

Monkey Pomander 533
French and Italian, 17th century

Enameled gold pomander, the round base with mottled grey crouching monkey chained

to a tree trunk, an apple in his paw, within vari-colored wreath of raised sprigs of fruit and flowers, the hinged pierced back with a flat wreath round a central rosette *en suite,* containing the pad which was impregnated with musk and other aromatic substances. Four hanging chains attached to corona with four applied cinquefoils and suspension loop. Hanging within a bell-shaped crimson morocco box with tooled gilt overall formal floral design, and opening up vertically as a showcase lined with velvet with a mirror set in the base. Box Italian, pomander French. 44.487 (pomander), 73.6 (box)

D. of pomander 1-1/8 in (.028 m)
H. of case 3-11/16 in (.094 m)

History:
purchased in 1913
Notes:
The raised and fretted enamel compares with the frame of the cameo portrait of Lucretia de Medici illustrated in Ernest C. F. Babelon, *Catalogue des Camées Antiques et Modernes de la Bibliotheque Nationale,* Paris, 1897, no. 961, which is also designed as a garland of flowers in the naturalistic style of Gilles Legaré.

Perfumed Pendant 534
South German, 16th century

Enameled gold and jeweled pendant, the openwork back-plate of white, green, red and blue scroll and bandwork with applied group of a woman with two children, perhaps Medea abandoned by Jason. The figures are carved in ambergris in order to smell sweetly. She is draped round the hips, and wears a jeweled diadem, necklace, armlet and girdle, and stands beneath a pierced baldachino on a round diamond-set base with blue and white lambrequin framed by four red petaled and blue-centered cinquefoils and six outer flower heads, four of them cruciform clusters, and two solitaire table cut diamonds, in raised truncated pyramidal gold collets each springing from four spiky green leaves, backs *en suite.* The lower cruciform cluster has an additional square cut diamond in a raised pyramidal setting. Suspension loop, three hanging pearls (all replacements). French control mark on goods imported after 1893. (44.307)

H. 3-1/4 in (.081 m) W. 2-3/8 in (.06 m)

History:
reputedly in the collection of Baron Karl Meyer von Rothschild; collection of Arthur Sambon
Notes:
This rare example of scented jewelry compares with the Charity pendant, now in the Metropolitan Museum, New York, formerly in the Pierpont Morgan collection (George C. Williamson, *Catalogue of the Collection of Jewels and Precious Works of Art, the property of J. Pierpont Morgan,* London, 1910, no. 7). The layered design, open strap and scrollwork, and metallic flower head settings are close to the style of Daniel Mignot, a Huguenot working in Augsburg at the end of the 16th century. An enameled and jeweled aigrette in the Wallace collection, London, also of this date, has a similar cruciform cluster setting.

195

532

534

Notwithstanding the importance of pendants, chains from which they hung were also a prominent feature of renaissance jewelry. Chains, with or without pendants attached, were worn in abundance not only round the neck but in the hair, across the bodice and round the waist. They were sometimes enameled, and sometimes gem set, and had many different types of link. Since they represented capital, the more massive chains were an acceptable means of rewarding service. In the course of the 16th century, chains became progressively lighter, culminating in the delicate gem centered floral links of the type found in the Cheapside Hoard. Although 17th-century dress, with its lace trimmings, shimmering satins and soft lines, was so admirably suited to the fashion for long ropes of pearls, and these were therefore worn in profusion, chains still remained an important part of jewelry. By this date the progress made in faceting diamonds, and their availability due to the opening up of the mines of Brazil, and of Golconda in Hyderabad, India, is reflected in the number of designs for chains with openwork links of chased gold set with rose cut diamonds.

Portraits provide the best guide to the splendor of jeweled carcanets or necklaces formed of small plaques set with stones, or ornamented in some other way like the carcanet of Gabrielle d'Estrées listed in 1599, which consisted of sixteen pieces, seven of them representing the Planets. The poet Robert Herrick refers to the more usual formula:

> About thy neck a carkanet is bound
> Made of the rubie, pearl and diamond.

The drawings by Hans Mielich recording the jewelry of Duke Albert V of Bavaria are another source of information and Duke Albert's collar of the Order of St. George, perhaps designed by Mielich, preserved in the Munich Schatzkammer is the most complete survivor of the type made legendary by the great ruby collar of Henry VIII, "the lyke of which few men ever saw," and those worn on the shoulders of the Magi in paintings of the Epiphany. The Esterhazy marriage necklace (no. 535) and the collar of the Golden Fleece (no. 536) belong to this splendid category.

535 detail

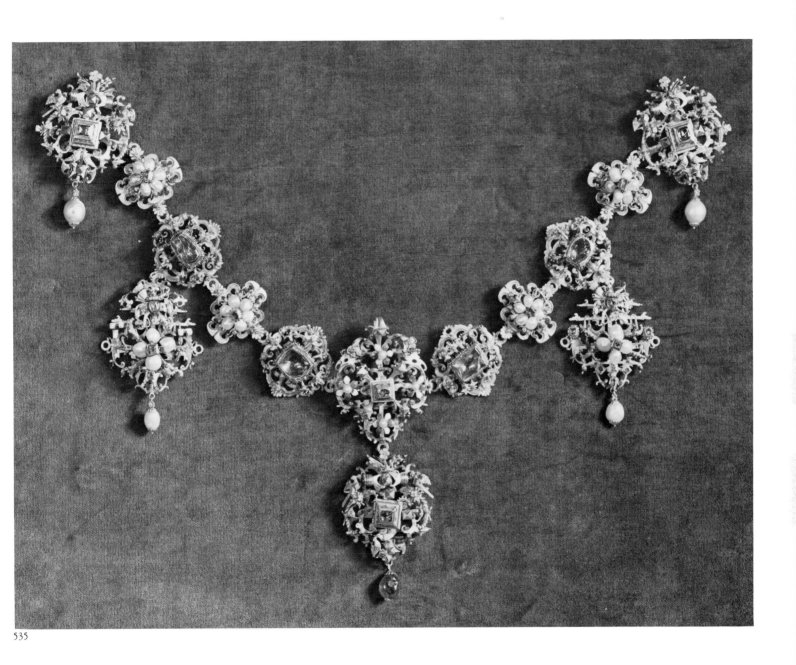

535

Esterhazy Marriage Collar 535

South German, or Hungarian, early 17th century

This magnificent piece is reputedly the collar worn at the wedding of Palatine Miklos Esterhazy in 1611. It has been assembled from a variety of links to represent a garland of flowers interspersed with references to love and marriage—the clasped right hands symbolic of trust, the parrots of docility, the doves of affection, the cornucopiae of the prosperity that comes with marital harmony. In style the collar represents the early 17th-century designs of Daniel Mignot with light openwork symmetrical structures enclosing gem-set blossoms introducing the fashion for jewels emphasizing gems rather than sculpture.

The enameled gold and jeweled collar is composed of fourteen pieces, eleven linked in a chain with three pendants, in five different designs, as described below:

a. Two outer links and central pendant: the openwork scrolled back-plate with white silhouette strapwork, the upper layer centered on a table cut ruby in raised box cusped collet, base and flanking scrolls also with white silhouette strapwork. To each side above and below are gold studs simulating pyramidal cut diamonds, the lower on a scrolled base supporting a pair of turtle doves beak-to-beak. The outer edges enclose flowers spilling out of cornucopiae, on which perch parrots with multi-colored wings and

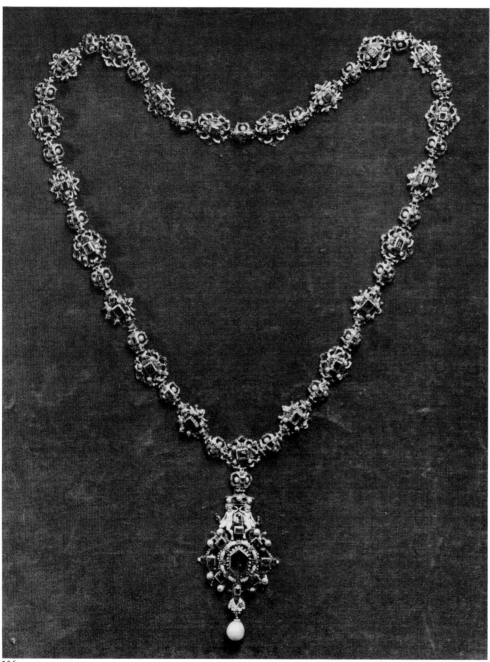

536

breasts studded with gold simulating triangular cut diamonds framing two right hands clasped with blue cuffs and gold bracelets. They hold a crowned heart from which issues a forget-me-not flower with green leaves studded with a gold pyramid and triangle respectively. The two outer links are hung with pearls with forget-me-not caps, the central pendant with an emerald, all replacements.

b. Two outer pendants: the openwork back-plate of horizontal strapwork with white silhouette ornament and punched pendant swags, the upper layer centered on a flower head set with table cut diamond in raised box collet, and pinned with four pearls amid vari-colored stamen. To each side table cut rubies in box collets with black serrated edges, and below a cluster set with two table cut rubies and a diamond in box collets above a ruby in a petal shaped collet. Crowned with a trophy of love emblems—a garlanded winged flaming heart set with a table cut diamond, a quiver, a bow and arrow, and a forget-me-not. Links for side attachment, modern hanging pearl with forget-me-not cap.

c. Four smaller links: Shield-shaped pierced scrolled back-plate flanked by white shells enclosing a flower head centered on a table cut ruby in high box collet the base with black serrated edge, pinned with six pearls amid green buds and leaves. The back channeled for enamel.

d. Four larger links: the cartouche openwork back-plate with shells above and below linked by monsters with black scaly tails, the upper layer centered on a large table cut paste foiled to simulate a ruby in rectangular cusped collet on a base with black serrated edge within an openwork wreath of eight leafy branches with colored details. Back channeled for enamel.

e. Central link: the openwork back-plate of horizontal strapwork and scrolls in white silhouette ornament, the upper layer centering on a table cut ruby in high cusped box collet with blue and white base within an openwork garland of eight flower heads alternately hexafoils with red and white leaves pinned with pearls, and lilies studded with gold simulating pyramidal cut diamonds, and crowned with a curved scroll similarly studded in gold. (44.586)

L. 18 in (.457 m)

History:
collection of Sigmund Bubich, Bishop of Kaschau; purchased from Jacques Seligmann, Paris

Exhibitions:
Cleveland, "Exhibition of Gold"

Publications:
"Exhibition of Gold," *BCMA;* Steingräber, *Alter Schmuck,* p. 114, fig. 189

Collar of the Order of the Golden Fleece 536
Italian, 16th century

Enameled gold and jeweled necklace composed of forty-three links, twenty-one large in two different designs, twenty-one small, plus one linking up with pendant. Each large link is set with a table cut emerald in a box collet with white dots on a red cartouche pinned with twin pearls, increasing to four after the tenth link, framed in white openwork bases alternately of scroll or strapwork, with touches of green, blue and red. The intervening small links are pierced ovals colored *en suite* and set with a table cut diamond in a box collet with white dots flanked by twin pearls. The pendant is set with a central hexagonal table cut emerald in a collet with white serrated base enclosed in a collar formed of the fire steels and flaming flints of the Golden Fleece outlined with white dots, within an openwork ring set with eight table cut emeralds in box collets with white dots linked with red scrolls and pinned with pearls. Two putti holding flaming torches frame a rose cut diamond supporting a floriated crown set with three pearls. Pendant Golden Fleece, and hanging pearl, and hook and loop joining two outer links.

The Order of the Golden Fleece was founded by Philip the Good in 1430 with the purpose of defending the Catholic faith and liberating the Holy Places, these being symbolized by the motif of the Golden Fleece, while the fire steels and impacting flints are the device of the House of Burgundy. This necklace compares with another composed of eleven medallions enameled with scenes of the Crucifixion surrounded by the collar of the Golden Fleece and surmounted by a crown, possibly made for the Emperor Rudolph II (1552-1612). The curving outlines, openwork style and the harmony of the vari-colored enamels with the gems and pearls all integrated by the unifying theme of the white dots suggest a similar late 16th-century date. (44.508)

L. of necklace 28-13/16 in (.773 m) H. of pendant including pearl 3 in (.08 m)

Exhibitions:
Cleveland, "Exhibition of Gold"
Publications:
"Exhibition of Gold," *BCMA;* Muller, *Jewels in Spain,* p. 57, fig. 60
Notes:
Muller compares the small links with those found in a late 16th-century hoard excavated in Seville, fig. 61. For the similar piece mentioned above see Joan Evans, *A History of Jewellery 1100-1870,* New York, 1953, plate 89.

Pendant 537
South German, or Hungarian, about 1600

Enameled gold link, the openwork scrolled back-plate with white silhouette strapwork, the upper layer centered on a high cusped box collet, small box settings and white scrolls to each side. The outer edges enclose flower filled cornucopiae, on which perch parrots with multi-colored wings and a triangular collet in each breast, above them two white hands with blue cuffs and bracelets with continuous band of settings. They hold a crowned heart with lozenge collet, from which issues a forget-me-not flower with leaves. All the settings now empty, and since in almost all respects the jewel compares with type a. in the Esterhazy marriage collar (no. 535), there should also be a pair of turtle doves beak-to-beak on lower scrolled base, and a hanging pearl. The pendants in the Esterhazy marriage collar have gold studs simulating pyramidal and triangular diamonds whereas all these settings once contained gems. Other surviving examples are in the Rijksmuseum and at Budapest. (44.413)

H. 2-1/4 in (.055 m) W. 2 in (.05 m)

Publications:
E.G.G. Bos, "A Renaissance Pendant with Marriage Symbols," *Bulletin of the Rijksmuseum,* 1966, pp. 65-70

537

Bracelets

Surviving examples of bracelets are as rare as earrings, yet they were worn in quantities, sometimes under slashed sleeves. Some were made of gold links, others bejeweled like miniature carcanets, and Mary Queen of Scots owned one that was a revival of the ancient Roman form of a snake. Beaumont and Fletcher in their play *Cupid's Revenge* allude to the fashion for bracelets incorporating a lover's hair. The inventory of the chatelaine of an estate in Perigord, Madame de St. Aulaire (died 1595) describes her bracelets in some detail: seven in number, they came in pairs and in sets of different sizes, some so long that they could be wound several times round the arm, and one pair was made to be worn over the sleeve. Seventeenth-century bracelets were often composed of slides sometimes set with cameos or intaglios threaded onto ribbons. (no. 539)

538

Bracelet Slides 538
French, about 1700

Pair of gold oval medallions enclosing portraits of the Duke and Duchess of Burgundy, parents of Louis XV, in late 17th-century dress; she wears girandole earrings, a pearl necklace and diamond bordered bodice. Framed in plain rims and fitted as slides for wearing on ribbon as bracelets, set with glass. (38.94-5)

D. 1 in (.026 m)

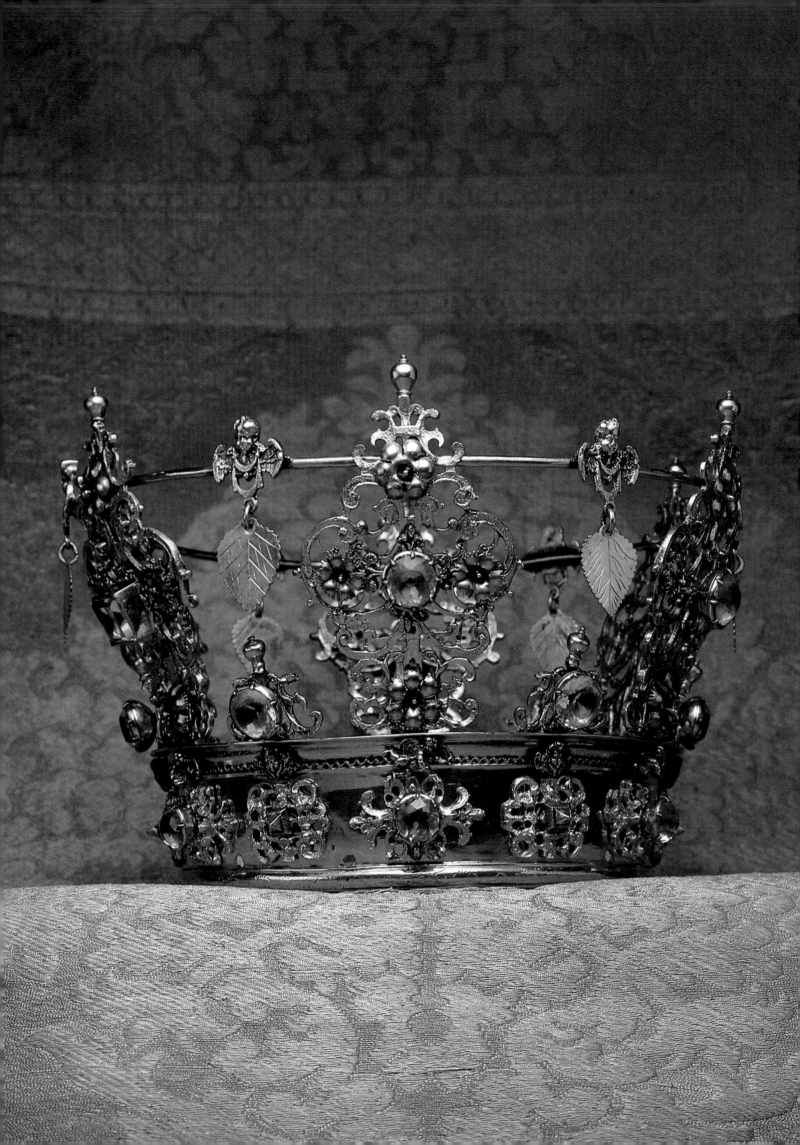

Wedding Crown 539
Swedish, late 17th century

The crown is silver gilt adorned with large paste jewels, cast silver ornaments, and stamped flowers of sheet silver. The circlet is framed with raised mouldings decorated with punched ornaments, its surface decorated with cast openwork designs, set alternately with a faceted paste or a silver ornament, imitating a pyramidal diamond. To the upper moulding are attached cast silver cherubic heads alternating with flying cherubs.

The major elements of the crown are six cast cartouches of interlaced strapwork, each ornamented with a central paste and four silver flowers. These cartouches are attached to an upper hoop, on which are six cast cherub heads with pendant heart-shaped leaves. Between the cartouches are mounted six paste jewels on the upper rim of the circlet. There are eight holes in the circlet to attach the cloth cap. (57.2047)

D. 7-3/4 in (.197 m) H. 5-7/8 in (.149 m)

History:
purchased from Ruth Blumka, New York, 1978

540

Dress Ornaments

Dress ornaments, designed to be sewn all over the costume, were another splendid feature of the Renaissance. These aglets, or appliques, reflect the style of other jewels and come in the shape of fruit or flowers, snakes and frogs, or cartouches with strapwork frames. They are usually made of enameled gold and set with pearls, foiled stones or cameos. Sometimes ambergris was inserted into them so that the wearer would smell sweetly. The 16th-century fashion of huge skirts and sleeves required big sets, and one of the largest belonged to Mary Queen of Scots, who had eighty-four in a pearl set pattern enameled black and white. Anne of Denmark ordered two dozen diamond buttons from the court jeweler Arnold Lulls in 1605, and this formal taste continued to influence dress ornaments in the 17th century. Queen Henrietta Maria wears a set of gold doves with diamond breasts in a portrait by Van Dyck. The stomacher or triangular bodice ornament was also subject to jeweled enrichment and sometimes had a fan holder attached to the point by a gold or silver chain, and elaborate designs for these in rock crystal and ivory were published by Erasmus Hornick of Nuremberg in 1562. He also designed the mounts for the marten and sable heads attached to fur skins sometimes seen in portraits and almost always lovingly stroked by the wearer. Inventories stress the craftsmanship and sparkle of these appealing jewels and the marten's head (no. 540),

which is superlatively embossed and studded with rubies and pearls, is a wonderful witness to their quality.

Marten's Head 540
Venetian ?, 1550-60

Enameled gold and jeweled marten's head, intended as an attachment to a fur piece, the surface of the upper jaw simulating fur and skin, and outlined by a pair of convergent scrolls, with a further pair above with black ribbing enclosing a white dove with facing mask between displayed wings, linked to vari-colored foliate swags terminating in white knotwork. Large almond eye sockets filled with black enamel under bushy brows, with center table cut ruby in raised box quatrefoil collet, with grotesque mask above joined to festoons of blue and black grapes devoured by black ducks perched on knotwork below. Pointed furry ears outlined in black enamel, and collar set with center pair of table cut rubies in raised box quatrefoil collets and encircled by others similarly set between pairs of seed pearls alternating with gold centered green and white petaled hexafoils, pinned with pearls. The lower jaw similarly chased with grotesque mask, swags, scrolls, tassels, and blue and white berries, surface simulating skin texture. Red moveable tongue and white teeth.

540 top

Facing: Swedish Wedding Crown (no. 539)

The marten symbolized chastity as its conception was believed to take place through the ear, thus the dove of the Holy Spirit, so prominently displayed here, is refering to the Incarnation which was similarly effected through the ear of the Virgin when the Archangel Gabriel appeared at the Annunciation. (57.1982)

L. 3-5/16 in (.084 m)

Publications:
John Hunt, "Jewelled Neck Furs and 'Flohpelze'," *Pantheon*, May 1963, pp. 151-157; Richard H. Randall, Jr., "A Mannerist Jewel," *BWAG*, vol. 20, no. 1, October 1967; Günther Schiedlausky, "More Details of the Jewelled Neck Fur," *Pantheon*, November-December 1972, pp. 469-480; Francis Weiss, "Bejewelled Fur Tippets—and the Palatine Fashion," *The Journal of the Costume Society*, no. 4, London, 1970, pp. 37-43

Dress Ornaments 541
European, about 1600

Enameled gold oval cartouches with black and white scrolls entwined round open punched moulded border, each set with an onyx cameo, the subjects as follows: a. Hercules strangles the Nemean Lion b. Two figures in classical dress by an altar with a satyr c. A rustic brings a goat and fruit for sacrifice (derived from A. Vico, *Monumenta Aliquot Antiquorum ex Gemmis et Cameis Incisa*, published in Parma, pl. 5). (57.553-5)

H. 3/4 in (.018 m) W. 1-1/16 in (.026 m)

Dress Ornaments 542
European, late 16th-17th century

Enameled gold cartouches with hanging pendants, each set with a shell cameo, at present sewn on a velvet ribbon, the subjects as follows: a. Aurora and Cephalus b. King David plays his harp c. damaged d. Diana hunts the stag e. Leda with Jupiter in the guise of a swan f. damaged g. St. Jerome translates the Bible h. Thisbe discovers Pyramus dead i. Aurora and Cupid j. Venus and Cupid k. portrait of a man wearing 16th-century costume with hat l. Venus and Adonis. Each has three holes for sewing to the costume and the group illustrates the variety of subject matter in demand. Here biblical scenes and characters, contemporary portraits, and mythological divinities are represented. Some of the hanging pendants enclose cinquefoils. (57.1115)

3/4 in (.02 m)

Dress Ornaments 543
European, late 16th century

Enameled gold and jeweled S-shaped openwork cartouches, each set with a cabochon emerald in raised collet between twin pearls (some missing). (44.444-8)

H. 13/16 in (.02 m) W. 1-3/16 in (.026 m)

Publications:
Muller, *Jewels in Spain*, fig. 157

Dress Ornaments 544
European, 16th-17th century

Enameled gold openwork cartouches set with oval shell cameos, all bucolic scenes, as follows: a. Pan uncovers a sleeping nymph b. a young faun plays his pipe in a garden of flowers c. a young faun blows his trumpet. In each setting opaque white dots enliven the color scheme and outline the scrollwork, and there are four loops for sewing onto the costume. (57.1116-8)

H. 1-1/2 in (.038 m)

Belts

Closely connected with necklaces in style are belts, many of them matching, and some designed individually. Elizabeth of Valois, wife of Philip II of Spain, is recorded as having a belt made of rock crystal leaves and S-links alternating with enameled gold branches, and master goldsmith Benvenuto Cellini once made a marriage girdle three inches wide embossed with small figures. Cellini also writes of another type of belt, made of leather and cloth, for which he designed a silver buckle, "the size of a child's head," carved with acanthus, putti and masks. These buckles, with matching tag end to hang down in front had an important place in the costume of the day. In many cases such ornamental fittings were designed to match the sword or dagger, as well as the purse, which all hung from the belt.

Belt 545
German (Silesia), mid-16th century

A belt made of nine embossed oblong sections, pierced and carved with leaf-scroll ornament within raised crenelated borders. The sections are hinged, numbered on the back II-IX, and the belt includes one section with a riveted plate engraved with floral scrolls, and possibly intended for mounting a sword. One end section is fitted with a hook, and the other with a ring and a chain of eleven cable links with a knob finial. To the chain is attached a six-pointed star of silver set with a crystal in a multifoil collet, stamped on the back with an unidentified maker's mark. (57.1866)

L. 23-13/16 in (.605 m)

History:
purchased in New York, 1957
Publications:
Steingräber, *Alter Schmuck*, figs. 124-125
Notes:
A belt with fittings of comparable foliate character is illustrated in Ilse Fingerlin, *Gürtel des hohen und späten Mittelalters*, Munich, 1971, cat. no. 99.

Belt 546
German, Augsburg, about 1600

Gold and silver, the heart-shaped buckle with openwork scrolls centering on a mask,

541

the pin *en suite,* hinged to buckle plate with crenelated and scrolled edges enclosing panels of tracery, the sides with arabesques and at one end an infant sleeping by a skull, and at the other Charity with her children, at the back arabesques and the initials WD. The tag end is decorated *en suite,* but with twin lion masks instead of the sleeping child, and Faith holding the Cross and Chalice instead of Charity. (57.1040)

Total L. 18-1/2 in (.468 m)

Buckle end 5-3/4 in (.145 m)

Tag end 4-1/8 in (.103 m)

Notes:

For makers mark WD see Marc Rosenberg, *Der Goldschmiede Merkzeichen,* vol. I, Frankfurt, 1890, p. 84, no. 490. It was suggested in Clifford Smith, *Jewellery* (London, 1908, reprinted 1973, p. 271) that such elaborate fittings as this, and the following were specimens submitted by belt makers in support of their application for membership of the Girdlers Guilds, and that the combination of tracery with Renaissance ornament at this date demonstrates the conservatism of such institutions. Inscriptions accompanying other examples of the child sleeping by the skull explain that this scene signifies that with the coming of death the miseries of this world will vanish.

Belt 547

German, Augsburg, about 1600

Gold and silver, the heart-shaped buckle with openwork scrolls centering on a fleur-de-lis, crowned double-headed eagle pin hinged to section with applied rosette attached to stepped oblong buckle plate with chiseled ornament terminating in snake's head hooks framing sunken panels of tracery and symmetrical open scrolls beyond. The sides and back are engraved with floral sprays and the initials CB. The tag end decorated *en suite,* but with a pair of rosettes applied to front terminal. (57.1041)

Total L. 22-1/8 in (.561 m)

Buckle end 5-1/4 in (.133 m)

Tag end 3-3/4 in (.095 m)

Notes:

For maker's mark CB see Marc Rosenberg, *Der Goldschmiede Merkzeichen,* vol. I, Frankfurt, 1890, p. 73, no. 453.

Belt Buckles 548

Hungarian, 17th century

Enameled silver gilt and jeweled belt buckles, each with central panel of openwork arabesques enclosing a huntsman shooting a stag, set with three jacinth pastes in blue, white and black curled petal collets within embossed scrollwork border with quatrefoils and beads framed in chainwork. Hinged tongues decorated *en suite* and set with sapphire pastes in similar petal collets, snake's head hooks. The sides with openwork arabesques set with four turquoise pastes in high round collets, the back plain but open for the insertion of leather or cloth girdle. (57.2000)

L. 13/16 in (.022 m) W. 2-11/16 in (.067 m)

History:

purchased from L. Blumka, New York, March 1972

542

545

546, 547

548

The combination of engraved gems, either cameos or intaglios, with settings of enameled gold is one of the most successful fashions of this period. It was used for pendants and rings as well as for links for necklaces, bracelets, and belts, and fortunately many of these settings have survived. Some of these cameos and intaglios are ancient, for gems at this time could be picked up daily in the ruins of Rome. Whereas no other jewelry from the classical world had survived in quantity, the gems, which could not be melted down, were still there to provide the link with antiquity. Collections were formed by Pope Paul II and Lorenzo de Medici and some gems were worn as jewels. The enthusiasm for gems, both as collectors' pieces and as jewels, stimulated the rise of a school of contemporary engravers whose ambition was to excell the ancients yet express the spirit of their own time. This meant that gem engraving was closely linked with the style and iconography of monumental sculpture and painting.

Foremost among the classical themes reinterpreted in this way is the portrait, now devoid of the abstraction of classical art, yet inspired by the same ideal of human beauty and dignity. This synthesis is exemplified by the Walters chalcedony head of a young man (WAG 42.1337), dating from late 15th-century Venice. Another innovation was the narrative gem recording events of history and mythology in an anecdotal and detailed manner far removed from the concentrated images of antiquity.

From Florence, Venice, Rome, and Milan the art of gem engraving was carried to the Tudor, Valois, and Hapsburg courts, and by 1600 thousands of standardized Lucretias, Cleopatras, Minervas, Cupids, nymphs, and satyrs were being produced to meet the demand. The taste for large sets of such subjects as the twelve Roman Emperors encouraged the use of soft substances like shell, which lowered quality still further, and the adoption of shiny mottled and banded stones was another encouragement to summary work, since the markings obscured the outline of the engraving. But although gems ceased to be carefully worked, their standing as cultural status symbols was not affected and in a letter to her lover dated 1653 a certain Dorothy Osborne describes this widespread fashion: "That daughter of my Lord Holland is here. She says that seals are much in fashion, and by showing me

543

544

some she has set me alonging for some too…", and later she mentions them again referring to a Mrs. Smith: "They say she wears twenty strung on a ribbon, like nuts boys play withal, and I do not hear of anything else."

Engraved Gems with Classical Portraits

549. Sardonyx cameo portrait of a woman, wreathed. Plain rimmed gold pendant. Gem 15th century, setting 18th century. (42.1222)

H. 1 in (.025 m)

History:
collections of Earl of Arundel, Theca 2, no. 30 "Semiramis"; Duke of Marlborough, cat. no. 121 "Venus wreathed in myrtle"; Henry Walters before 1931; Mrs. Henry Walters; purchased from Joseph Brummer, New York, 1942
Notes:
The gem compares with a cameo in Vienna (Fritz Eicher and Ernst Kris, *Die Kameen in Kunsthistorischen Museum,* catalogue, Wien, 1927, no. 150) and in the British Museum (O.M. Dalton, *Catalogue of the Engraved Gems of the Post-Classical Periods,* London, 1915, no. 404), both of them North Italian and of similarly idealized young women.

550. Sardonyx cameo portrait of Nero, wreathed. Plain gold ring. This portrait shows the Emperor Nero (37-68 A.D.) youthful and smiling, with the dark upper layer contrasting effectively with the pale ground. (42.1041)

H. of bezel 13/16 in (.02 m)

History:
collections of Earl of Arundel, Theca B, no. 27; Duke of Marlborough, cat. no. 430; Henry Walters before 1931; Mrs. Henry Walters; purchased from Joseph Brummer, New York, 1942

551. Sardonyx cameo portrait bust of the Emperor Hadrian (117-138 A.D.). In plain gold rimmed setting with bow-shaped suspension loop. (42.1043)

H. 15/16 in (.024 m)

History:
collection of Duke of Marlborough, cat. no. 460; Henry Walters before 1931; Mrs. Henry Walters; purchased from Joseph Brummer, New York, 1942

552. Foiled garnet cameo portrait of the Emperor Domitian, wreathed. Plain octagonal ring. (42.1040)

H. of bezel 13/16 in (.02 m)

History:
collections of Earl of Arundel, Theca A, no. 115; Duke of Marlborough, cat. no. 431; Henry Walters before 1931; Mrs. Henry Walters; purchased from Joseph Brummer, New York, 1942
Notes:
The shallow relief, treatment of hair and ears compare with another cameo, also in monochrome and from the Arundel collection in the Victoria and Albert Museum (M. 133-1922), which, like ours, seems to have been repolished in the 18th century.

Classicizing Portraits

553. Lapis lazuli cameo double portrait busts of Hercules and Omphale. Both wear lion skins on the head and knotted at the shoulder. Plain ring. (42.1057)

H. 1 in (.026 m)

History:
collections of Earl of Arundel, Theca C, no. 9; Duke of Marlborough, cat. no. 319 "a Ptolemy and his queen"; Henry Walters before 1931; Mrs. Henry Walters; purchased from Joseph Brummer, New York, 1942
Notes:
Another double portrait of this couple, also with the attributes of Hercules and Omphale, in the Bibliothèque Nationale (Ernest C. F. Babelon, *Catalogue des Camées Antiques et Modernes,* Paris, 1897, no. 953) was tentatively identified as Alfonso II d'Este and his wife, Lucretia de'Medici, at the time of their marriage, 1558-1561. However, other princes of the house of Este bore the name of Hercules, including Alfonso's brother Hercules I, and there is also a resemblance to Camillo Gonzaga, Count of Novellara, and his wife Barbara Borromeo, whose marriage took place in 1558.

Christian Iconography

554. Plasma with red inclusions intaglio. St. Barbara, nimbed and wearing classical dress, martyr's palm in her hand, stands by a miniature tower. Plain gold ring. The tower has three windows referring to St. Barbara's devotion to the Holy Trinity which led to her martyrdom. In the 15th century her image was a talisman protecting the wearer from sudden death. (42.1004)

H. 1-1/8 in (.029 m)

History:
collections of Henry Walters before 1931; Mrs. Henry Walters; purchased from Joseph Brummer, New York, 1942
Notes:
A late 15th-century medieval cameo of St. Barbara is in the Staatliche Sammlung in Munich.

555. Mottled red jasper intaglio. St. John the Baptist wearing skins and a cloak over his arm, holds the cross with banner attached, and a dish containing the Holy Lamb. Inscription in Roman capitals FPC. Plain gold ring. (57.1795)

H. 13/16 in (.02 m)

History:
gift of Laura F. Delano, June 9, 1947

549

553

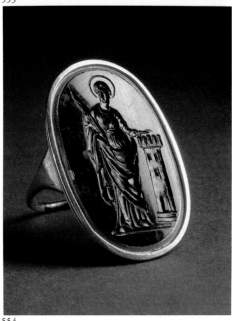

554

550, 551, 552

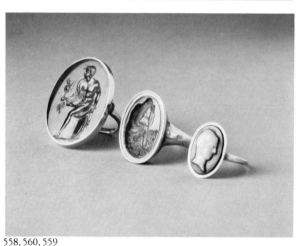

555

558, 560, 559

556

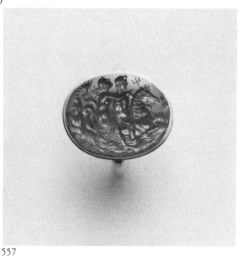

557

556. Banded agate intaglio. Fortune, hair in a cap, scarf held up as a sail to the wind, rides on the back of a dolphin. Plain gold ring. (57.1798)

H. 1-1/16 in (.027 m)

History:
gift of Laura F. Delano, 1947

557. Cornelian intaglio of Neptune and Amphrite. He holds a trident and wears a celestial crown, she is radiant with happiness as they ride through the foaming waves. Plain gold ring. (42.1201)

W. 15/16 in (.023 m)

History:
collections of Earl of Arundel, Theca A, no. 31; Duke of Marlborough, cat. no. 29

558. Banded sard intaglio. Diomedes, drawn sword in hand, clambers over the garlanded altar of Apollo holding the statue of the Palladium. Plain gold ring. The theft of the Palladium, or sacred image of Athena, from the sanctuary in Troy was a key event in the history of the Trojan War for the safety of the city depended on it. The subject occurs on renaissance medals, and also on a marble roundel in the courtyard of the Palazzo Medici Riccardi from the workshop of Donatello, and there were many versions of the fine Roman gems signed by Dioscourides, Solon, and Gnaios. (42.1184)

H. 1-1/4 in (.031 m)

History:
collections of Earl of Arundel, Theca E, no. 9; Duke of Marlborough, cat. no. 342; Henry Walters before 1931; Mrs. Henry Walters; purchased from Joseph Brummer, New York, 1942

559. Onyx cameo helmeted head of Diomedes. Plain gold ring. (42.1181)

H. 9/16 in (.02 m)

History:
collections of Medina, Leghorn; Earl of Bessborough, cat. no. 156 M.40; Duke of Marlborough, cat. no. 337; Henry Walters before 1931; Mrs. Henry Walters; purchased from Joseph Brummer, New York, 1942

560. Cornelian intaglio. Hercules rests from his Labors, seated with head bent down, his bow grasped in his hand, and trophies from his Labors—the ox of Geryon and the apples of the Hesperides—at his feet. Plain gold ring. (42.1089)

H. 3/4 in (.019 m)

History:
collections of Henry Walters before 1931; Mrs. Henry Walters; purchased from Joseph Brummer, New York, 1942
Notes:
A celebrated version of this subject was in the collection of Fulvio Orsini, and later in that of the Duke of Orleans

(La Chau and Le Blond, *Description des principales pierres gravees du Cabinet de S.A.s. monseigneur le Duc d'Orléans,* vol. I, no. 86, Paris, 1780-84), and there is another in the Devonshire collection, (Worlidge, *A Select Collection,* no. 150).

561. Banded agate intaglio. Mars, seated, nude except for his helmet, embraces Venus who stands beside him dangling his shield over her head. In plain gold locket mount. (42.1021)

H. 2-5/16 in (.059 m)

History:
collections of Henry Walters before 1931; Mrs. Henry Walters; purchased from Joseph Brummer, New York, 1942
Notes:
This compares with a bronze plaquette where the group includes a figure of Cupid in the Kaiser Friedrich Museum based on a composition by Giovanni Bernardi (1496-1553).

562. Onyx cameo. Cupid rides a dolphin, whip in hand. At the back, heliotrope intaglio of the Laocoon. In gold medallion. (42.1437)

D. 1-1/2 in (.039 m)

History:
purchased from Joseph Brummer (sale, New York, May 12, 1949, part II, lot 232)

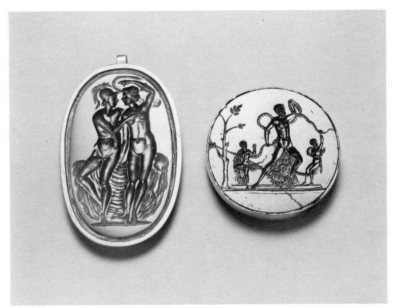

561, 562

Cameo Pendant 563
European

Onyx cameo. A lion passant. Plain gold pendant. (42.139)

H. 1 in (.024 m)

History:
collections of Charles Newton-Robinson (sale, Christies, June 27, 1909, no. 95); Morrison, cat. no. 11; purchased from Dikran Kelekian, 1909
Publications:
Burlington Fine Arts Club, *Exhibition of Ancient Greek Art,* London, 1904, no. M. 181
Notes:
This is comparable with the late 15th-century cameo formerly in the collection of Lorenzo de'Medici and now in the British Museum, O. M. Dalton, *Catalogue of the Engraved Gems of the Post-Classical Periods,* London, 1915, no. 32, but possibly ancient.

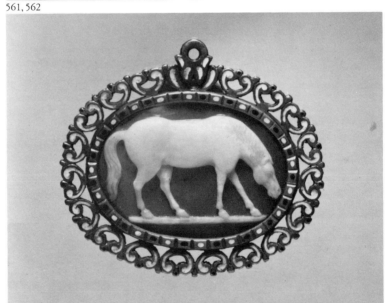

565

Intaglio Pendant 564
European

Rock crystal intaglio (with bluish tint). A cow grazing, head down. Inscription in Greek letters, APOLLONIDOU (Of Apollonides). Silver pendant setting. (42.1165)

L. 15/16 in (.023 m)

History:
collections of Henry Walters before 1931; Mrs. Henry Walters; purchased from Joseph Brummer, New York, 1942
Notes:
Pliny, *Natural History,* Book XXXVII, 8 refers to Apollonides as a celebrated engraver of the Hellenistic period, but no work with his signature has survived, although it is found on imitations of ancient gems, as here.

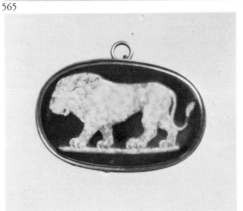

563

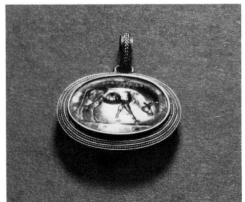

564

Cameo Pendant 565

European

Onyx cameo. A horse grazing. Brass pendant with heart-shaped volutes filled with white enamel. (42.145)

H. 2-7/8 in (.061 m)

History:
collection of Charles Newton-Robinson (sale, Christies, June 27, 1909, lot 115)
Publications:
Randall, "Jewellery Through the Ages," p. 499, no. 16
Notes:
In quality the cameo compares with fine bronze statuettes of horses, and iconographically with the rooms frescoed with the favourite horses in the Gonzaga stables, in the Ducal Palace of Mantua.

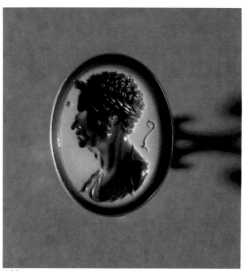

566

Pendant Seals

566. Nicolo intaglio. Wreathed head of Julius Caesar with star and lituus crook in the field. Gold mount with openwork handles. This type of Caesar occurs frequently in gems of the 16th and 17th century though rarely of this size and quality. (42.1083)

H. 1-15/16 in (.034 m)

History:
collections of Earl of Bessborough, cat. no. 19; Duke of Marlborough, cat. no. 382; Henry Walters before 1931; Mrs. Henry Walters; purchased from Joseph Brummer, New York, 1942
Publications:
The Marlborough Gems, vol. I, no. 3

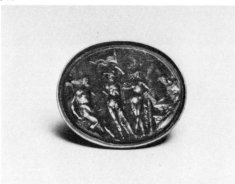

567

567. Heliotrope intaglio. An assembly of the gods: a bearded Mercury sits holding up a winged caduceus, a helmeted Mars brandishes his spear and shield, Venus leans on a column and holds a long arrow, and a bearded Vulcan bends over an anvil hammering a winged helmet or wings for Mercury's heels. Silver mount. (42.163)

L. 1-1/16 in (.027 m)

History:
collection of Raspe-Tassie, London, 1791 (*Descriptive Catalogue of Engraved Gems,* from the private collection of Mr. Tassie); Lord Carmichael, cat. no. 353; purchased from Joseph Brummer, 1927

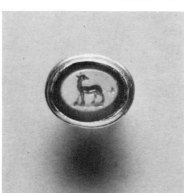

568

568. Nicolo intaglio. A wolf statant. Gold mount with openwork handle. (42.1138)

L. 7/16 in (.011 m)

History:
collections of Earl of Arundel, Theca A, no. 68; Duke of Marlborough, cat. no. 709; Henry Walters before 1931; Mrs. Henry Walters; purchased from Joseph Brummer, New York, 1942

Renaissance Rings

Perhaps at no other time have rings bee worn in such numbers and made to such hig standards as in the 16th century. Intaglio were set in signets, for seals were needed b all who had business to transact—nobility clergy, merchants, lawyers and privat individuals—and each had his persona device. Cameos were set in the large categor of decorative rings, designed in the sam excellent taste as other jewels, with peta like settings of chased and enameled golc the shoulders with caryatids, volutes, masks swags and strapwork. A further expressio of this sculptural character are those ring with bezels decorated with minute figure of animals and men *en ronde bosse.*

Many rings were associated with love an marriage, some with twin hoops bearin inscriptions referring to the permanenc of matrimony. Others with simpler mes sages, such as A QUIET WIFE PRO LONGETH LIFE, were known as posie and the symbol of two right hands claspe appears on rings just as on bracelets an belts. The devout wore rings bearing th emblems of faith, and the superstitiou carried talisman rings made of asses hoo and toadstone. Popes, kings, and bishop were invested with rings as signs of thei authority, and their subordinates wore then as badges of offices. Pride in possession le to the custom in some countries, notabl Germany, of wearing them on all fingers including the thumb, under slashed glove strung on chains in the cap, round the neck and at the wrist. In the 17th century the are worn much more sparingly, designs are simplified and vari-colored sculptura ornament is replaced by floral motifs i black and white. Signets become progres sively lighter, and the fashion for wearing intaglios in pendant seals hanging from the waist rather than in rings is introduced. The development of multiple faceting of gems resulting in the invention of brilliant cutting at the end of the 17th century was accom panied by the increased use of precious stones, especially the diamond, set either in cluster or solitaire.

The taste for symbols of mortality created a need for rings with death's heads and appropriate inscriptions, enameled with al the macabre trophies of the grave. Towards the mid 17th century these became associated with memorials of specific people in the form of mourning rings containing the hair and cipher of the deceased. The widespread adoption of the memento mori theme, already familiar in rosaries and devotional jewelry, owes much to the example of Henri III who owned eighteen dozen silver buttons embossed with death's heads. In the same mood are coffin shaped pendants containing skeletons, and pomanders and watches shaped like skulls.

Ring 569

European, about 1600

Gold ring with amethyst intaglio portrait of a man. Oval bezel, sides and shoulders with foliated scrolls enameled black, convex hoop. Ring and gem circa 1600. Admirably characterized in the best Roman tradition, the gem and the fine ring are well matched. (42.1038)

H. 13/16 in (.02 m)

History:
collections of Lord Chesterfield; Earl of Bessborough, cat. no. 4C "Nerva"; Duke of Marlborough, cat. no. 509; Henry Walters before 1931; Mrs. Henry Walters; purchased from Joseph Brummer, New York, 1942
Publications:
The Marlborough Gems, vol. I, no. 18, London, 1780

Ring 570

European, 16th century

Enameled gold ring, clawed bezel set with four triangular diamonds, shoulders with relief strap and volutes, the hoop set with a continuous band of table cut diamonds, the inside with white interlaced strap on a black ground, the back of the bezel with spiral twists outlined on white. The adoption of the diamond ring as the device of the Royal house of Navarre, and the Medici and Este families is proof of its high status in the Renaissance. The design and faceting of this example compares with examples in the Grune Gewolbe, Dresden. (44.480)

D. 11/16 in (.18 m)

Ring 571

European, 16th century

Enameled gold ring, raised box bezel on inverted truncated pyramid set with a table cut diamond and supported by six eagles' talons, openwork shoulders enclosing grotesque masks, convex hoop. (44.313)

D. 1 in (.024 m)

Greyhound Ring 572

Italian, 16th century

Enameled gold ring, the oval bezel with greyhound statant on green and white grassy mound, shoulders with relief strapwork cartouches, each set with a table cut ruby in a quatrefoil collet, oval hoop. French gold guarantee mark. (44.479)

7/8 in (.02 m)

Notes:
This compares with a small group of decorative rings with sculptural motifs *en ronde bosse,* (see Gerald Taylor and Diana Scarisbrick, *Finger rings from ancient Egypt to the present day,* London, 1978, nos. 642-646), two of them of dogs.

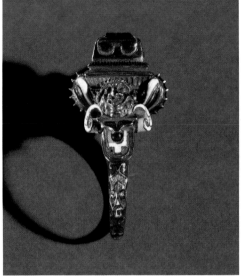

602 side

570

602

569

572

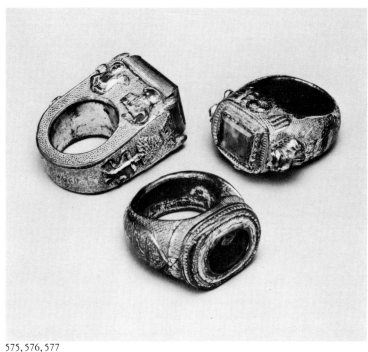

575, 576, 577

573

574

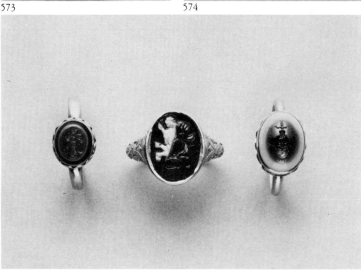

579, 578, 580

Ring with Clasped Hands 573

European, 16th-17th century

Gold ring, the flat bezel with a pair of clasped right hands, the shoulders with cuffs, each bearing a heart, plain hoop. The motif of the clasped hands symbolizing mutual trust originating in the Roman "dextrarum iunctio" was revived in the Middle Ages as a betrothal symbol and continued in use in the Renaissance for rings, belts, bracelets and pendants. It is the theme of three of the pendants in the Esterhazy marriage collar (no. 535). (57.1636)

D. 3/4 in (.019 m)

History:
purchased from Joseph Brummer, 1941

Skull Ring 574

European, 17th century

Enameled gold ring, the bezel in the form of a black and white jawless skull and crossbones, eyes set with triangular diamonds. Forked shoulders each set with a rose cut diamond in clawed collet, convex hoop terminating in acanthus ornament, the back of the bezel with a green trefoil. A fine example of the memento mori theme in jewelry. (44.478)

13/16 in (.02 m)

Papal Ring 575

Italian, 15th century

Gilt bronze ring, rectangular bezel set with foiled crystal, shoulders with Papal tiara and mitre, infulae enclosing the shield of Cardinal Gabriele Condolmerio (1408-31), and meeting at the base of the hoop. (54.434)

D. 1-9/16 in (.04 m)

Publications:
Indiana University and Tulane University, *The Medieval Craftsman and his Modern Counterpart,* February 2-25, 1959, cat. no. 11c

Notes:
There are two other rings with the same arms and ornament in the British Museum (O. M. Dalton, *Catalogue of the Finger Rings,* London, 1912, nos. 837 and 838). The purpose of this distinctive group of massive gilt bronze rings set with paste and bearing papal, royal, and episcopal insignia is obscure, but the design suggests that they were intended for use as an unmistakable form of credential or passport. Approximately one hundred examples have survived, all of 15th century date and Italian.

Papal Ring 576

Italian, 15th century

Gilt bronze ring, oblong bezel set with a foiled crystal in arcaded collet, the sides with the symbols of the Evangelists in high relief, pairs of shields between them. Round hoop with the biscione and double headed eagle. The biscione, device of the Milanese families of Sforza and Visconti, is a large snake with a child in its mouth. (54.433)

H. 1-1/2 in (.042 m)

Notes:
for a similar example in the British Museum, see O. M. Dalton, *Catalogue of the Finger Rings*, London, 1912, no. 850

Papal Ring 577
Italian, 15th century

Gilt bronze ring, raised oblong bezel set with a foiled table cut crystal, the sides with symbols of the Evangelists in high relief, an acorn at each angle and on one shoulder a tiara and crossed keys, on the other a crowned uprooted oak tree with ribbons, the hoop inscribed P. PA. SISTUS with the shield of Aragon. (54.432)

H. 1-7/8 in (.048 m)

Notes:
Pope Sixtus IV (1471-84) was a della Rovere, whose device was an uprooted oak tree; there is another such ring in the Victoria and Albert Museum (Charles Coman, *Catalogue of Rings*, London, 1930, no. 938).

Rings set with Classical and Later Gems 578-582

578. Gold ring with sardonyx cameo group of two men, the elder, a bearded poet is seated and holds a manuscript roll, the other stands behind reading out loud, hands raised as he declaims. Oval bezel, scrolled shoulders, convex hoop with acanthus ornament. This scene, taken from daily life, illustrates the importance of literature in the Graeco-Roman world. French control mark. Gem, 1st-2nd century, A.D., ring, 17th century. (42.1344)

D. 5/8 in (.016)

579. Gold truncated cone intaglio of Minerva, armed, holding shield and spear, a crescent beside her. The oval bezel is encircled by a raised serrated edge, round plain hoop. Graeco-Roman gem 1st-2nd century A.D., ring 17th century. (42.1135)

L. 3/8 in (.09 m.)

History:
collection of Duke of Marlborough, cat. no. 90; Henry Walters before 1931; Mrs. Henry Walters; purchased from Joseph Brummer, New York, 1942

580. Gold ring with convex sardonyx intaglio of a Canopic vase and inscription in Greek letters PHILIPPOU, referring to the owner. The sides of the bezel have a raised serrated edge, round plain hoop. Osiris, whose head emerges from the vase, was worshipped in this form at the town of Canopus. Graeco-Roman gem 1st-2nd century A.D., the ring 17th century. (42.1159)

D. 13/16 in (.021 m)

History:
collections of Earl of Arundel, Theca A 83; Duke of Marlborough, cat. no. 285; Henry Walters; purchased from Joseph Brummer, 1942

581. Gold ring with rock crystal intaglio standing figure of Helios the Sun god, wearing celestial crown, holding whip and orb, the back of the gem faceted. Oval bezel with arcaded sides filled with black enamel with blue dots, black cross hatching at the shoulders, convex hoop. Late Roman gem 3rd-4th century A.D., ring early 17th century. (42.1157)

L. 5/8 in (.015 m)

History:
collections of Earl of Arundel, Theca A, 48; Duke of Marlborough, cat. no. 266; Henry Walters; purchased from Joseph Brummer, 1942

582. Gold ring with cornelian intaglio portrait of Faustina the Younger, wife of Marcus Aurelius (died 175 A.D.). Square hoop, shoulders and sides of bezel with scrolls enameled black. Gem and ring late 16th century. (42.1071)

L. 9/16 in (.014 m)

History:
collections of Lord Chesterfield; Earl of Bessborough, cat. no. 104 "Julia Pia Felix"; Duke of Marlborough, cat. no. 472

581, 582

583

Earrings

Earrings were a favorite form of jewelry for both men and women in renaissance times. One of the diamond set marten's heads listed in the inventory of Marie de'Medici had pearl earrings, and the Queen herself was very partial to this form of jewel, reserving her best diamonds for wearing in her ears, in one instance set in a pair of miniature crowns. Earlier earrings are the vehicle of 16th-century fantasy, and were made in designs as varied as negro heads, Jerusalem crosses, rock crystal lions, even twin-tailed lute-playing mermaids. In the 17th century design becomes less individual, pearls are almost ubiquitous, though in Spain long emerald set pendants were favored, and another popular form, the diamond and pearl ribbon and chandelier type, was published by Gilles Legaré in 1663. For some time they were worn by men: Henry III of France owned a pair of diamond earrings, while Charles I went to his execution wearing the single pearl drop now in the collection of the Duke of Portland. Unfortunately, it was the usual fate of earrings to be refashioned to suit the taste of later wearers, and few examples have survived.

Pair of Earrings 583
French, 17th century

Enameled gold and jeweled pair of earrings designed as eight pointed stars set with table cut diamonds in square collets, points linked by arcs with black dots on pale blue ground, the back *en suite*. Three hanging pearls and pearl set bow, all replacements. French control mark. (44.522-523)

H. 2-1/8 in (.054 m)

Miniatures and Watches

The interest in personality that was such a feature of the spirit of the time is reflected in portrait jewels, some taking the form of medallions in enameled goldwork enclosing cameo or medallic portraits of heads of state, which were worn as badges of allegiance. While this was an international fashion deriving from Imperial Rome, a less official form of portable portrait was developed in England. This was the miniature painted on ivory or vellum in a technique introduced by Hans Holbein and adopted by Nicholas Hilliard for his ethereal images of Queen Elizabeth and her friends. Since Hilliard was both a jeweler and painter he set them in jeweled cases and by the time the fashion for miniatures became more widespread in the early 17th century the "picture box" designed to hang round the neck, or from the girdle, or pinned to the bodice was established as an important jewel. At the same time watches, which in early Renaissance times had assumed a wide variety of forms including the memento mori skull, were now enclosed in more convenient round cases.

The plain outline and regular surface of such containers opened up new possibilities for the enameler, as did miniature cases. At the turn of the century, designers, among them Stephen Carteron and Michel Le Blon, transformed the curves of arabesques and strapwork into broken stylized patterns outlined in gold on single color grounds. Sometimes called "schwarzornament" this silhouette style was followed by peapod patterns derived from pods, husks, and leaves published by Pierre Marchant and Balthasar Lemersier, and with this came the taste for naturalism stimulated by the opening of the Jardin des Plantes in Paris. Botany was the theme of a series of pattern books issued between the publication of the *Livre des Fleurs* by Francois Lefebure in 1639, and the *Livre des Fleurs Propres pour Orfèvres* by Jean Vauquer in 1680, and although the lead came from France, others made important contributions notably the Nuremberg designer, Johannes Heel.

A new method of enameling was devised by Jean Toutin (1578-1644) for the application of these floral motifs to jewelry, replacing the *champlevé, cloisonné* and *en résille sur verre* technique. The Toutin method of covering surfaces with an opaque monochromatic layer of enamel and using it as a canvas on which the decoration could be painted employing a wide range of easily fusible colors meant that not only bouquets of flowers could be reproduced but portraits, landscapes, and paintings of historical subjects as well. Watches and miniature cases decorated in this way, and both worn at the waist, constitute the largest surviving category of 17th-century jewelry. In the others the role of enamel has been confined

592, 591 front

592, 591 back

to the back since there was no place for such enrichment on settings designed to show off the brilliance of the stones. The best source of this magnificent but simplified style is the designs of Gilles Legaré. His sets of matching bows, bracelets, ribbon-like necklaces and earrings, the fronts set with multifaceted stones, the backs decoratively painted with flowers, though sumptuous and beautiful, bear the stamp of uniformity. Representing nothing deeper than the desire for luxury, they lead the way to the elegant but even more standardized creations of the 18th-century jeweler.

586

Portrait Miniature 584

European, 17th century

Enameled gold oval pendant containing portrait of a lady (perhaps the Queen of Bohemia) wearing large earrings, ostrich feathers in her hair, and on the bosom a crowned cluster diamond brooch. A double black thread hangs down under the bodice, perhaps with crucifix attached. Black frame with white heart-shaped volutes embellished with addorsed C-scrolls, interlaced raised strapwork at the back, formerly on a black ground. Three hanging pearls and suspension loop. The design in black and white enamel and the raised interlaced gold strapwork at the back is found in other miniature cases of this period. (38.211)

H. 1-5/8 in x 2-1/8 in (.041 m x .051 m)

History:
collections of (?) C. H. T. Hawkins; J. P. Morgan
Publications:
Williamson, *Catalogue of the miniatures,* no. 63; The Walters Art Gallery, *The Glass of Fashion,* September 12-October 12, 1958; The Walters Art Gallery, *A Selection of Portrait Miniatures,* 1966, no. 11

Miniature 585

English, 17th century

Enameled gold oval pendant enclosing portrait of a lady wearing pearls in her hair, earrings and necklace, under glass, the frame encircled by a vari-colored wreath of raised double flower heads, some with gold studs, alternating with flat pairs of trefoils between quatrefoils. Suspension loop with contemporary tassel in gold and silver thread. (38.219)

H. 1-1/8 in x 1-3/8 in (.028 m x .034 m)

History:
collection of J. P. Morgan
Publications:
Williamson, *Catalogue of the miniatures,* no. 34; PAFA, *Golden Jubilee Exhibition; A. Jay Fink Collection of Miniatures;* The Walters Art Gallery, *A Selection of Portrait Miniatures,* 1966

584

585

588

588 inside

587 open

587 shut

Miniature 586

English, 17th century

Gold pendant enclosing a portrait of Queen Henrietta Maria wearing a pearl necklace and earrings, a diamond cross pinned to a bow on her bodice, and a diamond ring on her little finger, under beveled glass. The portrait is by John Hoskins (died 1664) who adapted the Van Dyck manner to miniature painting. Hatched scalloped frame. Suspension loop. (38.241)

H. 2-3/4 in x 3-1/4 in (.069 m x .082 m)

History:
collections of J. P. Morgan; A. J. Fink
Publications:
Williamson, *Catalogue of the miniatures,* vol. 1, no. 92; Metropolitan Museum of Art, *Four Centuries of Miniature Painting,* New York, January 19-March 19, 1950; PAFA, *Golden Jubilee Exhibition*

Memento Mori Watch 587

German, early 17th century

Gilt metal skull watch case, the jaws opening to silver dial framed in continuous scrollwork. Suspension ring. Top plate inscribed JOHAN PLANG INN G(R) AT. (58.42)

H. 1-7/8 in (.047 m)

Cameo Watch 588

German, Augsburg, mid 17th century

Enameled gold and jeweled oval watch case, the lid set with an onyx cameo portrait of a young women bordered by pairs of diamond sparks alternating with rubies, and inside a topographical scene, the back of gadrooned cornelian, the dial with Roman numerals and framed in scrolled ornament. Thumb piece set with three rubies in oval collets. Suspension ring. Top plate inscribed Wilhelm Peffenhauser, an Augsburg maker who was active from 1647-76. (58.11)

L. 1-1/2 in (.037 m)

History:
purchased from G. Harding, New York, November 1921
Notes:
Comparable with a watch now in the Metropolitan Museum, New York, formerly in the collection of J. P. Morgan (George C. Williamson, *Catalogue of the Watches,* London, 1912, no. 91), also by Peffenhauser, set with an onyx cameo portrait, and made for a member of the banking family of Fugger. The inside of the lid is also enameled with the same topographical scene.

Cruciform Watch 589

European, 17th century

Gilt metal and amethyst colored glass cruciform watch case with beveled edges and hatched mounts. Silver dial with Roman numerals engraved with Crucifixion group and Instruments of the Passion, within foliate scrolls. (58.13)

H. 2-1/4 in (.056 m)

History:
collection of Miss Emilie Grigsby (sale, New York, January 22, 1912, no. 859)

Cruciform Watch 590

German, Munich, 17th century

Gilt metal and rock crystal cruciform watch case, the edges embellished with open scrolls and rays set with table cut crystals, some foiled red, the dial with Roman numerals enclosed in engraved cruciform frame with foliate and interlaced ornament. Top plate inscribed GOTTFRIDT TERBORCH MUNCHEN. (58.27)

L. 3-3/4 in (.096 m)

History:
purchased from Emil Rey, New York

Flowered Watch 591

French, Paris, 17th century

Enameled gold round watch case, the lid and back with bouquets of vari-colored mixed flowers outlined in gold on a translucent green ground, the dial center *en suite*. Inside the lid a landscape on white ground. Top plate inscribed Josias Jolly à Paris watchmaker (1608-1642). Suspension ring. (58.140)

D. 2-3/16 in (.055 m)

History:
collection of Anatole Demidoff, Prince of San Donato; purchased from Tiffany and Co., 1893, list no. 39
Publications:
Philippe Verdier, "Seventeenth-century French enameled watches," *Antiques,* vol. LXXXIV, no. 6, December 1963, p. 687

Flowered Watch 592

French, Paris, 17th century

Enameled gold round watch case, the back with bouquet of mixed flowers in pink *grisaille* outlined in gold on a translucent green ground, the dial center *en suite,* and framed in black and white scalloped border. The inside of the back has a vari-colored bouquet and birds on a white ground. Top plate inscribed G. GAMOD A PARIS. Suspension ring. (58.148)

D. 2-1/8 in (.055 m)

History:
collection of Anatole Demidoff, Prince of San Donato; purchased from Tiffany and Co., 1893, list no. 36
Publications:
Philippe Verdier, "Seventeenth-century French enameled watches," *Antiques,* vol. LXXXIV, no. 6, December 1963
Notes:
The case compares with another in the Victoria and Albert Museum ascribed to Henri Toutin (1614-1683) of Blois, which combines *champlevé* and painted enamel in a similar naturalistic floral design, in the style of Jaques Vauquer. Gregoire Gamod, watchmaker, established in the Rue de la Barillerie, Paris, 1652-73.

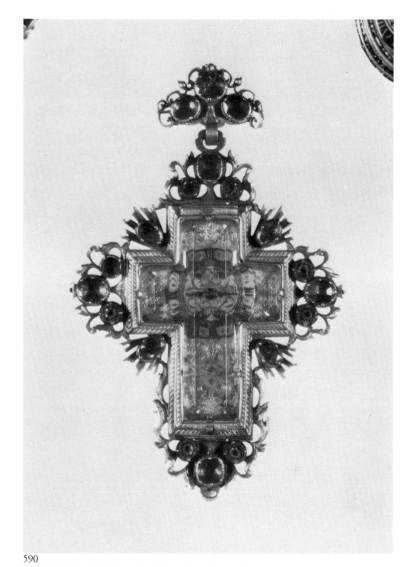

590

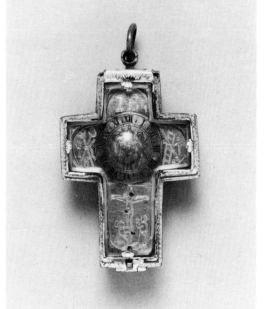

589

Jewelry from the Eighteenth to the early Twentieth Century

The 18th century saw a decline in colored enamels and an increase in the use of diamonds and other faceted gems or glass paste substitutes especially in jewelry intended to be worn in candlelight. Jewelry followed prevailing fashion, vividly reflecting the assymmetrical, naturalistic Rococo style in the second quarter of the century, and the more restrained Neo-classical style in the succeeding decades. These developments are partially illustrated in the collection by rings, portrait miniatures, some with jeweled frames fashioned to be worn as jewelry, and chatelaines. Chatelaines were intended for day and evening and were worn by men and women. A French example of about 1769, together with a pendant watchcase, exemplifies the pictorial use of quatre-couleur gold in which various colors were achieved with different alloys, copper for red, silver for green, iron for yellow, and silver or platinum for white. Other chatelaines, both French and English, are decorated with pictorial scenes in painted enamels.

A collection of finger rings, purchased by Henry Walters in Paris as a present for his sister documents changing styles in rings. Several of the earliest 18th-century rings are of the "cluster" type in which the circular bezel is set with a central stone surrounded by smaller stones, others dating from the third quarter of the century share distinctive, large openwork bezels set with stones or pastes, and a significant portion adhere to the "marquise" type of the end of the century. Derived from the laurel leaf of classical jewelry, the elongated, shuttle-shaped bezel of the "marquise" ring, is faced with an enameled plate, usually a translucent deep blue, surrounded by a border of diamonds or pastes and set with a centralized decorative motif also rendered in diamonds or pastes. The marquise ring occurs widely in continental European jewelry at the turn of the century and subsequently proved in France to be a remarkably enduring form through much of the 19th century. Other neo-classical rings, set with intaglios and cameos of both ancient and modern origin, reflect the enthusiasm for gem-carving which had waned in the preceding century but was revived in the late 18th and flourished during much of the 19th century.

The impact on jewelry production of the Industrial Revolution, first apparent in England, is manifested in such pieces as a pair of belt clasps in which Wedgwood ceramic medallions have been substituted for cameos and set in manufactured cut-steel frames with faceted studs simulating jewels.

To meet the market created by the affluent middle classes of 19th-century Europe and America, the decorative arts were increasingly mechanized. In jewelry, it was more often the manufactured, secondary jewelry, rendered with materials of minor intrinsic value, rather than the primary, gem-set, precious pieces that more vividly reflected fluctuations in fashion.

With the establishment of the First French Empire Paris again reassumed her role as an arbiter of taste. Cameos, inspired by ancient prototypes became fashionable and were worn in various forms including diadems and clasps as depicted by the painter J. L. David in his *Coronation of Napoleon I* in the Louvre. This fashion encouraged Napoleon to introduce in 1805, a *prix de Rome* for engravers of fine stones. The cameo (no. 652) representing the Empress Josephine carved by Teresa Talani, who was noted for her images of the Imperial family, is a fine example of this style.

With the end of the Napoleonic Wars and a return to a relatively prosperous period of peace in the 1820s and 30s, diamond jewelry became more abundant. Typical of this period is the demi-parure (no. 660) comprised of a brooch and earrings, the gems are mounted to best advantage *à jour,* in open prong-work, in a gold bouquet of flowers and stalks of grain, executed with the naturalism characteristic of precious jewelry through much of the century.

Secondary jewelry of the 1830s is exemplified by an elaborate parure (no. 661) in which half-pearls, diamond chips and small emeralds have been set in patterns over the enameled surfaces of a hollow framework of thin, machine-stamped gold. Here, the effects of display and color have been maximized with a minimum expenditure of labor and of materials of significant intrinsic worth.

Much English and American secondary jewelry was sentimental or associated with mourning. In the closing years of the preceding century there evolved a vocabulary of motifs including urns, broken columns, weeping willows and grieving widows and orphans, that replaced the earlier, more macabre memento moris. A rather conventional example is an American ring of the 1820s (no. 654), with a bezel bearing the figure of Hope, painted in sepia on ivory, encased beneath a crystal and surrounded by a border of diamond chips. An earlier, more distinguished ring (no. 653), commemorating the deaths of C. M. and A. E. Burnley in 1803 and in 1804, is separated transversely with the two hoops being held together by tiny pins and sockets. Each half of the bezel divides to form a triangular member in which are mounted plaits of hair.

Initially, in sentimental jewelry, the hair of the beloved or deceased was used in locks and plaits or worked pictorially and enclosed in various frames including lockets and the backs of miniatures and rings but by the 1840s it was being braided and woven into a number of shapes such as the pendant cross and chains composed of woven spheres of hair (no. 656).

Also esteemed as sentimental jewelry were portrait miniatures. Some American miniatures in watercolor on ivory, mounted in gold frames with hoops and pins so that they can either be suspended as pendants or worn as brooches, provide good examples. Several of their frames are of low-grade gold with engraved decoration characteristic of American work of the 1840s. Of exceptional quality is the mid-century miniature of an elderly man, enclosed by a border of alternating diamonds and pearls and mounted in a hinged bracelet of finely chased and pierced gold (no. 595).

Long periods of mourning were rigidly observed with Queen Victoria setting a precedent by grieving for her husband, Albert, from 1861 until her own demise in 1901. As a result, suites of jewelry evolved in the second half of the century made of such sombre materials as onyx, jet, and black glass.

Foreign travel was growing more financially feasible and convenient for an ever-increasing number of individuals. Many of the travelers' purchases abroad fall within the category of "souvenir jewelry." Shown here are an ivory brooch (no. 668) delicately carved with a hunting scene from Switzerland, several examples of so-called "peasant" jewelry from France, in which traditional forms have been retained long after they had fallen out of fashion in the urban centers, and a variety of works from the Italian states, all of which could be classified as souvenirs. From Naples and Genoa came quantities of coral, said to have been popularized by the marriage in 1845 of the Duchesse d'Aumale to the Prince of the Two Sicilies. It was turned in beads and carved into pseudo-classical heads and foliate forms, which were mounted in parures and individual brooches and bracelets. Miniature mosaics, in glass tesserae, showing traditional scenic views were manufactured in the Vatican workshops for various jewelry firms. The engraving of cameos, in hard stone or shell, which had initially been directed towards a limited market of wealthy *cognoscenti,* became increasingly a branch of the tourist trade for Rome, Florence and Naples. Early in the century, Pope Leo XII opened a public school devoted to cameo and medal engraving in the Ospizio di San Michele in Rome. At the 1862 International Exhibition, the Vatican was represented by the displays of six cameo carvers. The largest was that of Tommaso Saulini who had been commissioned by William

Walters to produce a shell cameo portrait (no. 674) of his recently deceased wife Ellen based on a bust carved in Rome by the expatriate Maryland sculptor W. H. Rinehart. Both this cameo, and another, showing a classical, helmeted warrior carved in agate and unsigned, were mounted in gold jewelry produced by the Castellani firm celebrated for its "Etruscan" style metalwork. Such pieces transcend the souvenir category and exemplify the eclecticism prevalent in mid-century jewelry design.

In Austria it was the medieval past rather than Antiquity that drew the attention of many designers. The vigor of the Gothic Revival in that country is exemplified by an elaborate gold bracelet formed of five ogive arches set with various colored stones (no. 663).

At the turn of the century, Henry Walters made a number of diverse purchases of contemporary jewelry. From the Tiffany and Co. exhibit at the Exposition Universelle of 1900, he bought a large "corsage ornament" in the form of an iris naturalistically rendered in American sapphires (no. 698). The piece not only exemplifies the opulence of much precious jewelry of the period, but more specifically, illustrates a commitment to indigenous gems on the part of George F. Kunz, director of the celebrated firm's jewelry department.

A more *retardetaire* purchase was a collection of gold, intaglio-mounted, necklaces and bracelets from Giacinto Melillo in Naples in 1903 (nos. 679-684) Melillo, a former employee of Alexandro Castellani, continued well into the 20th century, to produce "archaeological" jewelry with its characteristic granulation and filigree popularized by the Castellanis in the middle of the previous century.

More spectacular, was a selection of pieces purchased at René Lalique's exhibit, *Objets et bijoux d'art,* at the Saint Louis World's Fair in 1904 (nos. 706-714) Lalique, working in a style that was in many respects directly antithetical to that of the Tiffany iris brooch, dominated French Art Nouveau jewelry production. He introduced novel substances such as bone and horn, for their textural and coloristic effects, combining them with an array of precious and semi-precious materials to create works that were frequently more appropriate for display than for being worn. The examples shown here date from relatively late in Lalique's career as a jewelry designer when he had evolved a naturalistic style that was more personal than typically Art Nouveau. He was at this point, turning increasingly to glass, a medium which he was soon to adopt as his primary means of expression.

In the post World War I era, a number of artists, distinguished for their work in other media, drew designs for jewelry which were to be realized by the artisan. However, the

jewelry trade of the 20th century has been dominated by large firms employing designers, who for the most part have remained anonymous, a development that had been anticipated by Tiffany and Co. As a result, much present day commercial jewelry has been restricted to the setting of faceted gems with limited artistry. The role of the independent designer-craftsman, responsible for the conception and execution of his designs, represented here by Louis Rosenthal, has received insufficient attention though a resurgence in his role has now become discernible.

William R. Johnston

Above: In this portrait a lady in the fashionable dress of the time is shown wearing a portrait miniature pinned to her bosom. She is seated beside a cabinet of casts of ancient cameos, one of which she is about to study with the aid of a magnifying glass. The painting (WAG 37. 394) has been attributed to an artist of northern European origin, who was active in Rome about 1785.

Portrait Miniature 593

Swedish, about 1790

The gentleman is painted in watercolor on ivory by the Swedish painter Pierre Adolphe Hall (1739-1793). Rendered in hair on the reverse of the miniature are the letters MCO in script, a wreath, a pair of flanking doves and two burning hearts pierced by an arrow all enclosed within a laurel leaf border.

The miniature is mounted in an oval gold frame surrounded both on the obverse and reverse by a row of sixty-two diamonds in silver collets and an outer band of forty-nine half-pearls in gold collets. A loop for the suspension of the miniature is faced with three half-pearls. (38.316)

H. of case 2-7/16 in (.062 m)

History:
gift of the A. J. Fink Foundation in memory of A. J. Fink
Exhibitions:
Royal Academy of Arts, "Art Treasures Exhibition," London, 1928, no. 1196
Publications:
PAFA, *Golden Jubilee Exhibition,* no. 217; The Walters Art Gallery, *Maryland Heritage,* (ed. John B. Boles), Baltimore, 1976, no. 49

Portrait Miniature 594

Italian, early 19th century

Portrayed is Princess Luisa Carlotta, waist-length, wearing on her right shoulder, the Austrian order of the Starry Cross (see no. 651). The princess, the daughter of Francesco I (1777-1830), King of the Two Sicilies, married Don Francesco di Paolo, Infant of Spain. The miniature, in watercolor on ivory, has been cut-out, painted on the reverse to show the girl's back, and mounted between two panels of glass. These have been set in a plain oval gold frame with a loop for suspending the piece. A **similar miniature is preserved in the Musée Condé, Chantilly.** (38.174)

H. 2-1/4 in (.055 m)

History:
The miniature, together with the order, was acquired at an unknown date by Henry Walters.

Bracelet with Portrait Miniature 595

American, mid 19th century

This gold hinged bracelet is of pierced and chased scrollwork. It bears a large oval miniature portrait painted on ivory of an unknown elderly man (previously thought to be President Zachary Taylor). The miniature is framed by a row of small brilliant cut diamonds alternating with pearls. The two clasp ends are connected by a safety chain. (38.488)

D. 7-1/2 in (.190 m)

History:
gift of the A. J. Fink Foundation Inc. in memory of A. J. Fink, 1963

593

594

595, 596, 597, 598, 599

602, 603

600

Brooch with Portrait Miniature 596
American, 1840s

The miniature of an unknown man is mounted in an eight-sided frame of gold with a high copper content. The reverse of the brooch is decorated with engraved foliate motifs. Inset is a small oval frame containing an entwined strand of hair. A pin to hold the brooch is attached by a short chain. One of the two clasps for the pin is missing. (38.567)

Brooch H. 2-1/4 in (.057 m)

History:
gift of the A. J. Fink Foundation Inc. in memory of A. J. Fink

Brooch with Portrait Miniature 597
American, 1850s

The oval miniature is mounted in an imported Italian gold frame decorated with alternating bands of beaded, braided and woven patterns. Engraved on the reverse are the letters "E. A. H." in script. The miniature of Captain Nathan Hawks was painted by Richard Morrell Staigg (1817-1881), who was born in Leeds, England. Staigg came to the United States in 1831 and settled in Newport, Rhode Island. He worked primarily in the vicinity of Boston, Massachusetts. (38.482)

Brooch H. 2-5/16 in (.059 m)

History:
gift of the A. J. Fink Foundation Inc. in memory of A. J. Fink, 1963
Publications:
A. Jay Fink Collection of Miniatures, no. 280

Brooch with Portrait Miniature 598
Italian frame with American miniature, 1860s

The oval miniature of a Confederate General is enclosed in an imported gold Italian frame decorated with a band of beading and an applied band of braiding. It is the work of John Henry Brown, (1818-1891) of Lancaster, Pennsylvania. He began his career as a general painter and gradually came to specialize in miniatures working in the Philadelphia area. This miniature was once thought to be General Thomas Jonathan Jackson, 1824-1863. (38.494)

Brooch H. 2 in (.050 m)

History:
purchased from a descendant of General Jackson; collection of Albert Rosenthal; gift of the A. J. Fink Foundation Inc., in memory of A. J. Fink, 1963
Publications:
PAFA, *Golden Jubilee Exhibition; A. Jay Fink Collection of Miniatures,* no. 292

Brooch with Portrait Miniature 599
American, mid 19th century

A miniature of the Virginia statesman Henry Clay (1777-1852), painted in watercolor on ivory, is mounted in an oval, gold

brooch. Encircling the brooch is a concave gold band partially enameled blue and looped on both sides by a gold figure 8 band. The brooch is equipped on the reverse with a fastening pin. (38.453)

H. 1-15/16 in (.049 m)

History:
gift of the A. J. Fink Foundation Inc. in memory of A. J. Fink

Stomacher 600
Flemish, early 18th century

A popular fashion in the 18th century, stomachers were large, V-shaped brooches attached to the dress bodice. Usually they were in filigree, set with jewels, and often were executed in segments for flexibility. This unsegmented example is rendered in silver flat wire openwork and set with foil-backed, square-tabled, white pastes. Larger green pastes mounted in collets have been applied. (57.1770)

L. 6-3/8 in (.162 m)

History:
gift of Melvin Gutman, 1946

Pendant 601
Spanish, mid 18th century

Enameled gold double-sided pendant set with *verre eglomisé* miniatures, the Virgin of the Immaculate Conception, and St. Joseph with the Infant Christ, both in gilded rococo mirror frames enclosed in shields with cusped enameled borders, within outer frame of crowned openwork filigree scrolls and shells. (46.25)

L. 3-1/8 in (.08 m)

Notes:
for similar pendant see Melvin Gutman (sale, New York, Parke Bernet, April 3, 1970, Part IV, lot 42, Italian)

Chatelaines

Chatelaines were a popular form of 18th-century jewelry. They usually consisted of a top-plate from which hung series of chains supporting smaller plaques which, in turn, carried hooks for various devices. The top-plate was backed with a large flat hook used for suspending the chatelaine from the waist of the wearer. Watches and their signet seals often hung on chatelaines for men, whereas those for women carried *étuis,* watches, and sewing accessories.

In the 19th century, chatelaines returned to fashion in the Romantic era of the 1830s, at mid century, and again in the 1870s.

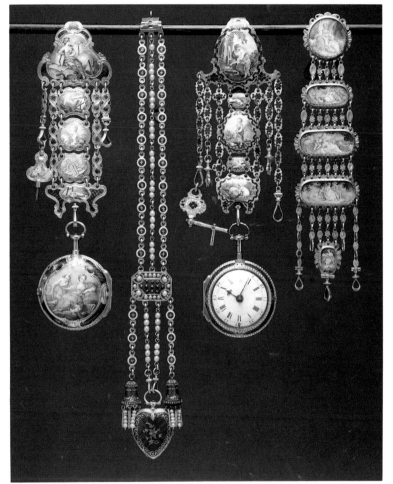

604, 605, 606, 607

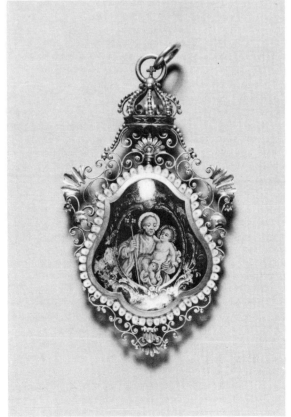

601

Chatelaine 602

French, Paris, 1769

Rendered in chiseled gold with inlays in quatrecouleur, this chatelaine was made by Jean Louis Baron who was active from 1748 to about 1792. From the upper, triangular hook-plate is suspended a row of four plaques connected by circular links. Running between the upper plate and the bottom plaque, on each side is a row of three S-shaped scrolls also connected by links. Two identical scrolls hanging from the corners of the hook-plate terminate in swivel hooks. Both the plate and the suspended plaques are decorated with circular and oval, musical and pastoral trophies on striated grounds. A loop has been soldered to the hook for purposes of display. (57.881)

L. 4-15/16 in (.125 m)

History:
collection of Anatole Demidoff, Prince of San Donato (sale, New York, Tiffany & Co., 1893, lot 84)
Marks:
Warden's mark "F" for 1769, the *fleur fleuronné* and the helmeted head of the fermier Julien Alaterre (1768-1774) and initials J.L.B. with crown for the maker Jean Louis Baron.
Notes:
Presently suspended from the chatelaine is a watch of similar style (W. 58.45) with a case in gold à quatre-couleur. Shown in an oval medallion is a seated hunter with his dog and some game. The case bears the Warden's mark "B" for 1765-6; the crossed branches of the fermier Jean-Jacques Prevost (1762-1768); PDM for maker; and the incised number 9305. The dial is signed *Filon / A PARIS*.

Chatelaine with Watch 603

French, 18th century

The gilt metal chatelaine is comprised of a hook-plate with three plaques hinged together and two lateral pendants, on one of which is suspended the watch-key and on the other a revolving seal of rock crystal. The seal which is unengraved is set in a mount formed by two dolphins and a mask. Neither the seal nor the key appear contemporaneous with the chatelaine and watch. The decoration of the chatelaine and outer watchcase consists of garlands and scrolls of gilt metal in a symmetrical pattern over panels of striated agate. (58.16)

L. with watch 6-15/16 in (.176 m)

Notes:
The back-plate of the watch is engraved: frs. Melly à Paris. Tardy, *Dictionnaire des Horlogers français*, Paris, n.d., p. 453 cites "Melly frères à Paris" on a Louis XVI clock.

Chatelaine and Watch 604

French, 1758-1761

A rococo, gold chatelaine composed of a triangular hook-plate, a central pendant of four linked plaques flanked by lozenges with ring connectors and two lateral pendants, one of which carries a key on its swivel-hook. Painted in enamels on the members of the chatelaine and the watch-case are, in descending sequence, the muse Urania, the emblems of architecture, sculpture, drawing and painting, and the muse Calliope. These enamels are framed in chased, gold scrolls with areas of translucent green enamel over diaper patterns. The watch-key is decorated with painted floral motifs. A faceted crystal serves as the push-button. (58.151)

L. with watch 7 in (.177 m)
Marks:
The interior of the watch-case is stamped: *P.D.M.* for the maker, portcullis for Paris charge mark of Eloy Brichard, 1756-62; *X* for the year 1761. The chatelaine is marked *J.E.* for maker, J.M.A. Écosse, Paris (1722-1781); *S*, Warden's mark for the year 1758; a portcullis duty mark of Eloy Brichard; open hand for Paris contremarque, 1762-1768; and a shell discharge mark. The watch is by Nicolas Charles Dutertre (c. 1715-1793) and his son Charles Nicolas (1758-1793).

Chatelaine with Watch 605

Swiss, 1830s

Suspended from a silver hook are three strands, the central one composed of a series of three pierced pearls, alternating with single gold links, and the lateral two of circular gold plaques with white and blue enamel. These strands support a rectangular plaque with a central section of translucent blue enamel over an engine-turned ground set with brilliants symmetrically arranged. From this lower plaque hang four strands; the central two are of pearls and gold links carrying the watch and the end strands carry bell-shaped gold tassels enameled in blue over an engine-turned ground and set with circles of brilliants. From these tassels hang strands of pearls and gold mesh. The heart-shaped watch is enameled in blue over engine-turning, and is set with brilliants in floral and drop motifs. (58.231)

L. with watch 10 in (.254 m)

Marks:
The watch-case is marked: 465, 10465, 18K and WS

Chatelaine and Watch 606

English, about 1775

The gold chatelaine and outer watch-case are decorated with oval pastoral scenes painted in enamels. The scenes show a woman filling her jar at a well accompanied by a boy playing a flute; a bonnet lying beside a basket of flowers; a child feeding a hen and her chickens; a couple of sheep; and a blind-man's bluff scene on the outer watch-case. The plaques of the chatelaine are connected by cruciform and oval lozenges joined by rings. Also suspended from the top-plate are four pendants formed of linked oval lozenges, one of which carries the watch-key. Transparent blue enamel is used for ribbon and floral motifs adorning the various members of the chatelaine and as a

ground for the guilloche patterns framing the outer watch-case. The push-button of the outer case is a faceted crystal. The inner case is pierced and engraved. A silk protective liner separating the inner and outer cases bears a landscape scene in watercolors and an inscription: "Time how short / Eternity how long." The watch verge is engraved: "2405 / Danl De St. Leu, Appnt. to her Majesty / London." Daniel De Saint Leu was recorded as a London watchmaker from 1753 to 1790. He served George III and, after 1770, was watchmaker to Queen Charlotte. (58.152)

L. of chatelaine with watch 7-1/4 in (.184 m)

Marks:
The outer watch-case is stamped: HT

Chatelaine 607

French, 1830

A chatelaine comprised of one circular, and four oblong, mother-of-pearl plaques connected by chains with flat disks. Each plaque is painted in watercolors with bucolic and *fête galante* scenes in watercolors. The hook is hinged and pierced. (58.150)

L. 6-3/4 in (.171 m)

History:
acquired together with an 18th-century watch from Anatole Demidoff, Prince of San Donato (sale, New York, Tiffany and Co., 1893, lot 28)

Ring Watch 608

French, about 1780

The white watch dial is surrounded by a ring of brilliants. These stones are also mounted to form floral sprays on the pierced shoulders of the ring. (58.50)

D. of dial 17/32 in (.013 m)
D. of hoop 3/4 in (.019 m)

History:
collection of Anatole Demidoff, Prince of San Donato (sale, New York, Tiffany and Co., 1893, lot 54)

Brooch Watch 609

Swiss, early 19th century

The gold case is rectangular with cut corners and is bordered with small pearls. Inset in the blue steel face are the watch dial and a balance set with brilliants. The back of the case is inscribed: "Tournez les E...illes/ Rémontés/a gauche" and the initials R.A. (58.53)

L. 15/16 in (.023 m) W. 5/8 in (.015 m)

History:
collection of Anatole Demidoff, Prince of San Donato (sale, New York, Tiffany and Co., 1893, lot 46)
Notes:
A similar watch equipped with automata and mounted as a bracelet is illustrated in Eugène Jaquet-Alfred Chapuis, *La Montre Suisse*, (Basle and Olten, 1945, plate 89).

Mandolin Watch 610

Swiss ? with Austrian Movement, early 19th
century

Switzerland was noted at this time for its
novelty watches in which the movements
were incorporated into a variety of jewelry
forms. In this example, the movement is
mounted in a mandolin-shaped brooch that
opens to reveal the dial. The sound board
of the mandolin is divided into zones of
red and cream-colored enamel. The interior
is blue enameled. A double chain is attached
for suspending the brooch. The back-plate
is inscribed: "Franz Schmit in Gratz." (58.34)

L. 2-7/16 in (.061 m)

Notes:
Similar novelty watches are illustrated in Eugene
Jacquet-Alfred Chapuis, *La Montre Suisse*, (Basle and
Olten, 1945, plate 87)

Ring 611

English, 18th century

Gold, silver collets, crowned reeded heart-
shaped bezel set with crystals. Channeled
hoop with foliate split shoulders each
enclosing a cinquefoil. (57.1799)

D. of hoop 11/16 in (.017 m)

History:
collection of Henry Walters; Laura F. Delano; gift
of Laura F. Delano, 1946-47

Ring 612

English, mid 18th century

Gold, silver collets, square reeded bezel
with three crystals table cut. Ribbed hoop,
with forked shoulders similarly set. (57.1778)

D. of hoop 9/16 in (.015 m)

History:
collection of Henry Walters; Laura F. Delano; gift of
Laura F. Delano, 1946-47

Ring 613

Italian, early 18th century

Gold, octofoil bezel with radiating crystals
table cut. Channeled hoop with forked
shoulders each set with a small crystal.
(57.1766)

H. of bezel 5/8 in (.016 m)
D. of hoop 3/4 in (.018 m)

History:
collection of Henry Walters; Laura F. Delano; gift of
Laura F. Delano, 1946-47
Marks:
ET Paris mark introduced 1864, for gold imported
from countries without customs conventions

611, 612, 613, 614, 615, 616

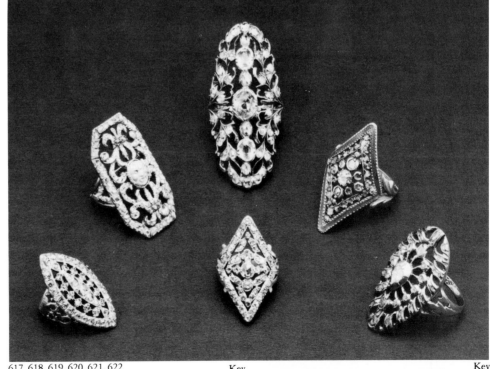

617, 618, 619, 620, 621, 622 Key Key

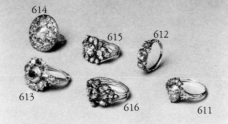

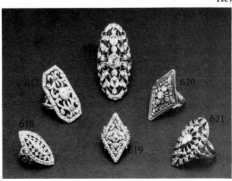

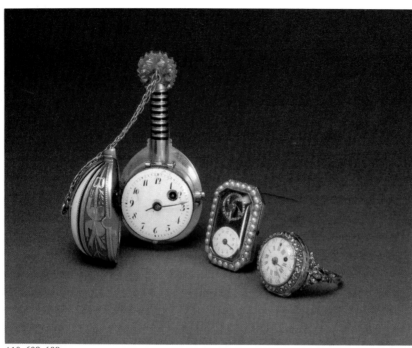

610, 609, 608

623, 624, 625, 626, 627

623 624
627
626 625

Key

Ring 614

French, 18th century

Gold, silver collets, round bezel, pavé-set with a cluster of crystals. Plain convex hoop. (57.1757)

L. of bezel 3/4 in (.018 m)

History:
collection Henry Walters; Laura F. Delano; gift of Laura F. Delano, 1946-47

Ring 615

Spanish, early to mid 18th century

Gold, silver collets, openwork cluster bezel with triple setting amid crescent and leafy spray, all set with diamonds. Wire hoop with shoulder pierced in trelliswork. (57.1782)

D. of hoop 5/8 in (.011 m)

History:
collection of Henry Walters; Laura F. Delano; gift of Laura F. Delano, 1946-47

Ring 616

Italian, 18th century

Gold, silver collets, openwork cluster bezel with foliate scrolls set with diamonds centered on a tourmaline. Triple wire hoop, open shoulders. (57.1761)

D. of hoop 11/16 in (.018 m)

History:
collection of Henry Walters; Laura F. Delano; gift of Laura F. Delano, 1946-47

Ring 617

French or Spanish, 1770

Gold, silver collets, openwork octagonal bezel with jadeite (?) cameo mask inlaid with gold amid tied palmettes within a border all set with diamonds, the ribbons with rubies. Wire hoop, split shoulders enclosing a trefoil similarly set. (57.1762)

H. of bezel 1-1/4 in (.033 m)
D. of hoop 5/8 in (.017 m)

History:
collection of Henry Walters; Laura F. Delano; gift of Laura F. Delano, 1946-47

Ring 618

Spanish ?, second half of 18th century

Gold, silver collets, openwork marquise bezel with wreathed central vesica enclosed in a plain border all set with diamonds. Wire hoop, pierced scrolled shoulders. (57.1791)

H. of bezel 1-1/8 in (.029 m)
D. of hoop 9/16 in (.014 m)

History:
collection of Henry Walters; Laura F. Delano; gift of Laura F. Delano, 1946-47

Ring 619

Spanish, second half of the 18th century

Gold, silver collets, lozenge bezel with openwork cruciform center amid leaves within a plain border, all set with diamonds. Chaneled hoop, pierced scrolled shoulders. (57.1788)

H. of bezel 1-1/16 in (.027 m)

D. of hoop 9/16 in (.0145 m)

History:
collection of Henry Walters; Laura F. Delano; gift of Laura F. Delano, 1946-47

Ring 620

French, late 18th century

Gold, silver collets, lozenge bezel with openwork cruciform center within a plain border all set with diamonds in orange enamel frame. Plain hoop with foliate shoulders. (57.1793)

H. of bezel 1-5/16 in (.335 m)

D. of hoop 11/16 in (.175 m)

History:
collection of Henry Walters; Laura F. Delano; gift of Laura F. Delano, 1946-47

Marks:
Eagle's head, double outline, Gold restricted warranty mark for gold manufactured and sold in France introduced in 1847; unidentified maker C...M in lozenge form introduced in 1793

Ring 621

French, late 18th century

Gold, silver collets, openwork marquise bezel with radiating design in border of pierced bandwork, all set with crystals. Convex hoop, forked shoulders enclosing a cinquefoil. (57.1786)

H. of bezel 1-1/4 in (.032 m)

D. of hoop 3/4 in (.019 m)

History:
collection of Henry Walters; Laura F. Delano; gift of Laura F. Delano, 1946-47

Marks:
unknown maker's mark with letters C P in lozenge form introduced in Paris in 1793

Ring 622

French, late 18th century

Gold, silver collets, openwork marquise bezel with central row of alternating pink and white diamonds framed in pairs of floral sprays all set with diamonds. Channeled hoop with forked shoulder. (57.1774)

H. of bezel 1-3/4 in (.044 m)

D. of hoop 3/4 in (.019 m)

History:
collection of Henry Walters; Laura F. Delano; gift of Laura F. Delano, 1946-47

Marks:
Eagle's head, double outline; France, Paris, Gold, restricted warranty, introduced in 1847; Maker's mark: unknown C...M in lozenge form introduced in 1793

628, 629, 630, 631, 632, 633, 634, 635, 636, 637

Rings with Enameled Grounds

Ring 623

French, about 1770

Gold, silver collets, octagonal bezel with a bird and branch on a foiled dark blue enameled ground set with diamonds, the bird's eye with an amethyst, within a diamond-set border. Plain hoop expanding at shoulders. (57.1790)

H. of bezel 1-1/8 in (.028 m)

D. of hoop 3/4 in (.019 m)

History:
collection of Henry Walters; Laura F. Delano; gift of Laura F. Delano, 1946-47

Ring 624

European, late 18th century

Gold, silver collets, rectangular bezel with a basket of flowers on foiled dark red enamel ground set with diamonds in a border similarly set. Plain hoop expanding at the shoulders. (57.1751)

H. of bezel 1-1/16 in (.027 m)

D. of hoop 5/8 in (.165 m)

History:
collection of Henry Walters; Laura F. Delano; gift of Laura F. Delano, 1946-47

Marks:
Weevil in oval, for gold imported from countries with customs conventions, introduced in 1864

Ring 625

English, second half of the 18th century

Gold, silver collets, octagonal bezel with floral spray on foiled dark blue enamel ground set with diamonds in a border similarly set. Plain hoop expanding at the shoulder. (57.1785)

H. of bezel 13/16 in (.022 m)

D. of hoop 11/16 in (.017 m)

History:
collection of Henry Walters; Laura F. Delano; gift of Laura F. Delano, 1946-47

Marks:
Weevil in oval, mark for gold imported from countries with customs conventions introduced in 1864

Ring 626

European, late 18th century

Gold, silver collets, marquise bezel with tied floral spray on foiled violet enameled ground set with diamonds within a border similarly set. Plain hoop expanding at the shoulders. (57.1760)

H. of bezel 1 in (.025 m)

D. of hoop 5/8 in (.016 m)

History:
collection of Henry Walters, Laura F. Delano; gift of Laura F. Delano, 1946-47

Marks:
Weevil in oval, standard mark introduced 1864 for gold imported from countries with customs conventions

Ring 627

English ?, late 18th century

Gold, silver collets, marquise bezel with floral spray on foiled red enamel ground within a border all set with diamond sparks. Plain hoop. (57.1776)

H. of bezel 1-5/16 in (.033 m)

D. of hoop 11/16 in (.017 m)

History:
collection of Henry Walters; Laura F. Delano; gift of Laura F. Delano, 1946-47

Rings with Celestial Imagery

The shuttle-shaped, marquise ring, enameled dark blue and set with diamonds was popular in France in the last third of the 18th century. It bore celestial allusions and was known as the *bague au firmament*. According to Maximin Deloche, this ring form gave way after the birth of the Dauphin in 1785 to the *bague à l'enfantement,* in which colored stones were arranged around a large diamond in the center of the bezel.

Marquise rings of this nature evidently became fashionable in Spain. Priscilla E. Muller mentions one worn by the wife of the painter Goya and illustrates an example by Pere Arquér y Rosés.

During the 19th century, marquise rings continued to be made as a feature of the 18th-century revival. Henri Vever mentions that

Frederic Philippi (1814-1892) was noted for his Louis XVI style marquise rings.

Notes:
see Maximin Deloche, *La Bague en France à travers l'histoire,* Paris 1929, p. 50; Muller, *Jewels in Spain,* p. 176; Henri Vever, *La bijouterie francaise au XIX e siècle,* Paris, 1906-08, vol. II, pp. 195-197

Ring 628

French, second half of the 18th century

Gold, silver collets, oval bezel with a sunburst on a foiled violet blue enamel ground set with diamonds within a border similarly set. Plain convex hoop, wide shoulders. (57.i765)

H. of bezel 1-1/4 in (.032 m)

D. of hoop 9/16 in (.014 m)

History:
collection of Henry Walters; Laura F. Delano; gift of Laura F. Delano, 1946-47

Ring 629

Italian ?, about 1800

Silver, marquise bezel with a galaxy of stars round a central rosette on a foiled dark blue enamel ground, all set with crystals within a border similarly set. Plain hoop. (57.1754)

H. of bezel 1-9/16 in (.040 m)

D. of hoop 3/4 in (.018 m)

History:
collection of Henry Walters; Laura F. Delano; gift from Laura F. Delano, 1946-47

Marks:
swan in an oval, French 1893 mark for imported silver and silver sold publically of indeterminate origin

Ring 630

French, 1770-1800

Gold, silver collets, lozenge bezel with a galaxy centered on a solitaire on foiled dark blue enamel ground all set with diamonds within a border similarly set. Convex hoop with forked shoulders each enclosing a leaf. (57.1763)

H. of bezel 1-13/16 in (.047 m)

D. of hoop 3/4 in (.019 m)

History:
collection of Henry Walters; Laura F. Delano; gift of Laura F. Delano, 1946-47

Ring 631

French or Italian, late 18th century

Gold, silver collets, marquise bezel with a galaxy around central star on foiled dark blue enamel ground, all set with diamonds within an openwork border similarly set. Convex hoop, forked shoulders similarly set. (57.1796)

H. of bezel 1-1/2 in (.039 m)

D. of hoop 10/16 in (.017 m)

History:
collection of Henry Walters; Laura F. Delano; gift of Laura F. Delano, 1946-47

Marks:
illegible

Ring 632

French, first half of the 19th century

Gold, silver collets, marquise bezel with nine stars on a foiled violet enamel ground set with diamonds within an open backed border similarly set. Convex hoop, forked shoulders enclosing a leaf. (57.1759)

H. of bezel 1-3/8 in (.034 m)

D. of hoop 3/4 in (.019 m)

History:
collection of Henry Walters; Laura F. Delano; gift of Laura F. Delano, 1946-47

Marks:
Eagle's head without frame, Gold, restricted warranty, 1838-1847; stamped "B"; unidentified maker's mark

Ring 633

French, late 18th century

Gold, silver collets, octagonal bezel on foiled dark blue enamel ground with a galaxy of stars set with diamonds within a border similarly set. Plain hoop expanding at the shoulders. (57.1792)

H. of bezel 1-1/16 in (.027 m)

D. of hoop 11/16 in (.018 m)

History:
collection of Henry Walters; Laura F. Delano; gift of Laura F. Delano, 1946-47

Marks:
Eagle's head, unframed, Gold, restricted warranty, France, Paris, 1838-1847; unidentified maker's mark, A...P in lozenge

Ring 634

Italian or Swiss ?, late 18th century

Gold, silver collets, marquise bezel with triple setting within open twist on a foiled dark blue enamel ground all set with diamonds within a border similarly set. Narrow hoop, forked shoulder enclosing a leaf. (57.1767)

H. of bezel 1-3/4 in (.044 m) D. 11/16 in (.017 m)

History:
collection of Henry Walters; Laura F. Delano; gift from Laura F. Delano, 1946-47

Marks:
Weevel in oval, French mark introduced 1864 for gold imported from countries with customs conventions

Ring 635

French ?, late 18th century

Gold, silver collets, marquise bezel with rows of stars alternating with ribbons on a foiled dark blue enamel ground all set with diamonds, in a border similarly set. Triangular hoop with forked shoulders enclosing a leaf. (57.1752)

H. of bezel 1-5/8 in (.041 m)

D. of hoop 11/16 in (.017 m)

History:
collection of Henry Walters; Laura F. Delano; gift of Laura F. Delano, 1946-47

Ring 636
Italian ?, early 19th century

Gold, silver collets, marquise bezel set with three diamonds on a foiled dark blue enamel ground painted with rosettes within an open-backed border of diamonds similarly set. Plain hoop with trilobate shoulders. (57.1789)

H. of bezel 1-3/8 in (.034 m) D. of hoop 3/4 in (.019 m)

History:
collection of Henry Walters; Laura F. Delano; gift of Laura F. Delano, 1946-47

Marks:
ET, Paris mark, 1864, for gold imported from countries without customs conventions

Ring 637
French, mid 19th century

Gold, silver collets, marquise bezel with foiled green enamel ground set with three diamonds within a border similarly set. Plain hoop, forked shoulder. (57.1756)

H. of bezel 1-3/16 in (.031 m)

D. of hoop 5/8 in (.016 m)

History:
collection of Henry Walters; Laura F. Delano; gift of Laura F. Delano, 1946-47

Marks:
Eagle's head in double outline, Paris restricted warranty mark for gold manufactured or sold in France, introduced 1846

639, 638, 640

Portrait Rings

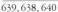

Ring 638
French ?, 18th century

Gold, shuttle-shaped bezel with a miniature painting of a lady as Venus, in a landscape, under glass. Bright cut border. Channeled hoop with forked shoulders enclosing a trefoil. (57.1777)

H. of bezel 1-3/8 in (.355 m) D. of hoop 3/4 in (.019 m)

History:
collection of Henry Walters; Laura F. Delano; gift of Laura F. Delano, 1946-47

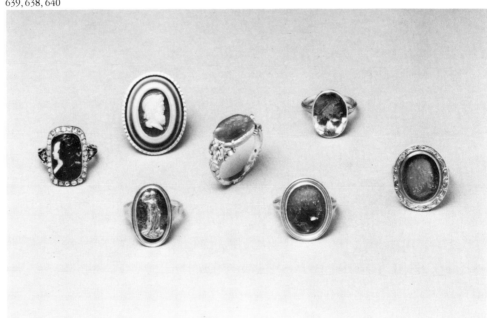

641, 642, 643, 644, 645, 646, 647

Ring 639
Italian ?, mid 18th century ?

Gold, enameled oval bezel with a miniature portrait of a lady seated before a curtain holding a letter, within a hatched, serrated border. Plain hoop. (57.1753)

H. of bezel 1 in (.025 m) D. of hoop 5/8 in (.016 m)

History:
collection of Henry Walters; Laura F. Delano; gift of Laura F. Delano, 1946-47

Marks:
ET warranty mark for gold and silver imported from countries without custom conventions, introduced in 1864

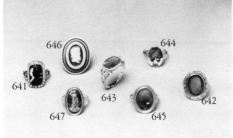

Key

Ring 640
French, early 19th century

Gold, oval bezel with an enameled miniature portrait of a lady as Diana. She wears a baldric and cloak, one breast bare, and holds a flower in her hand, a crescent moon and floral aigrette in her hair. Channeled hoop with forked shoulders enclosing a leaf. (57.1750)

H. of bezel 13/16 in (.021 m) D. of hoop 11/16 in (.018 m)

History:
collection of Henry Walters; Laura F. Delano; gift of Laura F. Delano, 1946-47
Marks:
Eagle's head, unframed, France, Paris, gold, restricted warranty mark introduced 1838; illegible maker's mark C...P

Ring with Sardonyx Cameo 641
French, late 18th century

Gold, silver collets, oblong bezel with sardonyx cameo portrait of Queen Marie Antoinette and the Dauphin of France in border of diamond sparks. Channeled hoop with forked shoulders each enclosing a tulip set with a crystal (one missing). (57.1787)

H. of bezel 3/4 in (.019 m)
D. of hoop 11/16 in (.017 m)

History:
collection of Henry Walters; Laura F. Delano; gift of Laura F. Delano, 1946-47

Ring with Carnelian Intaglio 642
18th century

A carnelian intaglio carved with the head of Aesculapius, god of healing, and a staff entwined with a snake, is set in an 18th-century gold ring. The border of the oval bezel is engraved with stylized flowers and leaves and the shoulders with husks and feathers. Plain hoop. (42.1108)

D. 5/8 in (.012 m) H. of intaglio 5/8 in (.016 m)

History:
collection of Duke of Marlborough, cat. no. 251; purchased by Henry Walters at Joseph Brummer sale, New York, 1942
Notes:
The benign, Jupiter-like features compare with those in the British Museum, (H. B. Walters, *Catalogue of the engraved gems and cameos, Greek, Etruscan and Roman,* London, 1926, no. 1686).

Ring with Carnelian Intaglio 643
18th century

Gold ring with oval, carnelian intaglio. Wreathed imperial head. Oval bezel, convex back chased with sunflower. Foliate scrolled hoop, split shoulders each enclosing a terminal figure. (57.1797)

D. 3/4 in (.020 m) H. of intaglio 9/16 in (.019 m)
History:
collection of Henry Walters; Laura F. Delano; gift of Laura F. Delano, 1946-47

Marks:
eagle's head, unframed; French warranty mark introduced 1838

Ring with Citrine Intaglio 644
18th century

Gold ring with citrine intaglio. Head of a young ruler wearing celestial crown, perhaps Elagabulus, Roman Emperor A.D. 218-222. Oval bezel with fluted sides formerly filled with white enamel. Back of bezel bears simulated cameo portrait of a young woman in white on a blue enamel ground. Tripartite channeled hoop. (42.1073)

D. 13/16 in (.017 m) H. of intaglio 5/8 in (.016 m)

History:
collections of Lord Chesterfield; Lord Bessborough, cat. no. 15 C, as Ptolemy; Duke of Marlborough, cat. no. 492; purchased by Henry Walters at Joseph Brummer sale, New York, 1942
Publications:
The Marlborough Gems, vol. II, no. 1, as Ptolemy Auletes; Worlidge, *A Select Collection,* no. 90

Ring with Hyacinthine Garnet Intaglio 645
18th century

The hyacinthine garnet, engraved with the head of Marcellus facing right, has been attributed to the English gem carver Nathaniel Marchant (1739-1816). Oval, open-backed bezel. Fluted hoop expanding at the shoulders. (42.1137)

D. 3/4 in (.018 m) H. of intaglio 5/8 in (.017 m)

History:
collection of Duke of Marlborough, cat. no. 411; purchased by Henry Walters at Joseph Brummer sale, New York, 1942

Ring with Sardonyx Cameo 646
18th century

Gold ring with sardonyx cameo. Wreathed head of Jupiter within a raised border with beveled edges. Oval bezel with clipped rim and open back, chaneled hoop. (42.1197)

D. 3/4 in (.018 m) H. of cameo 1-1/16 in (.026 m)

History:
collection of Duke of Marlborough, cat. no. 14; purchased by Henry Walters at Joseph Brummer sale, New York, 1942

Ring with Gold Relief 647
Late 18th century

A moulded, gold relief of Perseus holding the head of Medusa has been set against a dark, rough iron ground. This technique served as an alternative to reproducing engraved gems in glass or ceramics. The oval bezel has a raised edge and is attached to a plain hoop. (42.1220)

D. 11/16 in (.012 m) H. of relief 3/4 in (.018 m)

History:
collection of Duke of Marlborough, cat. no. 184; purchased by Henry Walters at Joseph Brummer sale, New York, 1942

Pair of Belt Clasps 648
English, 1780-1800

A pair of elliptical Wedgwood blue and white jasper medallions have been set in cut-steel frames. The use of faceted cut-steel studs to simulate jewels had occurred as early as the 17th century in the production of ornamental sword hilts. The practice was applied to jewelry in the 18th century and when used in conjunction with Wedgwood's ceramics it is generally associated with a factory established by Matthew Boulton in Birmingham in 1764. In these frames the filed and polished studs have been individually mounted on a base-plate of tin. Portrayed on the medallions, are scenes of sacrificing classical priestesses identical to those occurring on a tablet designed by Lady Templeton and Miss Crewe for Wedgwood's factory, Etruria, as noted in Eliza Meteyard's *Memorials of Wedgwood,* London, 1874, plate XXIV. (48.1770-71)

Medallions H. 2-17/32 in (.064 m)
Frames H. 3-5/16 in (.084 m)

History:
purchased by William and Henry Walters in Vienna, 1878

Necklace 649
French, late 18th century

With the disruption in the economy in the late 18th century these arose in France a fashion for jewelry rendered in non-precious metals. This neoclassical copper-gilt necklace is composed of a chain of flat wire links with subordinate loops, from which hang pendants in the form of spheres with rounded, arrowhead drops. (57.1738)

L. 17-1/2 in (.444 m)

History:
gift of Saidie A. May, 1945

Decoration 650
French, 1811

A gold eagle grasps in his talons thunderbolts between which hangs a medal by Bertrand Andrieu (1761-1822) and André Galle (1761-1844) commemorating the birth of the "King of Rome" in 1811. On the obverse of the medal are the double portraits of Napoleon I and Marie Louise and, on the reverse, the portrait of their infant son, Napoleon Francis Joseph Charles (1811-1832), the 'King of Rome.' On the obverse the medal is marked: *Andrieu F.* while the reverse reads: NAPOLEON F.J.C. ROI DE ROME GALLE / XX MARS / MDCCCXI. (57.951)

H. 1-1/4 in (.032 m) D. of medal 5/8 in (.016 m)

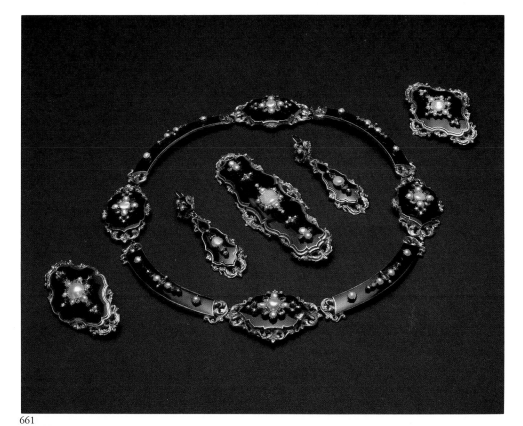

661

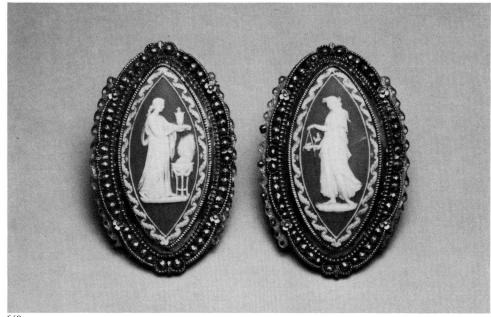

648

History:

acquired by W. T. Walters in 1892 from Pierre Sichel together with other Napoleonic memorabilia said to have belonged to Marshal H. G. Bertrand (1773-1844)

Notes:

A similar medal without the eagle mounting is listed in L. Bramsen, *Medaillier de Napoleon Le Grand: Le Consulat et L'Empire*, Paris, 1907, p. 24.

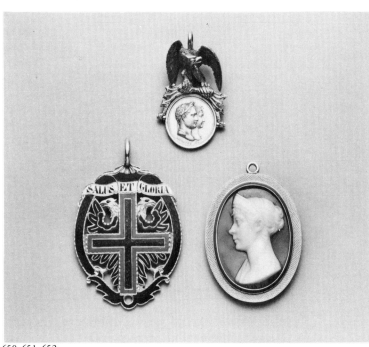

650, 651, 652

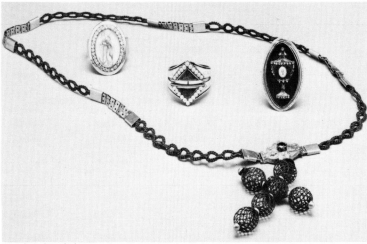

653, 654, 655, 656

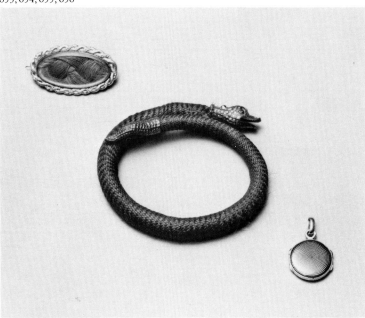

657, 658, 659

Order of the Starry Cross 651

Austrian, early 19th century

The order in red, blue, and black enamel on chased gold is inscribed on both faces: SALUS ET GLORIA. This Austrian order was acquired together with a portrait miniature (no. 628) of Princess Louisa Carlotta, daughter of Francis I, King of the Two Sicilies (1770-1830). In the miniature, the princess wears the order pinned to her left shoulder. A gold ring has been mounted on the top of the medal for suspension. (44.515)

H. 1-7/8 in (.047 m)

Marks:

The ring bears the Owl mark for gold imported into France from countries without customs conventions (1892).

Pendant with Cameo Portrait of Empress Josephine 652

Italian, about 1797

The work of Teresa Talani, this shoulder-length profile of the Empress is carved of white and grey agate. It is mounted in a finely chased gold frame with a blue enameled inner border. A loop has been applied for suspending the cameo. The cameo is signed at bottom: (TE)RESA TALANI. (42.202)

H. of frame 1-9/16 in (.039 m)

History:

This cameo was acquired with several miniatures by W. T. Walters, through his friend and advisor George A. Lucas, from the Paris dealer, Philippe Sichel in 1892. In a letter to Lucas, dated 27th July, 1892, Sichel reported that the objects belonged to the Marquis A. Biron who inherited them from his grandmother, the wife of Marshall Henri-Gratien Bertrand (1773-1844), who had accompanied Napoleon to Saint Helena.

Publications:

Anonymous, *The Walters Collection*, Baltimore, 1895, p. 102, no. 188, and subsequent Walters catalogues

Notes:

L. Forrer in *Biographical Dictionary of Medallists* (London, 1916, vol. VI, pp. 8-9), mentions an agate cameo of Josephine and Napoleon conjoined by this gem carver of Roman extraction who worked in Naples

Mourning Ring 653

English, about 1803-04

This bipartite ring bears on its hoop two inscriptions in gold lettering against a white enamel ground banded in black. They read: *C.M. BURNLEY. DIED. 3. MAR. 1804. AGED. 19* and *A.E. BURNLEY. DIED. 8 JULY. 1803. AGED 20.* The white enamel ground signifies that the deceased were unmarried. The bezel consists of two triangular sections, each containing a plait of hair beneath glass, framed with small white and grey pearls. The hair of the elder

brother was dark brown and the pearls employed, white, whereas the younger, had light brown hair which is shown with grey pearls. The two sections of the ring are held together by a pair of small pins and sockets. (44.528)

D. 3/4 in (.019 m)

Mourning Ring 654
American, about 1820

The large oval bezel bears a miniature in sepia on ivory showing Hope with her anchor mounted with a convex crystal and set with small, brilliant cut diamonds. (57.1875)

D. 13/16 in (.020 m)

History:
gift of Mrs. Charles E. Rieman, 1958

Brooch 655
English, 1785

This piece has been transformed from a mourning ring to a brooch by replacing the hoop with a pin. On the elongated, oval bezel a red enameled urn, outlined with rose cut diamonds, is set against a blue enameled ground. in the center of the urn is a white oval enclosing the letters *MG*. The reverse of the bezel contains a socket for hair, now removed, and is engraved: Mary Gilpin Ob. 14 Jan. 1785. Ae 39. (57.846)

H. 1-1/4 in (.032 m) D. 3/4 in (.019 m)

Hair Necklace and Pendant Cross 656
English, about 1850

A pendant cross composed of six spheres of woven hair connected with thin gold loops hangs from an embossed and chased hollow gold clasp set with a faceted garnet. The necklace is of loops of braided horsehair interspersed with sections of flat, gold links. (57.2046)

H. of cross 1-15/16 in (.049 m)
L. of necklace 18-1/4 in (.463 m)

History:
anonymous bequest, 1970

Mourning Brooch 657
English or American, about 1850

The oval, low-grade gold brooch bears beneath a crystal, a woven braid of brown hair. The face of the brooch is decorated with a machine-stamped braided border. (57.2060)

H. 3/4 in (.019 m) W. 1-5/16 in (.034 m)

History:
gift of Mrs. Sara D. Redmond

Serpent Bracelet 658
English ?, 1840s

The flexible bracelet is rendered in tightly woven hair with the serpent's head and tail of low grade gold. The serpent's head is

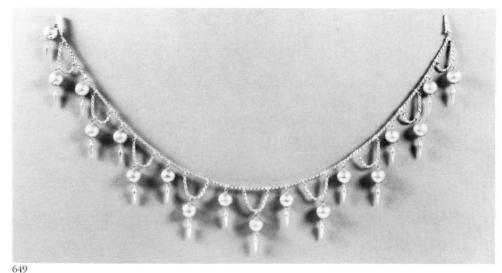

649

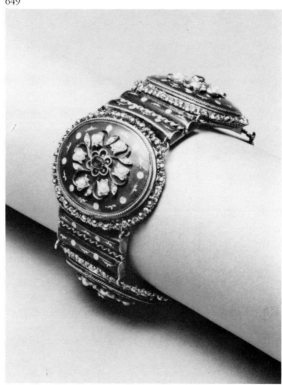

662

tufted, decorated with a scale pattern of stamped circles and set with red garnet eyes. The tail bears a similar scale pattern. (57.2059)

D. 2-9/16 in (.065 m)

History:
gift of Mrs. Sara D. Redmond

Locket 659
American, mid 19th century

The gold case of the circular locket is decorated with concentric bands of black enamel. Within the case is a plait of hair beneath a crystal. (57.1590)

D. 5/8 in (.016 m)

232

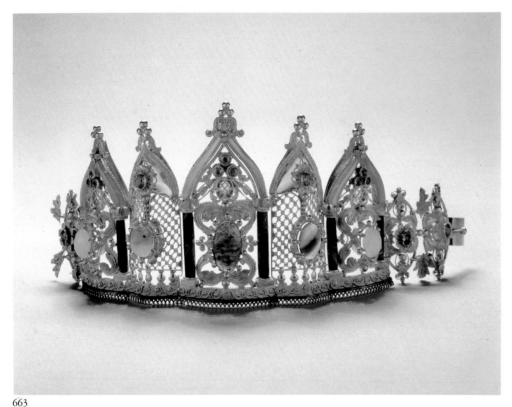
663

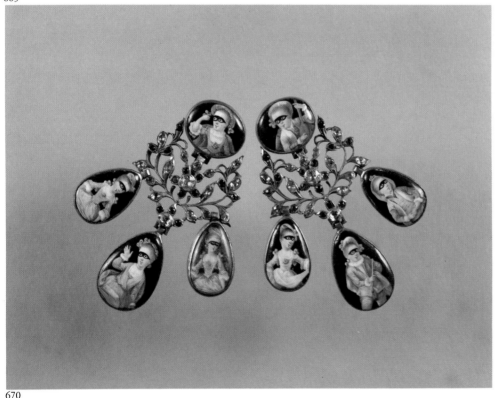
670

Brooch and Earrings 660

French, 1820s

The brooch is in the form of a bouquet of roses, thistles, rye-ears, and forget-me-nots, rendered in reddish gold and mounted *à jour* with brilliant and pendeloque diamonds. Bound around the stems of the flowers is a ribbon set with small diamonds. As is true of much 19th-century jewelry, the earrings have suffered later adaptations. The entire upper members, diamond-mounted studs with screw fittings, appear to be relatively modern, whereas the tripartite drops, with pendeloque and cushion diamonds mounted with prongs, are original. (57.1881)

H. of Brooch 2-9/16 in (.065 m)
L. of Earrings 1-1/2 in (.038 m)

History:
gift of Stanley L. Balmer, 1959
Marks:
The reverse of the ribbon on the stem of the floral bouquet is incised with the letter "E". An illegible 19th-century, French maker's mark in a vertical lozenge is visible on the pin of the brooch. The modern screw studs of the earrings are stamped *14 K*.

Parure 661

French, about 1835

In France in the 1830s and 40s machine-stamped jewelry of modest intrinsic value became popular. Characteristic is this parure or matching suite that includes a segmented collier or short necklace, a pair of long, pendant earrings, two brooches, and an elongated belt-clasp. The pieces are bordered by foliate scrollwork in stamped gold. Each is enameled black and set with half-pearls, emeralds and diamond sparks in clawed, silver collets, arranged in rosettes and lozenges. This jewelry is very light in weight and is composed of two layers of stamped metal, fastened by pins. Preserved with the jewelry is its case in scarlet, straight-grained, morocco leather with symmetrical designs in narrow line gouges and decorative, small toolwork, some picked out with colored inlays. (57.1927-31)

D. of necklace 4-11/16 in (.119 m) L. of earrings 2-1/2 in (.064 m) L. of belt-clasp 3-9/16 in (.091 m) W. of brooches 2-3/16 in (.055 m)

History:
bequest of Nelson and Juanita Greif Gutman, 1963
Marks:
Earrings: ram's head, Paris, restricted warranty, 1819-1838; Necklace: tongue marked with illegible maker's mark in a vertical lozenge

Bracelet 662

English ?, 1840-1850

The bracelet is composed of four oval medallions connected by rings to four concave-shaped interstices. These are enameled in cobalt blue and contain alternating rosette and sprig motifs in gold. Mounted in each medallion are curving tulip plants in raised,

flat gold wire, radiating from a central emerald in a gold collet. Half-pearls are set in each tulip blossom and leaf. The enameled ovals are bordered by twisted wire. Surrounding the medallions are gold bands of twisted flat wire and alternating spirals and spheres. The enameled interstices are divided by a twisted flat wire. The bracelet closes with a tongue and clasp and is provided with a safety chain. (57.1889)

L. about 8 in (.24 m) H. 1-9/16 in (.040 m)

History:
gift of L. Manuel Hendler, 1959

Bracelet 663
Austrian, 1830-1870

Five flamboyant gothic gold ogive arches are hinged together with the surviving three of five linked, foliate sections to form a bracelet. In the central and largest arch and in the two end arches the vaulting, outlined in carnelian rises from columns with leafy capitals of gold and shafts of malachite. Beneath these arches are mounted in intricate foliage, cabochon cut stones; moss agate in the center and moon-stones at the ends, and in their tympana are oval diaper grids, backed with cabochon cut amethysts, and surmounted by three faceted aquamarines. The two intervening arches are of gold with tympana of shaped amethysts faced with gold flowerets set with foil-backed rubies. Below the tympana are diaper grids in gold against which are set cabochon cut striped agates. All the arches rise from bases with running scroll and interlocking arcade ornamentation. They are topped by pinnacles with three spheres surmounting foliate crockets. Two of the three foliate sections of the bracelet band are mounted with foil-backed amethysts in gold flowerets and the other bears a ruby. Indentations in the fabric liner of the original leather case indicate that there were once two other foliate sections.

It has been suggested that this extraordinarily intricate piece of jewelry may have been intended for use in the theater or at a costume ball. Plausibly, this piece was initially a diadem which was later transformed into a bracelet with the two missing foliates sections being used for other purposes, perhaps as earrings. (57.1999)

H. 2-3/4 in (.069 m) L. 7 in (.177 m)

History:
collections of anonymous Austrian; Felix Laurence, Paris; Raphael Esmerian, New York; gift in memory of Paul Esmerian, 1972
Publications:
Dora Jane Janson, *From Slave to Siren, The Victorian Woman and Her Jewelry From Neoclassic to Art Nouveau*, Duke University, Durham, N.C., 1971, p. 36, no. 64, illus.

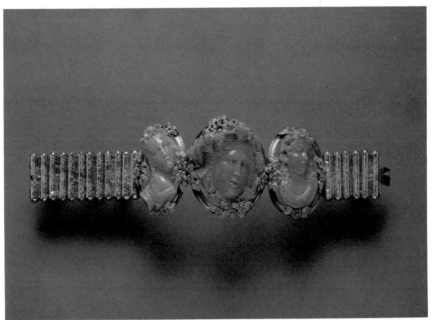

664

660

Bracelet 664
English or Italian, 1860s

The head of Bacchus and the busts of two bacchantes, carved in red coral, have been mounted in gold frames, convex in cross-section, festooned with finely chased blossoms. The flexible band is contrived of cylindrical gold links chased with floral designs. (57.1887)

H. 1-13/16 in (.046 m) L. about 6-3/4 in (.171 m)

History:
gift of Mrs. Bernard Trupp, 1959

665

666

667 668

Demi-Parure 665
Italian ?, 1860s-1870s

The head of a bacchante festooned with grapes and vine leaves and framed in a wreath of roses and leaves, with a pendant sprig of roses, carved in pink coral, is mounted on a gold wire frame to form the brooch. Accompanying it are two pairs of earrings, one composed of branches of roses with heads of bacchantes and the other with the roses alone. In each piece the rose leaves are separately mounted on gold wire stems. (57.1855 a-c; 57.1857 a-b)

H. of Brooch 2-3/4 in (.070 m) L. of Earrings 1-7/8 in (.048 m) H. of Earrings 1-1/2 in (.038 m)

History:
gift of Miss Josephine C. Morris, 1955
Marks:
Weevil in oval, gold imported into France from countries with customs conventions, introduced 1864

Demi-Parure 666
English, 1870s

This demi-parure comprised of a brooch and a pair of earrings exhibits the naturalism prevalent in English jewelry of the 1870s. In the earrings bunches of grapes, rendered in coral beads, hang from twigs with leaves of finely chased, bloomed gold. A bunch of larger grapes in coral with gold leaves is mounted in the center of the brooch. Its stem is twisted and looped to form the framework of the brooch. The demi-parure has been kept in its black leather case. (57.2048 a-c)

D. of brooch 1-3/4 in (.044 m)
L. of earrings 1-7/8 in (.048 m)

History:
gift of Mrs. J. Griswold Webb

Brooch with Sulphide Relief 667
English or American, 1860s

A large oval, faceted glass crystal is mounted in an elaborate scrollwork frame of pinchbeck, a copper-zinc substitute for gold. Embedded in the crystal is a white, sulphide relief of Leda and the Swan. The sulphide technique of enclosing porcellaneous reliefs within crystals was patented in England by Apsley Pellatt in 1831. (57.2014)

H. 1-5/8 in (.041 m) W. 2-1/8 in (.054 m)

History:
gift of Mrs. John N. Adkins, 1972

Brooch 668
Swiss, mid 19th century

A stag and a doe are set in a minutely carved woodland scene. The border of overlapping branches is tinted black. Such pieces once thought to have originated in Dieppe in the 1840s are now believed to have been made in Switzerland for the growing tourist trade in the 19th century. (71.1160)

H. 1-9/16 in (.040 m)

History:
gift of Mrs. Cyril Keene, 1977

Pair of Earrings and Brooch 669
Italian ?, 1840s

The earrings and brooch in the form of a cross are executed in gilded, base metal filigree with vine leaf motifs and flowerettes, and set with table cut quartz crystals. The earrings are formed of three-sided drops dependant from upper members, which separate to form stud earrings. (57.1860 a-c)

H. of earrings 3-1/8 in (.079 m)
H. of cross 1-5/16 in (.033 m)

History:
gift of Mrs. Nelson Gutman, 1956

Pair of Earrings 670
Italian ?, 1830s

These pieces are characteristic of girandole earrings, a form popularized in the 18th century and revived during the 1830s when women's hairstyles again permitted the display of such jewelry. The wire suspension hooks, now missing, were mounted on the backs of oval silver members faced with painted enamels. These members carry openwork, silver, floral sections set with variously colored faceted stones from which, in turn, hang the three pear-shaped drops characteristic of the girandole form. In this instance the drops are silver, faced with painted enamels rather than the more usual faceted stones. In all the enamels, masked youths and ladies are portrayed. (44.524-25)

H. 2-7/16 in (.061 m)

Marks:
Weevil in rectangle, French warranty mark for silver imported from countries with customs conventions, introduced 1893

Pair of Earrings 671
Venetian ?, 1840s

The faceted cat's-eye drops surrounded by flat wire, scrollwork set with alternating, square, table cut, diamonds, emeralds and single rubies, depend from faceted cat's-eye beads. (57.1768-69)

H. 2-9/16 in (.065 m)

History:
collection of Luigi Grassi (sale, New York, American Art Association, January 1927, no. 414); Mrs. Henry Walters (sale, New York, April, 1941, no. 1278, $30.00); gift of Melvin Gutman, 1946

Pair of Earrings 672
French, about 1850

Small earrings became fashionable in France in the 1850s. The heads of this pair in enameled gold are in the form of Black-a-Moors wearing turbans. Their chests are enameled green. Three small ruby pastes are set in the rims of each of their turbans and larger oval, ruby pastes are mounted in their chests. (44.581-82)

H. 1 in (.025 m)

Marks:
Eagle's head in double outline without frame, Paris, restricted warranty mark for gold introduced 1847

Pair of Earrings 673
Bavarian ?, mid 19th century

In this pair of enameled, gold earrings, the heads are in the form of Black-a-Moors. They wear green headgear set with three ruby pastes and green shirts with white collars decorated with blue dots and set with one large and two small ruby pastes. The gold suspension hooks are hinged to the bases of the Black-a-Moors. (44.526-27)

H. 7/8 in (.022 m)

Notes:
Eugene Fontenay in *Les Bijoux Anciens et Modernes*, (Paris, 1887, p. 128) mentions a somewhat similar pair of earrings which he attributes to Augsburg.
Marks:
ET in rectangle for gold and silver imported to Paris from countries without customs conventions, introduced 1864

Brooch with Cameo
Bust of Ellen Walters 674
Italian, after 1862

Mrs. William T. Walters, born Ellen Harper (1822-1862) is shown bust-length in a shell cameo. A signature on the cameo, which was initially deciphered as being that of Luigi Saulini (1819-1883) is now thought to be that of his father, Tommaso Saulini (1793-1864), who founded the popular stone and shell cameo business in Rome about 1836. The cameo is based on a marble bust of Mrs. Walters (WAG, no. 2818) carved in Rome, the year of her death by her friend, the Maryland sculptor, William H. Rinehart (1825-1874).

The oval gold mounting, decorated on its face with twisted wire and coil decoration and on its edges at top and bottom with filigree palmette and wave designs, bears on the back the reversed C's of the Castellani firm. Another cameo with this subject belongs to Walters' descendants in Pennsylvania. (57.2001)

Cameo H. 2-1/4 in (.057 m) Frame H. 2-5/8 in (.067 m)

History:
gift of Mrs. Frederick B. Adams, 1972 (granddaughter of subject)
Publications:
William R. Johnston, "Luigi Saulini's Cameo Portrait of Ellen Walters," *BWAG*, vol. 30, no. 6, March 1978

Brooch with the Cameo Spring 675
Italian, after 1874

The shell cameo showing the personification of Spring strewing flowers is based on a lost marble relief executed by the American sculptor William H. Rinehart in Rome in 1874. It is mounted in an Italian gold frame

674

675

decorated with twisted wire and chain designs. This brooch is one of several known to have been commissioned in Rome by W. T. Walters. (57.854)

Cameo H. 2-1/8 in (.054 m) Brooch H. 2-9/16 in (.650 m)

Publications:
Philippe Verdier, "A Rediscovered Cameo After W. H. Rinehart," *BWAG,* vol. 14, no. 8, Baltimore, May 1962, p. 1, illus.

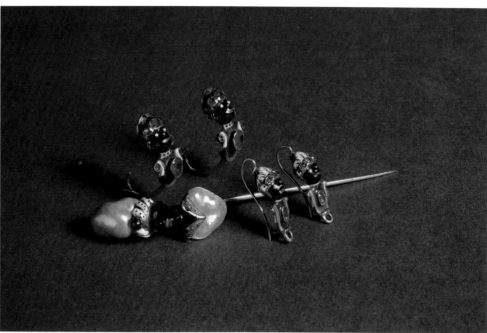

673, 672, 694

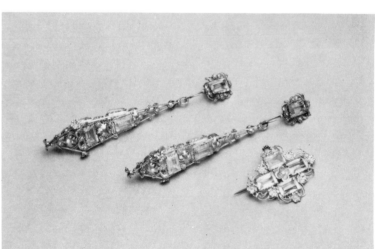

669

671

Pendant 676
French, possibly Bourg-en-Bresse, 19th century

A basket of flowers in enameled copper-gilt is suspended by a gold chain from an upper gold section. Dangling between the chains is a pink topaz. The chains are composed of double ringed members strung in the middle with small seed pearls. Both the basket and the top section are enameled pale blue with foliate wheel motifs in pink and white. The flowers are in three tiers: the lowest of small globules of enamel, the middle of blossoms with individually enameled petals and stamens and the top of three large blossoms in the centers of which are gold bosses set with faceted crystals. A bird with white and pink plumage is perched in the center of the basket. This attractive, colorful pendant exemplifies the unsophisticated qualities associated with 19th-century peasant jewelry. (44.520)

H. 3-1/8 in (.080 m)

Marks:
An eagle's head is stamped in a loop on the reverse of the top section.

Brooch 677
French, Normandy, 19th century

This brooch is characteristic of peasant jewelry made in areas relatively unaffected by the stylistic developments of the major urban centers. The brooch, divided into two segments connected in the center by a looped band, is rendered in pierced openwork gold set with small brilliants. The crest at the top of the brooch and several of the sections of the pierced scrollwork are decorated with engraved motifs. This piece has been broken at the upper right side. (57.1107)

L. 3-1/2 in (.088 m) D. 2-7/8 in (.073 m)

Notes:
A more elaborate pendant of this type has been published in M.D.S. Lewis, *Antique Paste Jewellery,* Boston, 1970, plate 34.
Marks:
The back of the crest bears a maker's mark composed of a letter (illegible), a key, and the letter Y in a lozenge, and two warranty marks in the form of an eagle's head, unframed, facing right, similar to the 1838 eagle's heads of Paris. The loop connecting the two members and an adjoining area of the upper member are stamped with a chariot, the restricted warranty mark for the North District of France, 1819-1838.

"Archaeological jewelry" refers to 19th-century goldsmiths' work simulating in appearance ancient jewelry that had been excavated in Italy. Although there were predecessors, the Roman jewelers, Fortunato Pio Castellani (1793-1865) and his sons Alessandro (1822-1883) and Augusto (1829-1914) are generally regarded as the principal proponents of the style. Fortunato Pio Castellani was in business in Rome by 1814-15 and by the 1830s, had turned to the archaeological style working in association with the antiquarian, Michelangelo Caetani, duca di Sermonetta (1804-1883).

Castellani was determined to emulate the marvelous granulation and filigree decoration of Etruscan jewelry which he had had the opportunity to study at first hand while advising the Papal government on purchases of goldwork from the Regolini Galassi tomb discovered at Cervetri in 1836. The eventual, partial success of the firm in this endeavor, was attributed by the Castellanis to their discovery of peasant jewelers in the village of Sant'Angelo in Vado, where techniques had allegedly been preserved since Antiquity. Current research indicates, however, that it was Alessandro Castellani who learned to approximate the ancient technique of applying granulation and filigree with colloidal hard soldering by substituting an arsenite flux with an impalpably fine solder, a technique that he had evolved by the mid-sixties as was demonstrated at the Exposition Universelle of 1867.

Other notable practitioners of Archaeological Jewelry included the Neapolitan, Carlo Guiliano (1831-1895), who opened a workshop in London in 1860, after having been associated with the Castellanis while they were exiled in Naples following the abortive 1848 revolution in Rome, and Giacinto Melillo (1846-1915), who also trained in Naples with Alessandro Castellani. Giuliano worked in a number of other revivalist styles becoming famous for his superb enameling, whereas Melillo apparently adhered to the goldsmith traditions of the Castellanis although he also turned to silversmithing in the archaeological style winning the Grand Prix and the Legion of Honor at the Exposition Universelle of 1900.

In April, 1903, Henry Walters made substantial purchases at the firm of Giacinto Melillo. Unfortunately, the surviving receipts do not specify the works acquired, many of which were not retained in the Walters collection. However, it is assumed that the signed necklace and the other unsigned necklaces and bracelet were acquired on this occasion.

676

677

678

684

685, 687, 686

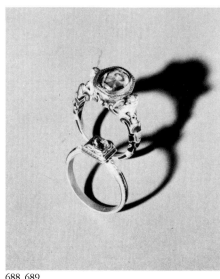

688, 689

Bracelet 678
Italian, 1860s

A helmeted warrior is represented at shoulder-length in a rose, brown, white and umber colored circular agate cameo cut in high relief. The cameo's gold frame is decorated with twisted wire and rosettes encircling its face. The bracelet band in the archaeological style consists of seven loop-in-loop chains terminating in clasps hinged by eyes and loops. Flexible fasteners at the ends are inserted into slits in the frame of the central cameo. A large decorative knot in thick gold wire slides the length of the bracelet band. Around a section of this knot is a wire loop suggesting that the bracelet may once have been equipped with a safety chain or a pendant. (57.1993)

D. of cameo 1-11/16 in (.043 m) D. with frame 2-3/16 in (.055 m)

L. of bracelet 7-5/8 in (.193 m)

History:
purchased from S. J. Phillips & Son, London, 1971
Marks:
The reversed "C's" of the Castellani firm appear on the back face of both the clasps of the bracelet.

Necklace 679
Italian, before 1903

Gold necklace in the archaeological style by Giacinto Melillo, composed of alternating opened and closed palmettes connected by a pair of loop-in-loop chains extending through eyes on the back of each section. The chains end in clasps of oblongs with palmette terminals bordered in beading. A small frog is mounted on each clasp. All the palmettes are decorated with rosettes and their petals are delineated by a filigree of tightly twisted wire. Nineteen Egyptian and pseudo-Egyptian steatite and lapis lazuli scarabs, in partially beaded frames are attached to the closed palmettes of the spherical beads. (57.1530)

L. 14-7/16 in (.367 m)

Marks:
Signature on clasp: G. Melillo/Napoli

Necklace 680
Italian, before 1903

Gold necklace in the archaeological style attributed to Giacinto Melillo. Composed of granulated beads alternating with cylindrical beads to which are fastened mounted scarabs, strung over a concealed loop-in-loop chain. At the ends of the necklace are cylindrical beads with eye hooks. The superbly granulated spherical beads are decorated with rosette, leaf and circular motifs. Around each cylindrical bead, at the ends and in the center, are rings flanked by twisted wire decoration. The Etruscan scarabs are mounted in beaded frames with granulated saw-tooth edges and palmette motifs at top and bottom. Issuing from the ends of the

scarab frames are pyramids of ten granules. The twenty-three sard scarabs are engraved *a globolo* with figurative and animal motifs, and are graduated in size as are the spherical beads. This necklace presents many similarities in appearance to an Etruscan necklace of carnelian scarabs excavated at Canino and presented to the British Museum (no. 2273) as part of the Castellani collection in 1872. (57.1531)

L. 16-3/4 in (.425 m)

Necklace 681
Italian, before 1903

Gold necklace in the archaeological style. Strung over a concealed loop-in-loop chain are cylindrical beads carrying intaglios, biconical beads, and twisted wire loops from which are suspended pearls. The Roman intaglios are of plasma and are graduated in size. They are set in gold frames decorated with twisted wire borders, lateral bosses and triangles of ten granules each, at their bottoms. The necklace is attributed to Giacinto Melillo. (57.1533)

L. 14-3/8 in (.365 m)

Necklace 682
Italian, before 1903

Gold necklace in the archaeological style. The beads are strung over a concealed loop-in-loop chain. Arranged in sequence are biconical beads, small cylindrical beads from which are suspended granulated spherical drops, and larger cylindrical beads to which are fastened intaglios. The necklace ends in eye loops which may have been connected by an S-hook now missing. The cylindrical beads are decorated with tightly twisted wire loops. Engraved on the Roman intaglios, which are variously colored in sardonyx, moss agate, striped agate and rock crystal, are representations of ancient deities and heroes. Each intaglio is mounted in a gold frame decorated with twisted wire with gold bosses at each side and triangles of ten granules each at the bottom. The piece is attributed to Giacinto Melillo. (57.1534)

L. 14-1/4 in (.361 m)

Necklace 683
Italian, before 1903

Gold necklace in the archaeological style. Attributed to Giacinto Melillo, it is composed of cylindrical beads, biconical beads and beads of six interconnected gold spheres strung over a concealed loop-in-loop chain terminating in a hook and eye fastener. From the cylindrical beads, which are decorated with loops of tightly twisted wire, are mounted twenty-five Roman, variously colored, chalcedony, sardonyx and agate intaglios in frames decorated with loops of

twisted wire and pyramids of ten granules. Gold bosses on both sides of each frame serve to separate the intaglios. The intaglios are graduated in size and apart from the central piece which shows a Julio-Claudian emperor, are engraved with representations of deities. (57.1535)

L. 17 in (.431 m)

Bracelet 684
Italian, before 1903

Gold bracelet in the archaeological style. Attributed to Giacinto Melillo, it consists of a band of twelve, Roman variously colored, chalcedony, sardonyx, and moss agate intaglios, separated by bars composed of three rods, connected by wire loops and mounted on a pair of loop-in-loop chains. At the top and bottom of the frame of each intaglio is a triangle of the granules. The bracelet is fastened by two pairs of pin-and-socket connectors. (57.1532)

L. 7-1/2 in (.190 m)

Nineteenth Century Rings

Ring 685
Italian, about 1800

Gold, marquise bezel with foiled dark blue enamel ground set with a pearl framed in filigree volutes in an openwork border of pairs of filigree spirals and alternate pearls and gold beads. Plain hoop, forked shoulders enclosing twin filigree spirals. (57.1783)

H. of bezel 1-3/16 in (.031 m) D. of hoop 3/4 in (.019 m)

History:
collection of Henry Walters; Laura F. Delano; gift of Laura F. Delano, 1946-47

Marks:
Four badly worn, illegible marks appear on the back of the bezel.

Ring 686
French, 19th century in 18th-century style

Gold, silver collets, openwork giardinetti bezel, formed as a vase of flowers, set with a sapphire, diamonds, rubies and peridots. Openwork hoop with foliate shoulders. (57.1780)

H. of bezel 1 in (.025 m) D. of hoop 11/16 in (.018 m)

History:
collection of Henry Walters; Laura F. Delano; gift of Laura F. Delano, 1946-47

Marks:
C M in a lozenge, unidentified maker after 1793; eagle's head, unframed, Paris, gold restricted warranty, 1838 and later

Ring 687
French, 19th century in Louis XVI style

Gold, silver collets, marquise bezel with faceted topaz within a double border enclosing openwork wreath all set with diamonds.

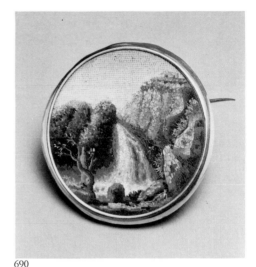

690

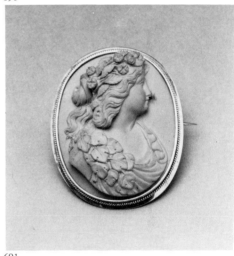

691

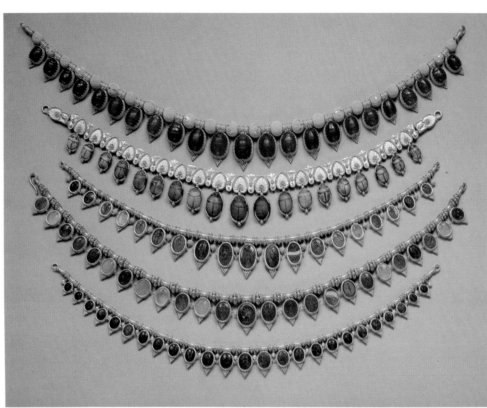

680, 679, 682, 683, 681 (top to bottom)

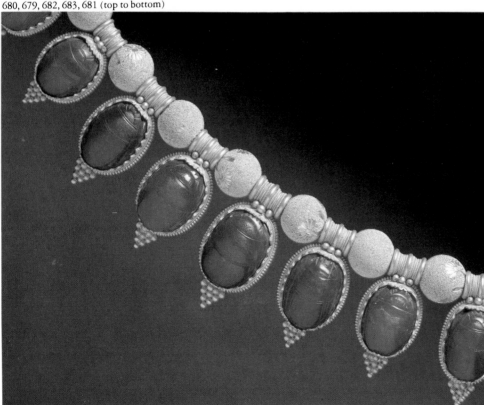

680 detail

Double hoop, shoulders pierced with chevrons. (57.1749)

H. of bezel 1-7/16 in (.037 m) D. of hoop 13/16 in (.021 m)

History:
collection of Henry Walters; Laura F. Delano; gift of Laura F. Delano, 1946-47
Marks:
illegible maker's mark

Ring 688

French, mid 19th century

Gold, raised hexagonal fluted bezel with a miniature portrait of a lady in 16th-century costume under faceted crystal. Convex hoop with winged terminal figure at the shoulders, enameled and set with diamonds. A neo-renaissance ring. (57.1779)

H. of bezel 1/2 in (.013 m) D. of hoop 3/4 in (.019 m)

History:
collection of Henry Walters; Laura F. Delano; gift of Laura F. Delano, 1946-47
Marks:
Eagle's head, unframed: France, Paris, gold restricted warranty, manufactured in France, 1838-1847

Ring 689

Spanish, 19th century ?

Gold, reeded box bezel set with diamonds in quatrefoil collet, enameled red and black. Hoop partially enameled green. (57.1794)

H. of bezel 1/4 in (.07 m)

History:
collection of Henry Walters; Laura F. Delano; gift of Laura F. Delano, 1946-47

Brooch 690

Italian, early 19th century

A circular mosaic executed in fine glass tesserae showing the waterfalls at Tivoli is mounted in a plain gold frame equipped with a pin and eye. (43.46)

D. 2 in (.050 m)

History:
collection of George W. Kosmak, M.D.; gift of Miss Katharine Kosmak and Mr. George Kosmak
Notes:
Glass tesserae mosaics, produced in the Vatican workshops, figured prominently in the Papal States' displays in 19th-century expositions and were a common item in the tourist trade.

Brooch 691

Italian, mid 19th century

Mounted in a gold frame is an oval, grey lava medallion showing the head of a pseudo-classical bacchante facing right, carved in high relief. The frame is decorated with a single strand of twisted wire. Lava jewelry generally originated in the region of Pompeii. This example is preserved in a black leather case bearing within its lid the name

and address of the retailer in New York: TIFFANY & CO. / [550] B.WAY / NEW YORK. Tiffany & Co. was located at 550 Broadway from 1854 until 1870. (41.257)

H. of medallion 1-7/8 in (.048 m) H. of brooch 2-1/16 in (.052 m)

History:
gift of Mrs. J. Griswold Webb

Tie and Stick Pins

Horse-Head Stick-Pin 692
American or English, about 1880

The animal's head on the gold pin is carved in intaglio in the crystal and then naturalistically painted. (57.1122)

D. 7/8 in (.022 m) L. 3-1/8 in (.079 m)

History:
Presumed to have been purchased by William or Henry Walters at Tiffany and Co.
Notes:
Reverse painted intaglios of animals were made popular in England in the 1860's by the firm of Hancock and Co. This technique was subsequently adopted by Tiffany and Co., New York, (see Charlotte Gere, *American and European Jewelry,* New York, 1975, p. 195). There is some question as to whether such stick-pins with intaglios were manufactured in the United States or imported from England by Tiffany and Co.
Marks:
TIFFANY / CO.

Tiepin with Tooth 693
American, 1875-1900

An incisor tooth is mounted by a gold chain to the bead head of this gold pin. The shaft of the pin is twisted. (57.1238)

L. of pin 3 in (.076 m) L. of tooth 31/32 in (.024 m)

Black-a-Moor Stick-Pin 694
French, mid 19th century

The head of the gold pin is in the form of a Black-a-Moor with an enameled face. Both his turban and chest are baroque pearls. The rim of the turban is in white enamel with diagonal rows of black dots and is set with a red paste. This decorative motif was introduced to France from Italy in the 18th century. (44.583)

L. 3-3/4 in (.095 m)

Marks:
Eagle's head, double outline, unframed, Paris restricted warranty, introduced 1847; illegible anvil mark

Eagle Tiepin 695
American, 1875-1900

The head of this pin is in the form of an eagle rendered in pavé set small diamonds. It is hinged to the gold pin which is twisted to grip the fabric of the tie. (57.1109)

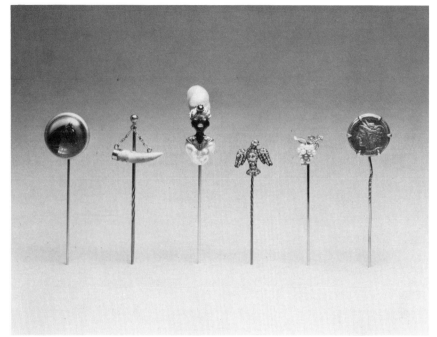

692, 693, 694, 695, 696, 697

L. of pin 2-7/16 in (.062 m) W. of head 3/4 in (.019 m)

Stick-Pin With Grapes 696
American, about 1910

The head of the pin is in the form of a cluster of grapes made of thirteen seed pearls of varying hues. Three leaves are added, each of gold faced with platinum with a small diamond brilliant inset. (57.1984)

L. 2-7/8 in (.073 m)

History:
bequest of August Mencken, 1967
Notes:
The pin belonged to the donor's brother, H. L. Mencken. It is preserved in its original, unmarked, leather case.

Tiepin with Greek Coin 697
American, 20th century

The head of this pin consists of a Greek coin, a Carthage Stater of the 340-242 B.C. period, showing the head of Persephone. It is mounted by six claws to a reinforced gold circle which is attached to the gold, twisted pin. It was worn by Henry Walters. (59.699)

D. 7/8 in (.022 m) L. 3-5/16 in (.084 m)

History:
gift of Mrs. John Russell Pope, 1947

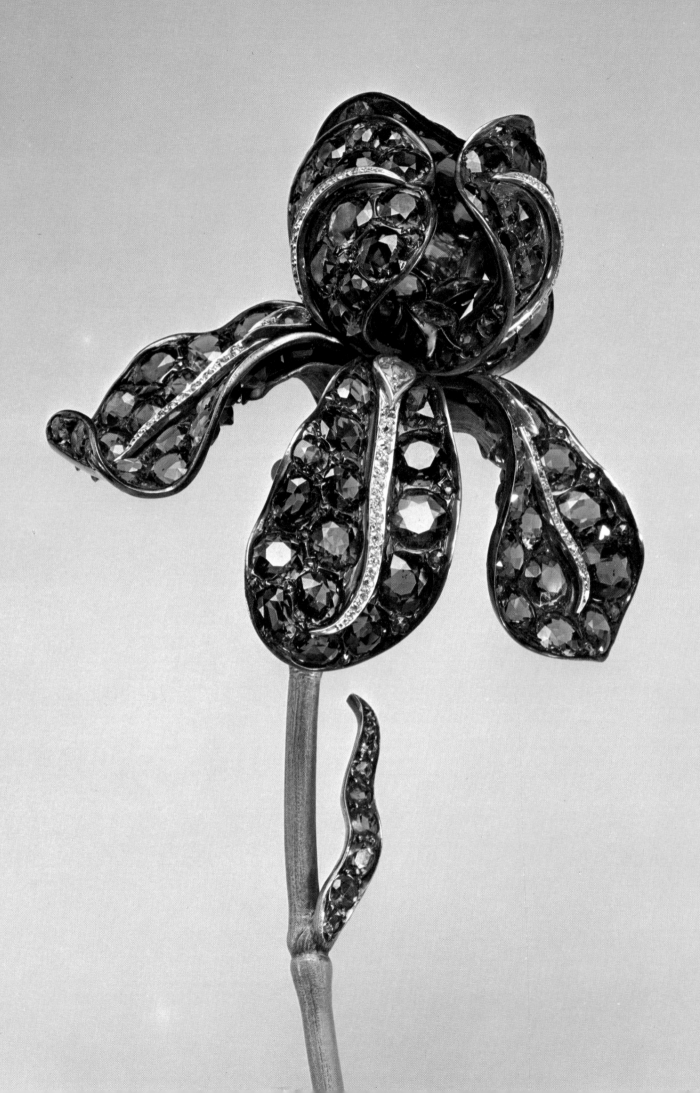

Tiffany and Co.

The famed firm began in New York in 1837 as the fancy goods shop, Tiffany and Young, and four years later became Tiffany, Young and Ellis. Goods imported from the Orient and fine quality paste jewelry were included in the early stock. In 1848 the Paris branch opened. Two partners withdrew from the business in 1853 leaving Charles Lewis Tiffany (1812-1902) sole proprietor until 1868, when the firm was incorporated. Under the direction of Edward C. Moore, Tiffany's silver department won international acclaim for its innovations, including the importation of Japanese techniques and designs. Tiffany's however, was best known in the late 19th century for its spectacular jewelry characterized by the lavish use of precious stones. Tiffany's success in this regard can in part be attributed to its gem specialist George F. Kunz, the distinguished mineralogist and champion of American gems and pearls.

Iris Corsage Ornament 698
Tiffany and Co., New York, about 1900

This fabulous large brooch is in the form of an iris, naturalistically treated. The blossom is comprised of three upright petals or "standards," three drooping sepals or "falls," and three small style branches, all in oxidized silver set with faceted blue sapphires varying in intensity of color and hue as well as in size. All together one-hundred and twenty sapphires appear. These are listed in the Tiffany and Co. catalogue as being of American origin. Ribs of diamond sparks set in platinum have been applied to the three falls and to two of the standards. The bearding of the falls is suggested by citrines mounted in gold, shaped collets. The blossom emerges from a long, etched gold stem from which spring three leavelets or spathes rendered in demantoid garnets mounted *à jour* in gold frames. (57.939)

698

H. of blossom 2-3/4 in (.069 m)
L. with stem 9-1/2 in (.241 m)

History:
believed to have been purchased by Henry Walters at Tiffany and Co.
Publications:
Anonymous, *Tiffany and Co.'s Exhibit, Paris Exposition Universelle,* New York, 1900, p. 5
Marks:
TCO monogram

701

700

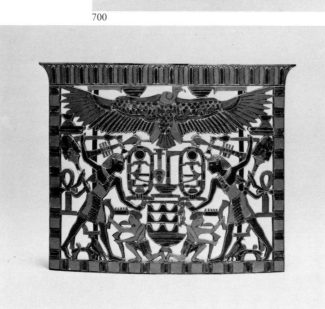

702

Pearl Pendant 699
Tiffany and Co., New York, 1900-1910

Mounted in a platinum cage is a large, ovoid, mauvish pink pearl of the Common Conch (Strombus gigas). The cage, which is hinged at the base to open, is comprised of five bands of leaves and blossoms rendered in platinum, set with minute diamond sparks. A foliate cluster, surmounting the cage, turns to allow the bars to be disengaged. The pendant is suspended from a long trace chain of equal oval links. Every thirtieth link is set with a diamond spark. (57.2034)

Weight of pearl 4.71 grams L. of chain 20 in (.509 m)

History:
purchased by Henry Walters from George F. Kunz at Tiffany and Co., New York; he subsequently presented it to his niece Laura Delano; gift of Miss. Laura F. Delano

Marks:
Eagle's head, restricted warranty

Ring 700
Tiffany and Co., New York, last quarter of the 19th century

This small, annular ring is composed of a braided gold wire to which a wire spiral of six coils has been soldered. Suspended from the spiral are four pendants, each comprised of a pearl and faceted coral bead. The ring is preserved in a red leather box stamped in gold letters TIFFANY & CO. / UNION SQUARE, the address of the firm from 1870 to 1905. (57.2051)

D. 9/16 in (.014 m)

History:
gift of Mrs. Sara D. Redmond

Nautical Ring 701
Tiffany and Co., New York, 1893

A large aquamarine, with its table engraved to show a bell and a compass, is set in a gold ring. The shoulders are in the form of mermaids holding anchors whose tails intertwine to complete the shank. Large fish accompany the mermaids. This ring presumably belonged to Henry Walters, an enthusiastic yachtsman. (57.1123)

D. 19/32 in (.015 m) L. of stone 7/8 in (.022 m)

Marks:
A globe is superimposed on the letter "T". This mark was applied to wares made specially for the World's Columbian Exposition, Chicago, held in 1893. The ring has been kept with its original chameleon-skin box marked *Tiffany & Co./New York/Paris-London.*

Buckle in Form of Egyptian Pectoral 702

French or American, early 20th century

This piece is a replica of the pectoral of Queen Mereret of the XII dynasty discovered in the excavations of J. de Morgan at Dahshur in 1894 (Cairo Museum, no. 52003). The enameler has rendered in red, blue and brown enamels on silver gilt the appearance of the Egyptian original which is of gold inlaid with carnelian, lapis lazuli and faience. The piece is in the form of a kiosk. Above, the vulture Nekhebet holds the signs of life and stability. Below, King Amnenemes III, in opposed halves, strikes with a mace his bedouin foe. The king's prenomen is in a central cartouche. The enamel colors, particularly the red, are darker in hue than the colors of the original pectoral. The reproduction is also smaller than the Egyptian pectoral (3-3/16 in x 4-1/8 in) (.079 m x .104 m). (57.1482)

H. 2-15/16 in (.075 m)

History:
presumed to have been purchased by Henry Walters from Tiffany and Co.

Publications:
Edward S. King and Marvin C. Ross, *Catalogue of the American Works of Art,* Baltimore, 1956, p. 59, no. 218

Necklace with Pendant 703

Hungarian, late 19th century

From a silver-gilt chain in scrolled openwork, set with small turquoises and seed pearls, is suspended an elaborate pendant. The upper section of the pendant is composed of a round turquoise bordered with seed pearls and tiny turquoises and flanked by a pair of winged griffins, each set with a pearl and a turquoise. The central and largest member of the pendant bears a large, oval turquoise, also bordered with seed pearls and turquoises within a raised, foliate silver-gilt border. Below, hangs a turquoise surrounded by seed pearls. The segments are all backed in cast, silver-gilt, openwork. (57.872)

L. of chain 22-1/4 in (.565 m)
H. of pendant 4-1/4 in (.108 m)

History:
purchased in Budapest, 1929

Marks:
The tongue of the clasp is marked with KT in trapezoid for the maker, P for Pesth; and a greyhound's head in a lozenge, the Austrian-Hungarian warranty mark (1866-1922)

704, 703, 705

699

Hungarian, late 19th century

The band is made up of six oval members each composed of alternating, concentric, stepped rows of turquoises and seed pearls. In the center of each, with the exception of the central member, there is a single, raised oval turquoise in a silver collet. The center of the central, and largest member is a large turquoise flanked by two small turquoises, enclosed by a twisted wire. Each member is backed with an elaborately scrolled, cast, openwork plate and is connected to its adjoining section by a pair of links. (57.873)

L. 7-1/2 in (.191 m)

History:
purchased in Budapest, 1929
Marks:
Tongue marked KT in trapezoid for maker; P for Pesth; and a greyhound's head in lozenge, the Austrian-Hungarian warranty mark (1866-1922)

Bracelet 705
Hungarian, late 19th century

In this bracelet a large rectangular element is flanked by four smaller, rectangular elements connected by pairs of links. The middle section is mounted with a central turquoise surrounded by rows of seed pearls and small turquoises, four turquoises in each corner bordered by seed pearls, and four half-pearls placed in between. The smaller sections are mounted with oval turquoises surrounded by rows of seed pearls and turquoises. The reverse is backed with cast, silver-gilt, openwork. (57.880)

L. 7-3/4 in (.197 m)

History:
purchased in Budapest, 1929
Marks:
KT in trapezoid for maker; P for Pesth; and a greyhound's head in a lozenge, the Austrian-Hungarian warranty-mark, 1866-1922

René Jules Lalique
French, 1860-1945

Lalique, who was born in Ay in 1860 and died in Paris in 1945, was one of the most imaginative designers in the history of jewelry. He utilized a wide array of precious and non-precious materials to create works that bridged the traditional division between the fine and the industrial arts. After training in Paris and briefly in London, Lalique began to draw designs for the leading jewelry houses in Paris producing a number of compositions for naturalistic, floral pieces rendered in diamonds. In 1885 he was able to acquire the fully manned and equipped atelier of Jules Destape and to turn to the fabrication of his own pieces. Five years later he established a larger studio with fittings of his own design on 20 rue Thérèse. It was here between 1891 and 1895 that two series of jewels were produced for the actress Sarah Bernhardt in her roles of Iseyl and Gismonda. In 1895, the year he received a third class medal for a controversial figurative corsage at the exhibition of the *Société des Artistes français,* his jewelry was also featured among the works in various media by the most progressive international artists of the period, assembled by Samuel Bing for the *Salon de l'Art nouveau.* Perhaps the apogee of Lalique's career as a jeweler was the *Exposition universelle* of 1900. Many of the extraordinary, large, and at times bizarre pieces produced for this event have been preserved in the Calouste Gulbenkian Foundation in Lisbon. Although he continued to exhibit jewelry in international exhibitions at the beginning of this century, Lalique's interests were gradually being diverted to the manufacture of art glass. In 1909, the year he received a contract from Coty for the production of perfume bottles, Lalique acquired a glass works at Comb-la-Ville near Paris and in 1921 he moved to a larger factory at Wingen-sur-Moder, Alsace, where he continued to produce the moulded glass for which he is noted until World War II.

It was at the Saint Louis World's Fair of 1904 that Henry Walters purchased the Lalique jewelry presently in the Gallery. The Walters' pieces are not among those listed in the French Section of the *Catalogue général officiel de l'exposition universelle de Saint-Louis* (Paris, 1904, p. 44) and therefore they were presumably shown in Lalique's own exhibits of *Objets et bijoux d'art,* no. 27, in Département D, Manufactures, Palais des Manufactures.

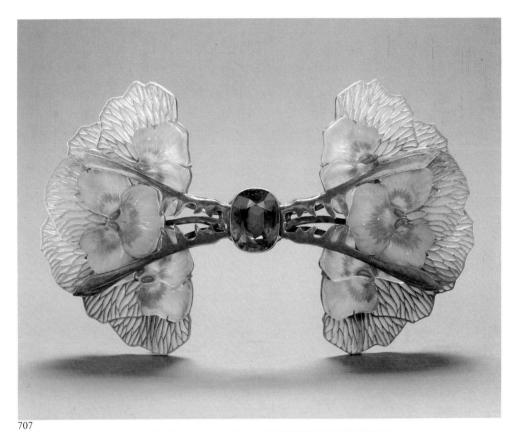

707

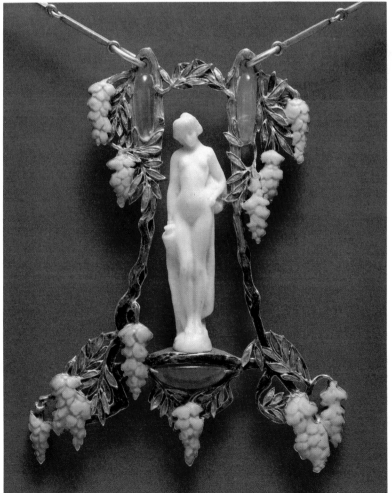

706

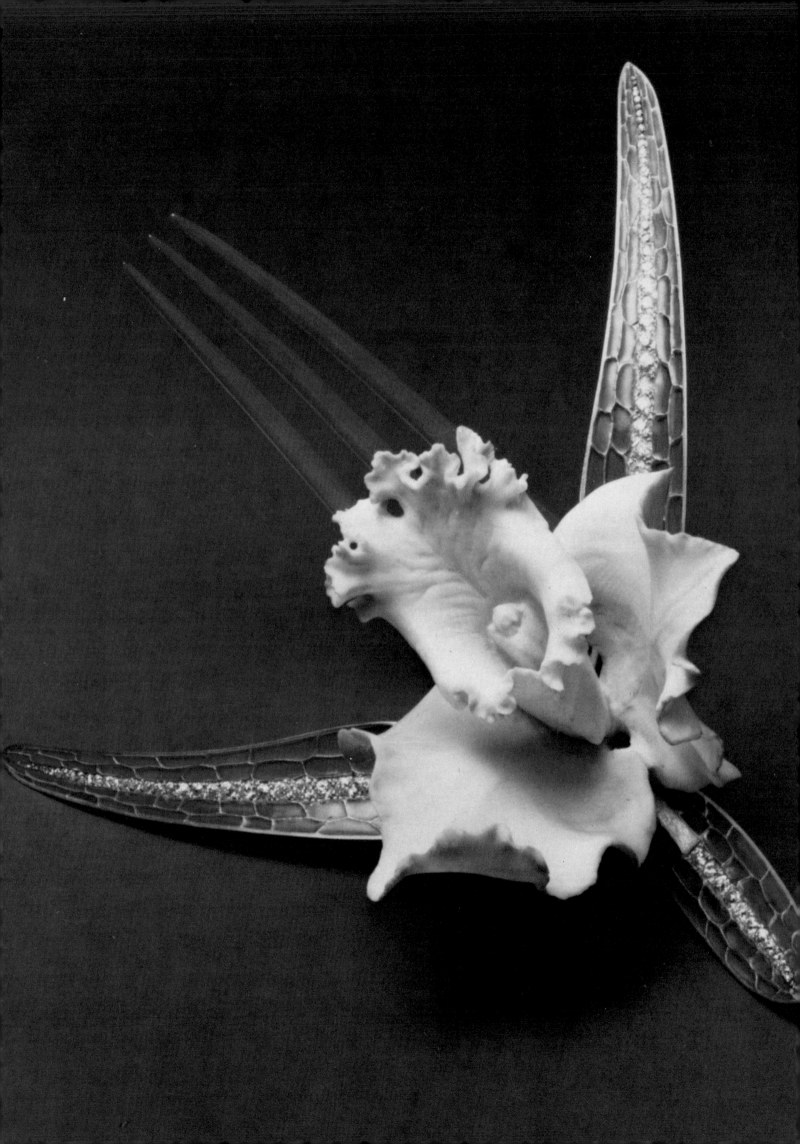

Lalique Pendant and Necklace 706
French, about 1902

A partially draped, female figure holding a pitcher (*La Source*), carved of ivory, is surrounded by wisteria vines with the stalks enameled deep blue, leaves, green, and blossoms, opalescent white. Rounded pale orange Mexican opals are set in the vines above her head on either side and below her feet. The chain is composed of blue enameled elongated links and gold rings. The reverse of the pendant is carefully tooled but is not enameled. (57.941)

H. of pendant 3-1/8 in (.079 m)
L. of chain 22 in (.559 m)

History:
acquired by Henry Walters at the Saint Louis World's Fair, 1904, as *No. 53, Pendant,* for $600.00
Publications:
Henri Vever, *La bijouterie française au XIXe siècle,* Paris, 1906-08, III, illus. p. 739; Barten, *René Lalique,* p. 330, no. 678; Emile Sedeyn, "A travers les Expositions," *L'Art Decoratif,* Paris, 1903, vol. 14, p. 229
Marks:
on left edge: *LALIQUE*

Lalique Pansy Brooch 707
French, about 1903-04

From a large, faceted, cornflower blue, simulated step cut sapphire in a gold collar with blue enameling extend pairs of leaves enclosing stems of three overlapping pansies. Translucent blue enamel varying in depth, covers these leaves and stems. Each pale blue blossom is composed of a layer of moulded glass with varying tints of blue, attached by prongs to *plique-à-jour* enameled petals below. The flower clusters are fastened together by small screws and are hinged to the central unit. (57.943)

H. 3-1/6 in (.081 m) W. 5-1/2 in (.139 m)

History:
acquired by Henry Walters at the Saint Louis World's Fair, 1904, as *No. 32, Pin,* for $2,000.00
Publications:
Randall, "Jewellery Through The Ages," p. 79, fig. 18; Barten, *René Lalique,* p. 414, no. 1061
Notes:
Similar blossoms occur in a "Pansy Necklace" illustrated in Marc and Marie-Claude Lalique, *Lalique par Lalique,* Paris, 1977, p. 39

Lalique Orchid Comb 708
French, about 1903-04

The orchid comb carved from a single piece of ivory is set on a gold stem striped with brown enamel. Three leaves extend from the base of the blossom rendered in *plique-à-jour* enamel graduated in hue from delicate peach to pale olive. The central vein of each leaf begins with a short section of light grey enamel and is followed by a row of graduated diamonds. Brown enamel covers portions of the leaves, both front and back. The stem is attached by a gold hinge to a three-pronged horn comb. (57.936)

H. 5-1/4 in (.133 m)
L. including comb 7 in (.178 m)

History:
acquired by Henry Walters at the Saint Louis World's Fair, 1904 as *No. 1 Diadem* for $1,000
Publications:
Barten, *René Lalique,* p. 175, no. 302; Graham Hughes, *Jewelry,* London, 1966, illus. p. 32
Notes:
An orchid comb with a more complicated blossom and set with a topaz, made between 1897 and 1900, was made for the *Exposition Universelle* of 1900 and is now in the Calouste Gulbenkian Foundation, Oeiras, Portugal.
Marks:
The word *LALIQUE* is marked on the upper edge of the right leaf.

Lalique Brooch of Leaves and Berries 709
French, about 1903

The brooch, of three parts connected by hinges, is composed of elongated leaves in mottled brownish-green enamel and berries of translucent glass mounted with prongs to olive-toned, enameled grounds. Within the central unit is mounted a cushion-shaped faceted citrine of champagne color. (57.940)

H. 2-5/8 in (.067 m)

History:
acquired by Henry Walters at the Saint Louis World's Fair, 1904, as *No. 38, corsage ornament representing snowballs,* for $700.00
Publications:
Barten, *René Lalique,* p. 412, no. 1055, (drawing no. 1055a); Henri Vever, *La bijouterie française au XIXe siecle,* Paris, 1906-08, III, p. 765
Marks:
marked at top edge of central section: *LALIQUE*

Lalique Opal and Diamond Brooch 710
French, about 1903-04

A large cushion-shaped opal is mounted in a silver-gilt frame set with small diamonds of varying size. Extending laterally are diamond-set stalks which terminate in two layers of fern leaves. The four uppermost, mounted with prongs, are of opalescent cameo glass tinted with soft hues of green and silver enamel. The lateral segments are hinged to the central unit to permit movement. (57.935)

H. 2-3/4 in (.070 m)

Facing: Lalique Orchid Comb (no. 708)

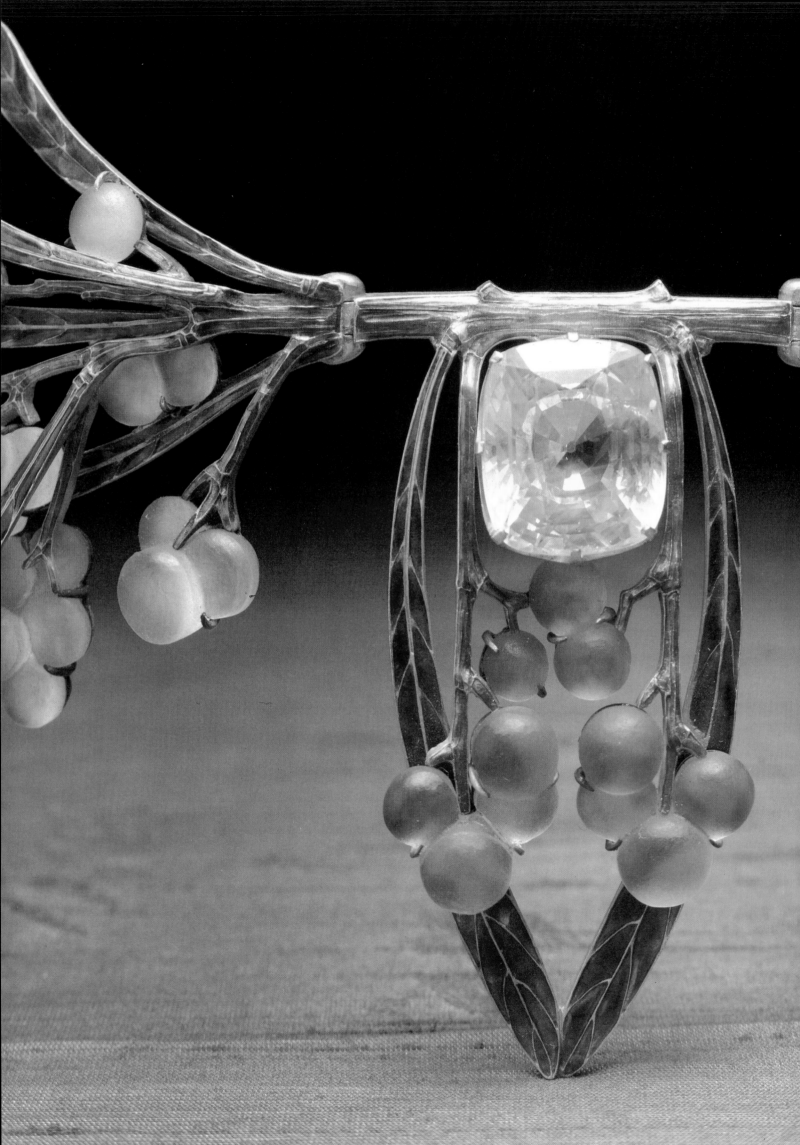

History:
acquired by Henry Walters at the Saint Louis World's Fair, 1904, as *No. 34, Pin,* for $900.00
Publications:
Barten, *René Lalique,* p. 414, no. 1060A
Marks:
marked at top edge of opal mounting: *LALIQUE*

Lalique Brooch with Fruit Clusters 711
French, about 1903

A large pale pink pearl is surrounded by leaves and fruit of laurel extending from a short central stalk. The branches are enameled brown and the leaves are covered with thin white, translucent enamel. The clusters of fruit are carved of white mother-of-pearl. (57.942)

H. 1-7/16 in (.037 m)

History:
acquired by Henry Walters at the Saint Louis World's Fair, 1904, as *No. 24, Pendant...one pink pearl 38 1/2 g. 1/32* for $1,800.000
Publications:
Barten, *René Lalique,* p. 412, no. 1053
Marks:
reverse of top, right leaf: *LALIQUE*

Lalique Grape Necklace 712
French, 1903-04

Stylized elongated clusters of grapes alternate with leaf and vine formations in gold with green *cloisonné* enamel. The ten grape clusters are of moulded, translucent glass and are attached by prongs to green enameled grounds. (57.937)

D. 5-1/4 in (.133 m) L. of grape clusters 2-1/8 in (.054 m) W. of vine formations 1-5/16 in (.034 m)

History:
acquired by Henry Walters at the Saint Louis World's Fair, 1904, as *No. 42* for $750.00
Publications:
Barten, *René Lalique,* p. 246, no. 346 (with preparatory sketch no. 246a)
Marks:
marked on clasp: *LALIQUE*

Lalique Brooch with Nude Woman 713
French, about 1902

A gold, kneeling nude woman, with her body turned at the waist and her arms raised behind her head, is placed against a curvilinear, symmetrical gold framework set with small diamonds. Enameled, auburn-colored hair cascades behind her. (57.944)

H. 1-1/2 in (.038 m)

History:
acquired by Henry Walters at the Saint Louis World's Fair, 1904, as *No. 22, Pendant,* for $350.00
Publications:
Barten, *René Lalique,* p. 321, no. 650.1
Marks:
in center of bottom edge: *LALIQUE*

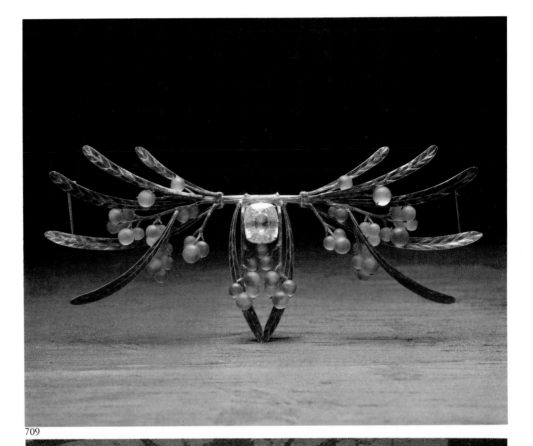

709

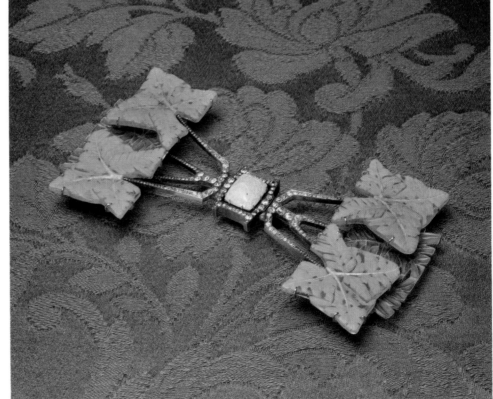

710

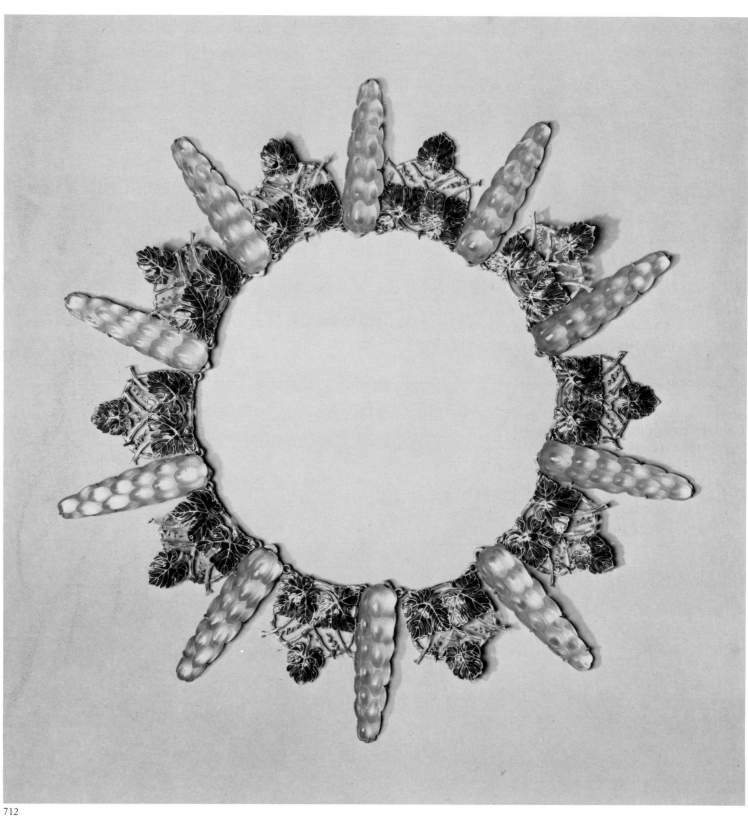

Lalique Tiger Necklace 714

French, about 1903-04

Reliefs of horn carved with striding cats alternate with pointed, brown tortoise-shell shaped feline incisory teeth. Beneath each cat is a polished, rounded triangle of brown agate mounted in gold. A claw extends from each side of the relief. The teeth and claws are set in gold mounts that are hinged together to form the necklace. The greenish gold sections are worked to suggest foliage and are tinted with brown enamel. (57.938)

D. 4-1/2 in (.144 m) L. of teeth 2-3/8 in (.061 m) W. of reliefs 2-1/8 in (.054 m)

History:
purchased by Henry Walters at the Saint Louis World's Fair, 1904; listed separately in surviving invoices.
Publications:
Randall, "Jewellery Through The Ages," p. 79, fig. 19; Institute for the Arts, Rice University, and The Art Institute of Chicago, *Art Nouveau, Belgium, France,* 1976, no. 415; Barten, *René Lalique,* p. 247, no. 349
Marks:
marked on clasp: *LALIQUE*

Ring 715

Louis Rosenthal, American, 1920s

Louis Rosenthal, born Leon Chatel, in Plungyan, Lithuania, in 1887, trained briefly in art in Vienna and Berlin before migrating with his family to Bird's Nest, Virginia in 1907. As a youth, he moved to Baltimore where he enrolled in the Rinehart School of the Maryland Institute under Ephraim Keyser. About 1918 he began to model in wax and cast in gold working for local jewelers, notably Maurice Caplan, and for dentists. During the twenties he earned considerable acclaim as a sculptor of miniatures exhibiting successfully at the Fifth Avenue Gallery in New York in 1925 and receiving a commission to execute the Balfour Monument presented by American Jews to the Earl of Balfour in recognition of his support for a Jewish homeland in Palestine. He was, as a result, elected a member of the Royal Society of Miniature Painters and Sculptors. In 1927, the Baltimore collector Jacob Epstein presented twenty-two miniature bronzes by Rosenthal of mythological subjects to the Baltimore Museum of Art. After 1940, Rosenthal turned to working in a larger scale. He died in this city in 1964.

This cast, gold ring showing a mermaid embracing a satyr as well as a resting cupid is said to illustrate P. B. Shelley's poem "Love's Philosophy." The sculptor modeled the ring in wax and cast it using a suction pump to draw the molten gold into the mould. (57.1838)

D. 5/8 in (.016 m) H. of bezel 7/8 in (.022 m)

History:
presented by Amelia A. Muller in memory of her parents Mr. and Mrs. James Clay Muller, 1950

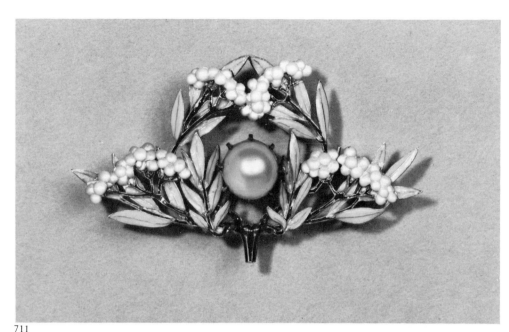

711

715

714 detail

713

Index of Abbreviated Titles

Aldred, *Jewels* Aldred, Cyril, *Jewels of the Pharoahs: Egyptian Jewelry of the Dynastic Period,* Praeger, New York, 1971

Alexander, *Jewelry* Alexander, Christine, *Jewelry: The Art of the Goldsmith in Classical Times,* The Metropolitan Museum of Art, New York, 1928

Amandry I Amandry, Pierre, *Collection Hélène Stathatos, Bijoux antiques,* Strasbourg, 1953

Amandry III Amandry, Pierre, *Collection Hélène Stathatos, Objects antiques et byzantins,* Strasbourg, 1963

ABC *Antiquités du Bosphore Cimmerien,* Imperial Archaeological Commission, St. Petersburg, 1854

Barten, *René Lalique* Barten, Sigrid, *René Lalique: Schmuck und objets d'art, 1890-1910,* Munich, 1978

Becatti, *Oreficerie* Becatti, Giovanni, *Oreficerie antiche, dalle minoiche alle barbariche,* Rome, 1955

Breglia, *Napoli* Breglia, Laura, *Le oreficerie del Museo Nazionale di Napoli,* Rome, 1941

Canby, *Ancient Near East* Canby, Jeanny Vorys, *The Ancient Near East in The Walters Art Gallery,* Baltimore, 1974

Canby, "New Egyptian Jewelry" Canby, Jeanny Vorys, "New Egyptian Jewelry at The Walters Art Gallery," *Journal of the American Research Center in Egypt,* vol. VI, 1967, pp. 111-112

Catalogue general Catalogue général des antiquités Égyptiennes du musée du Caire, Service des antiquités de l'Égypte, Institute Français d'archéologie oriental, Cairo

Cleveland, "Exhibition of Gold" Cleveland Museum of Art, "Exhibition of Gold," October 31, 1947 — January 11, 1948

CMS *Corpus der Minoischen und Mykenischen Siegel,* Akademie der wissenschaften und der literatur, Mainz, Berlin, 1964

Deér, "Mittelaltarliche Frauenkronen" Deér, Josef, "Mittelaltarliche Frauenkronen in Ost und West," *Monumenta Germaniae Historica,* Schriften, vol. XIII/2, Stuttgart, 1738-1951

"Exhibition of Gold," *BCMA* "Exhibition of Gold," *The Bulletin of the Cleveland Museum of Art,* no. 9, November, 1947

Furtwängler, *AG* Furtwängler, Adolf, *Die antiken Gemmen, Geschichte der Steinschneidekunst im Klassischen Altertum,* 3 vols., Leipzig-Berlin, 1900

Greifenhagen, *Berlin I* Greifenhagen, *Berlin II* Greifenhagen, Adolf, *Schmuckarbeiten in Edalmetall,* Staatliche Museen Preusischer Kulturbesitz, Antikenabteilung, Berlin, I, 1970; II, 1975

Hackens, *Classical Jewelry* Hackens, Tony, *Classical Jewelry,* Providence, Museum of Art, Rhode Island School of Design, 1976

Hadaczek, *Ohrschmuck* Hadaczek, Karl, *Der Ohrschmuck der Griechen und Etrusker,* Vienna, 1903

Higgins, *Greek and Roman Jewellery* Higgins, Reynold A., *Greek and Roman Jewellery,* London, 1961

Hoffmann and Davidson, *Greek Gold* Hoffman, Herbert and Patricia F. Davidson, *Greek Gold: Jewelry from the Age of Alexander, Mainz,* 1965

BMCR Marshall, Frederick H., *Catalogue of the Finger Rings, Greek, Etruscan and Roman,* in the Departments of Antiquities, British Museum, London, 1907

BMCJ Marshall, Frederick H., *Catalogue of the Jewelry, Greek, Etruscan, and Roman,* in the Departments of Antiquities, British Museum, London, 1911

Minns, *Scythians and Greeks* Minns, Ellis H., *Scythians and Greeks,* Cambridge, 1913

Montelius, *Civilisation primitive en Italie* Montelius, Oscar, *La Civilisation primitive en Italie depuis l'introduction des metaux,* Stockholm and Berlin, 1895-1910, (2 vols.)

Muller, *Jewels in Spain* Muller, Priscilla E., *Jewels in Spain, 1500-1800,* The Hispanic Society of America, New York, 1972

Otchët Otchët Imperialistichago Archeologicheskago Obshchestva, Saint Petersburg, irregularly from 1888

Romans and Barbarians Museum of Fine Arts, *Romans and Barbarians,* Boston, 1977

Pareti, *Regolini Galassi* Pareti, Luigi, *La tomba Regolini Galassi,* Rome, 1947

PAFA, *Golden Jubilee Exhibition* Pennsylvania Academy of Fine Arts, *Golden jubilee fiftieth annual exhibition of miniatures antique and contemporary,* Philadelphia, October 27 - December 2, 1951

Petrie, *Amulets* Petrie, W. M. Flinders, *Amulets, Illustrated by the Egyptian Collection in The University College, London,* London, 1914

Pfeiler, *Römischer Goldschmuck* Pfeiler, Barbara, *Römischer Goldschmuck des ersten und zweiten Jahrhunderts n. Chr. nach datierten Funden,* Mainz, 1970

Pharmakowski, "Russland" Pharmakowski, B., "Russland," *AA,* 29, 1914

Randall, "Jewellery Through the Ages" Randall, Richard H. Jr., "Jewellery Through the Ages," *Apollo,* December, 1966

Randall-MacIver, *Villanovans* Randall-MacIver, David, *Villanovans and Early Etruscans,* Oxford, 1924

Ross and Downey, "An Emperor's Gift" Ross, Marvin C. and Glanville Downey, "An Emperor's Gift—And Notes on Byzantine Silver Jewelry of the Middle Period," *JWAG,* vol. XIX-XX, 1956-7

Ross, *Migration Period* Ross, Marvin C., *Arts of the Migration Period,* Baltimore, 1961

Steindorff, *Catalogue* Steindorff, George, *Catalogue of the Egyptian Sculpture in The Walters Art Gallery,* Baltimore, 1946

Steingräber, *Alter Schmuck* Erich Steingräber, *Alter Schmuck,* Munich, 1956

The Marlborough Gems Story-Maskelyne, M. H. Nevil, *The Marlborough Gems,* London, vol. I, 1780; vol. II, 1791, illustrated by Bartolozzi, reissued in London, 1845

Strom, *Etruscan Orientalizing Style* Strom, Ingrid, *Problems Concerning the Origin and Early Development of the Etruscan Orientalizing Style,* Odense, 1971

A. Jay Fink Collection of Miniatures The Walters Art Gallery, *The A. Jay Fink Collection of Miniatures,* January 21–March 1, 1964

Byzantine Art The Walters Art Gallery, *Early Christian and Byzantine Art,* Baltimore, 1947

Williams, *Catalogue* Williams, Caroline Ransom, *Gold and Silver Jewelry and Related Objects,* Catalogue of Egyptian Antiquities, numbers 1–160, The New York Historical Society, New York, 1924

Williamson, *Catalogue of the miniatures* Williamson, George C., *Catalogue of the collection of miniatures the property of J. Pierpont Morgan,* London, 1906-08

The Dark Ages Worcester Art Museum, *The Dark Ages,* Worcester, Massachusetts, February 20–March 21, 1937

Worlidge, *A Select Collection* Worlidge, Thomas, *A Select Collection of Drawings from Curious Antique Gems,* London, 1798

Zahn, *Galerie Bachstitz* Zahn, Robert, *Galerie Bachstitz, s'Gravenhage, II, Antike, byzantinische, islamische Arbeiten der Kleinkunst und des Kunstgewerbes, Antike skulpturen,* Berlin, 1921

Zahn, *Schiller* Zahn, Robert, *Sammlung Baurat Schiller, Berlin, Werke antiker Kleinkunst,* Rudolph Lepke's Auctions-Haus, Berlin, Auction-Catalogue, March 19-20, 1929

Periodicals

AJA *American Journal of Archaeology,* (from 1885)

AK *Antike Kunst,* (Olten, from 1958)

BCH *Bulletin de Correspondance Hellenique,* (Paris, from 1877)

BMMA *Bulletin of The Metropolitan Museum of Art,* (New York, from 1905)

BMFA *Bulletin of The Museum of Fine Arts,* (Boston, from 1903)

BWAG *Bulletin of The Walters Art Gallery,* (Baltimore, from 1948)

Drevnosti *Drevnosti Trudy Imperatorskago Moskovskago Archeologicheskago Obshchestva*

AA *Jahrbuch des Deutschen Archäologischen Instituts. Archäologischer Anzeigen.*

JRGZM *Jahrbuch des Römisch-Germanischen Zentralmuseums Mainz,* (Mainz, from 1954)

JIAN *Journal International d'archéologie numismatique,* (Athens, from 1898–1927)

JWAG *Journal of The Walters Art Gallery,* (Baltimore, from 1938)

MAAR *Memoirs of the American Academy in Rome,* (Bergamo and Rome, from 1917)

ML *Monumenti antichi pubblicati per cura della Reale Accademia dei Lincei,* (Milan and Rome, from 1889)

NSc *Notizie degli Scavi di Antichità,* (Rome, from 1876)

SE *Studi Etruschi,* (Florence, from 1927)